ARTS OF THE EAST

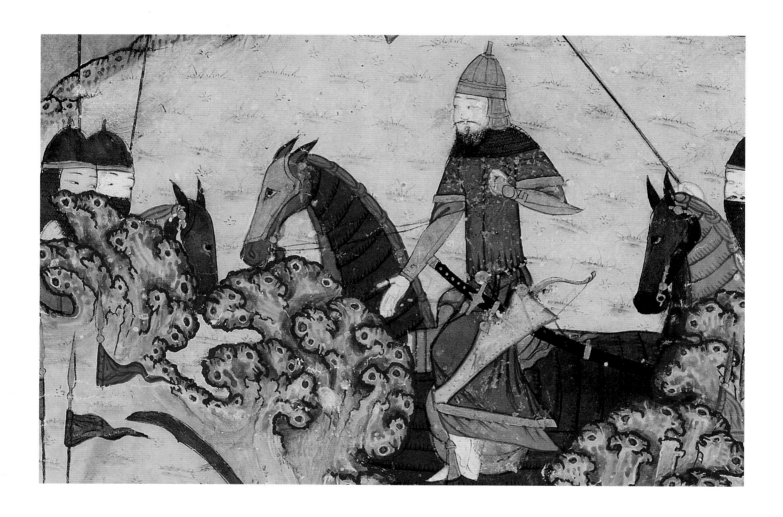

Detail from
Sultan Mahmud, Shah of Delhi, Retreating from Timur (Cat. No. 11)
Folio from a manuscript of *Zafarnameh* (Book of Victory) by
Sharaf al-din 'Ali Yazdi (d. 1454); Shiraz, Iran, 1436; opaque watercolour,
ink, and gold on paper; 28.5 × 19.3 cm

ARTS OF THE EAST

HIGHLIGHTS OF ISLAMIC ART FROM

THE BRUSCHETTINI COLLECTION

Edited by Filiz Çakır Phillip

 AGA KHAN MUSEUM HIRMER The Bruschettini Foundation for Islamic and Asian Art

CONTENTS

FOREWORD

A number of foundations in the world of Islamic art have made and continue to make notable contributions to advance the discipline. In Italy and Europe at large, particularly in its home base of Genoa, The Bruschettini Foundation for Islamic and Asian Art is renowned for its valuable work in the fields of Islamic art education, conservation, and scholarly endeavour.

With *Arts of the East: Highlights of Islamic Art from the Bruschettini Collection*, the Aga Khan Museum and the Bruschettini Foundation have joined forces to present for the first time in North America, and indeed the world outside Italy, an impressive selection of the Foundation's superb works of art, handpicked by Alessandro Bruschettini from a collection he has assembled over many years of dedicated connoisseurship.

There is much I could focus on in *Arts of the East*, but let me single out five outstanding objects, starting with the collector's perhaps greatest passion: carpets. In particular, the Simonetti-Bardini Dragon Carpet (Cat. No. 36) from the Caucasus is especially striking and is one of the oldest (1500–50) Caucasian rugs still in existence. Textiles are also an important element of the Bruschettini Collection. One of the silk sections featured in this exhibition might well be a fragment from a Mongol tent from the thirteenth century (Cat. No. 22). I find it intriguing that here we could have a connection with someone like Genghis Khan's grandson, Hülegü, the founder of the Ilkhanid dynasty (1256–1353).

Moving to metalwork and a different empire, this time the Mamluk (1250–1517), I am struck by the exquisite lines and shape of a brass bowl (Cat. No. 4) that likely originated in either Egypt (the Mamluks' base) or Syria and dates to the mid-fourteenth century. A ceramic bottle (Cat. No. 6) from the early sixteenth century is an exceptional representative of the world-famous Iznik wares the Ottoman Empire (1299–1923) was so justly celebrated for.

Lastly, we have some extraordinary examples of Islamic miniature paintings from manuscripts. One of these, from the early years of Iran's Safavid dynasty (1501–1736), presents a painting contest between Greek and Chinese artists (Cat. No. 15). The scene is taken from the *Masnavi-i Ma'navi* (Spiritual Couplets) by Rumi (d. 1273), Iran's renowned Sufi poet. What is really interesting about this painting is that it seeks to get at the very essence of art and how artists interpret nature. What is real? What is illusion? And how does art reflect either? Also fascinating about this painting is how it expresses what I think is one of the chief characteristics of *Arts of the East* — the way the exhibition clearly establishes the cross-cultural links

and mutual aesthetics that existed during the centuries that all of the objects in this catalogue were created.

That sentiment brings me back to the subject of foundations that promote and foster Islamic art. A driving force in that venture is the desire to build bridges between cultures and encourage social and educational exchanges of all kinds between peoples. The Aga Khan Museum seeks to do that, and so does the Bruschettini Foundation.

On behalf of the Aga Khan Museum, I want to thank Alessandro Bruschettini for sharing part of his collection with us and allowing us to partner in the spirit of pluralism once again. In order to spread diversity globally, we have to ensure the health and expansion of an interdependent world where different cultures and faiths can co-operate and understand one another. *Arts of the East* demonstrates that there was a time when others, too, thought this.

Henry S. Kim
Director and CEO, Aga Khan Museum
Toronto

FOREWORD

I encountered art very early in life. Our family library was particularly well stocked with illustrated art books. These books not only opened the door to my discovery of Western art but to the great traditions of Oriental art, as well. Upon entering that door, I was instantly left spellbound. An early trip to Paris proved fortuitous as both the Louvre and the Guimet museums granted me my first face-to-face encounter with many *objets d'art* from the ancient East, India, and China. Sometime later, after my first visit to the Arab-Norman city of Palermo, it was London's turn to show me its collections of Islamic art that were visibly abundant in the city's museums.

Just after entering my twenties, a trip to Egypt uncovered all the splendours of Cairo — a city to which I would return years later for a few weeks' stay at the time of the celebrations for Cairo's first 1,000 years since its Fatimid foundation. That stay afforded me an excellent opportunity to explore, with Creswell's maps in hand, the medieval part of Cairo. I also made numerous unforgettable visits to the Arab Museum and the National Library, where I saw some of the greatest masterpieces of Islamic art.

In the following years, whenever possible, I began taking a series of targeted trips to Spain, North Africa, Turkey, Syria, Iran, Afghanistan, and India. There, my interest focused on the direct experience of the great Islamic art tradition. The superb synthesis of form and colour that characterizes Islamic architecture and its decoration — the Minaret of Jam, as an exceptional example — was before my eyes. The long list of monuments I saw in that time significantly improved forever my interest and knowledge of Islamic art. Great days of my life!

I end now these biographical notes to give some information on my collector's life, which started quite soon.

Many years ago, if you were a collector of Islamic art in Italy, your chances of locally discovering such items were slim. Quite unexpectedly, however, a local opportunity presented itself. At a Florence Biennale, I encountered historical carpets from the Islamic world. Their special beauty, colours, patterns, and monumentality were enough to lead my artistic interests in their direction. This course was one from which I did not stray. In the moments that proved opportune for art collecting, my interests followed trails to the Islamic textiles, metalwork, ceramics, and above all, the art of the Islamic book. I still have very vivid memories of the many scholars, collectors, and specialists whom I met and spent time with over the span of many years.

There is no space here for a deep discussion about the connoisseurship and the collecting of Islamic art; however, allow me to comment briefly on this topic. Connoisseurship firstly represents love, vision, knowledge, and certainly intuition. Above all else, collecting has to do with finding, and when necessary, also saving, preserving, and passing down.

More precisely, I would like to share a few thoughts on what collecting Islamic art means to me. It is an exquisitely beautiful and personal experience that can become educational for oneself and for others. Over time, I have contributed, in one way or another, to the expansion of scholarship through scientific publications, symposiums, and the preservation of objects that belonged to both myself and others. These types of contributions represent a considerable task that thankfully is often taken on by many collectors.

I have much appreciated the invitation I received from the Aga Khan Museum in Toronto to send a selection of objects from my Islamic art collection for an exhibition to be held at the Museum. The difficulty that I immediately faced was the selection process itself: the number of objects and the size of many of them heavily influenced the choice. First of all, I decided to limit the chronology from 1250 to 1650 in order to ensure the presence of a homogeneous group of objects in the exhibition. Focusing on this specific period of time and space, I managed to gather a limited but hopefully significant selection.

The carpets belong to the classical period of Islamic production: I tried to choose a good number of pieces, but inevitably partial, from a corpus I put together during fifty years of research, following a path defined by precise historical and artistic criteria. While selecting textiles, ceramics, metalwork, and art of the book examples, I followed my personal taste.

Before closing, I would like to thank the Aga Khan Museum, and in particular, the work of Dr. Filiz Çakır Phillip, without whose involvement and experience this exhibit would not have been possible. My thanks also go to the authors of the book's introductions and catalogue entries, which amply demonstrate their diligence and commitment.

Alessandro Bruschettini

PREFACE

Sooner or later those who are interested in Islamic art come across Italy's Bruschettini Foundation for Islamic and Asian Art. The Foundation encourages projects on Islamic art in Europe, backs conservation initiatives dedicated to the preservation of cultural heritage, and supports art publications that have an educational purpose, especially those dealing with Islamic and Asian carpets and textiles.

In January 2015 in Genoa, I attended the exhibition *Art of the Ottomans 1450–1600. Nature and Abstraction: A Glimpse Beyond the Sublime Porte*, in which a splendid selection from the Bruschettini Collection was augmented with objects from Italian and other European collections. Fascinated by that particular choice and the quality of the works of art, I had my first inspiration to develop a similar exhibition at the Aga Khan Museum in Toronto, showcasing for North American and international audiences the richness of the Islamic art carefully collected by Alessandro Bruschettini over many decades.

More than forty works of art have been handpicked by the collector for the exhibition and catalogue *Arts of the East: Highlights of Islamic Art from the Bruschettini Collection*, revealing a limitless curiosity and deep passion for Islamic art that represent the epitome of the collecting spirit. The objects seen here provide a taste of the essence of the Bruschettini Collection, which itself reflects the vibrancy, innovation, technical perfection, and historical significance of one of the world's great genres of art.

This book is divided into five introductory essays with catalogue entries on metalwork, ceramics, works on paper, textiles, and carpets. "Metalwork: A Matter of Radiance" concentrates on inlaid brass and silver objects from the Ilkhanid to Mamluk dynasties together with a look at a work from the late-fifteenth-century Ottoman Empire. Cross-cultural relationships, artisan innovations, and shifting repertoires are all considered.

"Ceramics: Floral Harmony" focuses on Iznik polychrome objects to illustrate the independence of Ottoman craftsmen from the International Timurid Style and the development of their own vivid, naturalistic decorative designs that made wares from Iznik popular collectors' items in the West.

"The Art of the Book: Visions of Power and Emotion" was contributed by internationally renowned scholar Claus-Peter Haase, who emphasizes the importance of collecting Islamic manuscripts and paintings and links this worthy activity with the zest that has gone into

assembling an astonishing array of Turkmen, Iranian, and Mughal Indian miniature paint-ings and manuscripts from the fifteenth to seventeenth centuries. Along the way, Dr. Haase uncovers important historical aspects of the works and indicates new discoveries that have impressive educational ramifications.

"Textiles: Threads of Splendour" makes evident the transformation of techniques and styles over a vast territory that was encouraged by the ability of the Mongols to safeguard travel and trade roads from China to Italy. As a result, silk for clothing and decoration of domestic interiors became highly cherished, not only in the East but also in the West, which developed a seemingly insatiable desire for such luxury goods.

"The Art of the Carpet: A Triumph of Colour and Symmetry" is the work of Michael Franses, well known for his expertise in the realm of woven works, be they silk, cotton, or wool. His essay enhances this book with a general overview of the world of carpets from Spain to China, including Turkey, the Caucasus, Iran, and India, emphasizing their local traditions while appreciating their global acceptance as precious collectors' items.

In publishing *Arts of the East*, the Aga Khan Museum and the Bruschettini Foundation hope readers will appreciate the extraordinary aesthetics of Islamic art as represented in this publication and simultaneously be introduced to the vision of one of the field's most percep-tive collectors.

Filiz Çakır Phillip
Curator, Aga Khan Museum
Toronto

NOTE TO READERS:
Unless specified otherwise, the dimensions of objects
in this catalogue have height first followed by width.
For the carpets, it is length first followed by width.

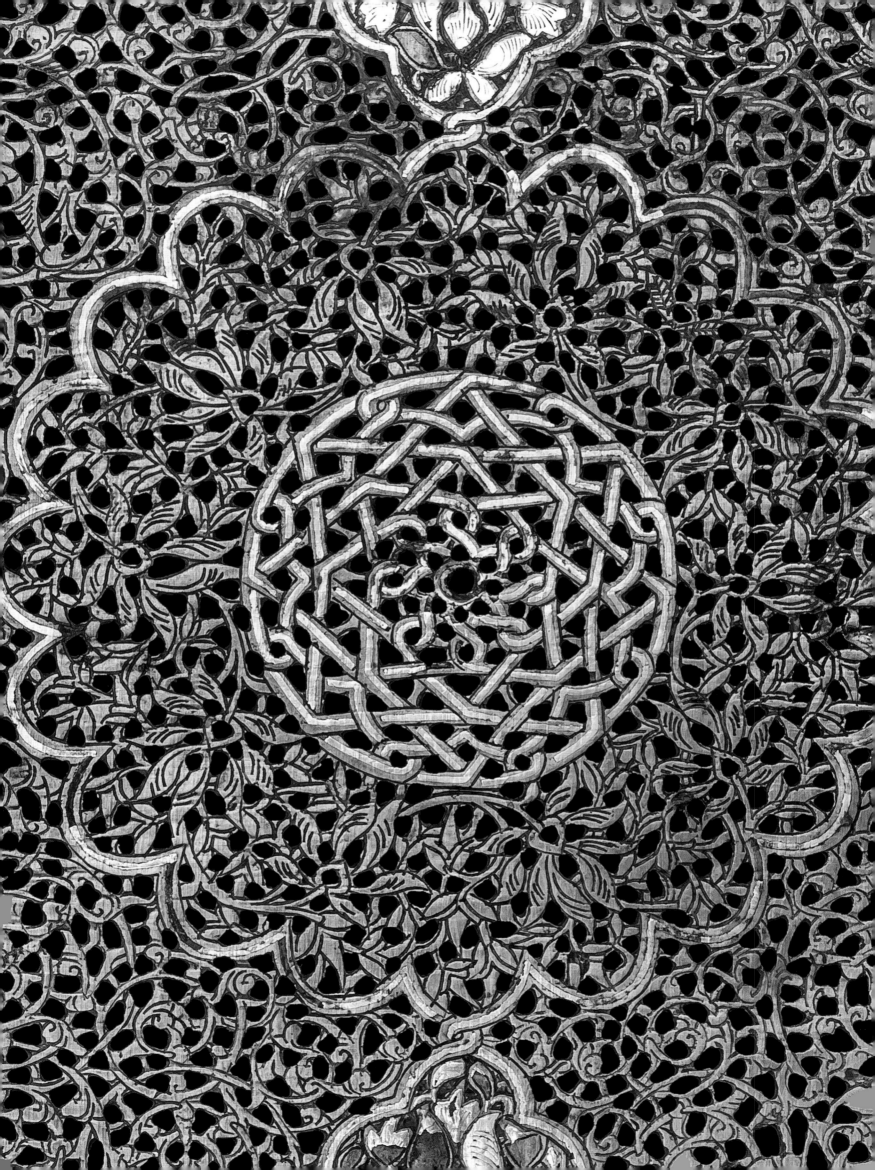

METALWORK

A MATTER OF RADIANCE

Filiz Çakır Phillip

Made from inexpensive alloys, brass and bronze might seem unlikely candidates for use in luxury metalwork. Yet for centuries, objects made from beaten brass or bronze inlaid with precious metals have held an indisputable place among the highest achievements of Islamic art.

As James W. Allan has memorably argued,[1] their introduction to the manufacture of luxury objects is inextricably tied to a shortage of silver. In the late eleventh century, silver mines in Afghanistan and surrounding areas were no longer capable of producing the vast quantities of ore required to service the silversmithing industry, but this dearth of materials did not quell the elite's desire for luxury objects. Silversmiths resorted to ingenious ends, using inexpensive alloys of base metals such as copper, tin, and zinc to produce objects in brass or bronze, and then applying the same techniques of repoussé and chasing, inlay, and inscribing that had been employed to decorate silver. They continued to use casting methods when required but relied heavily on working with sheet metal. They also discovered that gilding base metals with a gold sheet or with a mercury-and-gold mixture could be an attractive alternative to producing objects entirely of precious metals.[2]

In the eleventh century, artisans in Herat and Mosul were the first to experiment with alloys that could be polished to resemble more expensive materials and that were versatile enough to accommodate detailed inlay with precious metals. Applying their expertise to new materials, these artisans reinvented their trade and established new artistic traditions, re-creating many of the objects they had made in silver.[3] The success of their labours was abundantly clear when rulers and wealthy citizens alike began commissioning these objects for a variety of functions both secular and sacred. This variety is captured eloquently in the Bruschettini Collection, which contains objects as disparate as a pen box (Cat. No. 1), a ball joint from a window grille (Cat. No. 2), a decorative panel likely used

Detail of **Panel** (Cat. No. 3) Cairo, Egypt, 1330–50; brass; openwork and silver inlaid; 30.4 × 18.4 cm

as part of a Qur'an table or *kursi* (Cat. No. 3), and two bowls, one Mamluk and one Ottoman (Cat. Nos. 4 and 5).

In these exceptional objects, we gain a better understanding of values that shaped the societies in which they were created. The exquisite pen box, for instance, gestures to the esteemed status of writing and knowledge[4] that was a cornerstone of earliest Islamic civilizations. Tied to the sacred word of God as revealed in the Qur'an, this supreme regard of the written word was also evidenced by the founding of universities and libraries such as the House of Wisdom in Baghdad. A large measure of this esteem was transferred to the administrative secretaries at court,[5] who would be entrusted with recording the ruler's will and, in turn, with chronicling the court's history.

In the decorative window grille ball joint, we find a glimpse into the world of the Ilkhanids in Greater Iran (1256–1353), one of the four Mongol dynasties or khanates that emerged in the thirteenth century, the others being the Yuan in China (empire of the Great Khan, 1279–1369), the Chaghatay in Central Asia (ca. 1227–1363), and the Golden Horde in southern Russia (ca. 1227–1502).Through the Ilkhanids, who converted to Islam, the territory of northwest Iran had a direct conduit to Chinese and Central Asian culture that originated with Genghis Khan (1162–1227). These ties were strengthened when, during almost a century of peace following the thirteenth-century Mongol invasions, trade and cultural interaction were encouraged across all parts of the Mongol Empire.[6]

Ceremonial functions such as the ritual of ablution prior to prayer can be ascribed to the two bowls in the Bruschettini Collection. The inscriptions on each bowl also point to a key function of luxury objects: to affirm and celebrate the power of the ruler and the elite. The Mamluk bowl likely honours Nasir al-Din Hasan (r. 1347–51 and 1354–61), son of Sultan Nasir al-Din Muhammad (r. December 1293–December 1294, 1299–1309, and 1310–41), while the Ottoman bowl honours Alemshah (d. 1510), son of Sultan Bayezid II (r. 1481–1512). The boldness of the inscription on the Mamluk bowl speaks to the keen desire for promoting the Mamluk dynasty, which is further reinforced with the elemental symbolism of fish encircling a sun disc.[7]

The Mamluk panel, whose function is less clear, is more closely tied to a religious context. Bearing partial inscriptions from the Qur'an, the panel might have decorated a Qur'an table (*kursi*) that was in turn placed in a mausoleum.[8] The fact that it, like the Mamluk bowl, was not produced during a time when there was a silver shortage in Egypt suggests that brass, when inlaid, had attained a status worthy of objects made of pure gold or silver.[9]

The metalwork objects in the Bruschettini Collection offer a dynamic view of three centuries marked by tremendous social change. Trade of portable luxury goods encouraged the

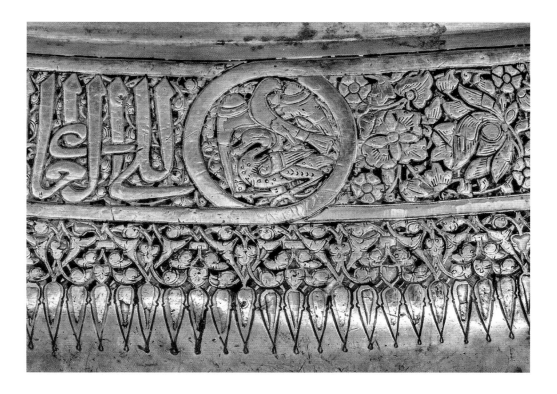

Detail of **Bowl** (Cat. No. 4)
Egypt or Syria, mid-14th century
Brass; inlaid with silver
Diameter 22 cm

transfer of artistic traditions and techniques throughout the Middle East, North Africa, and beyond. Artisans also contributed to this dissemination of skills and knowledge when, either by choice or compelled by socio-political circumstances, they found employment in other cities and regions. The Mongol invasions that culminated with the siege of Mosul in 1262 might account for a shift in metalwork production from the Jazira (which included present-day Syria, Lebanon, Jordan, Israel, the Palestinian territories, part of Iraq, and Turkey) to the Mamluk Empire in the thirteenth century.[10] The creation of the four distinct but still connected khanates within the Mongol Empire also resulted in interesting cultural dynamics: for instance, motifs found in Golden Horde silver are found in fourteenth-century jewellery produced at a point of contact between the Eurasian steppes and the Middle East.[11]

Surpassing even the Mongol Empire in its vast reach, the Ottoman Empire created the context for cultural interactions between China, the Balkans, Anatolia, and North Africa, inevitably leading to new styles and cultural synthesis. Payrolls for court artisans in the fifteenth century indicate that the majority of metalworkers were Iranian-born; they worked side by side with trained silversmiths from the recently occupied Balkans.[12] By the sixteenth century, the legacy of émigré artists and artisans from Iran was strongly felt in other media such as ceramics and textiles.

In these objects from the Bruschettini Collection, we therefore see how Central Asia and the Far East entered and circulated through the creative vocabularies of the Middle East. We

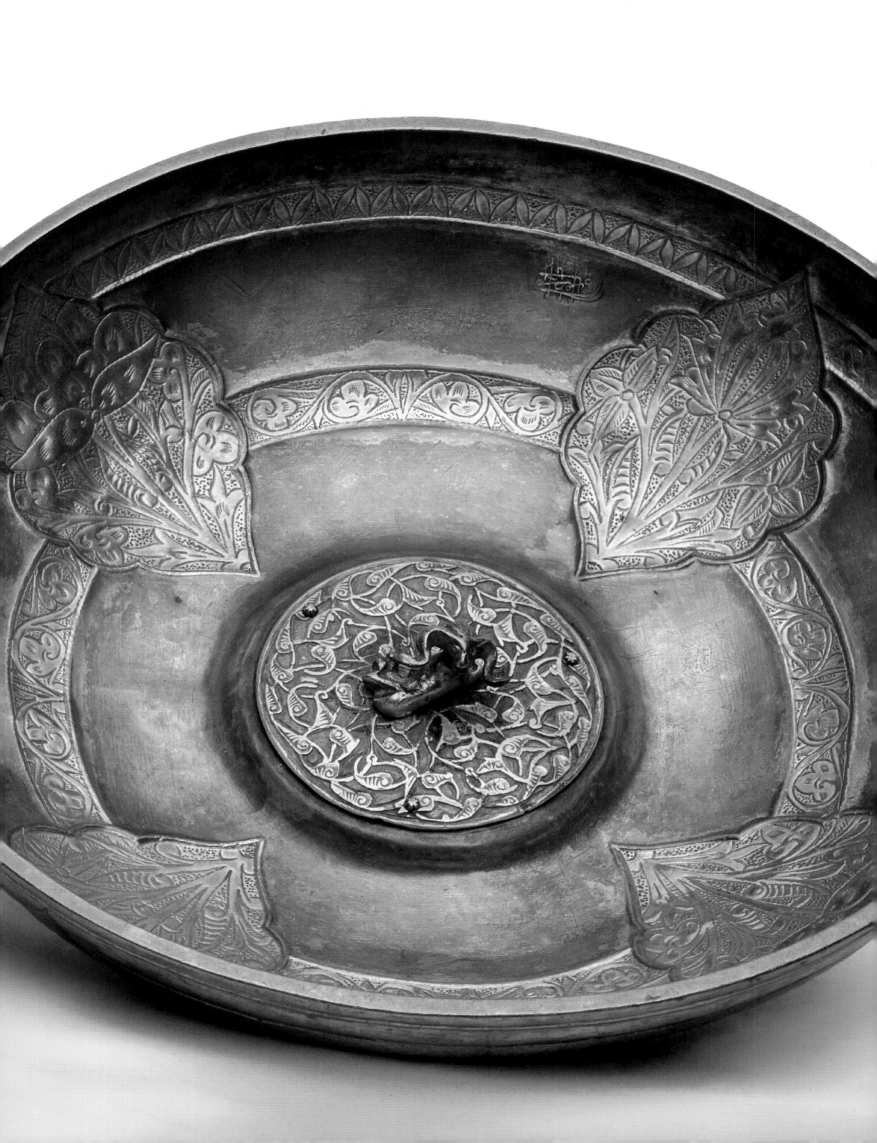

also see how the imagery used in other belief systems such as Buddhism, Zoroastrianism, Christianity, and paganism could be transformed and then transplanted to Islamic contexts.[13] The superior quality of the metalwork objects highlighted here allows us to appreciate from our twenty-first-century perspective the technical acumen of these artisans, yet it is in the sum of their parts that their beauty can truly be appreciated.

NOTES

1 James W. Allan, "Silver: The Key to Bronze in Early Islamic Iran," *Kunst des Orients* 11 (Wiesbaden, 1976/77): 21.

2 Allan, *Islamic Metalwork: The Nuhad Es-Said Collection* (London: Sotheby Parke Bernet Publications, 1982), 14–15.

3 Allan, "Merchants and Metal in Early Islamic Iran," *Akten des VII. Internationalen Kongresses für Iranische Kunst und Archäologie, München* (September 7–10, 1976) (Berlin, 1979): 522; Allan, *Islamic Metalwork*, 14.

4 Eva Baer, *Metalwork in Medieval Islamic Art* (New York: State University of New York Press, 1983), 66.

5 A.S. Melikian-Chirvani, "State Inkwells in Islamic Iran," *The Journal of the Walters Art Gallery* 44 (1986): 70–71.

6 Linda Komaroff and Stefano Carboni, *The Legacy of Genghis Khan: Courtly Art and Culture in Western Asia, 1256–1353* (New York: Metropolitan Museum of Art, 2002), 171.

7 Rachel Ward, ed., *Court and Craft. A Masterpiece from Northern Iraq* (London: Courtauld Gallery in association with Paul Holberton Publishing, 2014), 69. For fish symbolism, see Eva Baer, "'Fish-Pond' Ornaments on Persian and Mamluk Metal Vessels," *Bulletin of the School of Oriental and African Studies, University of London* 31, no. 1 (1968): 14–27. See also Maria Sardi, "Swimming Across the Weft: Fish Motifs on Mamluk Textiles." In *Art, Trade and Culture in the Islamic World and Beyond: From the Fatimids to the Mughals. Studies Presented to Doris Behrens-Abouseif* (London: Gingko Library, 2016), 254–63. James Allan discusses the symbolic connections between fish and the sun, and the notion of the sun as a source of life. See Allan, *Islamic Metalwork*, 98.

8 Doris Behrens-Abouseif, *The Arts of the Mamluks in Egypt and Syria: Evolution and Impact* (Göttingen, Germany: V&R Unipress, 2012), 47.

9 Allan, *Islamic Metalwork*, 20.

10 Julian Raby, "The Principle of Parsimony and the Problem of the 'Mosul School of Metalwork.'" In Venetia Porter and Mariam Rosser-Owen, eds., *Metalwork and Material Culture in the Islamic World: Art, Craft and Text* (London: I.B. Tauris, 2012), 54.

11 B.I. Marshak and M.G. Kramarovsky, "A Silver Bowl in the Walters Art Gallery, Baltimore: Thirteenth-Century Silversmiths' Work in Asia Minor," *Iran* 31 (1993): 120–22.

12 Brigitte Pitarakis and Christos Merantzas, *Treasured Memory: Ecclesiastical Silver from the Late Ottoman Istanbul in the Sevgi Gönül Collection, Istanbul* (Istanbul: Sadberk Hanım Müzesi, 2006), 153–54.

13 Allan, *Metalwork of the Islamic World: The Aron Collection* (New York: Sotheby's, 1986), 46.

Detail of
Bowl (Cat. No. 5)
Turkey, before 1510; silver;
gilded, repoussé; diameter 18 cm

1

PEN BOX

Signed by Abu'l Qasim b. Sa'id Muhammad al-Is'irdi
Southeastern Turkey, 1235–45
Brass; inlaid with silver
Height 5.2 cm, width 6.3 cm, length 28.5 cm

The exquisite detailing on this pen box or *dawat* speaks to the considerable labour and artistic skill that went into its creation. Planetary iconography on the lid, now worn and difficult to discern, can be deciphered through comparison to another similar pen box, dated 1245–46, in the Louvre Collection. From the Louvre example, it can be determined that the Bruschettini *dawat* once depicted seven medallions containing planets, each personified and positioned in order of their believed proximity to Earth: the Moon, Mercury, Venus, the Sun, Mars, Jupiter, and Saturn.[1]

In addition to showing signs of surface wear, this pen box is missing its inkwell. Yet it is otherwise in good condition. A honeycomb pattern in silver inlay covers the interior base, and the inlay on the inside of the lid features an inscription in *naskhi* script flanked by two rosettes.[2] Z-fret swastikas[3] inside the rosettes are echoed in a border pattern running along the contours of the lid, emphasizing the rounded corners that might have identified the owner's employment; writing in the fourteenth century, Mamluk historian al-Qalqashandi observes that the *dawats* of treasury scribes had square corners while those of government scribes were rounded.[4] Eva Baer suggests a geographical link, noting that square-cornered *dawats* prevailed in northern Meso-potamia, while *dawats* with rounded corners were more prevalent in Iranian material culture.[5]

The artisan's inscription ("Abu'l Qasim b. Sa'id Muhammad al-Is'irdi")[6] assists in dating this pen box. Three other *dawats* attributed to Abu'l Qasim have been dated between 1237 and 1245, placing the Bruschettini piece in the first half of the thirteenth century when Mosul was the manufacturing centre for inlaid brass. Abu'l Qasim might have produced this *dawat* in Mosul, working amid the vibrant community of artisans there, or he might have done so in Siirt, a town in present-day southeastern Turkey. The geographical designation, or *nisbah* "al-Is'irdi," appears with his name, identifying Siirt as his place of origin, not necessarily his place of residence.[7]

Produced in a variety of materials, including ebony, sandalwood, and steatite,[8] the *dawat* had a practical and symbolic function. It could hold and protect reed pens and a sharpening knife in addition to an ink pot, starch paste, and sand, and was generally hinged for easy

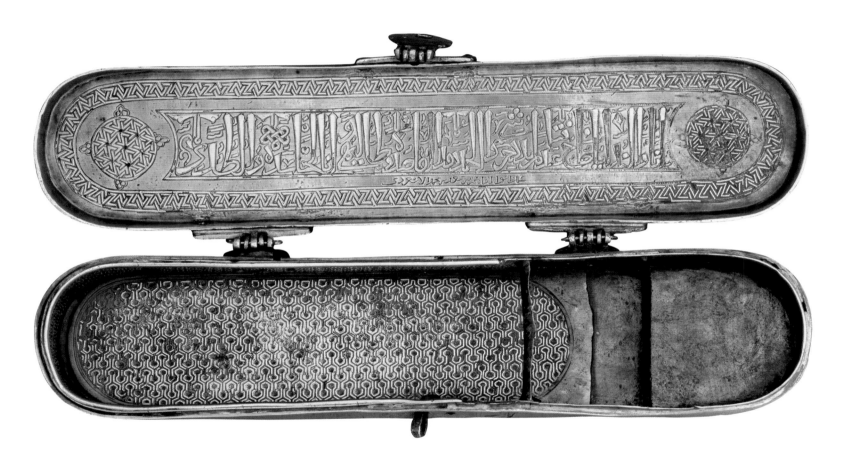

opening. Across the Jazira, as well as in present-day Iran and Egypt, *dawats* were presented as esteemed gifts to royalty and the elite and were used by court scribes and high-ranking officers.[9] For this reason, they were not only essential to the administrative business of court and the recording of knowledge but also important markers of rank and role. Historian al-Qalqashandi eloquently affirmed the *dawat*'s enduring significance a century after the Bruschettini pen box was produced. "A scribe without a *dawat*," he observed, "is like a man who enters a fight without a weapon."[10]

NOTES

1 *Art d'Orient: Vente aux encheres publiques* (Paris: Drouot, 1998), Lot 5. The Bruschettini pen box was previously in the collection of the Toulouse-Lautrec family. A signed pen box by "Umar al-Is'irdi" now in Russia in the collection of the State Museum of Oriental Art, Moscow (Inv. No. 1590, dated approximately 1225–50), is closely related to the Bruschettini pen box in style of inscriptions and in its use of the images of the seven planets on top of the lid. See S.B. Pevsner, "Bronzovyi penal v sobranii Gosudarstvennogo Muzeya kul'turi i iskusstva narodov vostoka," *Epigrafika Vostoka* 19 (1969): 51–58. I thank Julian Raby for sharing his exceptional knowledge about the period and the style of artists and for his support during my research for the Bruschettini pen box.

2 According to Raby, 30–31 (see page 17, note 10), these octagonal rosettes represent a brand, a possible workshop, or guild emblem.

3 In medieval Islamic metalwork, a variety of geometric patterns on inlaid objects express the richness of the artistic repertoire. Different types of swastikas, so-called frets, were highly popular. Besides Z-frets, T- and Y-frets are also common on Mamluk metalwork.

4 See James W. Allan, *Metalwork Treasures from the Islamic Courts* (London: Islamic Art Society, 2002), 27; mentioned also by Deniz Beyazıt in *Court & Cosmos: The Great Age of the Seljuqs*, eds. Sheila R. Canby, Deniz Beyazıt, Marina Rugiadi, and A.C.S. Peacock, eds., *Court & Cosmos: The Great Age of the Seljuqs* (New York: Metropolitan Museum of Art, 2016), 334.

5 Eva Baer, *Metalwork in Medieval Islamic Art* (New York: State University of New York Press, 1983), 71. Also see "A Gold-and Silver-Inlaid Brass Penbox, Jazira, Mosul or Siirt, Third Quarter 13th Century" (London: Sotheby's, 2009), Lot 78: "The *dawat* could be round-ended, as here, or square-ended. Square-ended penboxes were popular with accountants because they used paper of a size that could be fitted in the lid. Scribes preferred the lighter, round-ended penboxes as their scrolls had to be carried separately anyway." For a discussion of the pen box as a status symbol in Pre-Islamic Iranian culture and its adaptation in Islamic tradition, see A.S. Melikian-Chirvani, "State Inkwells in Islamic Iran," *The Journal of the Walters Art Gallery* 44 (1986): 70–71. For detailed information about different types of pen boxes, see Melikian-Chirvani, 83.

6 For the earliest reference to this artisan, see L.A. Mayer, *Islamic Metalworkers and Their Works* (Geneva: A. Kundig, 1959), 26–27. The candlestick that Mayer located is in Sweden, formerly of the Martin Collection and Lamm Collection. Compare Raby, Appendix, Table I.Ia.

7 Sotheby's, 2009, Lot 78. Raby mentions three artworks executed by the same artisan: a pen box dated 1237 in the Museum of Islamic Art, Cairo; the pen box at the Louvre; and another pen box dated approximately to 1245, location unknown. See Raby, Appendix, Table I.Ia. For further information about Siirt metalwork production, see Allan, *Islamic Metalwork: The Nuhad Es-Said Collection* (London: Sotheby Publications, 1982), 19.

8 Barbara Drake Boehm and Melanie Holcomb, *Jerusalem 1000–1400, Every People Under Heaven* (New York: Metropolitan Museum of Art, 2016), 97, notes 1 and 2.

9 Boehm and Holcomb, 97, notes 1 and 2. The elongated pen box served as a vehicle for symbols conveying the idea of universal kingship through image and/or text. See both Melikian-Chirvani, 83, and Allan, *Metalwork Treasures*, 27.

10 Baer, 67.

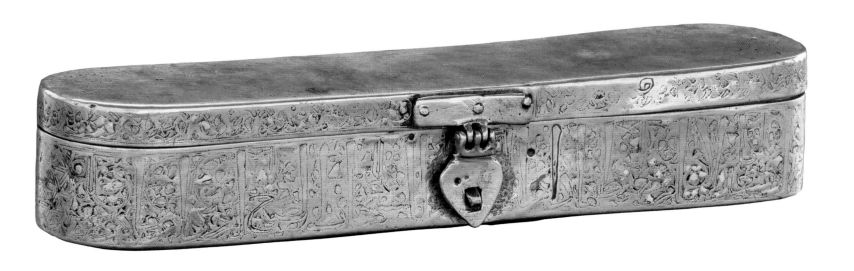

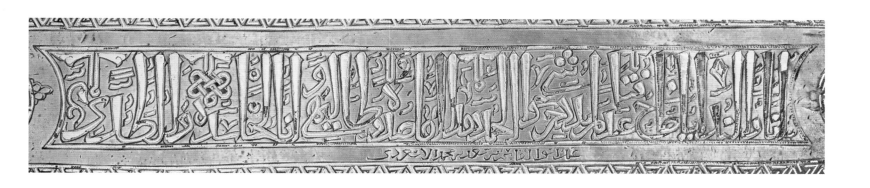

2

BALL FROM WINDOW GRATING

Northwest Iran, early 14th century
Brass; incised and inlaid with silver and gold
Diameter of spherical body 9.5 cm

Unlike well-known examples found in the Aron Collection and the Museum of Islamic Art in Cairo, this exquisitely detailed window grille ball joint was created from two pieces of metal that were later joined together.[1] The window struts would have fitted into the sphere's four holes,[2] forming an axis and ultimately creating a window covering that would afford privacy and security, filter light, and be pleasing to the eye. Requiring less skill than a single casting, the two-part process used in the ball's production might suggest that it was not intended for a prestigious location.[3] However, the quality of workmanship evident in the silver-and-gold inlay is considerable. On one side, five medallions containing sinuous floral and leaf patterns are regularly placed upon a ground of Z-fret designs;[4] on the other, a single medallion containing a geometric pattern is centred upon a ground of abstracted floral and leaf designs. In this manner, each side of the window ball features a design that is inversed on its opposite side.

Dating the window grille ball joint in the Bruschettini Collection proves far less problematic, considering existing comparable examples and contemporary sources. Although metal inlay had flourished in present-day Iran since the twelfth century, it was not until the Ilkhanid period — after Mongol invasions had swept from Samarqand to Baghdad — that the highly prized technique was widely applied to architectural elements besides door fittings and knockers.[5] Until then windows of public and residential buildings were often fitted with wooden *mashrabiyas* to filter light and provide privacy.[6]

The Great Mongol Shahnameh (Book of Kings) affirms the Mongols' taste for richly decorated window fittings; several of its miniature paintings depict elaborate grillework on the upper and lower floors of palaces.[7] In the 1970s, scholar S. Gandjavi described a window ball joint bearing the image of a Mongol equestrian astride his horse, possibly from Sultaniyya.[8] Moreover, at the Museum of Islamic Art in Cairo, the two ball joints cast in one piece of metal bear the name and titles of the Ilkhanid Sultan Oljaytu.[9] According to a contemporary account, Oljaytu employed 3,000 smiths between 1305 and his death in 1316 to create nails, metal fittings, and sheets intended for buildings in his new capital of Sultaniyya.[10] Among

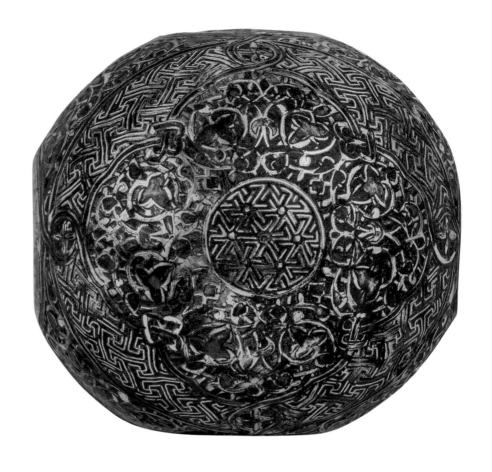

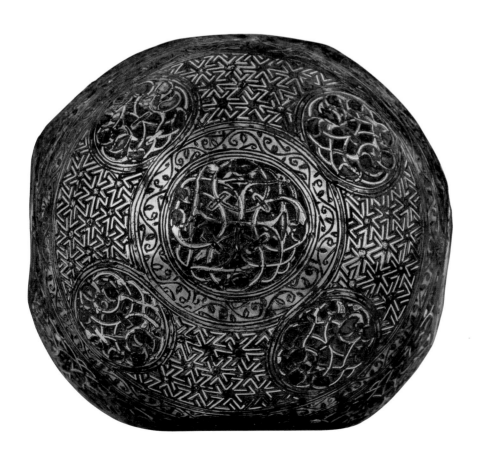

Sultaniyya's architectural gems were an impressive mausoleum and tomb (originally intended for Imam 'Ali and Imam Husayn, eventually becoming the final resting place of Oljaytu himself) whose windows and portals featured ornate grillework.[11]

Although it remains unknown if the Bruschettini window grille ball joint was created for use in the tomb at Sultaniyya, it would not be out of place there or in similar monuments,[12] affirming as it does both the powerful legacy of Iranian metalwork and the ability of artistic traditions to accommodate new influences and tastes.

NOTES

1 *Art of the Islamic and Indian World* (London: Christie's, 2012), Lot 80; James W. Allan, *Metalwork of the Islamic World: The Aron Collection* (New York: Sotheby's, 1986), 130. Arthur Upham Pope identifies it as one of three in Arthur Upham Pope, ed., *A Survey of Persian Art: From Prehistoric Times to the Present* (London: Oxford University Press, 1938), pl. 1357A, diameter 13 cm, 2505. Also see Et. Combe, J. Sauvaget, and G. Wiet, *Répertoire chronologique d'épigraphie arabe* 14, nos. 5376–78 (Cairo, 1931–82).

2 Almut von Gladiss, "Islamic Metalwork." In Claus-Peter Haase, ed., *A Collector's Fortune: Islamic Art from the Collection of Edmund de Unger* (Munich: Hirmer, 2007), 128.

3 Allan, *Metalwork of the Islamic World*, 130.

4 A very close example is at the Los Angeles County Museum of Art (LACMA): Acc. No. M73.5.124 and attributed to a period from the late thirteenth to early fourteenth centuries. Also see Linda Komaroff and Stefano Carboni, *The Legacy of Genghis Khan: Courtly Art and Culture in Western Asia, 1256–1353* (New York: Metropolitan Museum of Art, 2002), 124–25.

5 Almut von Gladiss, 128.

6 James W. Allan, "'Oljeitu's Oranges': The Grilles of the Mausoleum of Sultan Oljeitu at Sultaniyya" (unpublished essay). I thank James Allan for his support while I researched the window grille ball.

7 Allan, "'Oljeitu's Oranges.'" Excellent examples of this architectural decoration can be seen in the albums of Topkapı Palace Library, especially in the album H.2153: H2153-54A; H2153-55A. This album is sometimes described as the Fatih Album because it contains a portrait of Sultan Mehmet II; at other times it is described as the Yaqub Album because it contains miniatures of the Aqqoyunlu period of the reign of Yaqub Bey. The album is dated between the fourteenth and sixteenth centuries. I thank Dr. Lale Uluç for her support.

8 S. Gandjavi, "Prospection et fouille à Sultaniyeh," *Akten des VII. Internationalen Kongresses für Iranische Kunst und Archäologie, München* (September 7–10, 1976) (Berlin, 1979): 523–26. This example is similar to a window ball from the Keir Collection, which is today in the Dallas Museum of Art on long-term loan. See von Gladiss, 128. An earlier publication about the ball mentioned by Gandjavi can be found in Geza Fehervari, *Islamic Metalwork from the Eighth to the Fifteenth Century in the Keir Collection* (London: Faber & Faber, 1976), Cat. No. 132. For the window grille of the Keir Collection, see Linda Komaroff and Stefano Carboni, 280.

9 Allan, *Metalwork of the Islamic World*, 130. Also see Combe, Sauvaget, and Wiet.

10 Donald P. Little, "The Founding of Sultaniyya: A Mamluk Version," *Iran* 16 (1978): 170–75; Sheila Blair, "The Mongol Capital of Sultaniyya, 'The Imperial,'" *Iran* 24 (British Institute of Persian Studies, 1986): 143; Luitgard E.M. Mols, *Mamluk Metalwork Fittings in their Artistic and Architectural Context* (Delft: Eburon, 2006), 28.

11 See Komaroff and Carboni, 124–25, and "Gunbad-i Uljaytu," Archnet, https://archnet.org/sites/1671, accessed May 19, 2017.

12 See Komaroff and Carboni, 125.

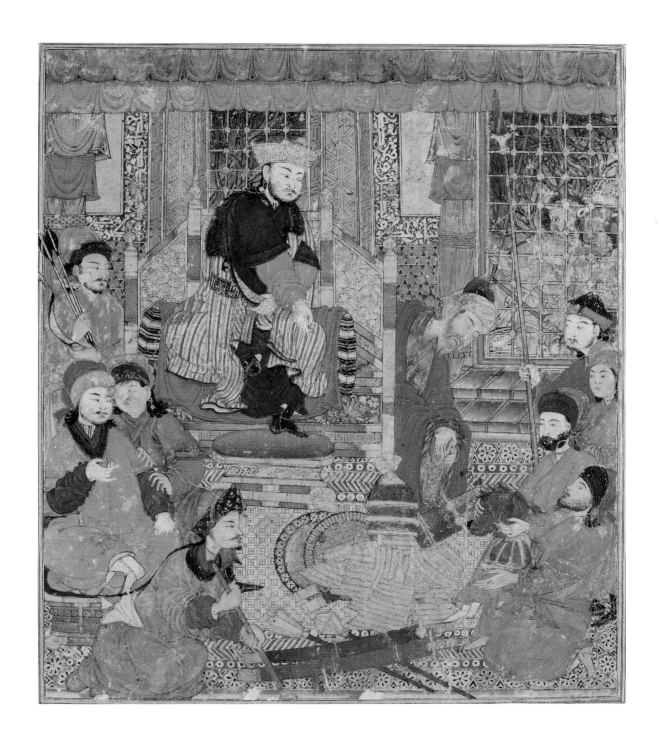

Detail of
Kai Khusrau Distributes
His Treasury to His Generals

Folio 55a from the Fatih Album,
late 14th–early 15th centuries
Opaque watercolour and gold on paper
Page: 22.7 × 19.3 cm
Copyright © Topkapı Palace Museum, Istanbul, H.2153

3

PANEL

Cairo, Egypt, 1330–50
Brass; openwork and silver inlaid
30.4 × 18.4 cm

Executed in pierced metal with silver inlay, the intricate designs on this rectangular panel clearly required the talents of a master artisan. A central medallion decorated with densely entwined patterns provides a focal point, while two quatrefoils and bold *thuluth* inscriptions running in a finely bordered band along the panel's top and bottom also dominate the composition. Close study of the intervening decoration reveals two different patterns at work: a winding lotus motif directly outside the central medallion, and a meandering vine pattern that is further organized into circular forms. A delicate fluted border in silver inlay separates these two patterns, creating the larger effect of a flower's petals or the rays of a blazing sun. A plain border surrounds the intricate design, and at the border's top and bottom are holes where pins were likely attached. Unlike the three holes at the centre and two sides of the decorated panel, these holes are unembellished, no attempt having been made to incorporate them into the larger design.[1]

The *thuluth* inscription is key to placing this panel in its original context. Rendered with strong, vertical strokes inlaid in silver, such prominent inscriptions are typical of Mamluk metalwork, as can be seen on the Mamluk bowl in the Bruschettini Collection (see Cat. No. 4). Neither of the inscriptions on the Mamluk panel is complete, suggesting its continuation on yet another panel. The upper band bears an excerpt from the Qur'an, Sura 9, verse 111, which alludes to paradise; the lower band is an excerpt from Sura 33, verse 56, which references salvation.[2] Not only are these quotations suitable for a funerary context,[3] but they are absent from existing Qur'an boxes.[4] It is therefore more likely that the panel was intended to decorate a piece of furniture inside a mausoleum.

Comparing the Bruschettini panel with those found on a hexagonal *kursi* (Qur'an table) in the Museum of Islamic Art in Cairo is instructive.[5] These *kursi* panels have similarly been created with pierced and inlaid metalwork dominated by a central medallion. Like the Bruschettini panel, the Cairo panels display entwined floral patterns and lotus motifs, though they also employ honeycomb patterns and their central medallions bear the name "Muhammad."[6]

The Cairo *kursi* predates the Bruschettini panel by at least a few years, having been commissioned by Qalawun's son, al-Nasir Muhammad (r. 1285–1341), in 1327.[7] It has been suggested that while the *kursi* was most recently traced to the hospital al-Mansur Qalawun (1222–90),[8] it was originally located within Qalawun's domed mausoleum, whose polygonal shape the *kursi* echoed.[9] Sophie Makariou and Carine Juvin suggest that the *kursi*, displayed with some of Qalawun's own garments, would have helped al-Nasir Muhammad affirm his own royal lineage in a very deliberate — and public — way.[10]

Apart from contributing to the *mise en scène*[11] within mausoleums and honouring both the dead (and the deceased's successors) through an exquisite object, the function of *kursis* is unclear. It has been pointed out that their limited interior space could accommodate only small copies of the Qur'an, and though called a "table," they did not have enough surface area to support a large open volume. Until this "mystery"[12] is resolved, we can continue to cherish and admire the extraordinary skill that went into creating such panels and appreciate the Mamluk enthusiasm for complex designs masterfully inlaid with silver.

NOTES

1 Christie's London, *Islamic Art, Indian Miniatures, Rugs and Carpets, April 28–30, 1992*, Lot 208.

2 Sophie Makariou and Carine Juvin, *The Arts of the Mamluks in Egypt and Syria: Evolution and Impact*, ed. Doris Behrens-Abouseif (Göttingen, Germany: V&R Unipress, 2012), 47.

3 Makariou and Juvin, 47.

4 Makariou and Juvin, 47.

5 An octagonal panel from the Louvre Collection (OA 5701), dated to the mid-fourteenth century, shares design motifs with the Cairo and Bruschettini panels. Like the Cairo *kursi* panels, its radial medallion quite clearly references the sun in its form. See Makariou and Juvin, 37–38, for a discussion of the Louvre *kursi*. For the relationship between geometric patterns, the sun, and the Prophet, see James W. Allan, "'My Father Is a Sun and I Am the Star': Fatimid Symbols in Ayyubid and Mamluk Metalwork," *Journal of The David Collection 1* (2003): 42. I thank Rachel Ward for her support on Mamluk artworks in this catalogue and for fruitful communications. See Rachel Ward, "Brass, Gold and Silver from Mamluk Egypt: Metal Vessels Made for Sultan Al-Nasir Muhammad," a Memorial Lecture for Mark Zebrowski, *Journal of the Royal Asiatic Society, 3rd Series* 14, no. 1 (April 2004): 62.

6 Allan, "'My Father Is a Sun and I Am the Star,'" 42.

7 Stanley Lane-Poole, *The Art of the Saracens in Egypt* (Beirut: Librairie Byblos, 2012 [reprint]), 190.

8 Lane-Poole, 190; Makariou and Juvin, 47.

9 Makariou and Juvin, 47.

10 Makariou and Juvin, 47.

11 Makariou and Juvin, 47.

12 Bernard O'Kane, *The Treasures of Islamic Art in the Museums of Cairo* (Cairo and New York: American University in Cairo, 2006), 153–55.

4

BOWL

Egypt or Syria, mid-14th century
Brass; inlaid with silver
Diameter 22 cm

This exceptional brass bowl offers a study in contrasts. On its densely textured exterior, arabesques entwined with leaves and flowers provide the ground for prominent bands of *naskhi* script; these bands are in turn flanked by roundels decorated with animals and birds resembling hawks and waterfowl. Yet the bowl's interior is smooth and strikingly simple, bearing the regular pattern of sixteen fish arranged in two rows around a whirling sun disc.

The appearance of inlaid metalwork in the Mamluk Empire, which included present-day Egypt and Syria, might be ascribed to the cultural exchange that accompanies trade: as portable and luxury goods from established metalwork centres such as Herat and Mosul travelled to the region, Mamluk artisans might have begun learning and adapting this technique. It is also possible that émigré artists and artisans from these centres relocated to the Mamluk Empire, seeking refuge from the Mongol invasions of the thirteenth century.[1]

Inlaid metalwork reached its artistic pinnacle during the third reign of Mamluk sultan Nasir al-Din Muhammad (1310–41).[2] Commissioning secular and religious buildings from palaces to mosques, he also encouraged the production of at least forty-six brass vessels with gold and silver inlay. Many of these were round-bottomed ablution bowls given to his officers (emirs) as gifts to mark their advancement.[3] Ibn Iyas, writing in the fourteenth century, also notes that metal bowls were used as drinking vessels on special occasions.[4]

Typical of inlaid bowls produced during the first half of the fourteenth century, the Bruschettini bowl boldly celebrates the power and longevity of the Bahri Mamluks (1250–1382), whose dynasty originated from Qipchaq Turks in southern Russia.[5] The *naskhi* inscription ("The Sublime Excellency, Our Master, the Great Emir, the Royal, the Wise, the Masterful, the Righteous, the Excellent, the Generous Administrator, the Supporter [the Officer] of al-Malik al-Nasir") affirms the ruler's absolute authority, an effect reinforced by the blazon-like roundels. The waterfowl depicted within these roundels might reference the Central Asian ancestry of the Bahri Mamluks; in Eurasia the goose was a totemic animal associated with power and leadership.[6] The whirling sun disc on the bowl's interior strengthens such symbolism,

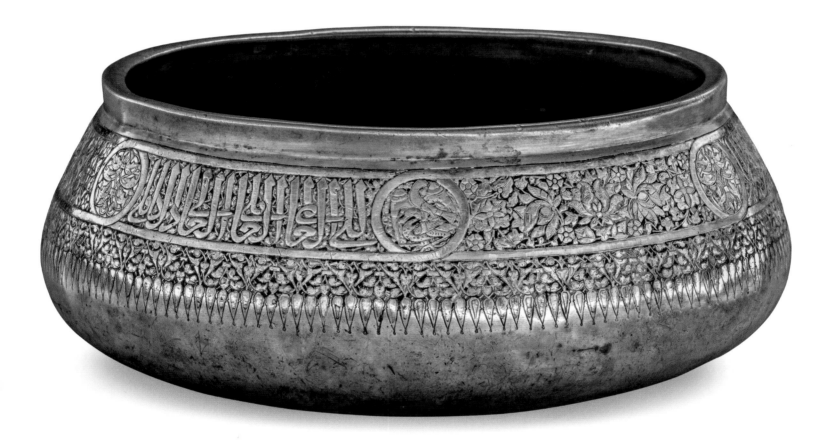

suggesting that, as the fish join in an eternal ring around the sun disc, so a sultan's people are to venerate and obey him, finding in him a source of life and sustenance. These fish would appear to swim when liquid was poured into the bowl.[7]

The presence of rich Asiatic imagery beyond the roundels — namely, the dense peony and lotus designs that fill the exterior ground — suggest that the Bruschettini bowl was created during the reign of Nasir al-Din Hasan (r. 1347–51 and 1354–61), son of Nasir al-Din Muhammad.[8] Decades after a peace treaty was signed between Nasir al-Din Muhammad and Ilkhanid Sultan Oljaytu, a flourishing trade was established between the Mamluk Empire and the Far East. Textiles, porcelain, and jade from China made their way into the Mamluk Empire along the Silk Routes, and a sea route soon opened between Aden, China, and India, adding to the influx of Eastern goods and the circulation of motifs and ideas.[9] Once again, the Bruschettini Collection provides persuasive evidence that socio-economic change produced fertile conditions for artistic inspiration and growth.

NOTES

1 Julian Raby, "The Principle of Parsimony and the Problem of the 'Mosul School of Metalwork.'" In Venetia Porter and Mariam Rosser-Owen, eds, *Metalwork and Material Culture in the Islamic World: Art, Craft and Text* (London: I.B. Tauris, 2012), 54.

2 Esin Atıl, *Renaissance of Islam: Art of the Mamluks* (Washington, DC: Smithsonian Institution Press, 1981), 15.

3 Rachel Ward listed forty-six brass vessels inlaid with silver and gold, which were produced for the Mamluk sultan Nasir al-Din Muhammad. Rachel Ward, "Brass, Gold and Silver from Mamluk Egypt: Metal Vessels Made for Sultan Al-Nasir Muhammad. A Memorial Lecture for Mark Zebrowski," *Journal of the Royal Asiatic Society, 3rd Series* 14, no. 1 (April 2004): 59 and the Appendix; 68.

4 Ibn Iyas (1448–1522) was a chronicler of the late Mamluk and early Ottoman periods in Egypt. His historical chronicle *Bada'i al-zuhur* (I:1445) is quoted in Doris Behrens-Abouseif, "The Jalayirid Connection in Mamluk Metalware," *Muqarnas* 26 (2009): 157.

5 Atıl, 12–16.

6 The name *Qalawun* is of Mongolian origin and means "goose." See Ferdinand Lessing and Mattai Haltod, *Mongolian-English Dictionary* (Berkeley, CA: University of California Press, 1960); Gerhard Doerfer, *Tuerkische und Mongolische Elemente im Neupersischen: unter besonderer Beruecksichtigung aelterer neupersischer Geschichtsquellen, vor allem der Mongolen und Timuridenzeit* 3 (Wiesbaden, Germany: F. Steiner, 1963); and Martine Irma Robbeets, *Is Japanese Related to Korean, Tungusic, Mongolic and Turkic?* (Wiesbaden, Germany: Harrassowitz, 2005). This meaning does not relate to Sultan Qalawun's identity as a Mongol as much as it emphasizes his Central Asiatic ancestry. The goose in Eurasia was a totemic bird related to the celestial sphere and symbolically equivalent to the Sun. See Edward Armstrong, "The Symbolism of the Swan and the Goose," *Folklore* 55, no. 2 (1944): 54–58; Ingeborg Hauenschild, *Tiermetaphorik in türksprachigen Pflanzennamen* (Wiesbaden, Germany: Harrassowitz, 1996), 35. Previous attempts to associate *Qalawun* with a "duck" are therefore less convincing. I thank Tune Phillip for bringing these references to my attention.

7 See Eva Baer, "'Fish-Pond' Ornaments on Persian and Mamluk Metal Vessels," *Bulletin of the School of Oriental and African Studies, University of London* 31, no. 1 (1968): 14–27. See also Maria Sardi, "Swimming Across the Weft: Fish Motifs on Mamluk Textiles," *Art, Trade and Culture in the Islamic World and Beyond: From the Fatimids to the Mughals. Studies Presented to Doris Behrens-Abouseif* (London: Gingko Library, 2016), 254–63. James Allan discusses the symbolic connections

between fish and the sun, and the notion of the sun as a source of life. See Allan, *Islamic Metalwork: The Nuhad Es-Said Collection* (London: Sotheby Publications, 1982), 98.

8 I thank Rachel Ward for her support through personal communication on this subject.

9 Atıl, 15. During the reign of Sultan Nasir al-Din Muhammad, embassies from the khans of the Golden Horde, Rasulids of Yemen, Ilkhanids of Iran, and sultans of Delhi, as well as the pope and the kings of Aragon, France, Byzantium, Bulgaria, Tunisia, and Abyssinia, worked to secure beneficial trade relations among all parties. See also "The Mamluks." In Markus Hattstein and Peter Delius, eds., *Islam: Art and Architecture* (Potsdam, Germany: HF Ullmann, 2013), 170–71.

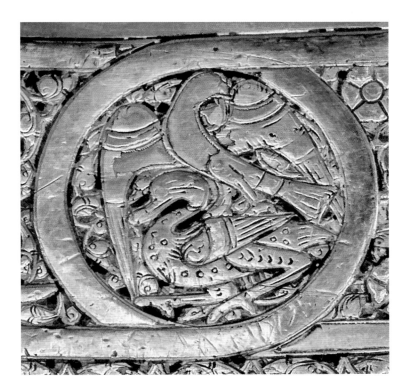

5

BOWL

Marked with the *tughra* of Alemshah (d. 1510)
Turkey, before 1510
Silver; gilded, repoussé
Diameter 18 cm

Resting gracefully with its head turned, a sculpted ram occupies the centre of this silver gilt dish (see pages 16 and 37). Three star-headed rivets affix the ram to a central plaque surrounded at four points by lobed cartouches decorated with alternating lily and lotus sprays. A fine band incised at regular intervals with an alternating leaf-and-braid pattern runs along the tops of these cartouches, while a thicker band of incised vegetal decoration joins the cartouches at midpoint. The technique of repoussé — hammering the metal from its underside — gives the cartouches and central plaque a subtle dimensionality. The *tughra* (the calligraphic mono-gram) of Alemshah, son of Sultan Bayezid II (r. 1481–1512) and governor of the Turkish cities of Menteshe (1481) and Manisa (1507–10), is engraved at the left of the top cartouche, dating this bowl no later than 1510, the year of Alemshah's death.[1]

Early sixteenth-century silver bowls with sculpted rams or stags at their centres have been found in Serbian churches where the imagery held a Christian resonance: as the animal rushes to water, so the faithful rush to Holy Scriptures to satisfy their thirst for salvation.[2] Such Christian imagery could be adapted to traditional Islamic contexts, a practice that became increasingly common as artisans from a wide range of territories annexed into the Ottoman state (and, in turn, the Ottoman Empire) found employment at the Ottoman court.[3] Along with Iranian artisans skilled in metalwork, Balkan silversmiths were active in Edirne at least since the 1360s when nearly a century of Ottoman expansion into the Balkans began.

Of less certain origin are the star-headed rivets that attach the plaque to the centre of the bowl.[4] However, the bowl's lotus and lily designs suggest the influence of art produced in the Golden Horde, a Mongol khanate established in the mid-thirteenth century.[5] Comprised of parts of present-day Russia, Ukraine, and Kazakhstan, the Golden Horde, which existed until 1502, had roots in China and Central Asian cultures and played a key role in exchanging and transmitting cultural knowledge from the east to points west and south.[6]

Ancient Greek vessels called *phiala* — which similarly inspired the Roman *patera* Iranian *piyale* — might have influenced this Ottoman bowl's form and function. A shallow bowl with

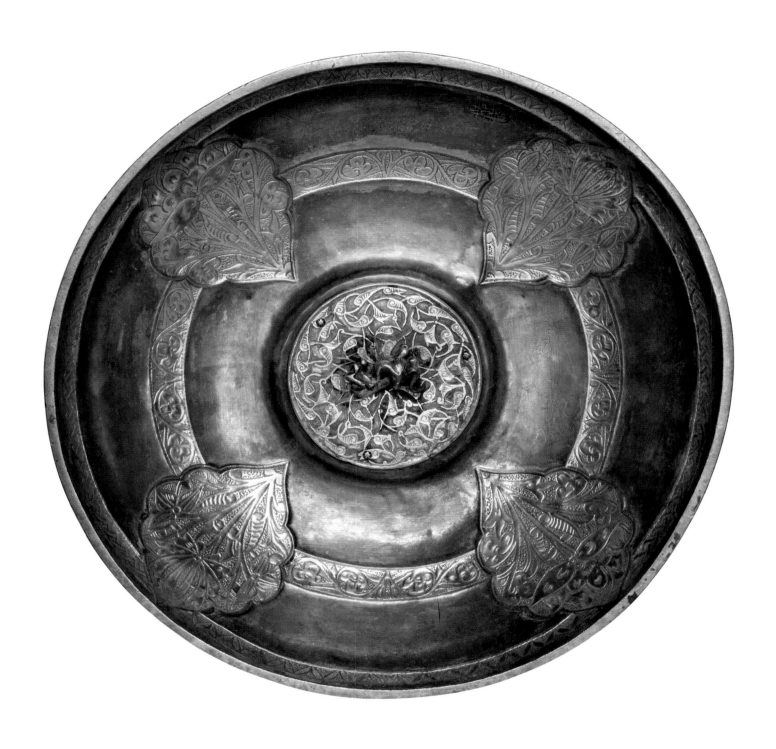

a raised knob or "navel" (*omphalos*), the *phiale* was used for medical preparations and to pour libations, often in a ceremonial context. Both uses might have informed how it was used in the Near East where it was also associated with ritual.[7]

Masterfully crafted, this exceptional bowl attests to the dynamic exchange of artistic traditions with as well as within the Ottoman Empire, which at its height in the sixteenth and early seventeenth centuries stretched from southeastern Europe to North Africa and western Asia.

NOTES

1 *Islamic Works of Art* (London: Sotheby's, April 25, 1990), Lot 447.

2 Brigitte Pitarakis and Christos Merantzas, *Treasured Memory: Ecclesiastical Silver from the Late Ottoman Istanbul in the Sevgi Gönül Collection* (Istanbul: Sadberk Hanım Müzesi, 2006), 153–54.

3 Indeed, Christian and totemic beliefs acquired new meanings as the Muslim Ottomans continued to expand their empire into new territory. In the Balkans, for instance, a dervish would bless a bowl filled with water that would then be sprinkled on farmland to ensure a fertile crop. See Meinrad Maria Grewenig, ed., *Schätze aus 1001 Nacht: Faszination Morgenland* (Annweiler, Germany: Völklinger Hütte — Springpunkt Verlag, 2005), 72.

4 John Carswell, *Iznik Pottery* (London: Published for the Trustees of the British Museum by British Museum Press, 1998), 33.

5 B.I. Marshak and M.G. Kramarovsky, "A Silver Bowl in the Walters Art Gallery, Baltimore: Thirteenth-Century Silversmiths' Work in Asia Minor," *Iran* 31 (1993): 119–26.

6 The Bruschettini silver dish with gilded four-lobed leaves has similarities with the silver dishes kept at the National Museum of Hungary in Budapest and the Hermitage in St. Petersburg. Compare National Museum of Hungary, KKO 17/1887, 1–6; Hermitage, Acc. No. Tb. 221. The fourteenth-century Hermitage bowl found in the northern Caucasus is probably from Crimea. See *Dschinghis Khan und seine Erben* (Munich: Hirmer, 2005), 262.

7 James W. Allan, *Metalwork of the Islamic World: The Aron Collection* (London: Sotheby's, 1986), 42.

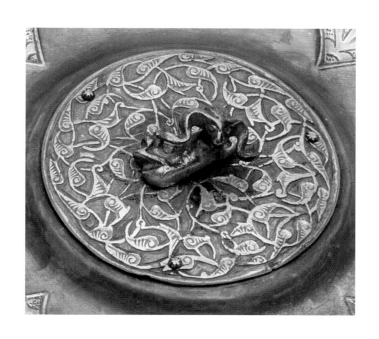

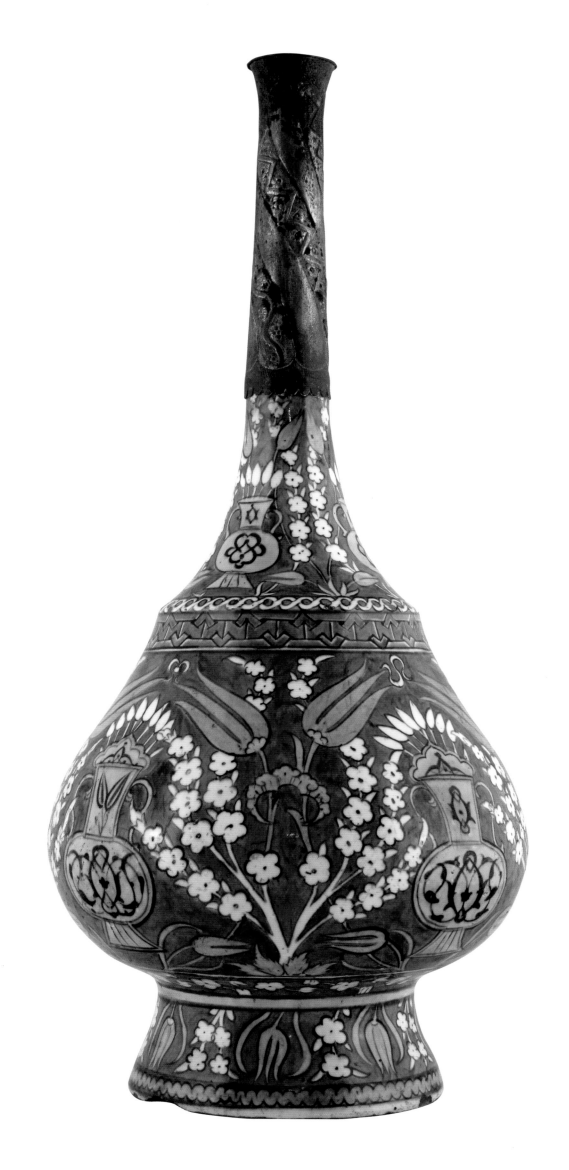

CERAMICS

FLORAL HARMONY

Filiz Çakır Phillip

In capturing Constantinople after a fifty-seven-day siege in the spring of 1453, Ottoman Sultan Mehmed II (r. 1444–46, 1451–81) did not merely conquer the Christian Byzantine Empire, an astounding feat in itself; he also transformed the Ottoman State into the Ottoman Empire, whose political might would be matched by tremendous activity in the realm of arts and culture.

An ambitious and tireless patron of the arts, Mehmed II wasted no time in reconstructing his capital.[1] Supporting new architectural projects from markets to madrasas and mosques, he also gave craftsmen and traders special tax privileges, raising their status within Ottoman society. Establishing libraries for his new empire, Mehmed II invited writers to copy manuscripts for burgeoning collections; and for new mosques, he employed artisans to produce illuminated Qur'ans.[2] He even permitted Venetian artist Gentile Bellini to paint his portrait,[3] setting the precedent for a portraiture tradition within Ottoman art.[4] Mehmed II clearly understood the importance of cultivating imperial power through artistic traditions old and new.[5]

Mehmed II's decision in 1459 to begin construction on a new palace marked another crucial stage in the development of Ottoman arts. The Topkapı Palace required extensive interior decoration by talented craftsmen. Moreover, its first courtyard was designated as a court atelier.[6] Here, luxury goods — often richly decorated in gold and silver — were produced for the palace and its diplomatic activities. With royal patronage, artisans maintained a successful livelihood dictated by a centrally organized set of standards and procedures.[7]

Particularly influenced by Ottoman metalwork,[8] ceramics and textiles began to share a newly coherent design language that initially was a variant of the International Timurid Style.[9] Until about 1520, this Ottoman modification combined Chinese and Iranian motifs — from *hatayi* flowers and Chinese cloudbands to arabesques[10] and Arabic inscriptions — often densely covering a ground of cobalt

Bottle (Cat. No. 6)
Iznik, Turkey, ca. 1535–45;
fritware; underglaze-painted;
height 53.3 cm

blue or white. This unique translation of the International Timurid Style prepared the way for an even more distinctive Ottoman style that evolved as the Ottoman Empire reached its political, economic, and cultural apex in the sixteenth century.

When they turned their attention to the production of ceramic tiles and wares, Ottoman artisans had a wealth of models to draw upon — among these, a considerable quantity of Ming dynasty porcelain kept at Topkapı Palace; Abbasid and Seljuq wares covered in white slip to imitate porcelain or overglazed in oxides to produce a rich surface lustre;[11] and extraordinary mosaic tiles of the late Ilkhanid and Timurid periods that adorned the interior and exterior of buildings.

Technical innovation had a tremendous impact on Ottoman ceramic production. In the early sixteenth century, Ottoman artisans (likely led by Habib, an émigré artist from Tabriz) perfected the *cuerda seca* technique originally developed in northwestern Iran.[12] Enabling adjacent coloured glazes to be fired at the same time without running into each other, this relatively inexpensive dryline technique not only streamlined production but also permitted the execution of complex polychrome designs. In the sixteenth century, Ottoman artisans achieved brighter, more highly saturated colours on their tiles and ceramic wares by substituting a body of white paste rather than the traditional red paste as their base. Artisans then covered this white body with white slip and applied polychrome glazes and a transparent glaze.[13] In doing so, they produced the optimal conditions to render the striking floral designs that became hallmarks of Ottoman design.

A third technical development was the evolution of pigment, which enabled artisans to move from a predominantly blue-and-white palette well suited to Chinese-inspired designs to a spectrum of colour that included turquoise, purple, olive and emerald green, and red.[14] With more colours at their disposal, Ottoman artisans could create increasingly naturalistic flowers, culminating in the *quatre fleurs* or four-flower compositions featuring roses, carnations, hyacinths, and tulips.[15] Their subject matter reflected a true love of horticulture in Ottoman society; in the sixteenth century, Istanbul boasted more than 200 flower shops,[16] and, through trade, many artisans were well aware of the strong tradition of European botanical prints and drawings (particularly in Venice) that had emerged early in the previous century.[17] Floral tiles and ceramics displayed in Ottoman homes created the impression of a "garden indoors."[18]

Suleyman the Magnificent (r. 1520–66), under whose reign the Ottoman Empire reached its zenith, had a significant influence on the development of Ottoman ceramics. Working closely with his court architect Sinan (d. 1588), he commissioned mosques, palaces, and a host of other new construction or renovation projects that called for tile decoration both inside and out.[19] With these projects, Suleyman — like Mehmed II in the previous century — sought

to celebrate his far-reaching power, which at its west spread into the Balkans and at its east reached the borders of Safavid Iran.

The implications of Suleyman's vision were enormous: the small collective of ceramicists employed at the court atelier (which, according to the royal wage register of 1526, included a chief craftsman named Habib and a small number of assistants)[20] could not possibly execute tiles on such a scale. An entirely new centre of ceramic production was required. Suleyman chose the city of Iznik, conveniently located near the natural resources required for ceramic manufacturing and just sixty-four kilometres from the court at Istanbul.[21] What developed was a uniquely symbiotic relationship between the two locations. Directors of the court atelier — first Shah Qulu, an Iranian émigré, then Kara Memi, his most talented pupil[22] — established design approaches that were executed by skilled artisans at Iznik; Iznik artisans in turn perfected techniques and pigments and completed court commissions while venturing into the increasingly lucrative world of commercial production. Iznik's location on the main road from Aleppo, Damascus, Bursa, and Izmir to Istanbul ensured that it could distribute its wares via well-established trade networks.[23]

The Ottoman court valued Iznik for its tile production; archival evidence reveals that, on more than one occasion, court officials brought Iznik workshops to task for selling tile shipments intended for the court to merchants instead.[24] Yet there is no evidence of Iznik ware having been collected by the court at the Topkapı Palace, where exquisite Chinese porcelain — particularly from the Ming Dynasty (1368–1644) — was highly prized.[25] Moreover, though Iznik ware was produced in such variety as to meet all needs, from tankards and cups to lamps, bowls, plates, and water jars,[26] the palace seems to have used it as a last resort: on occasions when its porcelain collection was not large enough to accommodate a large assembly of guests.[27]

Given the high quality of Iznik wares and tiles in the sixteenth century, it is not surprising to find this period well represented in the Bruschettini Collection. Covering a period of about 1535 to the end of the sixteenth century, the objects — an Iznik water bottle (ca. 1535–45, Cat. No. 6), a dish with flowers (ca. 1575, Cat. No. 7), a dish with scaled pattern (1580–85, Cat. No. 8), and a tile panel (late sixteenth century, Cat. No. 9) — reflect a fascinating evolution from what Hülya Bilgi has identified as the second to fourth phases of a five-phase development of Iznik wares and tiles.[28] In the second phase, which Bilgi locates from the beginning of Suleyman's reign to about 1540, ceramic wares and tiles revealed the influence of artist-cum-court atelier director Shah Qulu. From Shah Qulu came the *saz* leaf motifs that began to appear on Ottoman ceramics along with early experiments with floral naturalism.[29] Chinese motifs such as lotuses, cloudbands, and *hatayi* flowers were also still very much in

circulation, and a more freely flowing style, called the "Potters' style" by Julian Raby,[30] also characterized the tiles and wares of this phase.

By the fourth phase (1560–1600), additional forms of ceramic wares appeared,[31] and the influence of Kara Memi, the heir to the court atelier, was felt in the floral-infused compositions that now covered the surfaces of tiles and wares in a whole new range of colours. The longest of the five phases, this was also the most eclectic in its mixing of non-figurative motifs. Iznik workshops employed artisans from all corners of the empire who brought with them the unique design language of their native homes. The designs' eclectic exuberance affirmed a geopolitical reality: that by the late seventeenth century, the Ottoman Empire had expanded across three continents. Compounded by healthy trade networks, this intercultural mixing inevitably influenced the artistic production of the time. Although Suleyman's death in 1566 ceased the frenetic activity associated with royal building projects, the commercial demand for Iznik ceramics remained high within and outside the empire.

In his famous seventeenth-century travelogue *Seyahatname* (Book of Travels), Ottoman explorer Evliya Çelebi (1611–82) identified more than 300 Iznik workshops producing tiles and ceramic wares.[32] However, by Evliya's time, the production of high-quality ceramics in the Ottoman Empire had reached its height and would begin to decline over the next half century as the demand for cheaply produced commercial wares continued to grow. In the eighteenth and nineteenth centuries, Ottoman ceramics were widely imitated in Europe, and Kütahya replaced Iznik as a manufacturing centre.[33]

NOTES

1 Although this capital would become known as "Istanbul," it was still being called "Constantinople" or *Konstantiniye* at the end of the fifteenth century. See Caroline Campbell et al., *Bellini and the East* (London: National Gallery Company, 2005), 94.

2 Almut von Gladiss, "Decorative Arts: The Ottoman Empire." In Markus Hattstein and Peter Delius, eds., *Islam: Art and Architecture* (Potsdam, Germany: HF Ullmann, 2013), 566.

3 Almut von Gladiss, 566. See Isabella Stewart Gardner Museum, 78–79, Cat. No. 23; www.nationalgallery.org.uk/paintings/gentile-bellini-the-sultan-mehmet-ii, accessed May 19, 2017.

4 Almut von Gladiss, 566.

5 Nurhan Atasoy and Julian Raby, *Iznik: The Pottery of Ottoman Turkey* (London: Alexandria Press, 1989), 76.

6 Almut von Gladiss, "Architecture: The Ottoman Empire." In Markus Hattstein and Peter Delius, eds., *Islam: Art and Architecture* (Potsdam, Germany: HF Ullmann, 2013), 562.

7 Atasoy and Raby, 76.

8 Atasoy and Raby, 81.

9 Gülru Necipoğlu, "From International Timurid to Ottoman: A Change of Taste in Sixteenth-Century Ceramic Tiles," *Muqarnas* 7 (1990): 136–37. Sheila S. Blair and Jonathan M. Bloom, in *The Art and Architecture of Islam, 1250–1800* (New Haven, CT: Yale University Press, 1994), 69, write: "The Timurid visual vocabulary which had been developed in Iran and Central Asia in the fifteenth century came to permeate the visual arts of other regions, notably Turkey and Muslim

India, and there developed what has come to be called an International Timurid style. This style, characterized by chinoiserie floral motifs integrated into languid arabesques, became particularly important in the development of a distinct Ottoman style in the sixteenth century." See also Hülya Bilgi, *Dance of Fire: Iznik Tiles and Ceramics in the Sadberk Hanım Museum and Ömer M. Koç Collections* (Istanbul: Sadberk Hanım Müzesi, 2009), 25.

10 Atasoy and Raby, 76.

11 Sheila Blair and Jonathan Bloom, "Decorative Arts: The Abbasids" and "Decorative Arts of the Great Seljuks." In Markus Hattstein and Peter Delius, eds., *Islam: Art and Architecture* (Potsdam, Germany: HF Ullmann, 2013), 122 and 382–83.

12 Walter B. Denny, "Turkish Tiles of the Ottoman Empire," *Archaeology* 32, no. 6 (1979): 8; Necipoğlu, 142; Bilgi, 14. See also introduction to "Textiles: Threads of Splendour" in this catalogue (page 117).

13 Arthur Lane, "The Ottoman Pottery of Isnik," *Ars Orientalis* 2 (1957): 253.

14 Denny, 11; Bilgi, 17.

15 Maria Queiroz Ribeiro, "Eastern Islamic Art." In *Calouste Gulbenkian Museum* (Lisbon: Calouste Gulbenkian Foundation, 2011), 55.

16 Nurhan Atasoy, *A Garden for the Sultan: Gardens and Flowers in the Ottoman Culture*, trans. Robert Bragner and Angela Roome (Istanbul: Kitap Yayinevi, 2011), 11.

17 Atasoy and Raby, 222.

18 Necipoğlu, 157.

19 Gérard Degeorge and Yves Porter, *The Art of the Islamic Tile* (Paris: Flammarion, 2002), 200.

20 The document from 1526 identifies the chief as Habib from Tabriz, and he is almost certainly one of the craftsmen Selim I brought to his capital from Tabriz in 1514 after the Battle of Çaldıran near Tabriz. He had ten assistants recruited from various parts of the Ottoman Empire, including Bosnia, Trabzon, Skopje, Prespa, Nevrekop, and Varna. See Necipoğlu, 139; Bilgi, 14.

21 See Metropolitan Museum of Art, Acc. No. 17.190.20.83.

22 Banu Mahir, "Saray Nakkaşhanesinin ünlü Ressamı Şah Kulu ve Eserleri," *Topkapı Sarayı Müzesi: Yıllık-1* (Istanbul: Topkapı Sarayı Müzesi, 1986), 113–30; and "Osmanlı Sanatında Saz Üslubundan Anlaşılan," *Topkapı Sarayı Müzesi: Yıllık-2* (Istanbul: Topkapı Sarayı Müzesi, 1987), 123–33. Bilgi, 26, refers to Mahir's research in this area. See also Nazanin Hedayat Munroe, "Silks from Ottoman Turkey," *Heilbrunn Timeline of Art History* (New York: Metropolitan Museum of Art, 2012), www.metmuseum.org/toah/hd/tott/hd_tott.htm, accessed May 19, 2017.

23 John Carswell, "Ceramics." In Yanni Petsopoulos, ed., *Tulips, Arabesques & Turbans* (London: Alexandria Press, 1982), 80.

24 Atasoy and Raby, 118; also quoted by Bilgi, 28.

25 Tahsin Öz provides detailed documentation of these types in *Turkish Ceramics* (Ankara: Turkish Press, Broadcasting and Tourist Department, 1954), 27. Atasoy also mentions that the available documents were concerned with quantity, value, and size, and were compiled by clerks and administrators, not potters or connoisseurs. See Atasoy and Raby, 23–32, 37.

26 See the Louvre website, http://mini-site.louvre.fr/trois-empires/en/ceramiques-ottomanes.php. For general archival evidence, see Robert Anhegger, "Quellen zur Osmanischen Keramik." In Katharina Otto-Dorn, ed., *Das islamische Iznik* (Berlin: Archäologisches Institut des Deutschen Reiches, 1941), 165–95; Necipoğlu, 136–70; Atasoy and Raby, 23–32.

27 Bilgi, 25.

28 Bilgi, 26–32.

29 Necipoğlu, 148; Bilgi, 26–27.

30 Atasoy and Raby, 115–16. Raby explains: "the potters' search for emancipation from the strictures of court-inspired decoration gave rise to a style, 'The Potters' style.' In this group of wares are the contour lines acting as a 'halo' to a main composition which thus appears superimposed on a blue ground decorated with vestigial 'Baba Nakkaş' flowers. The 'Potters' style' has ability to combine different elements into successful ensembles."

31 Bilgi, 30–32.

32 Carswell, 86.

33 Bilgi, 32.

6

BOTTLE

Iznik, Turkey, ca. 1535–45
Fritware; underglaze-painted
Height 53.3 cm

Formerly part of the Lord Leighton Collection[1] and quite similar to an Iznik bottle in the Louvre Collection,[2] this finely decorated water bottle was originally comprised entirely of ceramic. The metal top[3] was likely added later in an effort to restore the upper neck, which was broken. Curving branches of white prunus (plum blossom) add a freedom of movement to a highly symmetrical composition centred by a double-handled vase in the shape of an amphora.[4] The vase-and-flower design is repeated on both the neck and body and separated at the bottle's shoulder by interlaced strapwork. On the bottle's tapered base, a variation on the tulip and prunus design is bounded by a band of solid turquoise and an undulating band of light blue.

The colour palette, stylistic features, and iconography of this bottle uniquely capture a period of transition between what Hülya Bilgi calls the first and second "phases" in a five-phase development of Iznik ceramic ware and tiles.[5] The blue-and-white colour scheme suggests the influence of Chinese porcelain, which, as "spoils of war,"[6] could be readily found in the Ottoman court after the occupation of Tabriz and fall of both Damascus and Cairo in the early sixteenth century. The appearance of turquoise (found most noticeably on the double-handled vases) dates the Bruschettini bottle at least to the 1530s, since it was not until then that Iznik artists began expanding their pigments to include copper oxide in addition to cobalt.[7]

The transitional nature of the Ottoman bottle in the Bruschettini Collection is further suggested in the rendering of its flowers. The tulips are simplified almost to abstraction, their stems and leaves reminiscent of vegetal arabesques on early metalwork. In contrast, the white flowers of the prunus[8] possess a degree of naturalism that would continue to be explored in late sixteenth-century Ottoman ceramics and architectural tiles.[9] Taken together, the floral motifs suggest less rigidity and symmetry than what is typical of the International Style. It might be here that the independent spirit of the "Potters' style" can be seen, suggesting the movement of Iznik artisans away from the decorative motifs dictated by the court atelier.[10]

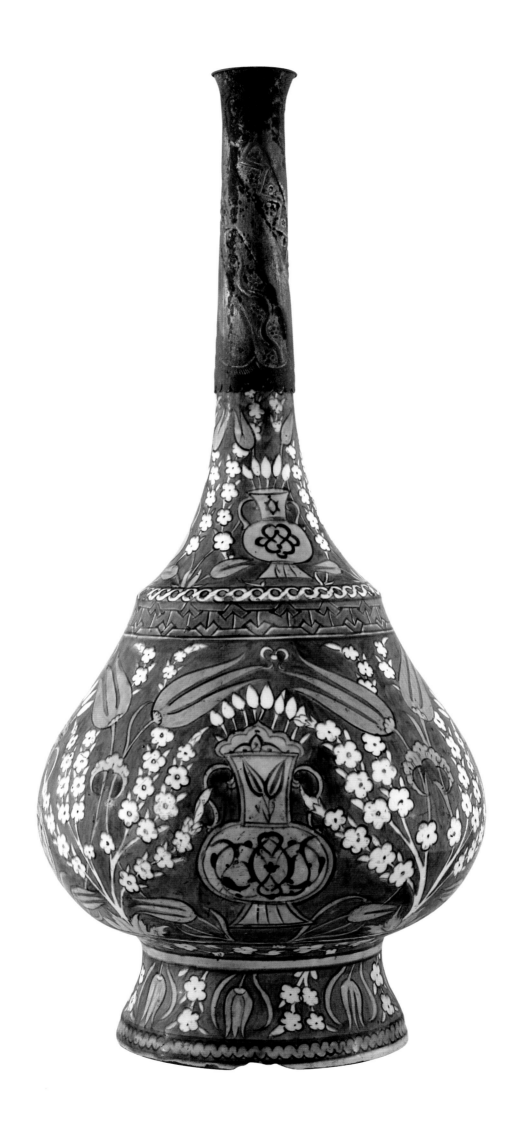

The symmetrical arrangements inside the double-handled vase of what appear to be closed tulips might be an early example of a "flowers in vase" motif found on a wide range of dishware and storage vessels in the mid to late sixteenth century. Examples of double-handled vases can also be found on architectural tiles of the 1560s and 1580s (for example, in Istanbul, the Rüstem Pasha Mosque, 1561; Sultan Atik Valide Mosque, 1583; and Mehmet Ağa Mosque, 1585).[11]

Poised on the cusp of what would become an internationally recognizable "Ottoman style," this bottle in the Bruschettini Collection offers a rare glimpse into the building of a design language that is still very much in use today.

NOTES

1 Nurhan Atasoy and Julian Raby identify this water bottle with Lord Frederic Leighton's Collection and suggest it is connected to the "Musli Group." "Musli" refers to Musli al-Din, whose name appears on a mosque lamp dated 1549 (now in the British Museum) and who has been linked to commissions by Suleyman the Magnificent. See *Iznik: The Pottery of Ottoman Turkey* (London: Alexandria Press, 1989), 135, 138. Bernhard Reckham provides sales catalogue information stating that this bottle was item no. 110 in a Paris auction that took place December 3–5, 1913. Edouard Aynard was one of the previous owners. See *Islamic Pottery and Italian Maiolica* (London: Faber & Faber, 1959), 27, No. 65.

2 More examples can be seen on tiles, dishes, and objects in various periods during the development of the artistic repertoire of Iznik ware. See Hülya Bilgi, *Dance of Fire: Iznik Tiles and Ceramics in the Sadberk Hanım Museum and Ömer M. Koç Collections* (Istanbul: Sadberk Hanım Müzesi, 2009), 146, 426–27. Also Musée du Louvre, Paris, Acc. No. 9142.

3 Nurhan Atasoy and Julian Raby, 139, use the term *metal top* to describe this repoussé piece.

4 In *A Garden for the Sultan: Gardens and Flowers in the Ottoman Culture*, trans. Robert Bragner and Angela Roome (Istanbul: Kitap Yayınevi, 2011), 82, Nurhan Atasoy provides an excellent example of a large double-handled jar in the Mundy Album (British Museum A 1974-6-17-013r, dated 1618). This album contains sixty folios with fifty-nine paintings and designs cut from paper. See www.britishmuseum.org/research/collection_online/collection_object_details.aspx?objectId=1478539&partId=1&searchText=mundy+Album&page=1, accessed May 19, 2017.

5 Bilgi, 26–28.

6 Maria Queiroz Ribeiro, *Iznik Pottery and Tiles in the Calouste Gulbenkian Collection* (Lisbon: Calouste Gulbenkian Foundation, 2009), 15; Carlo Beltrame, Sauro Gelichi, Igor Miholjek, *Sveti Pavao Shipwreck: A 16th Century Venetian Merchantman from Mljet, Croatia* (Oxford: Oxbow Books, 2014), 68.

7 Walter B. Denny, "Turkish Tiles of the Ottoman Empire," *Archaeology* 32, no. 6 (1979): 11; Denny, *Iznik: The Artistry of Ottoman Ceramics* (London: Thames & Hudson, 2010 [reprint]), 59, 62.

8 In China the pine, prunus, and bamboo were known as "the friends of winter" and came to symbolize virginity and purity. Nurhan Atasoy and Julian Raby locate the earliest use of the prunus by Islamic artists in the fourteenth century. See Atasoy and Raby, 223.

9 Bilgi, 28. Prunus blossoms became a favourite motif of Kara Memi, whose naturalistic depictions of flowers came to define a uniquely Ottoman style by the mid-sixteenth century. The prunus likely entered the decorative lexicon of Ottoman artisans through their Iranian counterparts, who had in turn been inspired by Chinese porcelain. See Atasoy and Raby, 223.

10 Raby ascribes the Potters' style to a brief period from about 1520 to the 1530s, deeming it "a first tentative step towards the exuberant floral naturalism of the second half of the 16th century." See Raby, 115–20.

11 I thank Dr. Hülya Bilgi for sharing her references.

7

DISH

Iznik, Turkey, ca. 1575
Fritware; underglaze-painted
Diameter 37 cm

Called a *tabak* or *sahan*,[1] this unusually large, shallow dish made of white paste shows the level of naturalism that Ottoman ceramics had attained by the late sixteenth century. With a free and expressive hand, the artisan has painted over white slip a myriad of floral and leaf designs that depart from pure symmetry and geometrical abstraction. On the dish's interior, intertwining roses, hyacinths, tulips, and other small flowers are depicted from bud to bloom to probable death; the broken stem in the upper-right area of the composition is a particularly naturalistic touch. On the exterior of the dish, rosettes and pairs of blue tulips continue the floral theme, evoking a garden and showing the influence of the *quatre fleurs* designs popularized by Kara Memi from the mid to late sixteenth century. Unlike the feathery *saz* leaves inspired by Memi's mentor, Shah Qulu of Tabriz, Memi's floral compositions pointed to a distinctly Ottoman style of decoration[2] that was also expressed widely in textiles.

Similar to the scaled Ottoman dish in the Bruschettini Collection, this dish demonstrates the expanded palette made possible by pigments that entered the design vocabulary in the 1550s and 1560s:[3] red (made from iron oxide), emerald green (made from copper oxide), and black (made from a chromite and spinel mineral[4]). Moreover, though this dish relies less on repetitive patterns than the densely scaled dish, it is equally dynamic in its composition. Tendrils and blossoms appear to grow across and around the dish's interior in a proliferation of colour and movement, while the exterior is decorated with six little blue tulips with green stems alternating with six blue blossoms with green centres.

The Bruschettini dish also shares design features with late-sixteenth-century dishes in the Metropolitan Museum of Art and Ömer M. Koç Collections,[5] favouring organic forms over the strictly geometric and showing a synthesis of cultural influences, including Chinese and Iranian. The skill with which these designs have been executed sets them apart from the less costly domestic wares produced in increasing quantities beginning in the seventeenth century. Perhaps, as is suggested by the "Iznik Dish Depicting Two Birds Among Flowering Plants"

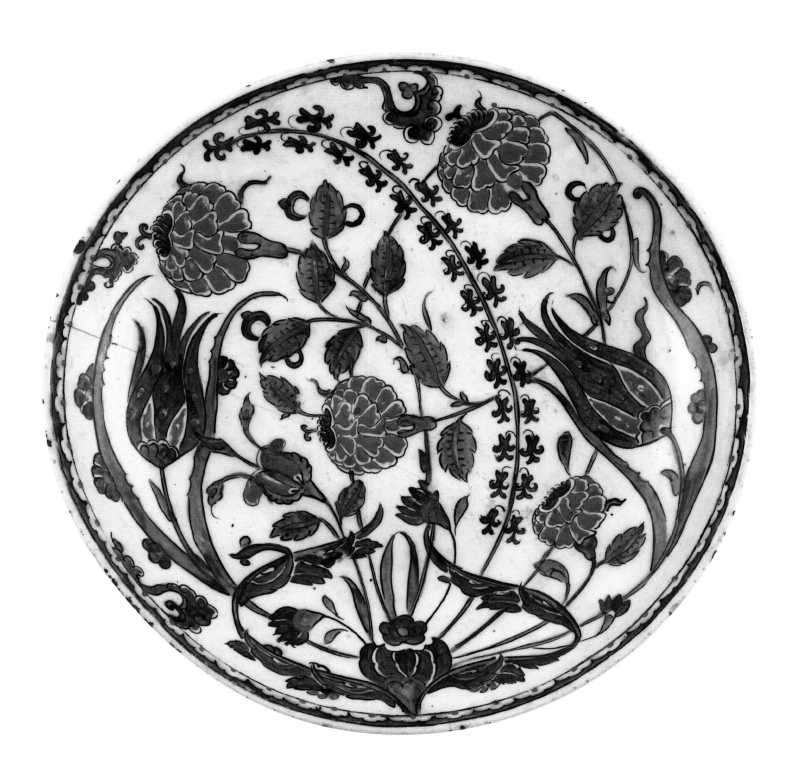

(ca. 1575–90) in the Metropolitan Museum of Art Collection, the Bruschettini dish was primarily used for display rather than serving.[6]

NOTES

1 Nurhan Atasoy and Julian Raby, *Iznik: The Pottery of Ottoman Turkey* (London: Alexandria Press, 1989), 38.

2 Atasoy and Raby, 222; Maria Queiroz Ribeiro, "Eastern Islamic Art," *Calouste Gulbenkian Museum* (Lisbon: Calouste Gulbenkian Foundation, 2011), 55; Maryam Ekhtiar et al., eds., *Masterpieces from the Department of Islamic Art in the Metropolitan Museum of Art* (New York: Metropolitan Museum of Art, 2011), 302.

3 Walter Denny places the introduction of emerald green "during the late 1560s" and the appearance of red "after 1555" in *Iznik: The Artistry of Ottoman Ceramics* (London: Thames & Hudson, 2010 [reprint]), 52. See also Maryam Ekhtiar et al., 302. The dish belongs to the fourth phase (1560–1600) identified by Hülya Bilgi in *Dance of Fire: Iznik Tiles and Ceramics in the Sadberk Hanım Museum and Ömer M. Koç Collections* (Istanbul: Sadberk Hanım Müzesi, 2009), 30–32.

4 Atasoy and Raby, 59.

5 The Bruschettini dish also shares design features with late-sixteenth-century dishes in the Metropolitan Museum of Art (Acc. No. 12.203) and Ömer M. Koç Collection. See Bilgi, 236, Cat. No. 125.

6 See catalogue entry for "Iznik Dish Depicting Two Birds Among Flowering Plants" (ca. 1575–90) in the Metropolitan Museum of Art Collection (Acc. No. 59.69.1), www.metmuseum.org/art/collection/search/451490?sortBy=Relevance&ft=ottoman+ceramics&offset=0&rpp=20&pos=9, accessed May 19, 2017.

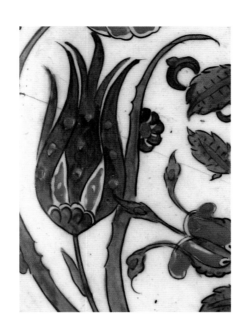

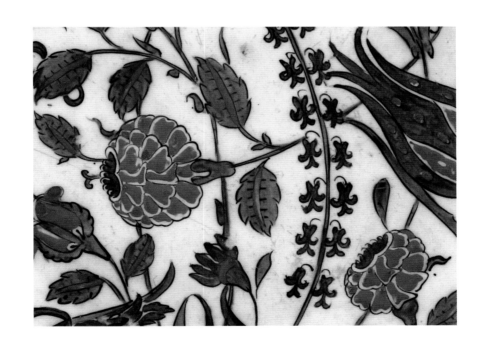

8

DISH

Iznik, Turkey, ca. 1580–85
Fritware; underglaze-painted
Diameter 34 cm

Dynamic polychrome patterns and motifs create the illusion of movement on this shallow dish with a flanged rim.[1] The scaled ground, which alternates between deep cobalt blue and emerald green and is interrupted by pairs of serrated leaves, intensifies this effect. Even the outer rim, decorated with a cobalt-blue band of palmette motifs, contributes to the design's irrepressible energy. The eight heart-shaped motifs punctuating the scaled ground in white and red are lone points of stasis in the composition. On the exterior of this object, as with the Cat. No. 7 dish, six little blue tulips with green stems alternate with six blue blossoms with green centres.

The pigments used on this dish confirm a production date after the mid-sixteenth century when Ottoman Sultan Suleyman the Magnificent (r. 1520–66) was in the final decade of his illustrious reign. Iron oxide (Armenian bole) created the unusual red, whose thick, "sealing wax"[2] consistency produced the effect of relief when applied. This colour became a favourite of court artist and atelier director Kara Memi,[3] whose naturalistic floral designs brought him and, by extension, the Ottoman ceramics industry, considerable renown from the mid to late sixteenth century. The black, derived from a chromite and spinel mineral,[4] and emerald green, made from copper oxide, are also newer colours that were soon applied widely to domestic and luxury wares.

The treatment of the scaled pattern is distinctly late sixteenth century. During Murad III's reign (1574–95), white highlights on scale patterns moved from the base of the scales to their upper edges, and blue and green fish scales were juxtaposed. Motifs such as cloudbands, white arabesques, or as in the Bruschettini dish, *saz* leaves often separated these coloured scales.[5]

The serrated *saz* leaves, gently waving here as if moved by currents of air or water, are not exclusive to late-sixteenth-century Ottoman wares and tiles. Influenced by Chinese and Iranian art, they had appeared in intricate drawings by the Iranian émigré Shah Qulu,[6] who joined the Ottoman court atelier in 1525 and soon became its director. With these drawings as inspiration, Ottoman artisans began incorporating *saz* leaves into Ottoman ceramics in the

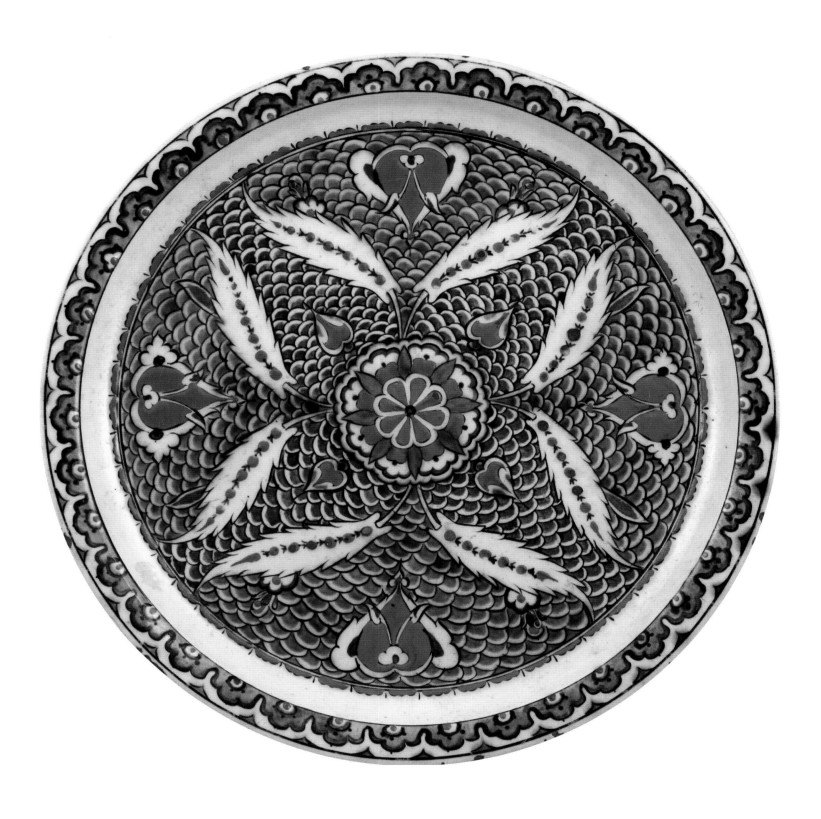

1540s.[7] They became inextricably associated with the *quatre fleurs* motif of carnations, roses, hyacinths, and tulips popularized by Kara Memi, who replaced Shah Qulu as atelier director after the latter's death in the 1550s.

However, that the Bruschettini dish features *saz* leaves woven into an already dense design is quite typical of a late-sixteenth-century aesthetic: in the fourth phase of Ottoman ceramics described by Hülya Bilgi,[8] motifs from earlier phases were used together with exuberance. It is as if the cosmopolitan nature of the Ottoman Empire were reaching full and unfettered expression. This phenomenon could not be sustained in the centuries that followed. By the early 1600s, the golden age of Ottoman ceramics had already reached its peak.

Scaled patterns began appearing on Ottoman ceramics in the mid-sixteenth century and seem to have two possible sources of influence: China and Italy. Scaled dragons on Ming dynasty wares (1368–1644) and Chinese celadon (green-glazed ware), and scaled motifs on Italian Majolica (1530s–1550s) made their way into the hands of Ottoman artisans through robust trade networks and as the result of imperial conquest and expansion.[9] Popular during Suleyman's reign, they continued to be produced after his death, as similar dishes from the collections of Ömer M. Koç, British Museum, Aga Khan Museum, and Metropolitan Museum of Art (all dated between 1575 and 1585) attest.[10]

NOTES

1 Nurhan Atasoy and Julian Raby, *Iznik: The Pottery of Ottoman Turkey* (London: Alexandria Press, 1989), Cat. No. 744.

2 Atasoy and Raby, 221.

3 Maryam Ekhtiar et al., eds., *Masterpieces from the Department of Islamic Art in the Metropolitan Museum of Art* (New York: Metropolitan Museum of Art, 2011), 302.

4 Atasoy and Raby, 59.

5 Atasoy and Raby, 260.

6 Nazanin Hedayat Munroe, "Silks from Ottoman Turkey," *Heilbrunn Timeline of Art History* (New York: Metropolitan Museum of Art, 2012), www.metmuseum.org/toah/hd/tott/hd_tott.htm, accessed May 19, 2017, drawing upon original source material by Banu Mahir. See Banu Mahir, "Saray Nakkaşhanesinin ünlü Ressamı Şah Kulu ve Eserleri," *Topkapı Sarayı Müzesi: Yıllık-1* (Istanbul: Topkapı Sarayı Müzesi, 1986), 113–30; and "Osmanlı Sanatında Saz Üslubundan Anlaşılan," *Topkapı Sarayı Müzesi: Yıllık-2* (Istanbul: Topkapı Sarayı Müzesi, 1987), 123–33. Hülya Bilgi, *Dance of Fire: Iznik Tiles and Ceramics in the Sadberk Hanım Museum and Ömer M. Koç Collections* (Istanbul: Sadberk Hanım Müzesi, 2009), 26, also refers to Mahir's research in this area.

7 Gülru Necipoğlu, "From International Timurid to Ottoman: A Change of Taste in Sixteenth-Century Ceramic Tiles," *Muqarnas 7* (1990), 143.

8 Bilgi, 30–31.

9 Sotheby's London, October 9, 2013, Lot. 151. The origin of the information is from Maria Queiroz Ribeiro, *Iznik Pottery and Tiles in the Calouste Gulbenkian Collection* (Lisbon: Calouste Gulbenkian Foundation, 2009), 79, where she calls the fashion eclecticism in the footsteps of John Carswell in *Iznik Pottery* (London: British Museum Press, 1998), 90–105. Carswell attributes the scaled pattern to two possible sources: either the scaly dragons on Chinese blue-and-white or,

more likely, the frequent use of such patterns on Chinese celadon (63). See also Bernhard Reckham, *Islamic Pottery and Italian Maiolica* (London: Faber & Faber, 1959), 21–51, 44.

10 For a comparable plate in the Ömer M. Koç Collection, see Hülya Bilgi, 301, Cat. No. 179, dated between 1575 and 1580. Atasoy and Raby note two water bottles from the British Museum with a similar design: Cat. Nos. 743 and 745; Inv. No. G.1983.116; Inv. No. G. 1983.83. The Aga Khan Museum also has two artworks with a similar fish-scale pattern: AKM873, a jug; and AKM880, a dish. Both are datable ca. 1575–80. The Metropolitan Museum of Art in New York has a similar polychrome painted dish with slightly different motifs on a scaled pattern dated ca. 1575–80. For further information about this pattern, see Danielle Maternati-Baldouy, *Un collectionneur et mécène marseillais: faïences provençales & céramiques ottomanes* (Marseille: Musées de Marseille, 2006), 398–402.

9

TILE PANEL

Iznik, Turkey, late 16th century
Fritware; underglaze-painted
38.2 × 29.6 cm

A pair of spotted red tulips inside a blue-and-red-striped vase forms the focal point of this vibrantly coloured two-tile panel. Sprays of red-centred prunus (plum blossoms) weave elegantly around the larger flowers, reaching upward to an unseen terminus on a now-missing third tile. Outlined in cobalt blue and black, these blossoms evoke floral decoration on Chinese porcelain. Smaller red tulips and king flowers give stability to the composition by "growing" in graceful curves along either side of the vase. The arabesque-like forms in cobalt blue, turquoise, and red near the top of the second tile suggest that the composition had originally been centred beneath one or more arches, perhaps as in a window. A second frame bounds the entire composition: crenellated and fixed within a turquoise border, it is comprised of alternating forms that appear to be red-spotted palmettes and lotuses. The centres of both are accented in cobalt blue and turquoise and are not in relief, as are the red centres of the plum blossoms.

Although considerably smaller, this tile panel resembles title panels found in notable late-sixteenth-century sites such as the Piyale Pasha Mosque (ca. 1570),[1] the Takyeci İbrahim Ağa Mosque (1592),[2] the Tomb of Selim II (1577) at Hagia Sophia, and the Hagia Sophia Library.[3] This abundance of examples affirms the extensive use of decorated tiles on architectural projects in the Ottoman Empire. In particular, the mid-sixteenth century experienced an exponential increase in tile production under the approving eyes of Suleyman the Magnificent (r. 1520–66) and his court architect-in-chief Sinan[4] (b. around 1490–1588). Commissioning large architectural projects to reflect the glory and enduring power of his empire, Suleyman encouraged his artisans literally to build upon the exemplars of the past — the long-standing tradition in Mesopotamia and Central Asia of architectural decoration. Moreover, with the nearby city of Iznik located conveniently on a trade route and within close proximity to natural resources, it seemed an ideal place to encourage a ceramics industry to support and augment the work of court artisans.[5]

The richness of colour on the Bruschettini tile panel is the result of technical developments: first, the use of white paste for the tile body itself, which allowed for greater vibrancy in

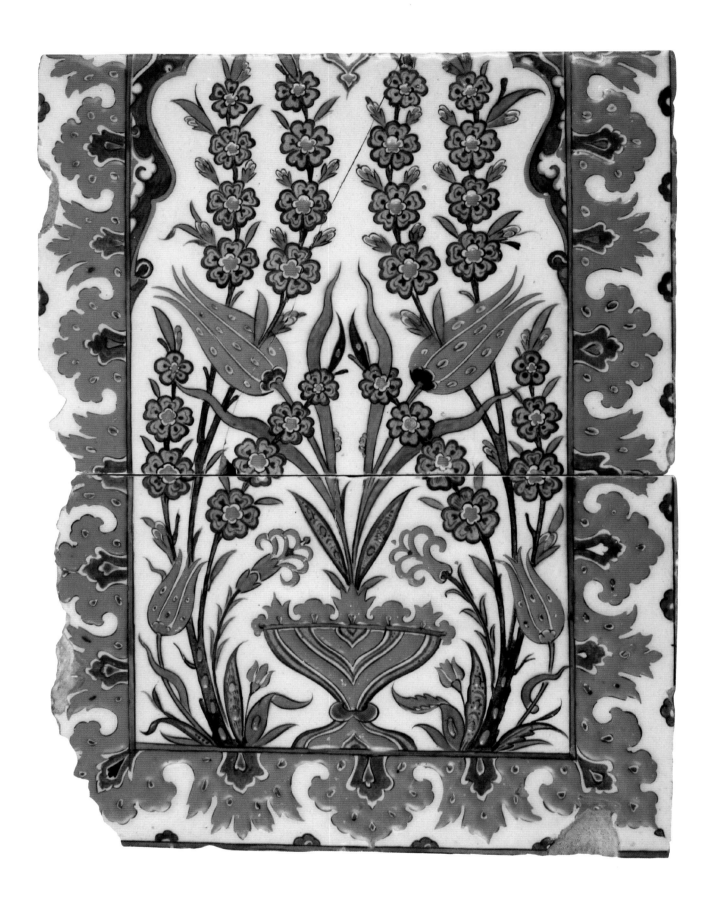

colour than the red paste covered in white slip that had previously been used. Colours painted onto a white paste body covered in white slip and then covered in a translucent glaze[6] possessed a saturated quality that has proven to be surprisingly durable. Moreover, the creation of red pigment from iron oxide (Armenian bole) in the mid-sixteenth century enabled artisans to expand their palette and to produce relief effects on the surfaces of their tiles and wares. Maintaining its vibrancy even at a distance, red tile decoration also caught light and shadow in unique ways, making them equally striking on the exterior and interior of buildings.

NOTES

1 See the Victoria and Albert Museum border tile (Acc. No. 781–1900).

2 Formerly from the Philippa Scott Collection. See John Carswell, "Ceramics." In Yanni Petsopoulos, ed., *Tulips, Arabesques & Turbans* (London: Alexandria Press, 1982), 94; Sotheby's auction, London, April 25, 1991, Lot 1150.

3 Hülya Bilgi, *Dance of Fire: Iznik Tiles and Ceramics in the Sadberk Hanım Museum and Ömer M. Koç Collections* (Istanbul: Sadberk Hanım Müzesi, 2009), 25.

4 Gérard Degeorge and Yves Porter, *The Art of the Islamic Tile* (Paris: Flammarion, 2002), 200.

5 Carswell, "Ceramics." In Yanni Petsopoulos, ed., *Tulips, Arabesques & Turbans* (London: Alexandria Press, 1982), 80. For the historical background of the city of Iznik, please see Katharina Otto-Dorn, ed., *Das islamische Iznik* (Berlin: Archäologisches Institut des Deutschen Reiches, 1941), 1–8; and Nurhan Atasoy and Julian Raby, *Iznik: The Pottery of Ottoman Turkey* (London: Alexandria Press, 1989), 19–22.

6 Arthur Lane, "The Ottoman Pottery of Isnik," *Ars Orientalis* 2 (1957): 251, 253; Bilgi, 15.

THE ART OF THE BOOK
VISIONS OF POWER AND EMOTION

Claus-Peter Haase

The Bruschettini Collection is rich in carefully chosen examples of the art of the book. The relatively small selection from that collection here concentrates on illustrations and manuscripts of central importance for art historical analysis and from different genres such as history (Cat. Nos. 11, 12, and 18), literature (Cat. Nos. 14–16), and religion (Cat. No. 19).

The signs of high-quality creations in design and technique — those two principal tokens for the rank of a work of art — were detected by the eye of the collector. The great differences in the ornamental illuminations, the illustrating images, and the calligraphed texts that have been assembled in this Genovese collection conserve a fantastic panorama of extremely varied artistic invention throughout centuries and continents. After a show of its Ottoman works of art in Genoa, its hometown, the Bruschettini Collection is now seen in Toronto's Aga Khan Museum for the first time in a coherent selection outside Italy.[1]

The last of the thirty equally long fascicules into which the Qur'an is split up for convenience of reading during the month of Ramadan, for example, is present in exceptionally beautiful calligraphy (Cat. No. 10) in the tradition of the Abbasid Caliphate (750–1258) court.[2] The great calligraphers, often pupils of the last court calligrapher Yaqut al-Musta'simi (d. 1298),[3] had founded schools that continued to keep vivid the traditional round scripts developed from the sober small *naskhi* and the monumental *thuluth*, especially the *muhaqqaq* style as in this example, according to the size of the manuscript commissioned.[4] The holy text remained separated from secular scripts that were springing up, especially in the innovative thirteenth and fourteenth centuries; only in the headlines with the names of the suras — which do not belong to the revelation — did the calligraphers make use of new styles.

Contrary to later remarks of Ottoman biographers, the main calligraphers were not affiliated with religious institutions but were associated with secular courts, which in no way affected their piety. Throughout the Mongol period and

later the new scripts *ta'liq* and *nasta'liq* were celebrated for literary and documentary luxury copies, as most of the other manuscripts and folios here reveal. But the embellishments that had been devised for the Qur'an as well as for any choice manuscript long since were continuously varied and refined according to new styles and techniques of ornament. In the Qur'an section here (Cat. No. 10), the "architecture" of the codex with a modest head ornament (*unvan*) and rather small friezes with rich ornaments stands back behind the extremely well-balanced and harmonious hieratic text lines.

Quite a different appeal is intended with the monumental folios from the *Falnameh* (Cat. No. 17), illustrating a popular religious book of presages assigned to Ja'far al-Sadiq (d. 765 in Medina), the Sixth Imam of the Twelver Shia, the Fifth of the Ismailis, and a descendant of the Prophet Muhammad and his son-in-law, 'Ali. The utmost possible enlargement of book illustrations seems to have been achieved in the present version, which could well have been shown to a larger assembly while someone read the monumental text lines in Persian. The manuscript has been produced by great artists most probably at the court ateliers of Shah Tahmasp (r. 1524–76), though his name is not connected to such a gigantic enterprise. In a typical way, the painters helped recollect remembrance and knowledge of the life of Saintly Prophets and pious early Islamic personalities whose council could help in certain critical periods of life such as travels, as in this folio. Only very few works have been realized in this monumental fashion — neither the original patronage nor the intention behind this manuscript are known, but there exist smaller versions and various similar books of omens that were very popular in the fifteenth to seventeenth centuries. Perhaps the magnificent blowing up of scenes originally drawn for manuscript illustration had a function to spread certain new interpretations of the faith in the early responsibility of Shia politics in Iran.

Obviously, much different is the background to the painting on an album leaf that we still believe to belong to a sort of religious representation in the wider sense, the transfer of the devotional image of Saint Mary Magdalene Penitent by a later Mughal collector into the love story of a maiden (Cat. No. 21). The original painting was done as a copy after a Flemish etching, and surely the original religious meaning of the latter was evident for the painter at some atelier of the Mughal Empire (1526–1857). Given the vast interest in several sorts of religious practice and the idea of God at the court of Mughal Emperor Akbar (r. 1556–1605), the matter of penitence also must have been discussed at large. It, too, is one of the most effective means to gather outsiders within the community, as well as being a Christian virtue and one of the preconditions in Islam to achieve access to paradise (*tauba*). The large horizon of artistic subjects and expression is not limited to the Mughal court — similar curiosities were also effective in Safavid Iran (1501–1736). It is the Iranian style of expressing sentiments in gesture and faces

Detail of
The Court of Humayun in Exile (Cat. No. 18)
Folio from the first manuscript of *Akbarnameh*
(Book of Akbar) by Abu'l Fazl 'Allami (d. 1602);
painting attributed in the lower margin to
Dharm Das, with faces by La'l; India, probably
1586–87; opaque watercolour, ink, and gold on
paper; 37 × 25.6 cm

that inspired the court painters of Mughal India. Later, when this painting was altered to fit into an album, the facial expression of the young lady and the requisites around her were not taken seriously anymore, so a Persian poem on the grief of love was added at the margins.

As for artistic competition and the creativity of art as a human problem, a rare piece illustrating the subject of "connecting art histories" is presented here (Cat. No. 15). The "painting of the painting" of one party of artists believing in the "traditional" ways of representative art through the act of reproduction — in the illustrated text here, the Chinese — is led into absurdity by the second party, the Greeks, who deny the use of representative means and reach out for the conceptual art by reflection. Also in the Islamic cultural debate the question of not only legitimacy but actual capacity of creative re-invention of nature continues forever. But here it is amusing to see a thirteenth-century poet and mystic philosopher inspiring an artist to "illustrate" the objection against illustration by the Greek artist, who merely polishes the wall extremely well to reflect the vision of the Chinese painting. The solution of the artist remains behind the high flow of the abstract vision of a theory of light and vision — he resorts to a very traditional style of ornamental painting by the Chinese artist and leaves the beholder with theoretical reflections alone.

Three further illustrations from manuscripts of history and historical epic lead us to the various mechanisms of Iranians coping with alien rulers and more or less radical changes in their historical phases (Cat. Nos. 11, 12, and 14). Two illustrations from the few chronographies left from early Timurid rule (1370–1507) prove the completely alien scenery in Iranian eyes that political and social ceremonies of the ruling Mongol Turkish classes represent (Cat. Nos. 11 and 12). This is a great subject in the manuscripts extant from that period, which vary in their illustrative designs from the historicist transfer of classical sceneries into contemporary lifestyles.[5] Always, the view of the Mongols as "the others" remains detached and rarely as magnificent as the successes exuberantly expanded in the texts would suggest. But on the other hand one notices the direction the patrons indicated and for which the painters found

new expressions, as in the emotions during the burial scene expressed in extreme simplicity and humility despite remaining indications of rank and high dignity. The styles developed in the famous Timurid court ateliers (*kitabkhaneh*) of the libraries of Timur's youngest son, Shahrukh (r. 1405–47), and Shahrukh's son, Baysunghur (d. 1433), in Herat and his other son, Ibrahim, in Shiraz remained influential for more than a century, well into the Safavid period, and created illuminations and images of extreme elegance.[6]

That the style of the arts of the court could be of such deep effect as to raise impressive talent in remote regions such as Gilan on the Caspian Sea, close to the terrifying woodlands of demons in Mazandaran, is another surprise. The few leaves of a richly illustrated *Shahnameh* (Book of Kings) from the end of the fifteenth century spread today among museum collections are extremely rarely in private hands. The patronage of the manuscript appears to bring the text back into authentic "Iranian" possession in the form of the Kar-Kiya dynasty, one of the few regional rulers of Pre-Islamic Iranian origin (Cat. No. 14).

The Aqqoyunlu, another dynasty of Turkoman origin from the neighbouring province of Azerbaijan, continued for some decades at the end of the fifteenth century the high cultural standards of Timurid and earlier Mongol courts in Tabriz and northwestern Iran (Cat. No. 13). Rivals of the early Ottoman Empire, they conveyed some cultural strategies and ambitions to the Ottomans before they succumbed to them. With the revolutionary start of the Safavid dynasty, new tendencies sprang up and new religious and philosophical trends were introduced, but in the arts at first the famous ateliers from Herat and even Central Asia (Bukhara) handed on their expertise when some of their great masters travelled to Tabriz and Qazvin, now the new artistic centres.

Detail of
Greek and Chinese Painter Competition (Cat. No. 15)
Folio from a manuscript of *Masnavi-i Ma'navi*
(Spiritual Couplets) by Jalal al-Din Rumi
(Maulana) (d. 1273); Tabriz, Iran, ca. 1540–50;
opaque watercolour, ink, and gold on paper;
22 × 14 cm

The subject of virtue and God-given sovereignty over real and supernatural forces is recalled with the figure of Sulayman/Solomon and on a nearly equal position his admirer, Balqis (the Queen of Sheba), at the opening of the "national" epic of the *Shahnameh* (Cat. No. 16). They probably stand exemplary for the just rule of the contemporary Timurid or Safavid members of a dynasty as well as pious Muslims, but they also reach out into interregional contacts with the Arab and other Muslim worlds that believed in the same, or nearly the same, Saints and Prophets.

With the expansion of the artistic horizon to the Mughal court, the final four works (Cat. Nos. 18–21) from the Bruschettini Collection continue the surprising *tour d'horizon* of Islamic art at the beginning of modern times. Iranian artists were attracted by the already great wealth of the court of Delhi in the sixteenth century and established ateliers similar to those found in Iran. The outstanding figure of Akbar conveyed many new initiatives in the art of the book, and due to his curiosity in diverse subjects, he employed numerous authors and groups of artists to co-operate in the creation of encyclopedic works not only concerning his reign but also about the history of Islam.

In different ways, the encouragement of the arts was likewise continued under his son, Salim, as his successor under the name Jahangir (r. 1605–27), and his grandson, Shah Jahan (r. 1628–58), but later rulers did not look after the works commissioned by Akbar. It seems that some of them, as was the case with the *Akbarnameh*, the record of his own rule, were never finished.[7] For example, the Great Millennium chronicle to commemorate 1,000 years since the Hijrah of 622 CE and to mark the death of the Prophet Muhammad ten years later was dispersed very early. The leaves in many collections and museums have not been properly registered yet, and it is a sheer coincidence that one of the outstanding examples for the method of the historians involved in its development can be shown here (Cat. No. 19). A difficult episode in the early history of the Abbasid Caliphate is treated on the one folio exhibited, and it becomes evident that the authors looked carefully into more than one source and were able to disentangle the events of the leaders of the *hajj* pilgrims of the year 199 AH/815 CE, who were apparently from the families of the Shia Imams.

The court artists sometimes had difficulties visualizing details in these faraway regions and periods. More interesting is the rising realism in their documentation work for the contemporary court, and a wonderful characterization of Jahangir — probably still as crown prince with the name Salim — as an energetic and quick actor in a fight with a lioness is preserved from an unknown work (Cat. No. 20). This confirms reports that his phlegmatic attitude occurred only in his later years.

Details of

The Lion Hunt of Prince Salim (Cat. No. 20)

India, 1605–06; opaque watercolour,

ink, and gold on paper; 30.6 × 24 cm

NOTES

1 An exhibition of some of the Bruschettini Collection's works of art, entitled *Art of the Ottomans 1450–1600. Nature and Abstraction: A Glimpse Beyond the Sublime Porte*, was held from October 3 to December 14, 2014, in Genoa at the Palazzo Nicolosio Lomellino di Strada Nuova, and then extended for another month.

2 The Abbasid Caliphate, the third of the four major caliphates established after the Prophet Mohammad's death, supplanted the Umayyad Caliphate (661–750) in 750 and ushered in a golden age of Islamic culture and art in a vast multinational empire that lasted until it was overthrown by the Mongols in 1258.

3 See Sheila R. Canby, "Yakut al-Musta'simi." In P. J. Bearman et al., eds., *The Encyclopaedia of Islam*, new edition, vol. 11 (Leiden, Neth.: Brill, 2002), 263–64.

4 The six canonical styles of Arabic calligraphy are: *naskhi, thuluth, muhaqqaq, rayhan, tawqi'*, and *riq'a*. See Annemarie Schimmel, *Calligraphy and Islamic Culture* (New York: New York University Press, 1984); Sheila S. Blair, *Islamic Calligraphy* (Edinburgh: Edinburgh University Press, 2006); and David J. Roxburgh, *Writing the Word of God: Calligraphy and the Qur'an* (Houston, TX: Museum of Fine Arts, 2007).

5 The new standards developed by Timurid artists and again in the following Safavid period have been brilliantly characterized in the catalogue of the collection of Sheikh Nasser Sabah al-Ahmed al-Sabah and Sheikha Hussah Sabah al-Salem al-Sabah in Kuwait. See Adel T. Adamova and Manijeh Bayani, *Persian Painting: The Arts of the Book and Portraiture* (London: Thames & Hudson, 2015), 159–61, 333–47.

6 See David J. Roxburgh, *The Persian Album, 1400–1600: From Dispersal to Collection* (New Haven, CT: Yale University Press, 2005).

7 See Abu'l Fazl ibn Mubarak, *The History of Akbar*. Trans. and ed. W. M. Thackston (Cambridge, MA: Harvard University Press, 2014).

10

QUR'AN SECTION

Section 30, Suras 78–114

Shiraz or Mashhad, Iran, second half 16th century

Ink and gold on paper

37 × 26.2 cm

The title page of this section from the Qur'an starts with the headline of Sura 78 in a two-part frieze with alternate colours in modest variation but extremely fine outlines. The title and the numerotation of the thirtieth fascicule as well as the number of the verses (forty) in the sura fill the three lapis-lazuli-blue, eight-pointed fields written in *thuluth* script with gold ink. The fields are formed by an orange-red plaited band and alternate with gold-ground half-star forms filled with the light blue cloudbands typical of Shirazi and Herati art of the book. This part is framed by a black bordure, and small black-grounded half pendants also appear in the straight headpiece above between extremely fine golden scrollwork on blue ground and delicately coloured alternated medallion forms.

The verse dividers are unusually formed of a five-lobed golden-plaited band, markers of every fifth verse in the margin as drop-like pendants in gold and lapis-lazuli blue with tiny variations. Sura headings are embellished in friezes with varied forms of cartouches and written in elegant *tawqi'* to distinguish it from the text of the revelation.

Muhaqqaq, like *tawqi'*, is one of the round "Six Scripts" of Arabic calligraphy reportedly developed in early Abbasid chancelleries and represents the tradition of great calligraphers of the late Abbasid Caliphate in Baghdad. Here we see the majestic and sober look of the letters on a ground line that only occasionally appears slightly raised at the end. The high letters slant in width downward and the fine compositions of letters are set one above the other either with flat, bow-shape lines under the ground line in slightly differing forms or with elegant "eyes" of the letters *mim* and *waw* when combined next to each other. Here one can observe an especially balanced distribution of the letters in the line and on the whole page, as well as extremely equal shapes of letter groups created by a great master.

The calligraphy is hard to date and shows individual features, but its letterforms point to the late Timurid period whose traditions lasted until high Safavid works of art.[1] As for the ornamentation, its forms are typical for Shiraz from the mid-sixteenth century onward.[2]

The extremely white well-burnished Oriental paper confirms the luxury production of this object, as does the cover in nearly wholly gilt outside faces, only interrupted by leather-coloured rulings separating the bordure from the main field and fringes. The cover ornamentation in finest relief pressed into the leather reveals split-corner medallions and a large central medallion with pendants and separate scrollwork with cloudbands, while inside there are medallions with gabled leaves. The bordures are filled with extremely fine wave scrolls. For a Qur'an binding, this is rather unusual, since other similar bindings of fascicules contain Qur'an verses in these features.[3] The usual fine leather filigrane on variously coloured grounds ornate the doublures inside.

NOTES

1 Compare examples for this script from the Baghdad school in the catalogue of Qur'ans in the collection of the Museum of Turkish and Islamic Art in Istanbul. See Seracettin Şahin, ed., *The 1400th Anniversary of the Qur'an* (Istanbul: Antik A.Ş. Publications, 2010), Cat. No. 46, dated Baghdad 600 AH/1204 CE; Cat. No. 57, dated 734 AH/1333–34 CE, by a calligrapher from Shiraz; Cat. No. 66, ca. 1430–40 CE, Shiraz; and Cat. No. 74, dated 962 AH/1554–55 CE, by Muhammad b. Ahmad al-Khalili al-Tabrizi in Herat.

2 The closest for comparison is Şahin, *The 1400th Anniversary of the Qur'an*, Cat. No. 90, dated 1007 AH/1599 CE, Shiraz, still written in the traditional style of alternate golden and black ink lines.

3 See the very similar one in the Metropolitan Museum of Art, Rogers Fund 1908, Acc. No. 08.124.1.

Front Cover of

Qur'an Section

11

SULTAN MAHMUD, SHAH OF DELHI, RETREATING FROM TIMUR

Folio from a manuscript of *Zafarnameh* (Book of Victory) by Sharaf al-din ʿAli Yazdi (d. 1454)

Shiraz, Iran, 1436

Opaque watercolour, ink, and gold on paper

28.5 × 19.3 cm

The scene in this painting, the fourteenth in the manuscript according to the research by Eleanor Sims, is a conventional landscape before and between chains of hills under a golden sky, rendered in a fashion similar to other depictions of war in the *Zafarnameh* (Book of Victory), a biography of Timur (d. 1405) commissioned by his grandson, Ibrahim Sultan (d. 1435). This courtly version of the *Zafarnameh* was copied by Yaqub b. Hasan in 1436, while the chronicle was mainly composed in 1424–25.[1]

But here there are impressive variations in the illustrative detail. Timur, singled out in greater size and with a parasol, rides a horse in full armour but is himself only protected by a helmet to the shoulders and bracers, which signifies that he is not actively involved in the fighting, just as the text of an earlier version of the *Zafarnameh* (1404) by Nizam al-din Shami confirms. Furthermore, he is separated from the warfare by a dramatic formation of rocks with "eyes." One of his warriors is highlighted by the golden armour of his horse, another by a gold helmet — surely making them identifiable to themselves or their families in the original text.

The other figures could be either Indians or Mongols, and the fierce fighting does not reveal the winner yet. However, the accompanying two short lines of text distinguish the scene as Timur's invasion of India in 1398 and the battle against Mahmud Tughluq (r. 1394–1413), the Turkish sultan of Delhi, who was weakened by internal strife within his dynasty. After Timur's brief conquest, Mahmud Tughluq barely gained control of the Delhi Sultanate, and with his death in early 1413, the dynasty ended.

NOTES

1 *Catalogue of Fine Indian and Persian Miniatures and a Manuscript*, Cary Welch Collection (London: Sotheby & Company, December 12, 1972), Lot 185; Eleanor G. Sims, "Ibrahim-Sultan's Illustrated *Zafar-nameh* of 839/1436," *Islamic Art* 4 (1990–91): 175–77; David J. Roxburgh, ed., *Turks: A Journey of a Thousand Years, 600–1600* (London: Royal Academy of Arts, 2005), 196–97.

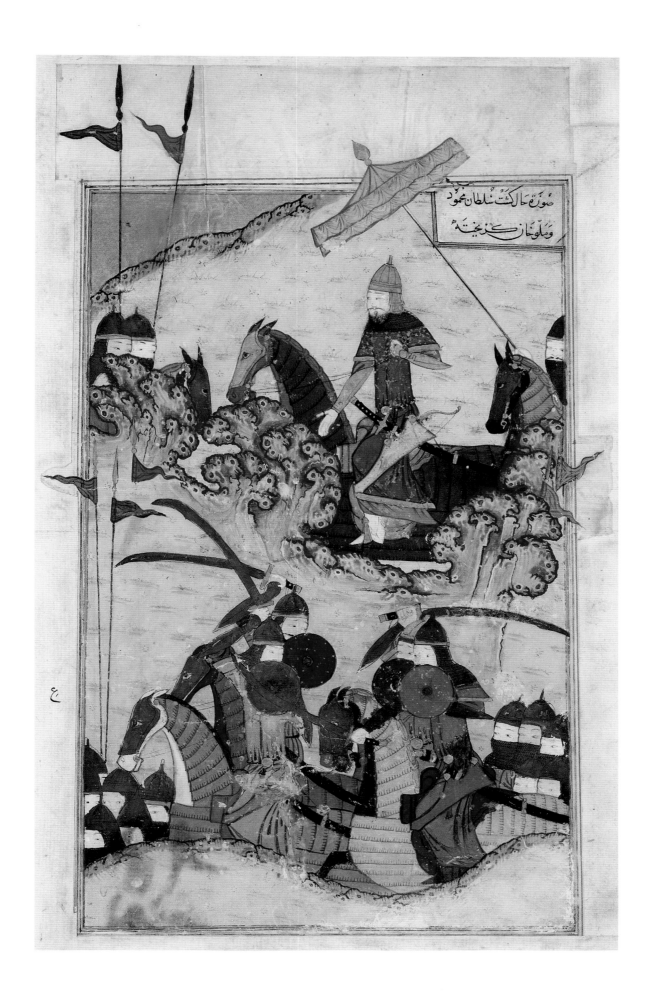

12

FUNERAL SCENE

Folio from a manuscript of *Zafarnameh* (Book of Victory) by Sharaf al-din ʿAli Yazdi (d. 1454)
Shiraz, Iran, 1436
Opaque watercolour, ink, and gold on paper
39 × 54.5 cm

These are the twenty-seventh and twenty-eighth illustrated folios of the now dispersed copy of the *Zafarnameh* (Book of Victory) by Sharaf al-din ʿAli Yazdi for Timur's grandson, Ibrahim Sultan, governor of Shiraz. This double image illustrates the mourning ceremony at the bier of Muhammad Sultan, Timur's favourite grandson, who died near Izmir, Turkey, during the Anatolian campaign in 1403.[1] His father, Jahangir (1356–76), was Timur's first son, which might have contributed to Muhammad Sultan's special role in the shaping of the dynasty and the distribution of powers. The grandson was married to a Chaghatay Mongol noblewoman, which gave him greater acceptance as a potential ruler in the eyes of the conservative Mongol tribes. Also, Timur had nominated him governor of the northern borders of his territories near the Mongolian heartlands. All this and his seeming military gifts made him the perfect heir to the old warrior, and he had actually been nominated to this position shortly before and against claims from Timur's other sons.

The shock over Muhammad Sultan's death was a major drawback in Timur's streak of luck, which no doubt contributed to the reason for this impressive image. It should be remembered that mourning scenes for deceased rulers were a major subject in Mongol/Ilkhanid art.[2] Perhaps the most famous such scene is the majestic one at the bier of Iskandar/Alexander the Great in the Great Mongol *Shahnameh* of ca. 1335, which despite showing high emotions among the women retains an elevated ceremonial dignity.[3]

The scene in the Bruschettini double folio surprises with a concentration on expressions of deepest private sorrow, even when Timur is placed apart on a special carpet and with his usual dark blue caftan with a violet turban around a dark green hat. The gesture by which the hardened warrior covers his tears under visibly closed eyes, along with his curved pose, is heart-rending, and one can feel how he would rather take the place of the traditionally lamenting women at the bier (see details on page 77). One of these women reveals among her undergarments a textile tinted in Timur's blue. In the sparse landscape with a small stream of finely drawn waves, there is only a single tree in each image, cut out of the natural hilly

space in the same manner as the catafalque and the mourners. Due to this, the gestures of the lamenting and speechless family members appear more intense and hard to bear.

Contrary to the crude appearance in photographs, the drawing and colouring of the scene are of highly delicate quality and rich in details. A little overpainting of damaged parts, as in Timur's handkerchief where his hand has unfortunately been overpainted, contributes to the impression of austere black hair and garments. The hair of the lamenting women originally all had some reddish strokes — possibly indicating dyeing for the festivity — and fall in single hairs over the slightly more black garments. As for the elderly men walking in the first line of the procession, one also has reddish and white dots in his hair, as does the one in front of the "crowd." The lady following and tearing her garment frontally must be very prominent, perhaps the young noble wife of the deceased. The garments, when not painted over, are differentiated with plaits. All of the faces have varied expressions.

The biography — or rather hagiography — of Timur was started only after his death. Records during his lifetime were maintained in rather dry notes, and the unofficial biography by a young apprentice in his retinue, Nizam al-din Shami, with the same title *Zafarnameh*, also kept to rather short descriptions without further embellishment. It had, according to the author's self-description, been written in close contact during the very last years of the belligerent ruler but was labelled too "ineloquent" by the author of the new biography, Sharaf al-din 'Ali Yazdi.[4] One can easily guess what the heirs of Timur, his grandson, Ibrahim,[5] and others missed in those documents: the glorification and the "global concept" of politics based on cruelty. And the old retinue of Timur, who were themselves still active as tribal leaders or whose offspring wanted to hear more about their role in those heavy wars for a grand empire, needed to be pleased as well under the new and restrained circumstances.

This new version of the *Zafarnameh* was intended as a panegyric for the old ruler as well as proof of the rightful succession through his youngest son, Shahrukh (r. 1405–47 in Herat, since 1409 in the whole empire), and the latter's appropriate deeds, commensurate with ancient Mongol rule. The manuscript was finished in 828 AH/1424–25 CE, as recorded in notes in the later Timurid chronographies by Abd al-Razzaq Samarqandi (1413–82) and by Muhammad Khvandamir (d. ca. 1534–37), and was dispersed in many copies during the following decades. According to its colophon, the dispersed copy for Timur's grandson, Ibrahim, son of Shahrukh, was commissioned during his governorship in Shiraz and completed in 839 AH/ June-July 1436 CE, only after the death (838 AH/1435 CE) of its patron.[6] Its design is imperial, with twenty-four illustrations, thirteen of which are double pages.[7]

The illustrations for the text constitute a well-defined series of imperial deeds and decisions. Although some text lines or verses are given, the artist of the image proudly develops

 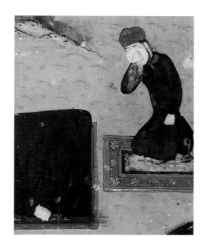

the information of the text much farther. The nearly full-page illustrations seem to continue some of the album leaf paintings marking historical events without text or preserved text in the Istanbul Saray Albums and Berlin Diez Albums.[8] A ceremonial effect, similar to the double-frontispiece pages, is conveyed by the many double-page illustrations that are actually, as Eleanor Sims has already observed, single compositions not always matching the cohesion but which set a new, purely visual standard for Timurid, early Mughal, and Ottoman illustrations for historiography.

NOTES

1 The double folio has been in the Bruschettini Collection since 1996 when it was purchased at a Sotheby's auction on April 23 that year in Lot 16.

2 See Linda Komaroff and Stefano Carboni, eds., *The Legacy of Genghis Khan: Courtly Art and Culture in Western Asia, 1256–1353* (New York: Metropolitan Museum of Art, 2002), 106–08.

3 See *The Bier of Iskandar (Alexander the Great)* from a *Shahnameh*, Tabriz, Iran, ca. 1330–36; Freer Gallery of Art Purchase F1938.3, Washington, D.C. For another funeral scene, see in Komaroff and Carboni, 106, *A Funeral Scene from the Diez Album*, Iran, early fourteenth century; Staatsbibliothek zu Berlin (Diez A fol. 71, S. 55). Also see in Maryam Ekhtiar et al., eds., *Masterpieces from the Department of Islamic Art in the Metropolitan Museum of Art* (New York: Metropolitan Museum of Art, 2011), 96–97, *The Funeral of Isfandiyar*, Tabriz, Iran, 1330s; Metropolitan Museum of Art, New York; Purchase, Joseph Pulitzer Bequest, 1933, 33.70.

4 See Eleanor G. Sims, "Ibrahim-Sultan's Illustrated *Zafar-nameh* of 839/1436." *Islamic Art* 4 (1990–91): 175–217, pls. VIII–XIII; Eleanor G. Sims, "Ibrahim-Sultan's Illustrated *Zafarnama* of 1436 and Its Impact in the Muslim East." In Lisa Golombek and Maria Subtelny, eds., *Timurid Art and Culture: Iran and Central Asia in the Fifteenth Century* (Leiden, Neth.: Brill, 1992).

5 See the short biography of Ibrahim Sultan b. Shahrukh b. Timur, governor of Shiraz, in the *Encyclopaedia Iranica* at www.iranicaonline.org/articles/ebrahim-soltan, accessed July 12, 2017.

6 See Thomas W. Lentz and Glenn D. Lowry, *Timur and the Princely Vision: Persian Art and Culture in the Fifteenth Century* (Washington, DC: Smithsonian Institution Press, 1989), 103–05, 334, Cat. No. 29.

7 Only seven illustrations remain within the codex in private possession. Three of them are double pages and two are halves. The rest are dispersed, with some double pages separated, according to the collation of Sims, "Ibrahim-Sultan's Illustrated *Zafar-nameh* of 839/1436," 212–13.

8 A facsimile of the Saray Albums is in preparation. For the Diez Albums in Berlin, see Julia Gonnella et al., eds., *The Diez Albums: Contexts and Contents* (Leiden, Neth.: Brill, 2016), www.brill.com/products/book/diez-albums, accessed June 23, 2017.

13

BINDING OF A MANUSCRIPT OF *KHAMSEH* (QUINTET) BY NIZAMI (D. 1209)

Shiraz, Iran, second half of 15th century
Leather; stamped and gilded
3.8 × 28 × 18.5 cm

This binding from a manuscript of the *Khamseh* (Quintet) of the Iranian poet Nizami (1141–1209) is from the Aqqoyunlu dynasty[1] in the second half of the fifteenth century and was once part of the library of Ottoman Empire Sultan Bayezid II (r. 1481–1512), whose small pointed seal impression with *tughra*, or calligraphic monogram, can be seen on a few of the folios.

The binding and its flap (see detail on page 80) are reddish-brown leather over pasteboards. The exterior of the binding has a block-stamped and gold-painted bordure with a central medallion featuring pointed scallops and lobed pendants as well as four scalloped corner pieces. In the medallion within a brown frame are four flying geese — not cranes — seen as a whirl from below in front of cloudbands and thin spiral flower scrolls, symmetrically standing out in embossed brown leather. In the pendants, a hare sits before a flower, while the four corners have two flying geese each seen laterally before a thin flower stem, all in the same technique. The gold ground is regularly stippled, and the leather surfaces are outstanding with carefully embossed flowers and animals. The geese and hares show finely tooled interior design.

Of equally exceptional craftsmanship are the interior doublures in light brown leather with double tooled and painted gold bordures and fillets. They show only one form of a pointed and scalloped medallion in the centre with tiny pendant leaves, its four segments repeated in the corners. All are filled with the same two systems of repeated wave scrolls on middle blue ground and spiralled gable leaf scrolls on light blue ground with a middle blue cartouche in the centre, all cut from fine leather filigree with stamped surfaces and lined in gold.[2]

The excellent craftsmanship might point to the late fifteenth century in Iran — the goose motif[3] is attested for a binding from Qazvin or Isfahan dated to the late sixteenth century by Duncan Haldane[4] — but it could also be traced to Khorasan or Herat, closer to the Chinese regions of the motif's origin.

NOTES

1 The Aqqoyunlu, or "White Sheep," were a loose confederation of Turkman tribes who ruled eastern Anatolia and western Iran from the late fourteenth century until they were subdued by the Ottomans in the late fifteenth century and conquered by the Safavids at the very beginning of the sixteenth century.

2 In the fifteenth century, stamping became common for manuscript bindings. The technique usually featured a central pointed oval medallion, cloud-collar corner pieces, and pendants. See Elaine Wright, *The Look of the Book: Manuscript Production in Shiraz, 1303–1452* (Washington, DC: Freer Gallery of Art, Smithsonian Institution, 2012), 265–71, 273.

3 The use of animal motifs in bookbinding began in the fifteenth century in Shiraz and Herat, influenced by chinoiserie fauna. See Topkapı Palace Museum, Istanbul, H.796, the so-called Yazd Anthology, dated 1407.

4 Duncan Haldane, *Islamic Bookbindings in the Victoria and Albert Museum* (London: World of Islam Festival Trust/Victoria and Albert Museum, 1983), 96–98, Cat. Nos. 95 and 96. For the Bruschettini binding doublure, compare the one in Haldane, 98, Cat. No. 96.

Flap (this page) and inside cover (page 81) of
**Binding of a Manuscript of *Khamseh* (Quintet)
by Nizami (d. 1209)**

14

THE COMBAT BETWEEN HUJIR
AND SIPAHRAM

Folio from a manuscript of *Shahnameh* (Book of Kings) by Firdausi (d. 1020)
Gilan, Iran, 1493–94
Opaque watercolour, ink, and gold on paper
34 × 24.2 cm

From a *Shahnameh* manuscript written and painted in the northern Iranian province of Gilan in the city of Lahijan at the Kar-Kiya dynasty court of Sultan 'Ali Mirza (d. 1494), this painting has text signed by Salik bin Sa'id and is dated 1493–94. The manuscript became famous and was nicknamed "Big Head" due to its 300 illustrations depicting figures with large heads.

The text at the lower end of the folio begins with the title "The Combat Between Zanga and Akhvasht," which is the eighth (or according to another version of the epic, the tenth) in the chapter on the "Twelve Combats Between Iranian and Turanian Heroes" of the *Shahnameh*.[1] Therefore, after examining the illustration and text directly following this leaf in the Freer and Sackler Galleries in Washington, D.C.[2] and taking into account the description of the combat in the text before this leaf, the illustration here could belong either to the seventh or eighth of these combats.[3]

The Freer and Sackler illustration evidently shows a combat with maces, which is described at the start of the battle between the Iranian hero Zanga, son of Shavaran, and the Turanian Akhvasht (variant name, perhaps originally Awkhast), and thus the Freer and Sackler illustration bears the name of these opponents in its title. A second illustration of the same eighth combat would therefore seem rather unusual. So it is proposed that the preceding seventh combat between the Iranian hero Hujir and the Turanian Sipahram is depicted here, which according to Firdausi's text, began with swords, of which the Iranian uses one, while the Turanian displays the continuation with maces. Still, it remains to be interpreted who the other combatants are and whether this scene can be compared to another double fight, the sixth, between the Iranian Bizhan and the Turanian Ruyin (also named Nastihan) in a painting in a private collection exhibited at the Fitzwilliam Museum in Cambridge, England.[4]

The Iranians in their shining armour on the left, with whirl designs on their reed shields, are dominant. The aggressively jumping spotted horse below and the far-reaching sabre above keep the opponents in a defensive posture. But the colouring of the men's garments and the

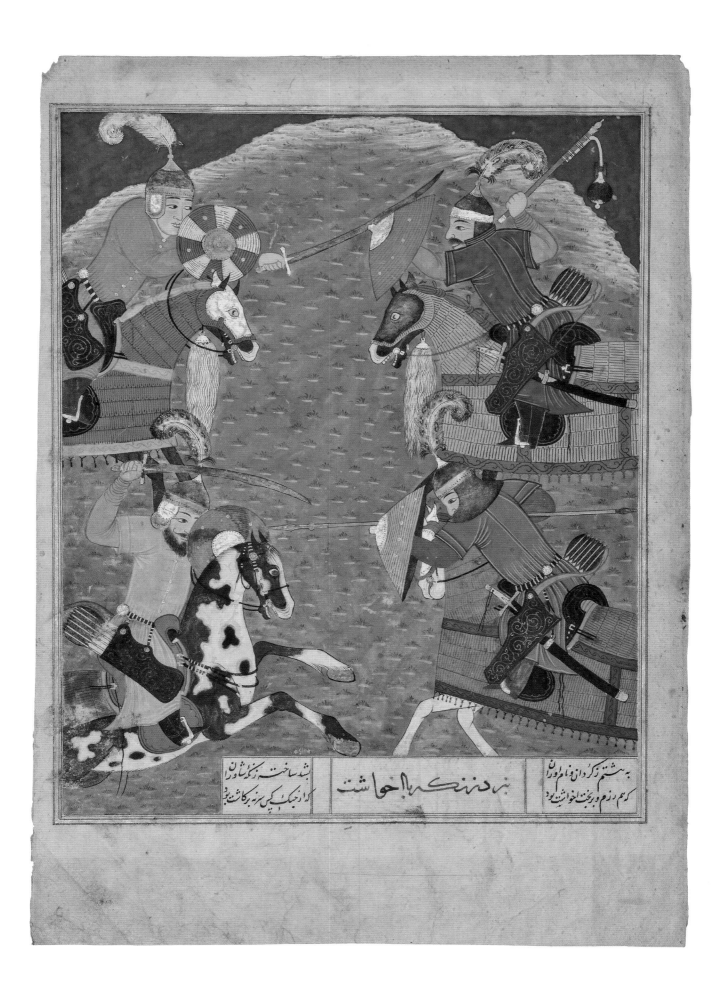

saddles or armour cloths of the horses are balanced and make the fight appear to be among equals. The fierce eyes of both warriors and animals are typical for this style of manuscript illustration, which is often admired for its inventiveness in detail and composition.

No matter that the colours of the whirls on the shields or the spotted horse reappear in other images in the manuscript connected with different persons. The details here are always interesting — for instance, the single flexible mace with the heavy head on a rope attached to a wooden shaft. In other paintings, either the metal head is already gone or the rope on the shaft is a sort of lash.[5] More often thick textiles covering the horse armour are visible, except for the metal shaffron,[6] seeming to indicate special heroism to ride without it and without the big tassels hanging from the stirrups otherwise. Also the white ivory or bone grip shells of the sabres are valuable details for identifying such objects.

Of the original two volumes of this *Shahnameh* preserved in Istanbul, the illustrations of one are partly dispersed.[7]

NOTES

1 Theodor Nöldeke notes eleven instances of fights between an Iranian hero and a Turanian. Theodor Nöldeke, *Das Irani-sche Nationalepos*. In Wilhelm Geiger and Ernst Kuhn, eds., *Grundriss der Iranischen Philologie*, vol. 2 (Berlin, 1896–1904; 2nd ed., Berlin, 1920; reprint, Berlin/New York, 1974), 130–211.

2 Inv. No. S 1986.176. Unfortunately, the text on the back of the exhibited leaf cannot be accessed at the moment.

3 Of the philological editions of the *Shahnameh*, only the Moscow one and the one by Djalal Khaleghi-Motlagh have the advantage of presenting similar versions of this chapter found in the manuscript, unlike several other versions of the combats in which two further battles are inserted between these two. See Firdausi, *Shahnama*, vol. 5, Rustam Aliyev and A. Nushin, eds. (Moscow: Institute of Oriental Studies of the Academy of Sciences of the U.S.S.R., 1967), "Dastan-i duvazdah rakh" ("Tale of the Twelve Combats"), 198. This page carries the verses 1930–31, while the Freer and Sackler Galleries illustration has the verses 1947–48; Firdausi, *The Shahnameh*, vol. 4, Djalal Khaleghi-Motlagh, ed. (New York: Persian Heritage Foundation, 1994), chapter "The Eleven Combats," 123–24, verses 1926, 1930, 1940–41.

4 See Barbara Brend and Charles Melville, eds., *Epic of the Persian Kings: The Art of Ferdowsi's* Shahnameh (London: I.B. Tauris, 2010), 162. Also see *Bizhan Slays Nastihan* at www.fitzmuseum.cam.ac.uk/gallery/shahnameh/vgallery/section3.html?p=61, accessed June 24, 2017.

5 This weapon is some sort of morning star, a medieval weapon resembling a mace. It is mentioned as *amud-i rumi* in the *Shahnameh's* sixth Battle of the Champions. Otherwise it is called a *gurz*, another kind of mace. See a variation of the *gurz* in Filiz Çakır Phillip, "The *Shahnama*: On the Forging of Heroes and Weapons." In Julia Gonnella and Christoph Rauch, eds., *Heroic Times: A Thousand Years of the Persian* Book of Kings (Munich: Edition Minerva, 2012). In Farsi the morning star is called a *kabastin*, a kind of battle flail with globular heads, sometimes with spikes, attached by a strap or chain to a handle. See Antoni Romuald Chodyński, ed., *Oręż perski i indoperski XVI–XIX wieku ze zbiorów polskich* (Malbork, Poland: Muzeum Zamkowe w Malborku, 2000), 91, image 44, f and g.

6 See Assadullah Souren Melikian-Chirvani, "Bargostvan," *Encyclopaedia Iranica*, vol. 3, facsimile 8, December 15, 1988, 795–96. Online, see www.iranicaonline.org/articles/bargostvan-armor-specifically-horse-armor-a-distinctive-feature-of-iranian-warfare-from-very-early-times-on, accessed June 24, 2017.

7 The first volume is at the Türk ve İslam Eserleri Müzesi, though some folios are dispersed. The entire second volume is at İstanbul Üniversitesi Kütüphanesi, Y.7954/310. See also Jonathan M. Bloom and Sheila S. Blair, eds., *The Grove Encyclopedia of Islamic Art and Architecture*, vol. 2 (Oxford/New York: Oxford University Press, 2009), 232.

GREEK AND CHINESE PAINTER COMPETITION

Folio from a manuscript of *Masnavi-i Ma'navi* (Spiritual Couplets) by Jalal al-Din Rumi (Maulana) (d. 1273)
Tabriz, Iran, ca. 1540–50
Opaque watercolour, ink, and gold on paper
22 × 14 cm

The short version of this meaningful scenario by the famous Sufi author Rumi (born 1207 in Balkh, present-day Afghanistan; died 1273 in Konya, present-day Turkey) from his monumental *Masnavi-i Ma'navi* epic speaks of two groups of painters whom a sultan orders to work in their usual style so it can be determined which one is better. On this page, the illustration of the palace building with the two rooms for the rivals in the upper floor fills three-quarters of the framed text field, but a narrow glance at "real nature" is introduced into the argument on the right margin with a (corroded) silver stream lined with trees and flowers but devoid of live creatures.[1]

Walls in the lower floor open toward a niche with a painted ornament bush of stylized white and red flowers. Some squinches and wall bordures, perhaps in glazed ceramic, as well as the wooden cupboard doors in the upper floor, seem to be ornamented in stylized gable leaf scrolls, while the rest of the architectural ornament is rather modest in colour and geometric form. But the two artists representing the groups, and the spectators below, burst out in colour and action, while the four ornamental niches that the painter with obvious Chinese eyes is designing and filling out contain nothing else than the "typical" Islamic stylized bunches of flowers and silver streams. Here the painter from the royal ateliers of Safavid Shah Tahmasp, probably around 1540–50, refuses to help the text author to visualize an extremely sophisticated philosophical introduction of representative art. Both the dense *nasta'liq* calligraphy of the text and the equally quiet illustration make the epic text appear even more avant-garde.[2]

The clever Greek painter, who has refused the colours offered to him, is shown burnishing a white wall much as a mirror is described in Rumi's epic: "The mirror's purity is like the heart's, / receiving images beyond all number. // ... the mirror of the heart is free of limits. // The mind is silenced here, or led astray, / because the heart's with Him, or is Himself [God] // The burnishers are free from scent and colour; / each moment they see instantaneous beauty // They left behind the form and husk of knowledge / and raised the flag of certainty

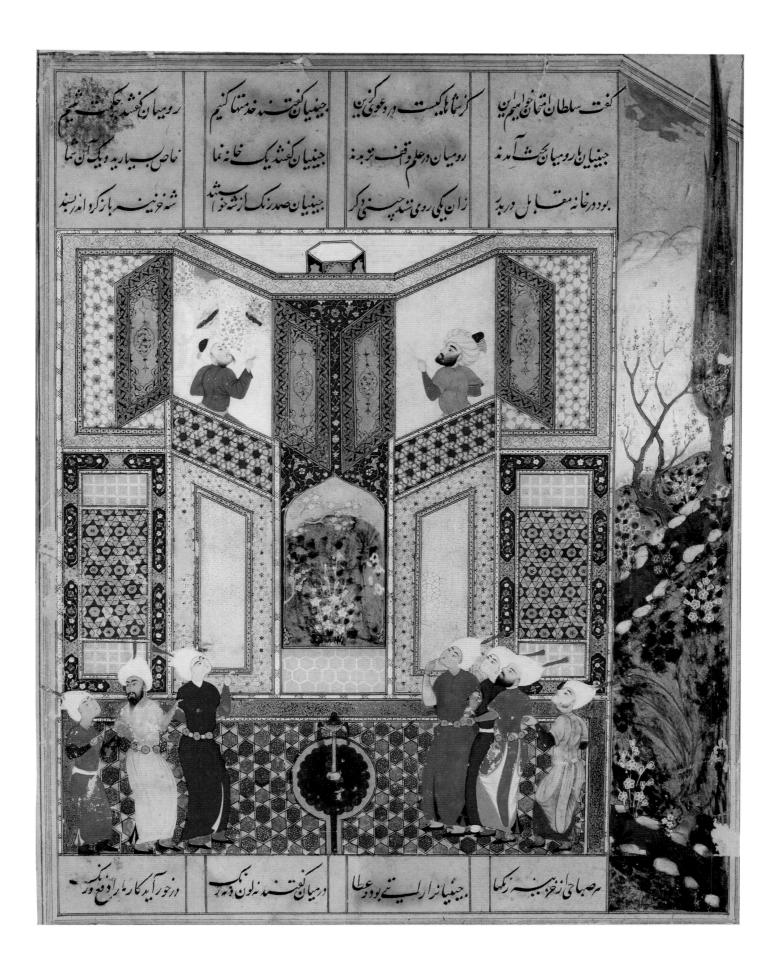

itself. // Mere thought is gone. They have attained to light; / they've got the strait and sea of recognition."[3]

It is interesting that Rumi reverses the story. In an earlier tale, the Iranian poet Nizami (d. 1209) has Iskandar/Alexander the Great during his travel to China enlisting a Greek painter from his retinue to compete with a Chinese artist — and the Greek loses. His work is admired as closest to nature, but when the curtain separating the two artists is drawn, the Chinese painter has polished a wall so much so that it reflects the colours and makes them shine even more. Commentators combine this story with the invention of the mirror by the Chinese to reflect the divine creation without other *materia* such as colours. Perhaps the reversion was because the Iranian (and Turkish) term for Greek is *Rumi*, from the Byzantine self-denomination *Romaioi*, and to the poet Rumi living in Anatolia under Rum-Seljuq rule in that period the "Rumi" victory seemed more appropriate and the Rum-Seljuqs and later the Ottomans "inherited" the name.[4]

As a metaphor, the idea of "polishing" something for more intense reflection shows up in Chapter 21, "Polishing the Mirror of the Heart," in the monumental work *Revival of Religious Sciences* by al-Ghazali (ca. 1056–1111).[5] Heart and soul could be purified by sincere reversal and repentance in order to receive the divine light as clearly as possible. The interest in the physical process of reproduction of colours and light as well as of their reflection is enhanced by the belief in the divine essence of "light." The great Arab physicist and philosopher Ibn al-Haytham (ca. 965–ca. 1040), known in the West as Alhacen, was an early pioneer in the experimentation of the human eye's optics and proved that sight bundles colours by reflecting light, which might have inspired poets and Sufis in their meditations concerning artistic reproduction and the use of metaphor to explain it.[6]

The contention of ancient Greek artists in painting is a frequent subject. The fame of classical Greek painting's naturalism was burnished and refined by ancient Romans and appears as an intercultural event in early Islamic literature. Pliny the Elder preserves the story of illusion in painting in the tale of the classical Greek painters Zeuxis and Parrhasios. Zeuxis painted grapes in such a naturalist way as to deceive birds, which flew toward the wall and tried to peck at them, while Parrhasios painted a curtain that deceived Zeuxis, who asked him to pull it away, and thus triumphed over him.[7]

NOTES

1 See *Arts du* xx*ᵉ* *siècle: art moderne, art contemporain, arts décoratifs du* xx*ᵉ* *siècle* (Paris: EVE Auctions, 2016). Catalogue for auction on June 20, 2016, at Drouot-Richelieu in Paris, www.auctioneve.com/html/fiche.jsp?id=6120097&np=1&lng =en&npp=10000&ordre=&aff=1&r= on June 22, 2017, accessed June 30, 2017.

2 See Martin Bernard Dickson, Stuart Cary Welch, and Firdausi, *The Houghton* Shahnameh (Cambridge, MA: Harvard University Press, 1981).

3 Jalal al-Din Rumi, *Spiritual Verses: The First Book of the Masnavi-ye Ma'navi*, trans. Alan Williams (New York: Penguin, 2006), 320–21.

4 Cemal Kafadar, "A Rome of One's Own: Reflection on Cultural Geography and Identity in the Lands of Rum." In *Muqarnas* 24 (2007): 7–25.

5 Al-Ghazali, *Revival of Religion's Sciences*, trans. Mohammad Mahdi al-Sharif (Beirut: Dar Al-Kotob Al-ilmiyah, 2011).

6 The *Kitab al-Manazir* (Book of Optics), a seven-volume treatise, was written by Ibn al-Haytham (Alhacen) between 1011 and 1021. See *Alhacen's Theory of Visual Perception: A Critical Edition*, translation and commentary by A. Mark Smith of the first three books of Alhacen's *De aspectibus*, the medieval Latin version of *Kitab al-Manazir* (Philadelphia: American Philosophical Society, 2001).

7 See Pliny the Elder, *Naturalis historia*, 3 vols., reviewed by D. Detlefsen (Berlin: Weidmann, 1866), Book 35, Chapters 64 and 66.

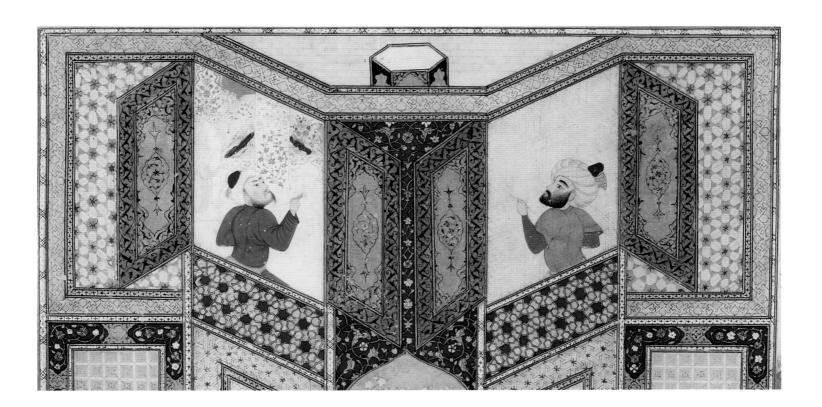

16

SULAYMAN AND BALQIS

Double frontispiece from a manuscript of *Shahnameh* (Book of Kings) by Firdausi (d. 1020)
Shiraz or Qazvin, Iran, 1540–50
Opaque watercolour, ink, and gold on paper
34 × 22 cm each

Sulayman/Solomon in the Islamic tradition is a king as well as a prophet and is according to his wish singled out by God to rule over men and the *jinn*, or demons. Despite one unbalanced judgment, he has never committed a sin and is a predecessor to other rulers in his belief in the unity of God.[1] The Queen of Saba/Sheba, or Balqis, is wise in her rule but has to learn from Sulayman. Still, he recognizes her virtues. It is typical that the male chronographers have tried to report about a marriage of the two, but in vain.

The depiction of the two sitting on their thrones on corresponding pages points to their equality after Balqis has accepted Islam. The bordures, perhaps added at a later date, combine Sulayman and Balqis with a reciprocal motif in dark blue and two shades of gold. But the illustrations also indicate differences — maybe here two versions have been conflated, since this is not always the case in similar frontispieces.

Sulayman, nimbed as a prophet with a flamed halo, sits with his entourage of angels, *jinn*, animals, and humans in a hilly landscape on a throne erected like a domed reception room and commands over hills and creatures. Balqis is secluded in a palatial room, with her retinue of multi-ethnic maidens carrying her gifts for Sulayman: gold and a letter, while from the right servants bring food. Her throne is smaller, with a narrow sitting place, but three angels or fairies (*pari*) fly from above, bringing heavenly food, including, strangely enough, two ducks.[2] In the open nature, Sulayman is protected from above by the mythical *simurgh*, or phoenix, and many tiny birds, while for his entertainment more or less wild animals and some unpleasant black creatures approach. Both have to their right a seated noble crowned person, female and male respectively; Sulayman, in addition, has an archangel to his left.

While the depictions of creatures are full of details and fantasy and the thrones display a variety of luxurious elements, the artist has simplified the textile ornaments and colours. His interest lies in faces — the elderly Sulayman and his human noble discussant show extremely fine features in their faces. Also some of the *jinn* and animals are characterized meticulously.

Lately, several double frontispieces with the subject of the royal visit of Balqis from the Safavid Shiraz ateliers of the mid to the end of the sixteenth century have been published or have appeared on the market. They are mostly identified as introductions for a *Shahnameh* manuscript, as the back of the Balqis image proves here with its prose preface by Prince Baysunghur, son of the Timurid Shahrukh.[3] This is celebrated in gold ink on typically rich ornament medallions with separate systems of ornaments for the fields in gold and dark blue.

The question is: how did the sudden connection of Sulayman and Balqis come about with the Iranian *Shahnameh* in which this episode is not mentioned? In this respect, Lale Uluç has pointed out the legends linking the prophet-king with monuments not only in Arab countries but also especially in Fars, the central province of Pre-Islamic and Islamic Iran, and its capital Shiraz.[4] One might add the volcanic Takht-i Sulayman region in northwestern Iran where the Mongol khans had built a palace by the end of the thirteenth century, as well as other legends surrounding the mythical religious geography associated with Sulayman/Solomon, according to biblical and Qur'anic stories.

The relationship of Sulayman with Iranian mythology might even be much older, as names in Pasargadae, the first capital of the Achaemenid Empire,[5] appear to indicate: for instance, the Takht-i Madar-i Sulaiman ("Tomb or Mosque of Sulayman's Mother") with the mausoleum of Cyrus the Great, and the *atashkadeh* (Zoroastrian fire temple) with the Zindan-i Sulaiman ("Prison of Sulayman").[6] These new Islamic interpretations, of course, helped to conserve the ancient buildings, and the literature of *Qisas al-anbiya'* ("Hagiographies of the Prophets") gave many stimulations to expand the legends.

The parallels between Qur'anic and Iranian stories in the assignment and visual interpretation need some explanation, of course. The Safavid rulers did continue the tradition of beautiful copies of the *Shahnameh* but further devotion to ancient Iranian or Pre-Islamic ceremonies has not as yet been observed except that some courtiers left inscriptions on another Pre-Islamic Iranian symbol of power and ceremonial and imperial claims — the legendary Takht-i Jamshid (Persepolis), the Achaemenids' subsequent capital after Pasargadae and a city associated initially with Darius I, the third king of the Achaemenid Empire.[7] Could one speak of some rivalry between the legends of Iranian origin and the Qur'anic versions?

NOTES

1 In the Qur'an, the biblical Solomon, here called Sulayman, is the third king of ancient Israel and a revered prophet. As in the Bible, he is associated with wisdom, and to Muslims is commemorated as one of the greatest monarchs of all time. God has granted him many gifts, including the ability to converse with animals, especially ants, and the power to control the *jinn*, whom he directs to help him build his many construction projects, in particular the First Temple.

Back of Balqis page of
Sulayman and Balqis

For a month, Sulayman is deprived of God's grace, represented by the loss of his signet ring, because of the lapse into idolatry of one of his wives. As punishment, he is forced to wander unknown in Jerusalem begging for bread.

2 See, for other examples, the *Shahnameh* in the Topkapı Palace Library, Istanbul, H.1507, date 900 AH/1494–95 CE; and the *Shahnameh* in the Berlin State Library, Ms. Or. Fol. 359, fol. 3a and 2b. Also see Serpil Bağcı, "Takdim Minyatür lerinde Farklı Bir Konu: Süleyman Peygamber'in Divani." In *Sanat Tarihinde Ikonografik Araştırmalar, Festschrift Güner Inal* (Ankara: Hacettepe Üniversitesi, 1993), 35–61; Claus-Peter Haase, "Sumptuous Hues of Gold and Colors to Serve the Iranian Narrative of Kings and Heroes: Yet Another Safavid *Shahnama* in Berlin." In Julia Gonnella and Christoph Rauch, eds., *Heroic Times: A Thousand Years of the Persian* Book of Kings (Munich: Edition Minerva, 2012), 36–37.

3 See Volkmar Enderlein, *Die Miniaturen der Berliner Bāisonqur-Handschrift* (Berlin: 1991), 51, image 1.

4 See Lâle Uluç, *Turkman Governors, Shiraz Artisans, and Ottoman Collectors: Sixteenth-Century Shiraz Manuscripts* (Istanbul: Türkiye İş Bankası, 2006), 33–39; Haase, "Sumptuous Hues of Gold and Colors …," 36–37.

5 The Achaemenid, or First Persian, Empire, was founded by Cyrus the Great (ca. 600–ca. 530 BCE), or Cyrus II, and flourished from 550 to 330 BCE. Cyrus claimed ancestry from a certain Achaemenes, a relatively obscure seventh-century BCE ruler who lived in southwestern Iran and was a vassal of the Assyrians. At its height the Achaemenid Empire extended from the eastern Balkans in Europe to the Indus River in India, including Egypt in North Africa, constituting the largest empire up to that time and one of the greatest in history, comprising 5.5 million square kilometres. The empire finally fell to Alexander the Great after the Battle of Gaugamela in 331 BCE.

6 See David Stronach, *Pasargadae: A Report on the Excavations Conducted by the British Institute of Persian Studies from 1961 to 1963* (Oxford: Oxford University Press, 1978), 146; Wilhelm Barthold, *An Historical Geography of Iran*, trans. by Svat Soucek (Princeton, NJ: Princeton University Press, 1984), 149f.

7 See Assadullah Souren Melikian-Chirvani, "Le royaume de Salomon: les inscriptions persanes de sites achéménides." In *Le Monde iranien et l'Islam*, vol. 1 (Geneva and Paris: Librairie Droz, 1971), 1–41, especially. 5–8, 24–26.

17

MOSES CHALLENGES PHARAOH'S SORCERERS

Folio from a manuscript of *Falnameh* (Book of Omens)
Qazvin, Iran, ca. 1550–60
Opaque watercolour, ink, and gold on paper
59 × 44 cm

This monumental picture from a *Falnameh*[1] portrays a depression in a mountain area at night with a whirl of highly unpleasant creatures — snakes, dragons, and dark half-naked men — while on the left margin there is a sorcerer with a snake in his hands and opposite him a chevalier whose head is aflame with a nimbus and who has a gold-and-silver (corroded) star for a right hand. A kingly rider with the "finger of astonishment" at his mouth looks on from behind the hills, attended by his multi-ethnic, partly caricatured retinue.

Among the series of known images from the dispersed copy of the *Falnameh* attributed to Ja'far al-Sadiq (d. 765 CE),[2] the sixth Imam (fifth according to the Ismailis), the Bruschettini folio is the eighth. Originally, this painting was part of a monumental album in which it filled the right-hand page, while its description, in eleven lines of expanded large *nasta'liq* Persian, was on the left-hand page, perhaps written by court calligrapher Malik Dailami in Qazvin.[3] Such a layout enabled a public viewing of the scenes for a larger courtly audience, as in the similar album of the tale of the hero Hamza from the Mughal court.[4]

The description of the scene in the Bruschettini painting is contained on the other side of the seventh image: "O, you, who are the possessor of this prophecy, you must be aware that the Prophet Moses has come into your prophecy. He threw his stick, and it became a serpent, and that serpent swallowed the magicians. Here is the good news for you who have this prophecy. Bad luck has vanished from your star ..."[5] By those words, the talismanic value of a picture representing the good effects of licit magic and wonder through God's miracle (*mu'jiz*) is appraised. The throwing of his stick, which was transformed into a serpent (*thu'ban*), and his hand becoming white and shining as if reflecting the light of God, are proofs of the prophethood of Moses/Musa demanded from him by the Pharaoh.[6] In the Old Testament's telling of the scene,[7] the Pharaoh does not recognize the higher value of right miracles and remains in disbelief.

The painter here has intensified the miracle by showing the proverbial "white hand of Moses" in the shape of the famous Iranian sun face, with a more superior red serpent-dragon

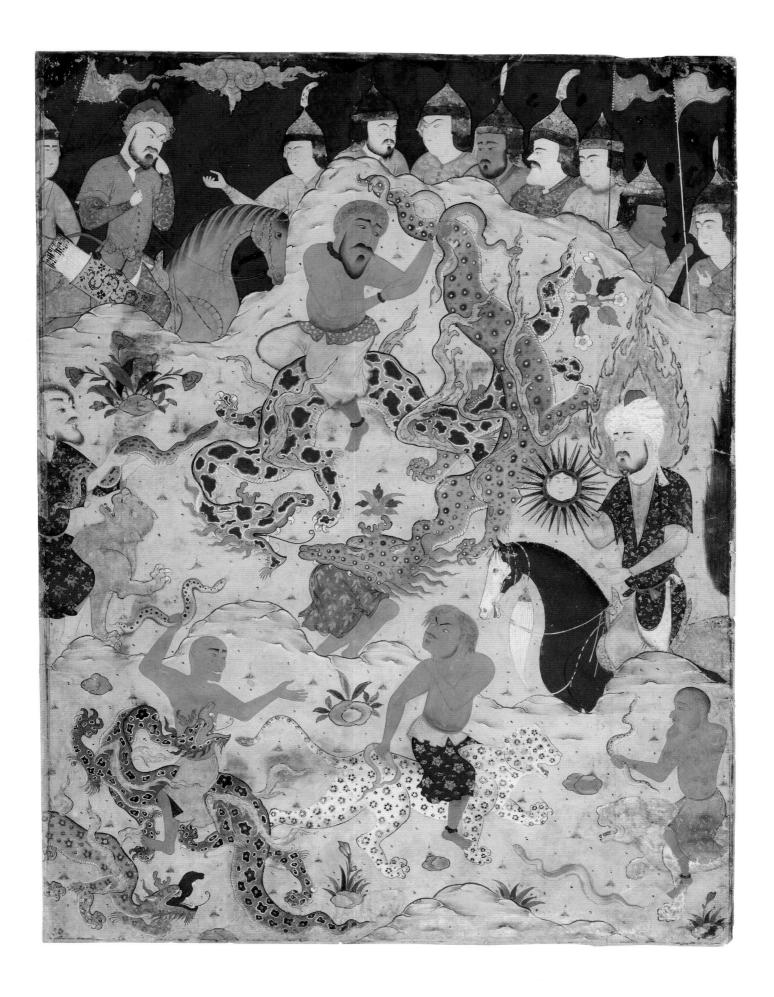

حضرت موسی پیغمبر عصا را چون فکند ...

Moses Challenges Pharaoh's Sorcerers (Text)

Folio from a manuscript of *Falnameh* (Book of Omens)
Qazvin, Iran, ca. 1550–60
Opaque watercolour, ink, and gold on paper
59.7 × 45.1 cm
Copyright © Aga Khan Museum, AKM96

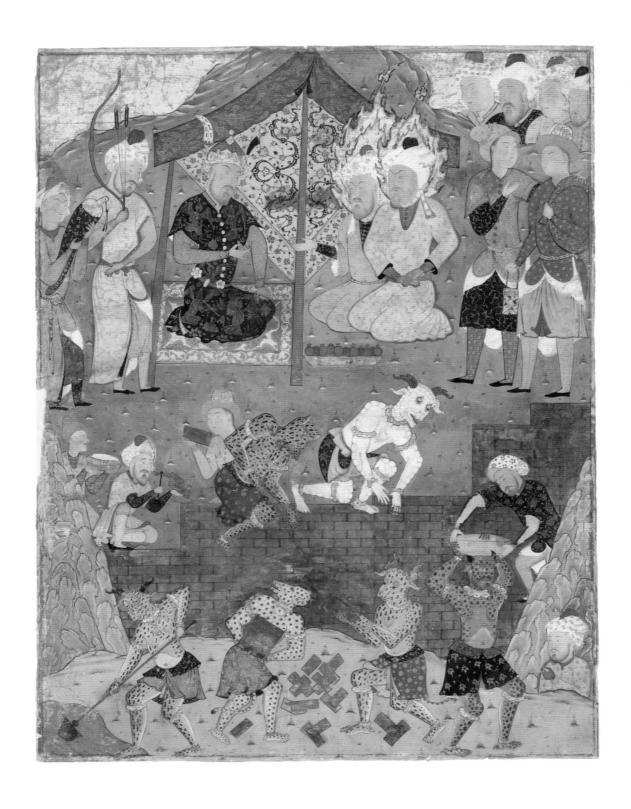

Iskandar Oversees the Building of the Wall Against Gog and Magog

Folio from a manuscript of *Falnameh* (Book of Omens)
Qazvin, Iran, ca. 1550–60
Opaque watercolour, ink, and gold on paper
59.4 × 45 cm

jumping into the scene from above and quickly devouring one of Pharaoh's sorcerers, while others ride minor dragons and wild beasts and hold dangerous snakes that bite the tail and protuberances of the red serpent-dragon.

Julia Bailey has observed that the scene is composed of two separate stories of the legend extended with a new final victory of good against evil — the accusation against Moses/Musa by the sorcerers to the Pharaoh, and the final triumph of the heavenly forces of Moses/Musa in which the sorcerers are not eaten but put to death afterward by Pharaoh. The ranking of Moses/Musa has also been improved by the painter who displays the prophet on horseback like the Pharaoh himself.[8]

The ecstatic movements of the snake-dragon and his blue-freckled salamander adversary as well as the exotic outlook of the spectators have been compared to similar figures in some of the illustrations of the *Shahnameh* (commissioned for Shah Tahmasp ca. 1525–35).[9] These have tentatively been assigned to the painter Abd al-Aziz of the royal atelier (*kitabkhaneh*), and it is possible he might have worked on another, more popular commission for some courtier after Shah Tahmasp lost his interest in the art of the book.

NOTES

1 See M. Beurdeley, *Maîtres Rheims et Laurin* (Paris: Palais Galliera, June 19, 1970), Lot 84.

2 See Armen Tokatlian, *Falnamah: livre royal des sorts* (Paris: Gourcuff-Gradenigo, 2007), Cat. No. 8, 26f, correctly after Cat. No. 7, 24f, where on the back side is the text belonging to this No. 8, Aga Khan Museum, Toronto, AKM96. The No. 8 has on its back side the text for the following No. 9. See, too, Tokatlian, 28f: *Iskandar Builds the Wall Against Gog and Magog*, in Dublin, CBL, Per 395.1, S.28f. See also Anthony Welch, *Collection of Islamic Art: Prince Sadruddin Aga Khan*, vol. 3 (Geneva, 1978), 67–68, 2 ill; Martin Bernard Dickson and Stuart C. Welch, eds., *The Houghton Shahnameh*, vol. 1 (Cambridge, MA: Fogg Art Museum/Harvard University Press, 1981), 219, 258; Giovanni Curatola et al., eds., *Eredità dell'Islam: Arte islamica in Italia* (Milan: Silvana, 1993), 439f, Cat. No. 288; Eleanor Sims, Boris I. Marshak, and Ernst J. Grube, *Peerless Images: Persian Painting and Its Sources* (New Haven, CT: Yale University Press, 2002), fig. no. 216; Jon Thompson and Sheila R. Canby, eds., *Hunt for Paradise: Court Arts of Safavid Iran, 1501–1576* (Milan: Skira, 2003), 36; and Massumeh Farhad and Serpil Bağcı, eds., *Falnama: The Book of Omens* (Washington, DC: Arthur M. Sackler Gallery, Smithsonian Institution, 2009), 128–31, Cat. No. 27.

3 AKM96, formerly in the collection of His Highness Prince Sadruddin Aga Khan, now in the permanent collection of the Aga Khan Museum in Toronto, was originally purchased by His Highness at Sotheby's in 1972. See Anthony Welch, *Collection of Islamic Art: Prince Sadruddin Aga Khan*, vol. 3 (Geneva, 1978), 67–68; Farhad and Bağcı, 128–31, 262, Cat. No. 27.

4 Gerhart Egger, *Hamza-Nāma: Vollständige Wiedergabe der bekannten Blätter der Handschrift aus den Beständen aller erreichbaren Sammlungen* (Graz, Austria: Akademische Druck- u. Verlagsanstalt, 1974); John William Seyller and W.M. Thackston, *The Adventures of Hamza: Painting and Storytelling in Mughal India* (Washington, DC: Freer Gallery of Art, 2002).

5 As mentioned in note 3, labelled there *A King Chased Out of a Holy Tomb* by Anthony Welch and translated in Welch, *Collection of Islamic Art: Prince Sadruddin Aga Khan*, vol. 3, 67–68, after a couplet rephrasing Qur'an 26:44–51 ("al-Shu'ara'," "The Poets"). In *Spirit & Life: Masterpieces of Islamic Art from the Aga Khan Museum Collection* (Geneva: Aga Khan Trust for Culture, 2007), 178, 187, Cat. No. 161, this painting is called *A King Being Chased Out of the Tomb of Imam 'Ali at Najaf*.

6 Qur'an 7:104–22 ("al-A'raf," "The Battlements").

7 Exodus 7:8–12.

8 Farhad and Bağcı, 102–03, 262, Cat. No. 15.

9 Dickson and Welch, 219, 258.

Iskandar Oversees the Building of the Wall Against
Gog and Magog (Text)

Folio from a manuscript of *Falnameh* (Book of Omens)

Qazvin, Iran, ca. 1550–60

Opaque watercolour, ink, and gold on paper

59 × 44 cm

THE COURT OF HUMAYUN IN EXILE

Folio from the first manuscript of *Akbarnameh* (Book of Akbar) by Abu'l Fazl ʿAllami (d. 1602)

Painting attributed in the lower margin to Dharm Das, with faces by Laʾl

India, probably 1586–87

Opaque watercolour, ink, and gold on paper

37 × 25.6 cm

This folio is trimmed, but its colours are beautifully preserved. It belongs to the dispersed first volume of the *Akbarnameh*, which was commissioned by the Mughal Emperor Akbar (r. 1556–1605) himself. The initial part of the book concerns the history of Timur's family; the reigns of Akbar's predecessors Babur (r. 1526–30) and Humayun (r. 1530–40, 1555–56), his grandfather and father respectively; and Akbar's birth and childhood. The text on the back of the Bruschettini folio deals with incidents and decisions of Humayun who, after being deposed, spent fifteen years in exile (1540–55) in Sind, Safavid Iran, and Afghanistan. Humayun battled for years to regain the Mughal throne, particularly with his rebellious brother, Mirza Kamran, who was finally defeated by Humayun in 1553, blinded, sent on *hajj* to Mecca, and died in 1557.

Here Humayun is shown, in keeping with his imperial claims, sitting in court in an act of generous bestowment as suggested by his hand gesture and the presence of someone singled out barefoot as a petitioner but of high rank signified by the man's dagger and bag. As usual in this great chronography of the life and rule of Akbar and his predecessors, the courtiers are divided left and right. To the left of the throne on the dais are two important officials while below them on the lower ground are four different ranks of people, including two falconers, a number of gift bearers in lively attainment, and in the front, several persons trying to restrain a rampaging stallion. On the right side, two personal attendants carrying a fly whisk and arms stand at leisure, along with four men, probably military, and three musicians. Outside the portal, at the bottom of the folio, vividly depicted people intimate a multitude of subjects rushing toward the gate with further gifts (see page 103).

The scene under a tent with uplifted front within a palace compound of seemingly modest dimensions portrays Humayun's court at some provincial residence, perhaps in Qandahar. The painters, thought to be Dharm Das with faces done by the famous Laʾl, effectively re-create the differences between the stiff attire and attitude of the high court officials and the chaotic nature of the lower ranks in the hierarchy.[1] This contributes to a realistic, lively scene in which

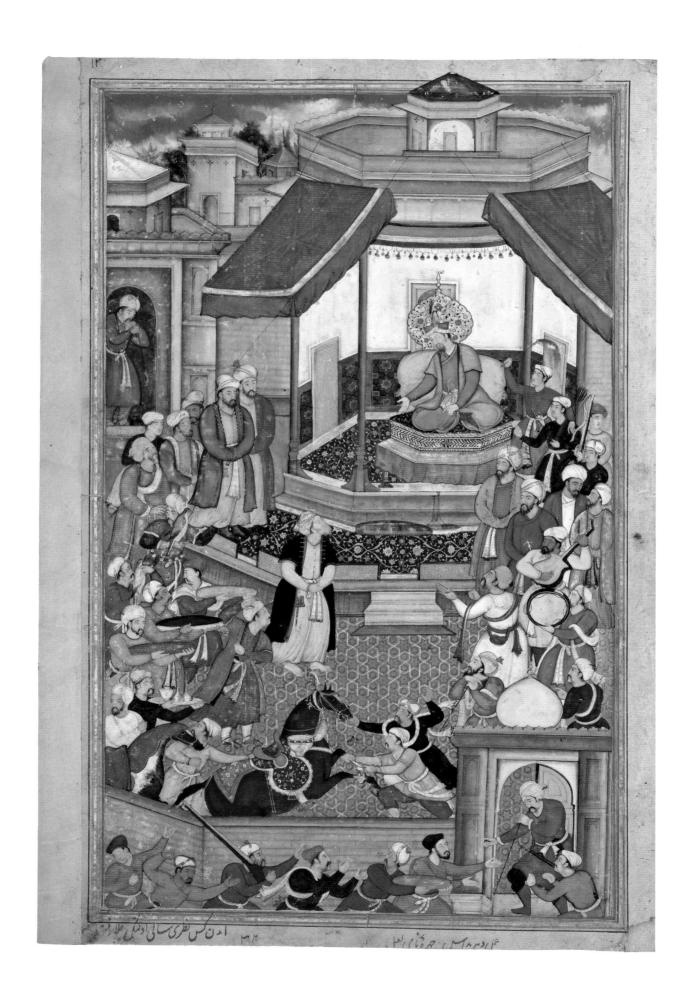

the gracious attitude of the monarch appears even more effective. The artists do not, however, indicate weakness on the part of the exiled ruler, since similar depictions occur in throne tableaux with Akbar himself. Not only have the able painters co-operated in their huge task to inject a degree of realism here but they have also expressed ceremonial praise for this multi-faceted ruler. The main single actors in the painting help to produce a positive atmosphere around the exalted ruler as, too, does the overall composition, from the subjects at the bottom of the painting to the culminating lantern on the palace roof above Humayun. Yet we are still impressed by another single portrait, in this case at the same level as the emperor: a door warden bent over his stick by age and responsibility.

A composition similar to the one in this painting can be found in an illustration by Basawan[2] (fl. 1580–1600) for the *Gulistan* by the poet Sa'di (d. 1291), dated 1596, and entitled *The Indulgent Vizier Pleads for the Life of a Robber's Son*.[3] Another painting showing one of Humayun's battles to regain his throne, entitled *Humayun Defending the Afghans*, is close to the period of the Bruschettini folio and is preserved in the Cleveland Museum of Art.[4]

At the bottom of this page is the black-ink numeral 32 as well as an inscription in the red-ink labelling used by librarians for the first edition of the *Akbarnameh*, which appears to indicate that the illustration is the work of the atelier (*kitabkhaneh*) of Akbar, specifically the prolific Dharm Das and for the faces (portraits) the equally renowned La'l, one of the most employed painters of the time and among those singled out by Abu'l Fazl 'Allami.[5] However, the description of the subject is not clearly identifiable and we do not know when the inscription and numeral were added to the folio. Since the analysis by John Seyller[6] of the main part that remains of this manuscript (housed in London's Victoria and Albert Museum), the illustrations have been assigned to an earlier date — 1586–87 — by stylistic comparison with other manuscripts from Akbar's court atelier.[7] Dharm Das was especially active in the late 1570s and 1580s, illustrating, for example, a *Darabnameh* in 1577–80.[8]

The question remains, however: how did these inscriptions become applied to these folios when we know that the first volume of the *Akbarnameh* was officially handed over to the emperor between 1592 and 1596? A second volume was prepared by 1598, and at probably already the same date a second series of illustrations of the first volume by younger artists was started, which until recently was dated 1604 after the death of Abu'l Fazl 'Allami. That volume seems to be even more dispersed to various collections.

NOTES

1 The reason for Getty Images to title this illustration *Abu'l-Fazl ibn Mubarak Presenting the* Akbarnama *to Akbar* is not evident. See Milo C. Beach, Eberhard Fischer, and B.N. Goswamy, eds., *Masters of Indian Painting*, vol. 1 (Zurich: Artibus Asiae Publishers, 2011), 111–18.

2 For general information and other examples of paintings executed by Basawan, see John Guy, "Early Hindu Sultanate Painting, 1500–1575." In John Guy and Jorrit Britschgi, *Wonder of the Age: Master Painters of India 1100–1900* (New York: Metropolitan Museum of Art, 2011), 38–50; for Basawan, 42–49.

3 See Los Angeles County Museum of Art, M.79.9.12; John Seyller, "Basawan." In Beach et al., 126–29.

4 Linda York Leach, *Indian Miniature Paintings and Drawings* (Cleveland, OH: Cleveland Museum of Art, 1986), 47–48, Cat. No. 13.

5 Abu'l Fazl 'Allami, *The Akbarnama*, trans. Henry Beveridge, vol. 1 (Delhi: 1972 reprint), 114. Abu'l Fazl lists thirteen artists who "have likewise attained fame." Twelve of these might have contributed either compositions or portraits to the Victoria and Albert Museum *Akbarnameh*. La'l and Miskina stand out as senior artists. The former was responsible for the composition of nine single and five double-page compositions. See Susan Stronge, *Painting for the Mughal Emperor: The Art of the Book, 1560–1660* (London: Victoria and Albert Museum, 2002), 55.

6 John Seyller, "Codicological Aspects of the Victoria and Albert Museum *Akbarnama* and Their Historical Implications," *Art Journal* 49, no. 4 (Winter 1990): 379–87; Seyller, "Baswan." In Beach et al., 126–29. In Stronge, 41, the author mentions the disagreement over the dating of the Victoria and Albert *Akbarnameh* illustrations. Abu'l Fazl wrote five versions of his text, with the fifth finished in 1596. The second volume of the work had been intended to cover the seventeenth regnal year to the middle of the forty-seventh, but Abu'l Fazl presented it incomplete to Akbar in 1598, the forty-second year of the emperor's reign. Stronge, 42, still has with other authors accepted a date in 1590 for folios such as this one in the Bruschettini Collection. She mentions that the illustrations for the Victoria and Albert *Akbarnameh* had been intended for another biography of Akbar, which is now lost, and that the lost work was superseded by Abu'l Fazl's definitive biography and the paintings were simply recycled for the *Akbarnameh*. It is not clear whether all the paintings were ready before the last version of the text, but John Seyller has argued convincingly that those of the first volume had been finished earlier. Also quoted by Milo Cleveland Beach, *The Imperial Image: Paintings for the Mughal Court* (Washington, DC: Freer Gallery of Art/Arthur M. Sackler Gallery, Smithsonian Institution, 1981), 83.

7 See Victoria and Albert Museum, IS.2:105-1896, 274 folios with 116 illustrations covering the rule of Akbar, 1560–78.

8 For general information about the *Darabnameh*, see www.iranicaonline.org/articles/darab-nama, accessed on June 30, 2017.

19

HAJJ *PILGRIMS IN MECCA*

Dedication copy of the *Tarikh-i Alfi* (Millennium Chronography of Islam) for Akbar
India, ca. 1592–94
Opaque watercolour, ink, and gold on paper
42.3 × 24.3 cm

The patronage since 990 AH/1582 CE of Mughal Emperor Akbar to produce an assemblage of chronicles in Persian of Islamic rule since the Hijrah in 1 AH/622 CE and to commemorate the Millennium Jubilee of the Prophet Muhammad's death (13 Rabi' 1 11 AH/June 8, 632 CE), which would fall in 1602, was not an easy task to fulfill. The court historians apparently chose as one of their main sources the Arab chronicle *al-Bidaya wa'n-nihaya* (The Beginning and the End) by the pious Sunnite Ismail ibn Kathir (d. 1373 in Damascus), which is quoted in this folio.[1]

Of course, the Mughal emperors recognized the official sequence of caliphate dynasties, in this case the early phase of the Abbasid period (750–1258) during which serious trouble arose when after the death of the fifth Abbasid caliph, Harun al-Rashid, in 809, his sons, al-Amin in Baghdad and al-Ma'mun in Merv (then the province of Khorasan in Iran but now part of Turkmenistan), competed for the succession despite a clear stipulation by their father that al-Amin should be the first and al-Ma'mun the second successor. This came to be called the Fourth Fitna.[2] In September 813, when al-Ma'mun conquered Baghdad and put his brother, al-Amin, to death, a series of uprisings occurred until about 815. Among those involved were some of the 'Alides, certain offspring of Shia Imams descended from the Prophet Muhammad and his son-in-law, 'Ali. One of these revolts is the subject of the text and illustration seen in this folio.

Al-Ma'mun stayed in Merv and tried to calm dissent in the Iranian parts of the empire, even choosing the eighth Shia Imam, 'Ali Ridha (in Persian Reza), as his successor in 817. Peace ended quickly, however, with the death the next year of 'Ali Ridha, which was probably caused by poison. After that a profound shadow was cast upon the Abbasids, contributing to losses of territory at the western and eastern margins of the empire.

The episode recounted in this text concerns the correct leadership of the caliphate, specifically focusing on the rise of Abu Saraya in Kufa in present-day Iraq. At first Abu Saraya rebels in the name of the 'Alid Ibn Tabataba against the caliphate of al-Ma'mun and is victorious over

forces sent from Baghdad against him in 813. Abu Saraya's followers plunder the houses of the Abbasid party in Kufa. A little later, after the death of Ibn Tabataba and his replacement by another 'Alid, the grandson of Imam Zaid bin 'Ali bin al-Hasan — the year of this event is left out in the text — Abu Saraya sends another 'Alid great-grandson of the line of al-Husayn bin 'Ali to Mecca, who arrives there at a moment when the representative of the Abbasid party has left and no responsible person is present to lead the *hajj* pilgrims in prayers and ceremonies. According to this text, the 'Alid, taking over for all believers, sits on the "chair" of the Imam and orders the black textile — which is the colour of the Abbasids — covering the Ka'ba to be changed for a yellow one inscribed in the name of Abu Saraya. Also he orders the treasure and all belongings in the Ka'ba to be taken away.

The story is told a bit differently by the critical historian al-Tabari (d. 923). He relates that some simple pilgrims led the prayers without naming as usual the ruler or imam, an event that occurred in Jumada II 199 AH/January-February 815 CE.[3] The rebellion of Abu Saraya was defeated, and he was killed in the summer of the same year.

The image, creeping into the text in a way typical for this dispersed manuscript, gives an excitingly selective glimpse into sumptuous courtyard architecture in perspective, with galleries and two high *ayvan* or entrance halls. Only the black cube in the middle, cut over by the ruling, indicates this is meant to depict the Haram, the holy precinct of the Ka'ba. But the horseshoe arch and niches of the *ayvan*, the columns with graded shafts signifying minarets and crenellations, reveal an Indian architecture (see detail above) rather

than the Haram before the embellishments in the age of Ottoman Sultan Suleyman the Magnificent (r. 1520–66).

The four or five severe men in the upper register, turban lashes under their chins indicating a theological rank, appear somewhat dubious concerning an obviously difficult situation. One of them wears the striped garment often used by pilgrims in this period. Of the two men at the Ka'ba in different stages of prayer, the one with a pinkish caftan seems to be the main actor in the scene and has a beautiful portrait-like face. But neither of the two is marked as an offspring of one of the Imams, who should wear green garments reported to be the colour of the Prophet. The light green of the coat of some other person depicted also does not represent the Prophet's colour. The ten persons in the lower register in casual habit and dress and of different facial colour, typical for crowds in India, represent pilgrims happy to have an imam for prayers (see detail below).

We presume the painter had not read the text, was in no way familiar with the *hajj* and the circumambulation (*tawaf*) of the Ka'ba, or that he consciously avoided symbols of religious antagonism and merely transmitted situations of the early caliphate at the beginning of the ninth century into his own period.

NOTES

1 Francesco Gabrieli, "Al-Ma'mun e gli 'Alidi," *Morgenländische Texte und Forschungen* 2, no. 1 (Leipzig, 1929); Milo Cleveland Beach, *The Imperial Image: Paintings for the Mughal Court* (Washington, DC: Freer Gallery of Art, Smithsonian Institution, 1981), 91–99; Ismail ibn Kathir, *al-Bidaya wa'n-nihaya*, vol. 14, ed. Abdallah bin Abdalmuhsin al-Turki (Giza, Egypt: 1998), 109 f.

2 The Arabic *fitna*, in its historical usage, came to mean "revolt," "disturbance," or "civil war," the last in particular being strife that sparks schism that causes serious danger for the faith of believers. In Islamic history, the major *fitnas* were: the First (656–61), the Second (680–92), the Third (744–47), the Fourth (809–27), and the Fitna of al-Andalus (1009–31).

3 Al-Tabari, *The History of al-Tabari*, vol. 32, trans. C.E. Bosworth (Albany, NY: State University of New York Press, 1987), 12–23, Arabic text III, 976.

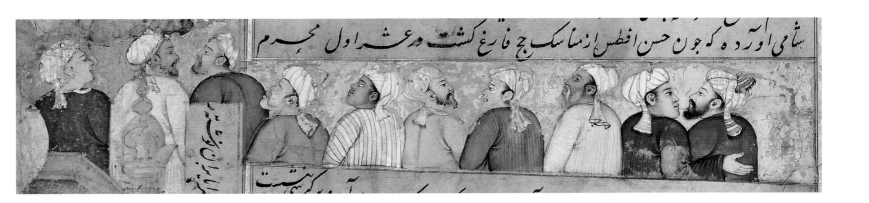

20

THE LION HUNT OF PRINCE SALIM

India, 1605–06
Opaque watercolour, ink, and gold on paper
30.6 × 24 cm

A dangerous scene in the long hunting story of Crown Prince Salim — the son of Akbar and known as Jahangir (r. 1605–27) when he became the Mughal emperor — is documented in this illustration. Separate from his retinue, he travels on an elephant on a hillside near a palace town featuring many domed temple-like structures when a lioness leaps from behind up to his sheltered seat. Although the elephant's mahout has not noticed the attack in time and is only now about to grab a long sword, Salim turns around at the last moment and uses the gilded, inlaid barrel of his gun to hit the beast on the head.

The youthful prince displays complete concentration in his eyes and has a tense mouth in an otherwise soft face. Although he has the broad dagger he reportedly used for heroic tiger killing at his girdle, it does not look as if he actually intended to hunt lions that day. The seven companions in the party are behind the rocks busy with their falcon and long lances, one of them a halberd with the imperial heron's feathers. Nothing indicates the many helpers usually employed to startle and control predators during special hunts. The attitude of the lioness, complementing the prince's energy, is extremely forceful as it daringly jumps and clings to the saddle cloth and balustrade of the seat. Its lowered head anticipates the blow, but its hind legs seem firmly rooted in the textile and the elephant's thick skin intimating that the fight might well last for a while. Only the elephant does not seem nervous — it is probably a young one from the imperial stable.

This masterly composition is also convincing in its landscape, with the central rocky out-crop echoing the power of the crown prince over the lion. A very similar element is used by the famous painter Abu al-Hasan (d. ca. 1630) of the imperial workshop in an illustration entitled *The Devotee and the Fox* for the *Bustan* by the Iranian poet Sa'di (d. 1291 or 1292). It is possible that Abu al-Hasan, in his younger years, assisted in this painting.[1]

The context of the illustration is not clear. It could well belong to an early collection of images from the life of Jahangir as a crown prince.[2] In the *Jahangirnameh*, the emperor refers to an incident when he was crown prince that was the source of various paintings of his adventures:

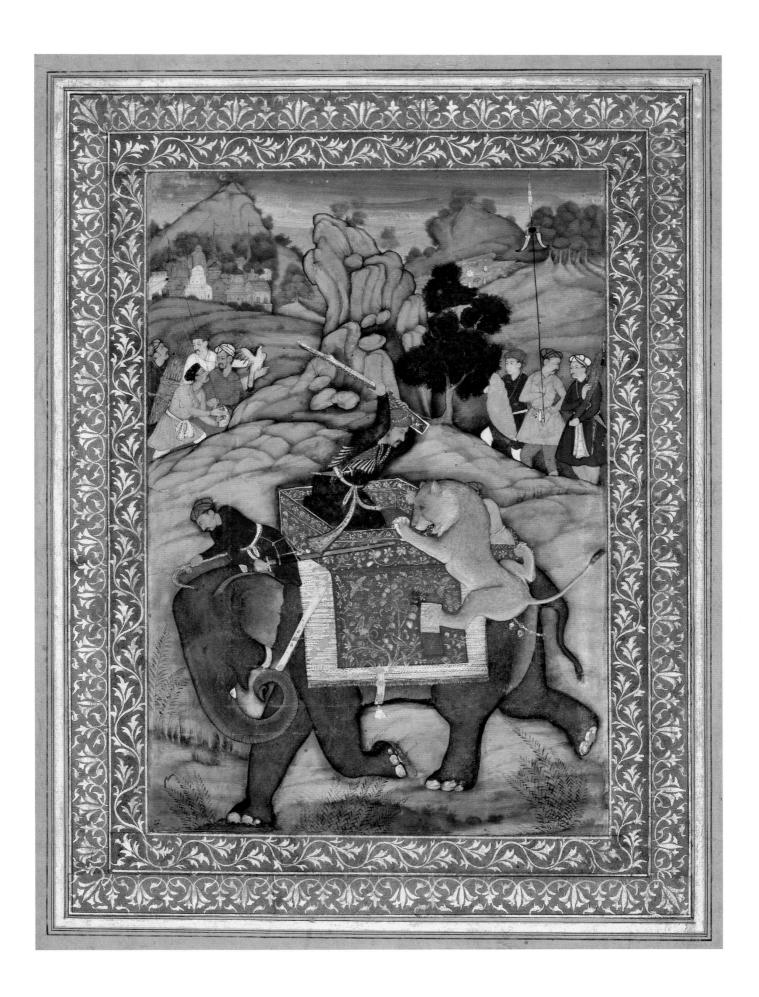

On Monday the fourteenth [February 20, 1608], while on the road, it was heard that two lions were menacing travelers between Panipat and Karnal. I got my elephants together and set out. When I reached the place they had been spotted, I got on a female elephant and ordered the other elephants to encircle the lions as in a gamargha. By God's grace I shot them both and eliminated the evil of these two, which had blocked the people's way.[3]

NOTES

1 See the Art and History Trust Collection, Washington, D.C., Arthur M. Sackler Gallery, Smithsonian Institution. Also see Milo C. Beach, "Aqa Riza and Abu'l Hasan." In Milo C. Beach, Eberhard Fischer, and B.N. Goswamy, eds., *Masters of Indian Painting*, vol. 1 (Zurich: Artibus Asiae Publishers, 2011), 215f, Cat. No. 23.

2 See Percy Brown, *Indian Painting Under the Mughals A.D. 1550 to A.D. 1750* (New York: Hacker Art Books, 1975), 133–35.

3 Jahangir, *The Jahangirnama: Memoirs of Jahangir, Emperor of India*, trans. W.M. Thackston (Washington, DC/New York: Freer Gallery of Art and Arthur M. Sackler Gallery, Smithsonian Institution/Oxford University Press, 1999), 91.

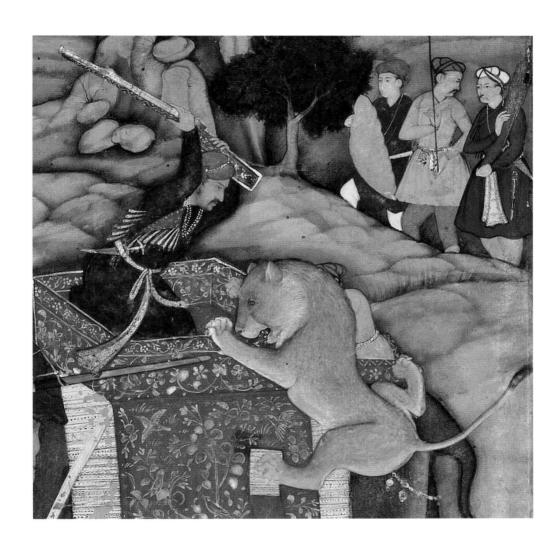

21

THE MUGHAL TRANSFORMATION OF
SAINT MARY MAGDALENE PENITENT

India, ca. 1605–10
Opaque watercolour, ink, and gold on paper
26.2 × 16.8 cm

This small painting on paper, with its upper part added to the original in order to make it fit into a pre-existing album, has an unusual appeal due to its strong contrast of light and dark. The margins show an equally dark and dense array of black scrolls with leaves, flowers, and birds, as well as predators in the outer corners, all of them outlined in gold and overlaid by four black cartouches with white Persian verses in *nasta'liq* script.

Subject, composition, dark nature, and expression are much repeated in Baroque paintings and studies, and it is no wonder that a Flemish etching after one of the most famous representations of emotion by Domenico Tintoretto (1560–1635), *Saint Mary Magdalene Penitent* (ca. 1598–1602), likely reached Mughal court circles.[1] The Tintoretto painting was frequently copied and adapted in Europe until the nineteenth century, and its popularity in Christian circles is understandable because of its ability to offer consolation in the midst of deep distress. An etching by Raphael Sadeler (ca. 1560–1632) influenced by Tintoretto's painting is dated 1602, and this might have reached Mughal India together with many other subjects of Christian iconography.[2] These already appealed to the court of Akbar, as well as that of his successor, Jahangir, who was interested in representations of Old and New Testament scenes.[3] Some inspiration might also have occurred with a new wave of Iranian artists arriving at the court in Delhi in the late 1590s.

The pale young woman with a veil on the back of her head and wringing half-raised hands peers desperately into the darkness around her. She sits at a table under a tree, her long, thick hair cascading from her head, a yellowish shawl swirling unnaturally around her left arm. A broken goblet, a small open book, a skull on a thicker book, and even a table crucifix fail to console her, but the Mughal painter apparently understands her attitude as enlightening amid the darkness. He might be suggesting that the woman is affected to a higher degree by the lecture in the small book — perhaps a prayer book — than by the emblems or even the crucifix. Obviously, his intention is to reinforce the highly emotional relationship between the repenting or praying young woman and the beholder. Only at a second glance does one

observe that the pale atmosphere in the centre of the picture is caused by a stream of light out of the cloud in the original upper right corner. The Persian verses stress an emotional sadness possibly caused by sorrow in a love affair — so the skull and crucifix would surely be ineffective in that case. But perhaps none of this is the original purpose of the painter. According to Luke 7:47, Jesus accepted Mary Magdalene's repentance because she was so deeply in love — it seems as if the unknown Mughal painter felt this from the etching transmitted to India, without intending the Christian religious connotation.

As for the artist, it has been proposed that she might be a lady at court such as Nadira Banu (1618–59), wife of Dara Shikoh, the brother of Mughal Emperor Shah Jahan (r. 1628–58). One signature of Nadira Banu is preserved on a related subject: the image of St. Hieronymus in the Gulistan Palace in Tehran.[4] She is said to have been a pupil of the great master, Abu al-Hasan,[5] during the time of Jahangir.[6]

In unusually dark and comparable colours and perhaps from a similar album is a presumed portrait of France's Louis XIV or the prince de Condé in armour, signed or assigned to 'Ali-quli Jubbadar, with the upper part of the curtain extended to fit the album page.[7] The artist is perhaps of European origin, but working in Isfahan.[8]

NOTES

1 Musei Capitolini, Rome, Pio di Savoia Collection, Inv. No. PC 32.

2 The Sadeler work, for example, is in the British Museum, London, Acc. No. 1929,0715.28 (www.britishmuseum.org/research/collection_online/collection_object_details.aspx?objectId=3046539&partId=1&searchText=Sadeler+Tintoretto &page=1), accessed June 30, 2017. It is signed in the lower right corner of the impression.

3 Milo Cleveland Beach notes: "Akbar proclaimed a religion of his own invention in 1582, the *Din-i Ilahi* (Divine Faith), composed of whatever he could accept from the various religions he had studied. The opposition of the orthodox Islamic community forced the abandonment of the scheme." See Milo Cleveland Beach, "The Gulshan Album and Its European Sources," *Bulletin of the Museum of Fine Arts, Boston* 63, no. 332 (1965): 63–91.

4 Beach, 63–91. Also see www.iranicaonline.org/articles/golsan-album, accessed June 30, 2017.

5 Milo C. Beach, "Aqa Riza and Abu'l Hasan." In *Masters of Indian Painting, 1650–1900*, Milo C. Beach, Eberhard Fischer, and B.N. Goswamy, eds., vol. 1 (Zurich: Artibus Asiae Publishers, 2011), 215–29. Abu al-Hasan himself copied Albrecht Dürer, see www.jameelcentre.ashmolean.org/collection/6/10238/10403/all/per_page/25/offset/0/sort_by/seqn./object/11209, accessed June 30, 2017. See also John Guy and Jorrit Britschgi, *Wonder of the Age: Master Painters of India, 1100–1900* (New York: Metropolitan Museum of Art, 2011), 74.

6 See Asok Kumar Das, *Mughal Painting During Jahangir's Time* (Calcutta: Asiatic Society, 1978); *Collection Jean Soustiel*, catalogue for auction on December 6, 1999 (Paris: Drouot Richelieu, 1999), Cat. No. 30.

7 Layla S. Diba and Maryam Ekhtiar, eds., *Royal Persian Paintings: The Qajar Epoch, 1785–1925* (New York: Brooklyn Museum of Art/I.B. Tauris, 1998), 110–13.

8 Assadullah Souren Melikian-Chirvani, *Le chant du monde: l'art de l'Iran safavide 1501–1736* (Paris: Somogy/Musée du Louvre, 2007), Cat. No. 150, 398 f. See also Jonathan M. Bloom and Sheila S. Blair, eds., *The Grove Encyclopedia of Islamic Art and Architecture*, vol. 2 (Oxford/New York: Oxford University Press, 2009), 55–56.

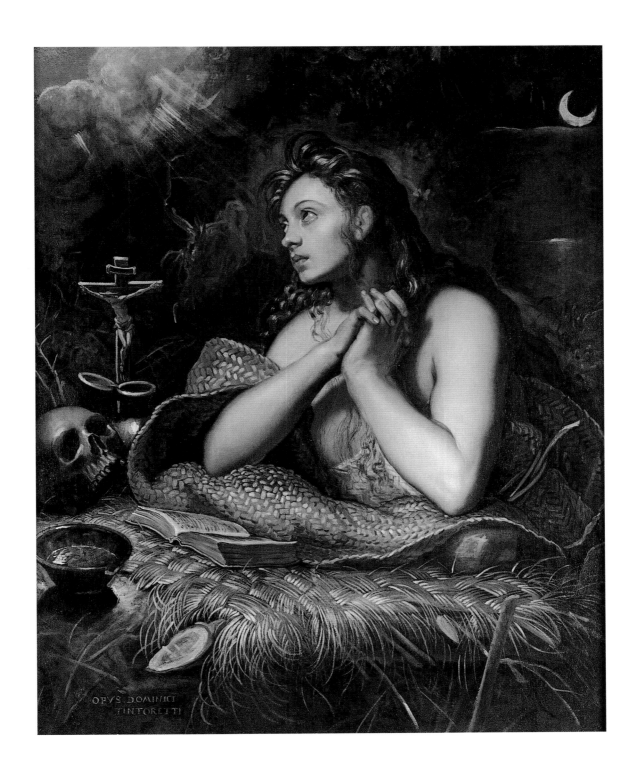

Saint Mary Magdalene Penitent

Painted by Domenico Tintoretto

Italy, ca. 1598–1602

Oil on canvas

114.5 × 92 cm

Copyright © Musei Capitolini, Pio di Savoia Collection, Rome, PC 32

Sovraintendenza di Roma Capitale, Foto in Comune

TEXTILES

THREADS OF SPLENDOUR

Filiz Çakır Phillip

The cultivation of silkworms, and with it, the production of silk textiles, originated in China around 2700 BCE,[1] and from about the fourth century BCE to the seventh century CE, a vigorous trade of raw silk and silk goods occurred between China and Iran.[2] By the sixth century, when the cultivation of silkworms began in Pre-Islamic Iran, the ruling Sasanian dynasty had already established a reputation for producing silk textiles of a quality fit for kings.[3] Called *parniyan* (polychrome) and *parand* (monochrome),[4] these silks are well documented in Persian poetry, Classical and Christian texts, and rock carvings in the grottoes of Taq-e Bustan.[5] Most of the extant examples have long been preserved in tombs and reliquaries, though some fragments have survived despite Iran's naturally humid climate.[6]

These textiles not only demonstrate the superb technical skill of Iranian weavers but also a distinctive iconography that would quickly spread west to Europe, north to Russia, and east to China. It consists of roundels — sometimes containing human or animal figures — surrounded by a border of circular forms resembling pearls or coins.[7] The use of paired animals is a later development that also appeared in China and Syria; producing this pattern required executing a reverse repeat on a draw loom.[8]

By the eleventh century, Iranian weavers introduced *lampas*, an innovative weaving technique that combines two structures and hence a combination of different weaves, whether plain, twill, or silk, within one fabric.[9] The Bruschettini textiles in this exhibition affirm the impact of this technology: four of the seven textiles — produced variously in thirteenth-century Iran, sixteenth-century Iran, and late-sixteenth-century Turkey — employ *lampas* weaves. The cross-cultural sharing of Iranian expertise, challenged in many ways by the Mongol invasions of Iran and Iraq in the early thirteenth century,[10] was also strategically encouraged: in order to revive the Chinese textile industry, the Mongols forcibly relocated three artisan colonies from Khorasan and neighbouring Turkestan to China in two waves, around 1220 and again during the 1270s.[11]

Detail of *Lampas* **Panel with Courtly Scene** (Cat. No. 26) Iran, 16th century; silk; *lampas*; 172 × 85 cm

117

Mongols also relied on the expert weavers from Iran and Iraq to produce the "Cloth of Gold" or *nasij* that would become a powerful symbol of the empire's far-reaching success and strength.[12]

The *Pax Mongolica* that was experienced for about a century following the period of invasion led to cross-cultural exchange, as well.[13] Connected efficiently by Mongol equestrians who exchanged information and goods across four four khanates (Yuan in China, Chaghatay in Central Asia, Golden Horde in southern Russia, and Ilkhanid in Greater Iran)[14] spanning modern-day Korea to Hungary,[15] the Mongol Empire created an environment in which disparate cultures interacted both politically and creatively.[16] European merchants also benefited from this peace, trading more actively along the Silk Routes, establishing colonies and merchant posts in the empire, cultivating direct contact with China, and taking knowledge of sericulture (cultivating silkworms) back to their own city-states and countries.[17] The Bruschettini Collection offers convincing evidence of Mongol influence on European culture: its crimson panel patterned with gold discs (Cat. No. 23) bears a striking resemblance to *panni tartarici*[18] depicted in an early fourteenth-century altarpiece by Italian master Simone Martini.[19]

By the time of the Timurids (ca. 1370–1507) — who ultimately subjugated Central Asia, greater Iran, and Iraq, in addition to parts of southern Russia and the Indian subcontinent — an "international style" combining elements of Chinese and Iranian cultures could be felt across all the arts.[20] This style would become a touchstone for early Safavid and Ottoman art, to be supplanted by two approaches unique to each: in Iran, a figurative approach influenced heavily by manuscript painting; and in the Ottoman Empire, a floral tradition that also deeply informed the ceramics industry.

Like the Mongols before them, Ottoman sultans capitalized on the talents of Iranian artisans. In 1514, when Tabriz was briefly occupied under Ottoman rule, Sultan Selim I (1512–20) harnessed the talents of a Tabriz native identified as Habib, who would later head ceramic production for the court.[21] The famed Shah Qulu, whose *saz* designs influenced countless Ottoman textiles and ceramics in the sixteenth century, was also from Tabriz.[22] Moreover, even as Suleyman the Magnificent was mounting invasions into Iranian territory, the illustrious sultan demonstrated admiration for Safavid textiles. Fragments of Safavid velvet in the Bruschettini Collection might have been used to adorn Suleyman's own tent during his campaigns of 1547 or 1554, as suggested by scholars in the past.[23]

For its part, Iran was assumed to have been introduced to velvet through Ottoman textiles, which allegedly in turn were heavily influenced by the work of Italian weavers.[24] This assumption will need to be reconsidered given the existence of the late-thirteenth-century velvet (Cat. No. 23) in the Bruschettini Collection. Characteristic of their extraordinary success

Detail of
Velvet Panel with
Golden Discs (Cat. No. 23)
Iran, late 13th century;
silk and gold-wrapped thread;
cut voided velvet; 55 × 21 cm

with silk weaving, Iranian artists took the production of velvet production to new heights, developing a complex technique of "pile warp substitution" that enabled up to fourteen different colours to be used within a single piece of fabric.[25] The Bruschettini Collection contains a range of examples, from the late-thirteenth-century velvet panel with gold discs (Cat. No. 23), likely made in Tabriz, to two sixteenth-century Safavid velvets (Cat. Nos. 24 and 25).

The sixteenth-century textiles from the Bruschettini Collection affirm the tremendous efficiency of textile industries in the Ottoman Empire and in Safavid Iran. At least since the previous century, the Ottoman government controlled the taxation of silk imports as well as the manufacture of silk textiles; all textiles produced within the empire were required to meet quality standards and be inspected by court officials.[26] Moreover, just as the city of Iznik became a satellite centre for Istanbul in the production of ceramics, so Bursa, a former state capital, supplemented the textile industry in Istanbul. Workshops in Bursa and Istanbul maintained different areas of focus.[27] Bursa produced the majority of textiles, ranging from everyday to luxury use, whether for the domestic or international market. Istanbul concentrated on producing "Cloth of Gold" (or "Silver") to be used as royal furnishings or garments that served a ceremonial or diplomatic function.[28] When political tension compromised the import of silkworm cocoons from Safavid Iran, sericulture also became a local endeavour.[29]

Safavid rulers also organized silk production for domestic and international markets into a highly codified system. Production was centralized, with the Safavid capital — first Tabriz, then Qazvin, then Isfahan — taking control over what had been a successful but loosely connected collection of independent workshops.[30] Court artists such as the famous painter of the Shah Tahmasp *Shahnameh*, Soltan Mohammed, worked closely with textile artists, a relationship that ensured the complementary subject matter and style between the two media.[31] Meanwhile, sericulture continued, giving the textile industry autonomy in all parts of its production cycle.[32]

Showing evidence of this chain of developments, the textiles of the Bruschettini Collection offer insights into textile design and production that cannot be appreciated in a less varied context. In them we find artistic creativity and innovation as well as enterprising business models that, even in our globally connected world, we would be hard-pressed to achieve, let alone surpass.

NOTES

1 Ron Cherry, "History of Sericulture," *Bulletin of the Entomological Society of America* 35 (1989): 83.

2 Multiple Authors, "Abrisam," *Encyclopaedia Iranica* 1/3, www.iranicaonline.org/articles/abrisam-silk-index, accessed May 19, 2017. For the importance of silk and its great cultural meaning for the Mongols, see Thomas T. Allsen, *Commodity and Exchange in the Mongol Empire: A Cultural History of Islamic Textiles* (Cambridge: Cambridge University Press, 1997).

3 See A.S. Melikian-Chirvani, "Parand and Parniyan Identified: The Royal Silks of Iran from Sasanian to Islamic Times," *Bulletin of the Asia Institute*, New Series 5 (1991), 175; Blair Fowlkes-Childs, "The Sasanian Empire (224–651 A.D.)," *Heilbrunn Timeline of Art History* (New York: Metropolitan Museum of Art, 2016), www.metmuseum.org/toah/hd/sass/hd_sass.htm, accessed May 19, 2017; and "Abrisam."

4 Melikian-Chirvani, 175.

5 Melikian-Chirvani, 175. See also Phyllis Ackerman, "Textiles Through the Sassanian Period." In Arthur Upham Pope, ed., *A Survey of Persian Art: From Prehistoric Times to the Present*, vol. 2 (New York: Oxford University Press, 1938), 691–92.

6 "Abrisam."

7 Melikian-Chirvani, 176. See also Michael W. Meister, 255–56, and collection entry for "Fragment of Textile with Horses" (Acc. No. 2004.255), Metropolitan Museum of Art Collection, www.metmuseum.org/art/collection/search/329610, accessed May 25, 2017.

8 A Mongol robe (AKM677) with this technique can be seen in the Aga Khan Museum Collection. See Philip Jodidio, et al., *Pattern and Light: Aga Khan Museum* (Toronto and New York: Aga Khan Museum/Skira Rizzoli, 2014), 135. The reverse repeat weaving technique is noted by Michael W. Meister, "The Pearl Roundel in Chinese Textile Design," *Ars Orientalis* 8 (1970): 258.

9 Louise W. Mackie, *Symbols of Power: Luxury Textiles from Islamic Lands, 7th–21st Century* (Cleveland: Cleveland Museum of Art, 2015), 214, 346. See also Elena Phipps, "Lampas." In *Looking at Textiles: A Guide to Technical Terms* (Los Angeles: Getty Publications, 2011), 47.

10 Marika Sardar, "Silk Along the Seas: Ottoman Turkey and Safavid Iran in the Global Textile Trade." In Amelia Peck, ed., *Interwoven Globe: The Worldwide Textile Trade, 1500–1800* (London: Thames & Hudson, 2013), 69. Sardar notes that "Selim I (r. 1512–20) called a complete halt to trade with Iran and exiled its traders …. Trade with Iran resumed under Suleyman but was interrupted by wars in the 1530s, 1540s, and 1560s. Similarly, various Italian merchants were alternately granted rights and stripped of them depending on political conditions."

11 Jonathan Bloom and Sheila Blair, "Decorative Arts: Islamic Mongols." In Markus Hattstein and Peter Delius, eds., *Islam: Art and Architecture* (Potsdam, Germany: HF Ullmann, 2013), 405. See also collection entry for "'Cloth of Gold'" with Medallions" (Acc. No. 2001.595), Metropolitan Museum of Art Collection, www.metmuseum.org/art/collection/search/64101, accessed May 19, 2017.

12 Morris Rossabi, *The Mongols: A Very Short Introduction* (Oxford: Oxford University Press, 2012), 32, 93, 103.

13 Mackie, 212.

14 See Linda Komaroff and Stefano Carboni, eds., *The Legacy of Genghis Khan: Courtly Art and Culture in Western Asia, 1256–1353* (New York: Metropolitan Museum of Art, 2002), 16, www.metmuseum.org/toah/hd/khan1/hd_khan1.htm, accessed on May 19, 2017.

15 Mackie, 212.

16 Anne E. Wardwell, "Flight of the Phoenix: Crosscurrents in Late Thirteenth- to Fourteenth-Century Silk Patterns and Motifs," *Bulletin of the Cleveland Museum of Art* 74, no. 1 (January 1987): 3; and Mackie, 213.

17 Daniel J. Boorstin, *The Discoverers: A History of Man's Search to Know His World and Himself* (New York: Random House, 1985), 125; "Abrisam."

18 Anne E. Wardwell, *Panni Tartarici: Eastern Islamic Silks Woven with Gold and Silver (13th and 14th Centuries)* (Genoa: Bruschettini Foundation for Islamic and Asian Art/New York: Islamic Art Foundation, 1989), 102; and Linda Komaroff, "Tragbare islamische Objekte." In Ulrich Pfisterer and Matteo Burioni, eds., *Kunstgeschichte Global: Europa, Asien, Afrika und Amerika 1300–1600* (Darmstadt, Germany: Wissenschaftliche Buchgesellschaft, 2017). I am grateful to Linda Komaroff, who shared her forthcoming essay with me.

19 See Simone Martini, *Saint Louis, Bishop of Toulouse, Crowning His Brother, Robert of Anjou, King of Naples, 1317*, 14th century. Oil on panel, 250 × 188 cm (with predella), Museo Nazionale di Capodimonte, Naples; Cathleen S. Hoeniger, "Cloth of Gold and Silver: Simone Martini's Techniques for Representing Luxury Textiles," *Gesta* 30, no. 2 (1991): 159; and Milton Sonday, "A Group of Possibly Thirteenth-Century Velvets with Gold Disks in Offset Rows," *Textile Museum Journal* (1999/2000): 103.

20 Nurhan Atasoy et al., *İpek: Imperial Ottoman Silks and Velvets* (London: Azimuth Editions, 2001), 227; Suzan Yalman, "The Art of the Timurid Period (ca. 1370–1507)," *Heilbrunn Timeline of Art History* (New York: Metropolitan Museum of Art, 2002), www.metmuseum.org/toah/hd/timu/hd_timu.htm, accessed May 19, 2017.

21 Gülru Necipoğlu, "From International Timurid to Ottoman: A Change of Taste in Sixteenth-Century Ceramic Tiles," *Muqarnas* 7 (1990): 139; and Hülya Bilgi, *Dance of Fire: Iznik Tiles and Ceramics in the Sadberk Hanım Museum and Ömer M. Koç Collections* (Istanbul: Sadberk Hanım Müzesi, 2009), 14; Sumiyo Okumura, "Garments of the Ottoman Sultans," Turkish Cultural Foundation, www.turkishculture.org/textile-arts-159.htm, accessed May 19, 2017.

22 Nazanin Hedayat Munroe, "Silks from Ottoman Turkey," *Heilbrunn Timeline of Art History* (New York: Metropolitan Museum of Art, 2012), www.metmuseum.org/toah/hd/tott/hd_tott.htm, accessed May 19, 2017.

23 Francesca Galloway, *Islamic Courtly Textiles & Trade Goods 14th–19th Century* (London: Francesca Galloway, 2011), exhibition April 4–May 6, 2011, Cat. Nos. 4, 10; Carol Bier, ed., *Woven from the Soul, Spun from the Heart: Textile Arts of Safavid and Qajar Iran, 16th–19th Centuries* (Washington, DC: Textile Museum, 1987), No. 33, 199; Hayat Salam-Liebich, "Masterpieces of Persian Textiles from the Montreal Museum of Fine Art Collection," *Iranian Studies* 25, nos. 1/2 (1992): 24; Dorothy G. Sheperd, "A Persian Velvet of the Shah Tahmasp Period," *Bulletin of the Cleveland Museum of Art* 36, no. 4 (1949): 46; Gertrude Townsend, "A Persian Velvet," *Bulletin of the Museum of Fine Arts* 26, no. 154 (1928): 25.

24 Milton Sonday, "Pattern and Weaves: Safavid Lampas and Velvet." In Carol Bier, ed., *Woven from the Soul, Spun from the Heart*, 82.

25 Mackie, 346.

26 Okumura, "Garments of the Ottoman Sultans."

27 Atasoy et al., 165.

28 Okumura, "Garments of the Ottoman Sultans."

29 Nazanin Hedayat Munroe, "Silks from Ottoman Turkey."

30 Rudolph P. Matthee, *The Politics of Trade in Safavid Iran: Silk for Silver, 1600–1730* (Cambridge, UK: Cambridge University Press, 1999), 21; Nazanin Hedayat Munroe, "Silk Textiles from Safavid Iran, 1501–1722," *Heilbrunn Timeline of Art History* (New York: Metropolitan Museum of Art, 2012), www.metmuseum.org/toah/hd/safa_3/hd_safa_3.htm, accessed May 19, 2017.

31 M.S. Dimand, "Persian Velvets of the Sixteenth Century," *Metropolitan Museum of Art Bulletin* 22, no. 4 (April 1927): 111. Dimand suggests the possibility that the painter Sultan Mohammed might have designed the patterns of carpets and cites as a reference F.R. Martin, *The Miniature Painting and Painters of Persia, India, and Turkey, from the VIII to XVIII Century* (London: B. Quaritch, 1912), plates 116, 117, 133.

32 Nazanin Hedayat Munroe, "Silk Textiles from Safavid Iran, 1501–1722"; Edmund Herzig, "The Iranian Raw Silk Trade and European Manufacture in the Seventeenth and Eighteenth Centuries." In Maureen Fennell Mazzaoui, ed., *Textiles: Production, Trade and Demand* (New York: Routledge, 2016).

LAMPAS PANEL

Eastern Iran, mid-13th century
Silk and gold-wrapped thread; *lampas*
114 × 30 cm

This textile fragment uses the *lampas* weave, an innovative technique that seems to have been developed by Iranian artisans in the eleventh century before spreading to modern-day Iraq, Syria, China, and Europe.[1] In contrast to Chinese silk, which at this time used single foundation warps,[2] *lampas* was a compound weave made up of a pair of structures. These structures were formed from various combinations of plain weave, twill, and/or satin bindings, imparting an attractive dimensionality to the design.[3] This fragment clearly shows that *lampas* weave could easily accommodate metallic threads, created when extremely fine metal leaf was affixed to a substrate (*lamella*) such as paper, animal gut, or leather. It has been suggested that the use of gold leaf with a paper *lamella* — in other words, gilded paper — might indicate the influence of Chinese textiles, while a gold-covered *lamella* derived from animals had Iranian roots.[4] In both cases, the resulting cloth was a luxury good admired by many, including fourteenth-century Italian painters, who came to know the textiles by the name of *panni tartarici* or "Tartar cloth."[5]

The spaced circles inside the borders separating the ogival panels on this textile fragment bear some resemblance to the roundel-and-pearl border design common to Pre-Islamic Sasanian textiles.[6] The ogival motifs themselves are unusual. While roundels are commonly found in thirteenth-century textiles — such as on the spectacular Ilkhanid fragment in the Cleveland Art Collection[7] — these pointed shapes do not emerge as a common motif until the sixteenth century, when, in the hands of Ottoman weavers, they became favoured ground designs. An excellent example can be found in the Bruschettini Collection (Cat. No. 28).

Given its dimensions and the existence of two nearly identical panels in The David Collection in Copenhagen, it is possible that this Bruschettini textile fragment once formed part of a Mongol tent.[8] If so, it might be an even earlier example than the five large interior panels or wall hangings currently held in the collection of the Museum of Islamic Art, Doha, which have been dated to the late thirteenth or early fourteenth centuries.[9] Persian historian Rashid al-Din (1247–1318) does record two tents made of expertly woven "gold-on-gold" cloth that were

given in 1255 and 1256 to Khan Hülegü (1218–65), the grandson of Genghis Khan and founder of the Ilkhanate in 1256. Hülegü would proceed to rule northwestern Iran for another decade, encouraging the flowering of arts and culture.[10]

NOTES

1 Louise W. Mackie, *Symbols of Power: Luxury Textiles from Islamic Lands, 7th–21st Century* (Cleveland: Cleveland Museum of Art, 2015), 214, 346. See also Elena Phipps, "Lampas." In *Looking at Textiles: A Guide to Technical Terms* (Los Angeles: Getty Publications, 2011), 47.

2 James C.Y. Watt and Anne E. Wardwell, *When Silk Was Gold: Central Asian and Chinese Textiles* (New York: Metropolitan Museum of Art), 138.

3 Phipps, 47.

4 See Phipps, 47, and collection entry for "Two Lampas-Woven Textile Fragments, Silk and Gilded Lamella of Animal Substrate, Both Spun Around a Silk Core and Woven Flat Eastern Islamic Area" (Inv. Nos. 4/1993 and 15/1989), The David Collection, Copenhagen, http://davidmus.dk/en/collections/islamic/materials/textiles/art/4-1993_og_15-1989, accessed May 19, 2017.

5 Anne E. Wardwell, *Panni Tartarici: Eastern Islamic Silks Woven with Gold and Silver (13th and 14th Centuries)* (Genoa: Bruschettini Foundation for Islamic and Asian Art/New York: Islamic Art Foundation, 1989), 102; and Linda Komaroff, "Tragbare islamische Objekte." In Ulrich Pfisterer and Matteo Burioni, eds., *Kunstgeschichte Global: Europa, Asien, Afrika und Amerika 1300–1600* (Darmstadt, Germany: Wissenschaftliche Buchgesellschaft, 2017).

6 A.S. Melikian-Chirvani, "Parand and Parniyan Identified: The Royal Silks of Iran from Sasanian to Islamic Times," *Bulletin of the Asia Institute*, New Series 5 (1991): 175.

7 See "Cloth of Gold Depicting Winged Lions and Griffins," Central Asia, ca. 1240–60, Ilkhanid (Mongol) period. Silk, gold thread, *lampas* weave, 124 × 48.8 cm, Cleveland Museum of Art, purchase from the J.H. Wade Fund 1989.50.

8 Kjeld von Folsach and Anne-Marie Keblow Bernsted, *Woven Treasures: Textiles from the World of Islam* (Copenhagen: The David Collection, 1993), 52, Acc. Nos. 4/1993 and 15/1989.

9 Mackie, 222. See also Acc. No. TE.40, Museum of Islamic Art, Doha, www.mia.org.qa/en/collections/textile/the-earliest-surviving-tent, accessed May 19, 2017.

10 Mackie, 222. Mackie quotes Rashid al-Din (1247–1318) and also includes the words of North African historian Ibn Khaldun (1332–1406), who says, "among the emblems of royal authority and luxury are small and large tents and canopies … according to the affluence of the dynasty." The collection entry for Inv. Nos. 4/1993 and 15/1989, The David Collection, Copenhagen, quotes Rashid al-Din, http://davidmus.dk/en/collections/islamic/materials/textiles/art/4-1993_og_15-1989, accessed May 19, 2017.

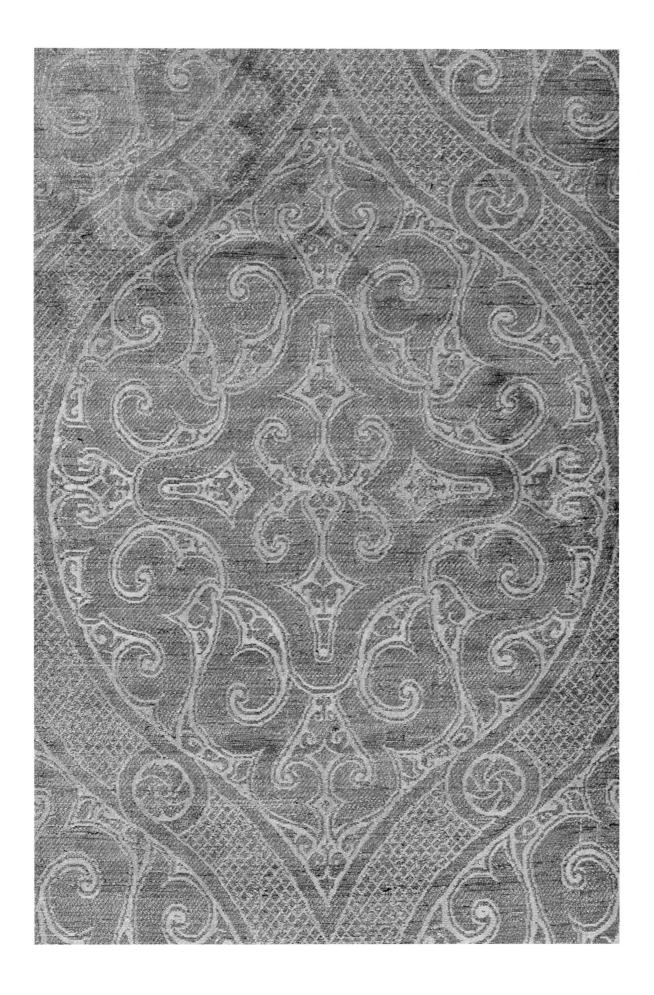

VELVET PANEL WITH GOLDEN DISCS

Iran, late 13th century
Silk and gold-wrapped thread; cut voided velvet
55 × 21 cm

Octagonal discs arranged in offset rows shimmer across a crimson ground in this velvet panel from the Bruschettini Collection. Rendered in a twill weave with costly metallic thread,[1] the discs resemble a shower of gold coins — a literal fortune — as well as suggesting çintemani, a Buddhist symbol of good fortune and protection that became popular with Ottoman artists and artisans in the fifteenth and sixteenth centuries.[2] The pattern might have been created by voiding velvet at regular intervals and filling these voids with gold or silk thread; in this manner, it might be the product of two weaving techniques, lampas and velvet.[3]

The pattern of offset discs so beautifully preserved in the Bruschettini panel was used throughout the thirteenth to fifteenth centuries and has been found on textiles in the Middle East, Central Asia, and Europe during this period. Its enduring popularity is affirmed in both material and archival evidence; for instance, Milton Sonday's careful study of this pattern in international collections identifies twenty-one similar textiles.[4] Moreover, three ecclesiastical inventories — the 1295 inventory of Pope Boniface VIII, the 1311 inventory of Clement V, and the 1341 inventory of the Church of San Francesco of Assisi — include such a cloth, described in the first instance as a "piece of red Tartar velvet with gold discs" (in the original Latin, unum pannum tartaricum pilosum rubeum ad medalias aureas).[5] A remarkable tribute to this same cloth appears in an altarpiece celebrating the canonization of St. Louis of Toulouse, who was consecrated by Pope Boniface VIII. Italian painter Simone Martini (ca. 1284–1344) from Siena masterfully depicts St. Louis wearing a crimson cope patterned with gold discs in the main panel of this altarpiece, now in the Museo Nazionale di Capodimonte in Naples. It also appears in two of the predella scenes: St. Louis's consecration as bishop and the saint on his deathbed.[6] Martini painstakingly executed the discs with gold leaf, emphasizing the value with which these "Tartar cloths" or panni tartarici were viewed in the Christian West.[7]

The origins of this offset disc pattern can likely be traced to thirteenth-century Tabriz,[8] the capital of the Mongol Ilkhanate (ruled by the House of Hülegü) from 1258 until 1306. That

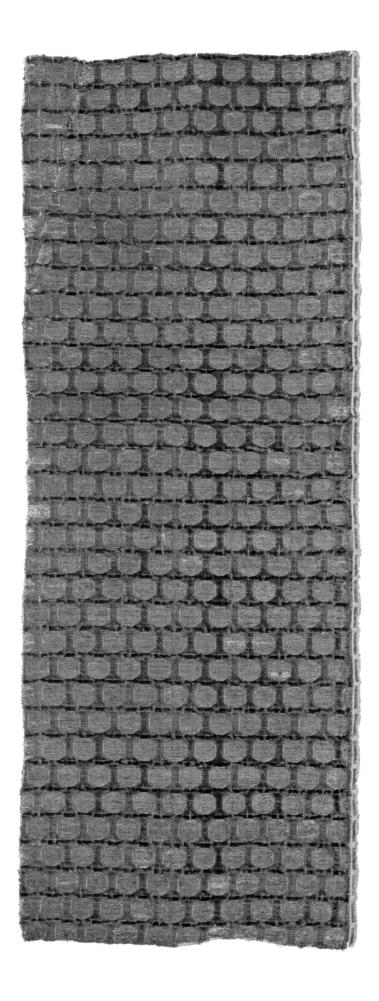

the 1295 inventory of Pope Boniface VIII specifically identifies Tabriz in connection with four of its textiles[9] affirms the city's reputation beyond the Mongol Empire as a centre for luxury textile production. How such textiles made their way to Italy might be explained through diplomacy and trade; during the *Pax Mongolica* of the thirteenth to fourteenth centuries, Mongols actively encouraged good relations with Europeans and with neighbours to the north, east, and south to secure their own position both politically and economically.[11] They did so through diplomatic missions[12] and through welcoming Europeans to their vast territory. From the 1280s onward, Italian merchants (particularly the Genoese), in fact, established a colony in Tabriz, which acted as an entrepôt from which to direct textiles back to a domestic market eager to assert its social status through luxurious clothing and interior furnishings.[13]

It is not surprising then that "Tartar cloth" — textiles ascribed to Mongol artisans — are documented in European collections around 1264, 1276, and 1281,[14] and that Iranian weaving techniques and patterns filtered to the West. By 1300, silk weaving had been established in Lucca, Venice, and Genoa, and Italian textiles were arriving in Spain and the eastern Mediterranean.[15] Particularly in Genoa and Venice, Europeans inspired by these examples worked diligently to develop local expertise both in sericulture and in weaving, eventually producing textiles that would rival those of Safavid and Ottoman artisans in the sixteenth century.[16]

NOTES

1 Milton Sonday, "A Group of Possibly Thirteenth-Century Velvets with Gold Disks in Offset Rows," *Textile Museum Journal* (1999/2000): 120.

2 Perhaps these discs are an earlier version of *çintemani*. See Gerard Paquin, "Çintamani," *Hali* 64 (August 1992): 104–19, especially figs. nos. 15 and 16. More specifically, see the painting with Alexander enthroned (Paris, Musée du Louvre, no. 7096) from the Great Mongol *Shahnameh*, 1330s. See Linda Komaroff and Stefano Carboni, eds., *The Legacy of Genghis Khan: Courtly Art and Culture in Western Asia, 1256–1353* (New York: Metropolitan Museum of Art, 2002), fig. 51. It is also interesting to note that a caftan with a *çintemani* motif (in this case, gold circles outlined in blue on a crimson ground) can be found in the collection of the Topkapı Palace Museum (TSM 13/41), while a textile likely from the early fifteenth century is described in a palace inventory as "drapery from Bursa with gold and polka dot pattern" (see vol. 1483, TSM, D.4). *Çintemani* motifs are also printed in silver on TSM, 13/198. See Tahsin Öz, *Turkish Textiles and Velvets* (Ankara: Turkish Press, Broadcasting and Tourist Department, 1950). The Turkish version of this book is Tahsin Öz, *Türk kumaş ve kadifeleri* (Istanbul: Millî Eğitim Basımevi, 1946), pl. XXVI; Sibel Alpaslan Arca catalogue entries in Deniz Erduman Çalış, ed. *Tulpen, Kaftane und Levni: höfische Mode und Kostümalben der Osmanen aus dem Topkapı Palast Istanbul* (Munich: Hirmer, 2008), 146, 152.

3 See Sonday, 142.

4 The institutions whose collections Sonday studied are those of the Cooper-Hewitt Museum, New York; Hispanic Society; Metropolitan Museum of Art; Cleveland Museum of Art; Museum of Fine Arts, Boston; V&A London; Koninklijke Musea voor Kunst en Geschiedens, Brussels; Museo Nazionale del Bargello, Florence; Museo Stibbert, Florence; and Canada. See Sonday, 104. The Canadian institution referred to by Sonday has been indentified as the Royal Ontario Museum in Toronto where two fragments are located, Acc. Nos. 909.16.72 and 925.22.124. I thank Anu Liivandi for her support.

5 See Anne E. Wardwell, *Panni Tartarici: Eastern Islamic Silks Woven with Gold and Silver (13th and 14th Centuries)* (Genoa: Bruschettini Foundation for Islamic and Asian Art; New York: Islamic Art Foundation, 1989), 111; Cathleen S. Hoeniger,

Saint Louis, Bishop of Toulouse,
Crowning His Brother, Robert of Anjou,
King of Naples, 1317

Detail of Altarpiece (without predella)
by Simone Martini (ca. 1284–1344)
Italy, 14th century
Oil on panel
250 × 188 cm (with predella)
Copyright © Museo di Capodimonte, Naples
Photograph by DeAgostini/Getty Images

"Cloth of Gold and Silver: Simone Martini's Techniques for Representing Luxury Textiles," *Gesta* 30, no. 2 (1991): 158; and Sonday, 103.

6 See Simone Martini, *Saint Louis, Bishop of Toulouse, Crowning His Brother, Robert of Anjou, King of Naples, 1317*, 14th century. Oil on panel, 250 × 188 cm (with predella), Museo Nazionale di Capodimonte, Naples; Hoeniger 1991, 159–60; and Milton Sonday, 103. For further information about the St. Louis Altarpiece, see Adrian S. Hoch, "The Franciscan Provenance of Simon Martini's Angevin St. Louis in Naples," *Zeitschrift füer Kunstgeschichte* 58, no. 1 (1995): 22–38.

7 Hoeniger 154, Wardwell, 102, and Linda Komaroff, "Tragbare islamische Objekte." In Ulrich Pfisterer and Matteo Burioni, eds., *Kunstgeschichte Global: Europa, Asien, Afrika und Amerika 1300–1600* (Darmstadt, Germany: Wissenschaftliche Buchgesellschaft, 2017).

8 See Louise W. Mackie, *Symbols of Power: Luxury Textiles from Islamic Lands, 7th–21st Century* (Cleveland: Cleveland Museum of Art, 2015), 228.

9 Wardwell, 111, 129, Inv. No. 156; Sonday, 138.

10 Mackie, 212.

11 See Patrick Wing, "'Rich in Goods and Abounding in Wealth': The Ilkhanid and Post-Ilkhanid Ruling Elite and the Politics of Commercial Life at Tabriz." In Judith Pfeiffer, ed. *Politics, Patronage and the Transmission of Knowledge in 13th–15th Century Tabriz* (Leiden, Neth.: Brill, 2014), 301–20.

12 See David Jacoby, "Silk Economics and Cross-Cultural Artistic Interaction: Byzantium, the Muslim World, and the Christian West," *Dumbarton Oaks* 58 (2004): 233.

13 See Hoeniger, 154; Sonday, 138.

14 Hoeniger, 154.

15 A western Spanish example of similar red silk and cut velvet, and with gold thread, is kept in the Art Institute of Chicago (Gift: Martin A. Ryerson through the Antiquarian Society, Acc. No. 1911.202). See Rosamond E. Mack, *Bazaar to Piazza: Islamic Trade and Italian Art, 1300–1600* (Berkeley, CA: University of California Press, 2002), 30.

16 See Mackie, 228.

24

VELVET PANEL WITH FLORAL MOTIF

Iran, 16th century

Silk, flat metal thread; cut and voided velvet

102 × 43.5 cm

In a lattice-like design, large palmettes and smaller peonies and rosettes cover this wedged-shaped panel, their delicate tracery showing the full talents of Safavid weavers and the Safavid love of gardens.[1] The artisans have created an elegantly textured effect across the panel by using six-colour pile for the flowers and meandering stems — each colour requiring its own warp insertion[2] — and reserving a flat weave for the ground, producing a "voided" effect. But the full splendour of this panel can be appreciated when imagining its original materials: silver thread once covered the ground, enabling the textile to reflect light whether in stasis or in motion.[3] Both in technique and design, this velvet panel in the Bruschettini Collection resembles textile fragments held in the Keir Collection, Metropolitan Museum of Art (Acc. No. 27.51.2), and the Textile Museum of Washington, D.C.[4]

Like the "*Lampas* Panel" and "Velvet Panel with Hunting Scene" in the Bruschettini Collection (Cat. Nos. 22 and 25), this textile fragment might have once been part of a tent. There is considerable difference of opinion about its exact provenance, however. It might, for instance, be one of sixteen textile fragments acquired by Prince Sanguszko, commander-in-chief of King Sobieski's army during the Battle of Vienna (1683). When Sanguszko claimed them, the fragments were in the possession of Ottoman Grand Vizier Kara Mustafa Pasha (1634/1635–83). They were said to have originally embellished the tent of Suleyman the Magnificent during the invasion of Iran (1534–47). These fragments remained in the Sanguszko family until 1920.[5]

Other theories date this fragment to a period after Suleyman's death in 1566. The first theory suggests that it came from a tent produced in Kashan, a centre of velvet production in Safavid Iran. This tent was given by Iranian ambassador Toqmaq Khan to Murad III at the time of Murad's succession to the throne.[6] The second theory dates the fragment still later — in 1600 during the time of Shah Abbas — and connects the artist Ghiyath, whose name appears on similar textiles now held in the Keir Collection, to the pattern's superior execution.[7]

It is equally possibly that this fragment was part of a larger textile made for export to Europe. The Safavid government nationalized textile production and ensured that the export

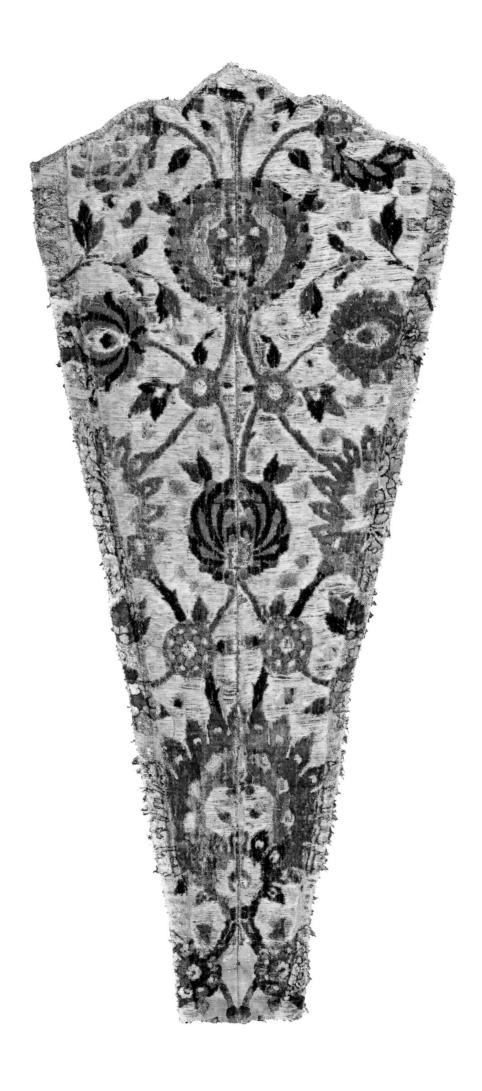

of textiles was an important revenue stream. Workshops were highly systematized: some were designated to serve a primarily international market, while others were to produce textiles for the court and more local markets.[8] This highly coordinated effort resulted in a veritable explosion in textile production throughout the Safavid period and the circulation of Safavid textiles in Asia, Europe, and the Middle East during the sixteenth and seventeenth centuries.[9]

NOTES

1 Patricia Baker, *Islamic Textiles* (London: British Museum Press, 1995), 117.

2 Hayat Salam-Liebich, "Masterpieces of Persian Textiles from the Montreal Museum of Fine Art Collection," *Iranian Studies* 25, nos. 1/2 (1992): 24–25.

3 Francesca Galloway, *Islamic Courtly Textiles & Trade Goods 14th–19th Century* (London: Francesca Galloway, 2011), exhibition April 4–May 6, 2011, Cat. Nos. 4, 10.

4 See Milton Sonday, "Pattern and Weaves: Safavid *Lampas* and Velvet." In Carol Bier, ed., *Woven from the Soul, Spun from the Heart: Textile Arts of Safavid and Qajar Iran, 16th–19th Centuries* (Washington, DC: Textile Museum, 1987), 57–72. The earliest publication about this group of textiles is Phyllis Ackerman, "Textiles Through the Sassanian Period." In Arthur Upham Pope, ed., *A Survey of Persian Art: From Prehistoric Times to the Present* (New York: Oxford University Press, 1938), pl. 1006, pl. 1023–25.

5 McWilliams discusses sixteen fragments from the Sanguszko tent to which the Bruschettini velvets might belong. McWilliams dates the group 1540–1640 and identifies seven different patterns. See Mary McWilliams, "A Safavid Velvet in the Isabella Stewart Gardner Museum, Boston — A Contribution to the 'Botanical' Study of Safavid Voided Velvets." In *Carpets and Textiles in the Iranian World 1400–1700*, proceedings of a conference held at the Ashmolean Museum, Oxford, on August 30–31, 2003 (Oxford and Genoa: May Beattie Archive at the Ashmolean Museum, University of Oxford, 2010), 172, where she analyzed thirty-four Safavid velvets, including the velvets associated with the Sanguszko tent; Galloway, 10; Carol Bier, ed., *Woven from the Soul, Spun from the Heart: Textile Arts of Safavid and Qajar Iran, 16th–19th Centuries* (Washington, DC: Textile Museum, 1987), Cat. No. 33, 199; Hayat Salam-Liebich, "Masterpieces of Persian Textiles from the Montreal Museum of Fine Art Collection," *Iranian Studies* 25, nos. 1/2 (1992): 24; Dorothy G. Sheperd "A Persian Velvet of the Shah Tahmasp Period," *Bulletin of the Cleveland Museum of Art* 36, no. 4 (1949): 46; Gertrude Townsend, "A Persian Velvet," *Bulletin of the Museum of Fine Arts* 26, no. 154 (1928): 254.

6 Louise W. Mackie, *Symbols of Power: Luxury Textiles from Islamic Lands, 7th–21st Century* (Cleveland: Cleveland Museum of Art, 2015), 352–56.

7 Phyllis Ackerman, "A Biography of Ghiyath the Weaver," *Bulletin of the American Institute for Persian Art and Archaeology* 7 (December 1934): 10; and Ackerman, 2094–96; Friedrich Spuhler, *Islamic Carpets and Textiles in the Keir Collection* (London: Faber & Faber, 1978), 169.

8 Hayat Salam-Liebich, 27.

9 Mackie, 344; Sonday, 83.

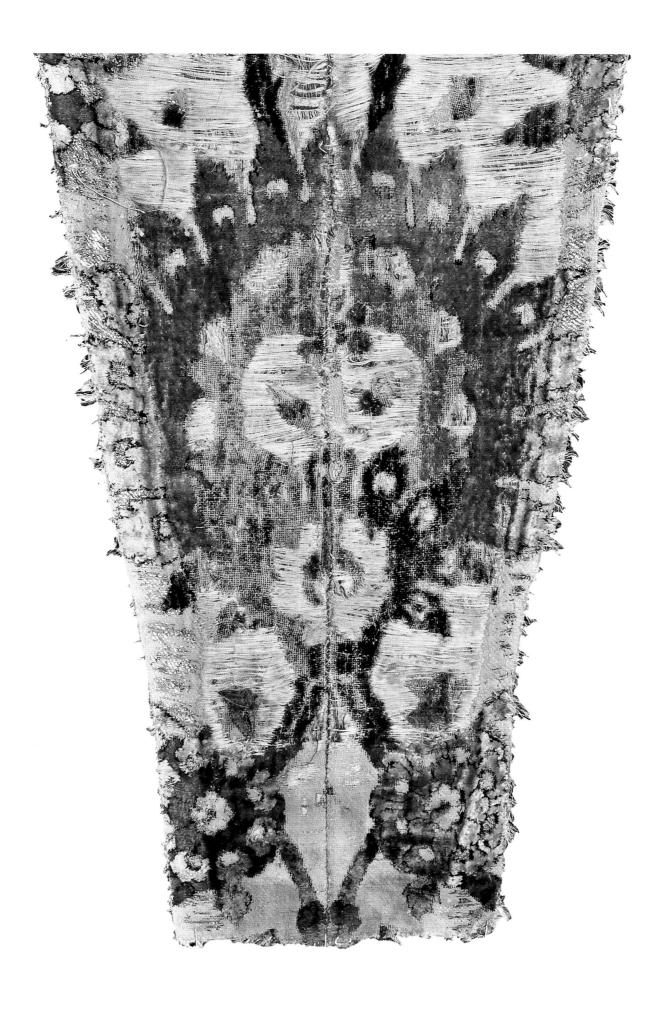

25

VELVET PANEL WITH HUNTING SCENE

Iran, 16th century
Silk, flat metal thread; cut voided velvet
45.5 × 45.5 cm

A lion captured in mid-leap, a coiled dragon waiting to strike, and a crouching jackal[1] with teeth bared are the fierce adversaries depicted on this textile segment. The presence of both fantastical and real creatures suggests there is a narrative for the composition: rather than offering a generic hunting scene, a favourite subject of Safavid textiles,[2] the subject matter might have been drawn from a painted manuscript that itself tells the tale of a hero's trials. Heroes such as Rustam, Siyavush, and Bahram Gur — all brought to life in the copy of Firdausi's *Shahnameh* produced for Shah Tahmasp — had mastered archery just as Iranian princes and nobleman were expected to do.[3] The exceptionally fine lines on the figures and varied use of colour throughout the composition, in fact, evoke the richness of such paintings, whose details were sometimes rendered with a tiny brush of squirrel hairs.[4]

Safavid textiles of the sixteenth century — particularly those in velvet — were known for their efforts to capture a moment of dramatic tension. In this velvet panel, we see a courtly hunter in the act of drawing his bow; in a textile fragment in the Textile Museum, Washington, D.C.,[5] a dragon slayer appears with arms upraised in the act of hurling a boulder. In addition to Firdausi's *Shahnameh*, illustrated magnificently during the reign of Shah Tahmasp (1524–76), a major source of inspiration for Safavid weavers was Nizami's *Khamseh*, which was deftly illustrated by Iranian, and later, Mughal artists. That painters oversaw Safavid textile workshops in service to the court increased the synergy between both media.[6]

Like the other Safavid textile in the Bruschettini Collection, this textile fragment might have been part of a tent. Its composition and technique are certainly similar to campaign tent fragments in the Metropolitan Museum of Art and Calouste Gulbenkian Museum collections.[7] Such examples might have been owned by Ottoman Grand Vizier Kara Mustafa Pasha (1634/35–83), whose possessions were seized at the disastrous Battle of Vienna (1638).[8] This battle began the Great Turkish War that would eventually diminish both the size and power of the Ottoman Empire.[9]

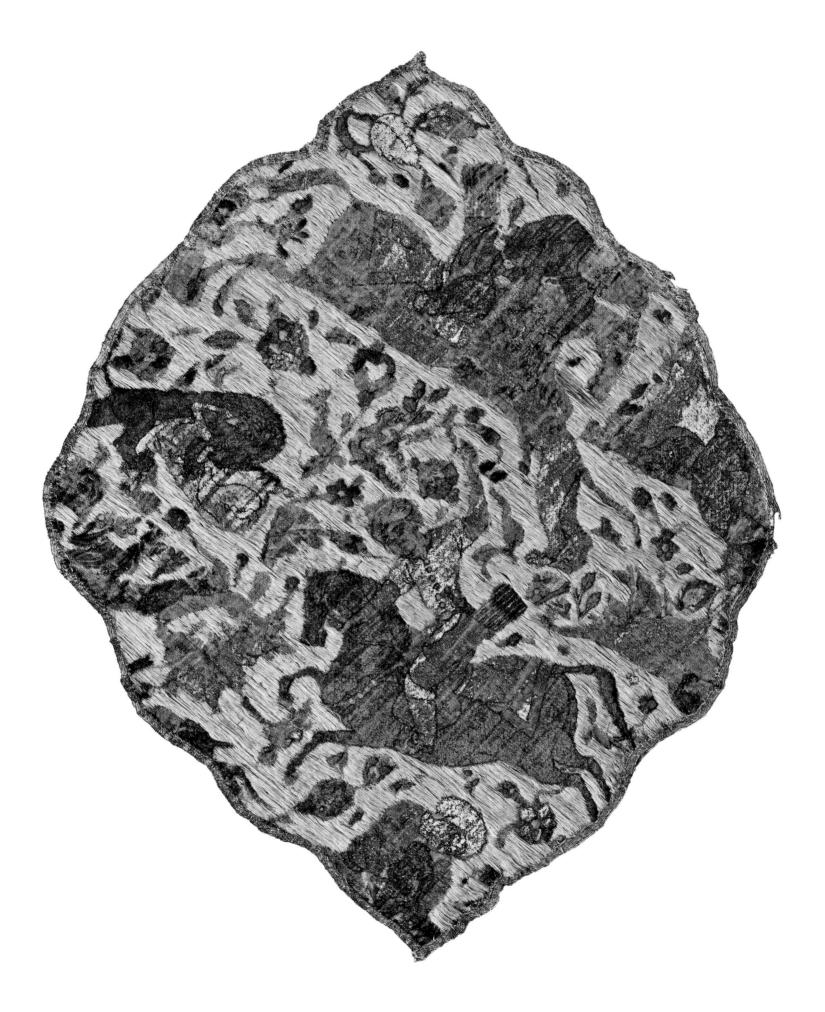

If not used as tent furnishings, such densely woven textiles could have been used to produce interior wall hangings, cushions, or ceremonial robes. If intended for royal use, they would have been manufactured at the royal workshop at Tabriz; other centres of textile production included Yazd, Herat, Rasht, and Isfahan.[10] Prized for their high artistry well beyond the borders of Safavid Iran, they marked the pinnacle of textile production in the sixteenth and early seventeenth centuries.

NOTES

1 Jackals figured prominently in the late-sixteenth-century paintings of *Anwar-i Suhayli (Lights of Canopus)* (1593). See also Anthony Welch, *The Collection of Islamic Art, Prince Sadruddin Aga Khan*, 4 vols. (Geneva: Château de Bellerive, 1972 and 1978); and Elizabeth Laird, *Two Crafty Jackals: The Animal Fables of Kalilah and Dimnah* (Toronto: Aga Khan Museum, 2014).

2 The hunt was also considered to be a mandatory part of a prince's education. Princes learned the art of riding while shooting an arrow or wielding a lance. This training was considered to be excellent preparation for actual war, and the hunt became a central topic in manuscript illustrations. See Filiz Çakır Phillip, *Enchanted Lines: Drawings from the Aga Khan Museum Collection* (Toronto: Aga Khan Museum, 2014), 52, Cat. No. 7, and 61. See also *The Metropolitan Museum of Art: The Islamic World* (New York: The Franklin Library, Metropolitan Museum of Art, 1987), 100; Nazanin Hedayat Munroe, "Silk Textiles from Safavid Iran, 1501–1722," *Heilbrunn Timeline of Art History* (New York: Metropolitan Museum of Art, 2012), www.metmuseum.org/toah/hd/safa_3/hd_safa_3.htm, accessed May 19, 2017.

3 See Sheila R. Canby and Jon Thompson, eds., *Hunt for Paradise: Court Arts of Safavid Iran, 1501–1576* (Skira, 2003); *The Shahnama of Shah Tahmasp: The Persian Book of Kings* (New York: Metropolitan Museum of Modern Art, 2014); Filiz Çakır Phillip, "The *Shahnama*: On the Forging of Heroes and Weapons." In Julia Gonnella and Christoph Rauch, eds., *Heroic Times: A Thousand Years of the Persian Book of Kings* (Munich: Edition Minerva, 2012), 58–63; Martin Bernard Dickson, Stuart Cary Welch, and Firdausi, *The Houghton Shahnameh* (Cambridge, MA: Harvard University Press, 1981).

4 See the appendix of Dickson, Welch, and Firdausi, 259–69. The appendix is an English translation of the treatise *Qanun as-suwar*, written (1576–1602) about the material, techniques, and painting methods of Sadiqi Beg (1533–1610), who was a master of the courtly workshop in Qazwin. See also Çakır Phillip, *Enchanted Lines*, 27.

5 Textile Museum, Washington, D.C., Acc. No. 3.309.

6 Louise W. Mackie, *Symbols of Power: Luxury Textiles from Islamic Lands, 7th–21st Century* (Cleveland: Cleveland Museum of Art, 2015), 346; Gisela Helmecke, "Brocade and Velvet." In Claus-Peter Haase, ed., *A Collector's Fortune: Islamic Art from the Collection of Edmund de Unger* (Berlin: Museum für Islamische Kunst, 2007), 84.

7 See Metropolitan Museum of Art Collection, Acc. No. 27.51.1, www.metmuseum.org/art/collection/search/447966?sortBy=Relevance&ft=27.51.1&offset=0&rpp=20&pos=1, accessed May 19, 2017; and Calouste Gulbenkian Museum Collection, Acc. No. 1505, https://gulbenkian.pt/museu/en/works_museu/fabric-fragment-2, accessed May 19, 2017.

8 Francesca Galloway, *Islamic Courtly Textiles & Trade Goods 14th–19th Century*, exhibition April 4–May 6, 2011, Cat. Nos. 4, 10; Carol Bier, ed., *Woven from the Soul, Spun from the Heart: Textile Arts of Safavid and Qajar Iran, 16th–19th Centuries* (Washington, DC: Textile Museum, 1987), Cat. No. 33, 199; Hayat Salam-Liebich, "Masterpieces of Persian Textiles from the Montreal Museum of Fine Art Collection," *Iranian Studies* 25, nos. 1/2 (1992): 24; Dorothy G. Sheperd "A Persian Velvet of the Shah Tahmasp Period," *Bulletin of the Cleveland Museum of Art* 36, no. 4 (1949): 46; Gertrude Townsend, "A Persian Velvet," *Bulletin of the Museum of Fine Arts* 26, no. 154 (1928): 254.

9 "Battle of Vienna," *Encyclopaedia Britannica*, www.britannica.com/event/Siege-of-Vienna-1683, accessed May 19, 2017.

10 M.S. Dimand, "Persian Velvets of the Sixteenth Century," *Metropolitan Museum of Art Bulletin* 22, no. 4 (1927): 111; Friedrich Spuhler, *Islamic Carpets and Textiles in the Keir Collection* (London: Faber & Faber, 1978), 163–64.

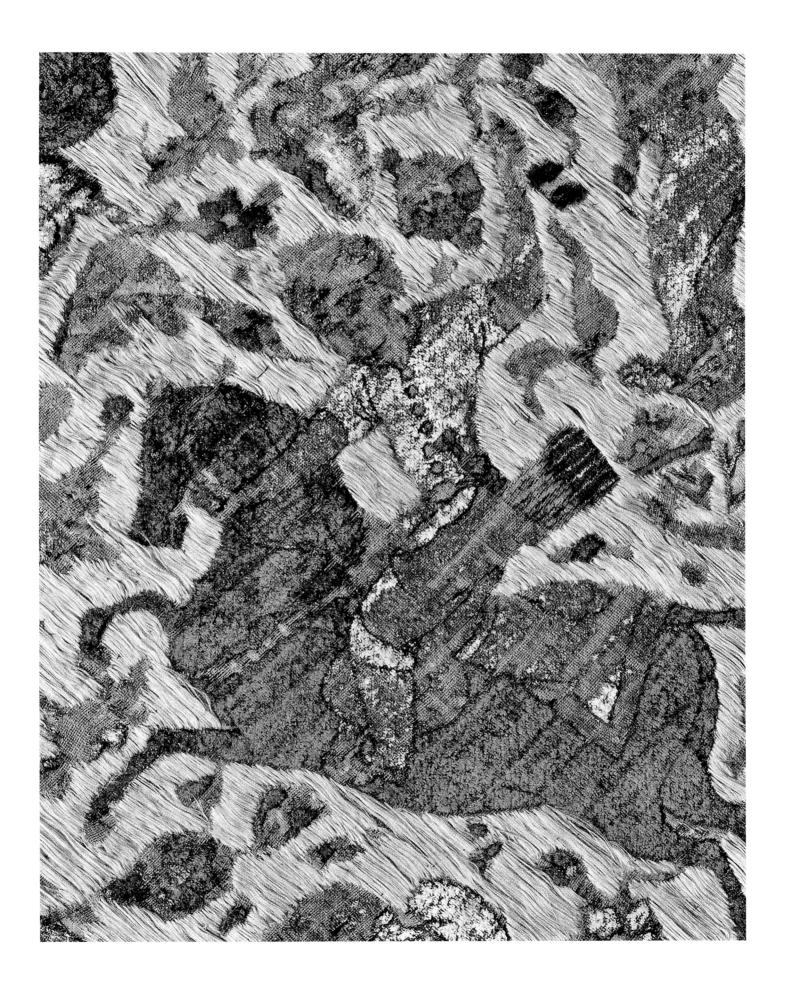

26

LAMPAS PANEL WITH COURTLY SCENE

Iran, 16th century

Silk; *lampas*

172 × 85 cm

Scenes of courtly life adorn this textile fragment, which is similar to fragments represented in the Keir Collection and others, including the Victoria and Albert Museum, London; the Whitworth Art Gallery, Manchester; Musée des Tissus, Lyon; and Musée des Arts Décoratifs, Paris.[1] At the top of this panel a seated royal figure — likely a prince — eats fruit while a servant kneels before him with a burgeoning tray of pomegranate. The enthroned prince eating pomegranate appears three times, alternating with rows of various seated figures. Around them other figures sit and stand, both alone and in pairs. Trees and palmette-like flowers fill the spaces between the figures, connecting them and giving a decorative logic to the shifts in human scale.

While this lively composition might have been influenced by the painted manuscripts and drawings that were being produced in abundance during the Safavid period, it does not appear to be linked to a single story popularized in the poetry of the day. Instead, like the hunting scenes that so often fill Safavid textiles, it celebrates noble pursuits and courtly values.[2] Traces of pastel green, blue, yellow, and pink remaining on some furnishing and on the clothing of certain figures show not only the delicacy of the Safavid palette but also its surprising breadth.[3] Unlike Mongol silks, which were often characterized by gold-on-gold weave, Safavid weavers used colour as if they were painters, creating a surprising continuum between textiles to painting that was unparalleled in contemporary Ottoman or earlier Mongol arts.

NOTES

1 Friedrich Spuhler, *Islamic Carpets and Textiles in the Keir Collection* (London: Faber & Faber, 1978), 185.

2 Louise W. Mackie, *Symbols of Power: Luxury Textiles from Islamic Lands, 7th–21st Century* (Cleveland: Cleveland Museum of Art, 2015), 346.

3 These colours also mirror the palette of Safavid fashion — see Nazanin Hedayat Munroe, "Fashion in Safavid Iran," *Heilbrunn Timeline of Art History* (New York: Metropolitan Museum of Art, 2013), www.metmuseum.org/toah/hd/safa_f/ hd_safa_f.htm, accessed May 19, 2017.

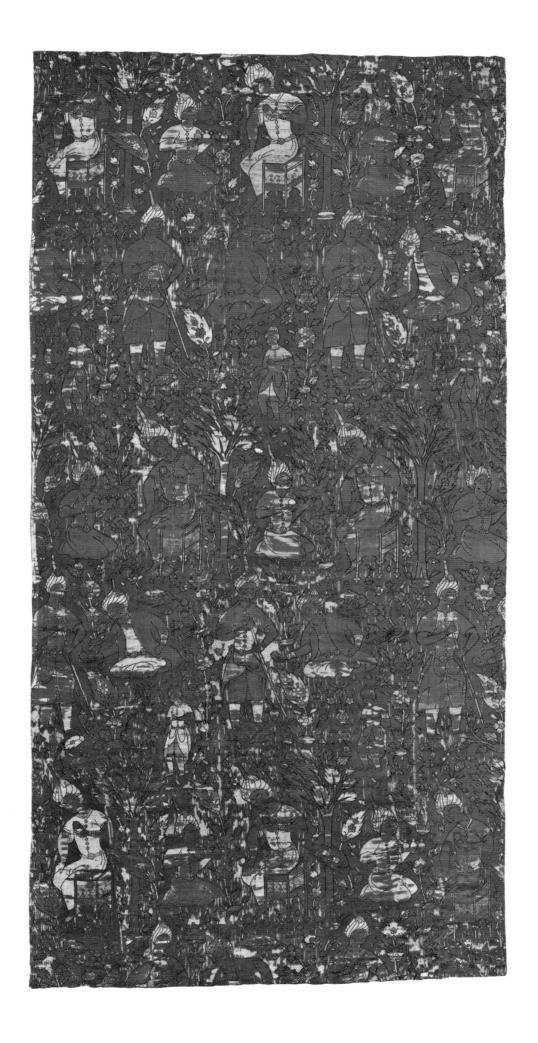

KEMHA WITH *ÇINTEMANI*

Turkey, 16th century
Silk, gold-wrapped thread; brocaded
13.5 × 29 cm

This boldly patterned *kemha*[1] made of three colours — light blue, dark red, and gold — affirms the extent to which Ottoman textiles absorbed technologies and motifs of other cultural traditions. The swirling cloudband, given contrasting texture from a twill weave, has a Chinese origin.[2] Perhaps its most memorable incarnation is found in the delicate blue-and-white porcelain of the Ming dynasty (1368–1644).

The dynamic tiger stripes in metallic thread have a more complex origin, combining the influence of Chinese, Iranian, and Mongol cultures. At its most ancient level, they evoke the Buddhist *çintemani*, originally depicted as three circles and a pair of wavy bands. The *çintemani*, a Sanskrit term that means "auspicious jewel," was thought to bring protection and good luck to its bearer.[3] As early as the ninth century, it was adopted in Islamic cultures: first on Abbasid pottery of the ninth century, and later on fifteenth-century coinage used in Iran and Central Asia. Ottoman artisans working in textiles and ceramics imbued the *çintemani* with additional connotations of virility and masculinity, embracing it so enthusiastically that it would become one of the most famous *nakkashanes* (house of patterns or designs) in their lexicon.[4] Intriguingly, the Ottoman *çintemani* resembles tiger stripes and/or leopard spots — perhaps evoking Rustam, the much-admired hero of Persian poetry often depicted wearing a tiger pelt and a helmet of leopard skin.[5]

The *çintemani* stripes in the Bruschettini *kemha* also acquire distinctly regal associations by nature of their execution in metallic thread: gold, so prized by the Mongols and very recently adopted by Ottoman weavers, inevitably conjured notions of kingship. There is a textile fragment in the Topkapı Palace Museum with a similar pattern combination but a different colour palette: tiger stripes in silver thread are edged with red silk on a black ground, and Chinese cloud patterns, wrought in yellow, complete the design.

The expensive Bruschettini textile might have been woven in one of the state-controlled workshops in Istanbul[6] where textile production concentrated on gold and silver fabrics made into imperial robes or interior furnishings as well as garments intended to be given as

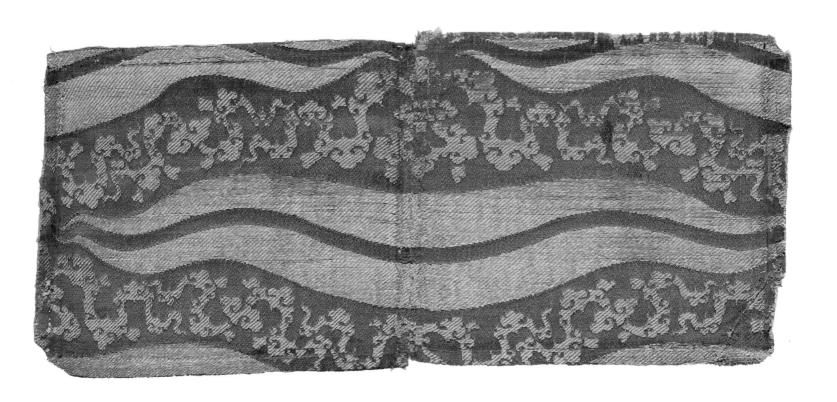

diplomatic gifts.[7] Moreover, it would have had to meet the exacting standards that governed all Ottoman textile production: inspection by a state-appointed *arşıncı*, who would evaluate the fabric's length, width, and quality of weave.[8] This level of exactitude ensured that, like the ceramic wares and tiles produced during this time, Ottoman textiles intended both for domestic use and for export achieved a consistently high level of craftsmanship.

NOTES

1 Brocades with or without metallic thread were called *kemha*, and they were much sought after by the Ottoman court. Istanbul — and more specifically Topkapı Palace looms — likely became the primary source of *kemha* production. See Hülya Tezcan, Selma Delibaş, and J.M. Rogers, *The Topkapı Saray Museum: Costumes, Embroideries and Other Textiles* (Boston: Little, Brown, 1986), 16.

2 Hülya Bilgi, *Dance of Fire: Iznik Tiles and Ceramics in the Sadberk Hanım Museum and Ömer M. Koç Collections* (Istanbul: Sadberk Hanım Müzesi, 2009), 25.

3 See Nurhan Atasoy et al., *İpek: Imperial Ottoman Silks and Velvets* (London: Azimuth Editions, 2001), 299; Gerard Paquin, "Çintamani," *Hali* 64 (August 1992): 104–19, 143–44 (for bibliography); Maryam Ekhtiar et al., eds., *Masterpieces from the Department of Islamic Art in the Metropolitan Museum of Art* (New York: Metropolitan Museum of Art, 2011), 324–25; Nazanin Hedayat Munroe, "Silks from Ottoman Turkey," *Heilbrunn Timeline of Art History* (New York: Metropolitan Museum of Art, 2012), www.metmuseum.org/toah/hd/tott/hd_tott.htm, accessed May 19, 2017.

4 From the early fifteenth century to at least the eighteenth century, this pattern was frequently employed by Ottoman artisans. See Nurhan Atasoy et al., 299.

5 Filiz Çakır Phillip, "The *Shahnama*: On the Forging of Heroes and Weapons." In Julia Gonnella and Christoph Rauch, eds., *Heroic Times: A Thousand Years of the Persian* Book of Kings (Munich: Edition Minerva, 2012), 58–63.

6 See Tahsin Oz, *Turkish Textiles and Velvets, XIV–XVI Centuries* (Ankara: Turkish Press, Broadcasting and Tourist Department, 1950), plate XXXVI.Pl.5602, 118.

7 Sumiyo Okumura, "Garments of the Ottoman Sultans," Turkish Cultural Foundation, www.turkishculture.org/textile-arts-159.htm, accessed May 19, 2017; Nurhan Atasoy et al., 156, 165.

8 Okumura, www.turkishculture.org/textile-arts-159.htm, accessed May 19, 2017.

KEMHA WITH FLORAL MOTIF

Turkey, 16th century
Silk, gold-wrapped thread; brocaded
65 × 54.7 cm; 69 × 55 cm

With its ground of crimson, this textile fragment is a study in restrained elegance. Blue interlace, vegetal in nature, borders large ogival shapes arranged in rows. On the fragment's underside, a single line of red scrollwork frames an arrangement of flowers that would be at home on Ottoman ceramic wares and tiles of the same period. Carnations, hyacinths, and prunus (in two colours, white and red) are arranged with delicate symmetry, recalling the *quatre fleurs* style of court artist and atelier director Kara Memi.[1] The use of gold-wrapped thread as a ground for the floral designs not only increases the textile's value but also enables the details of stem, petal, and leaf to be appreciated to their full effect.[2]

As the thirteenth-century "*Lampas* Panel" in the Bruschettini Collection (Cat. No. 22) attests, the ogival pattern — essentially an elongated oval with pointed ends — did not originate with the Ottomans. Its origins are likely Chinese, with Mamluk artisans of the fourteenth and fifteenth centuries developing the pattern in intriguing ways.[3] The pattern would also be adopted in Italian and French textiles well into the eighteenth century.[4] Yet nowhere was it more consistently employed than in the sixteenth-century textiles produced in Bursa and Istanbul.[5]

Unlike their Safavid contemporaries, Ottoman artisans did not favour figurative subjects; their textiles do not present mirrors of courtly life or the tales of heroes and lovers illustrated in manuscript paintings. Preferring geometric and floral designs as well as patterns with symbolic meaning like *çintemani*, the Ottomans found in the ogival pattern a beautiful frame that imparted symmetry and coherence to a larger composition regardless of how often it was repeated within a given fabric. The ogival pattern was endlessly versatile, suitable for decoration on garments as well as on furnishings of all kinds.

Bursa, the first capital of the Ottoman Empire, was also the empire's first centre for textile production. During times of relative peace, raw silk could enter Bursa's workshops from northern Iran through well-worn trade routes. With this trade came exposure to the artistry and techniques of Iranian craftsmen in all media. During Suleyman's reign (1520–66), select

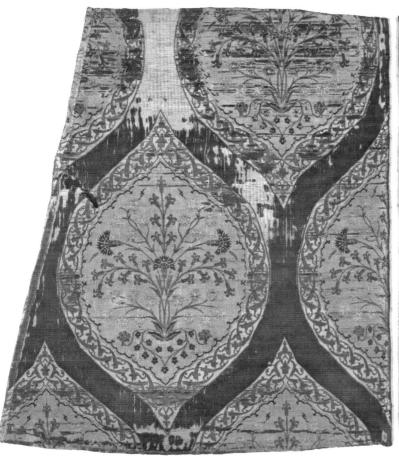
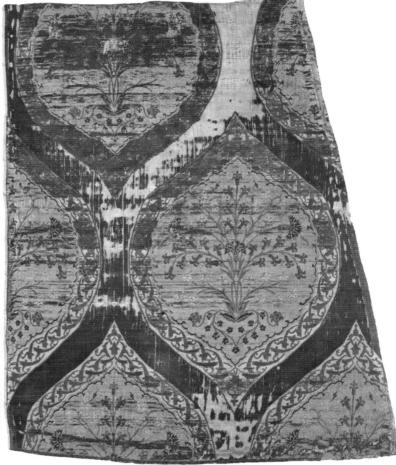

weavers from Bursa were relocated to Istanbul to establish a second textile centre that primarily serviced the court.[6] However, like Iznik, which became the primary centre for ceramic production both for the court and for commercial use, Bursa handled the bulk of textile production in the sixteenth century. In addition to luxury velvets (*çatma*) and metal-ground silks (*seraser* or *kemha*), it produced fabrics favoured on the European market.[7] Like the Mongol "Cloth of Gold," many Ottoman textiles appeared in Italian, and later, northern European paintings as symbols of status and wealth, and Ottoman garments can still be found among the collections of European churches.[8]

NOTES

1 Maria Queiroz Ribeiro, "Eastern Islamic Art." In *Calouste Gulbenkian Museum* (Lisbon: Calouste Gulbenkian Foundation, 2011), 55.

2 Another fragment of the same textile is kept in the collection of the Textile Museum, Washington, D.C., Inv. No. 1.50. See Nurhan Atasoy et al., *İpek: Imperial Ottoman Silks and Velvets* (London: Azimuth Editions, 2001), 273, fig. 209.

3 Esin Atıl, *Renaissance of Islam: Art of the Mamluks* (Washington, DC: Smithsonian Institution Press, 1981), 223–24; Nurhan Atasoy et al., 227.

4 James Trilling, *Ornament: A Modern Perspective* (Seattle: University of Washington Press, 2003), 52–54.

5 Maryam Ekhtiar et al., eds., *Masterpieces from the Department of Islamic Art in the Metropolitan Museum of Art* (New York: Metropolitan Museum of Art, 2011), 322.

6 Sumiyo Okumura, "Garments of the Ottoman Sultans," Turkish Cultural Foundation, www.turkishculture.org/textile-arts-159.htm, accessed May 19, 2017.

7 Nurhan Atasoy et al., 156, 165.

8 Nazanin Hedayat Munroe, "Silks from Ottoman Turkey," *Heilbrunn Timeline of Art History* (New York: Metropolitan Museum of Art, 2012), www.metmuseum.org/toah/hd/tott/hd_tott.htm, accessed May 19, 2017.

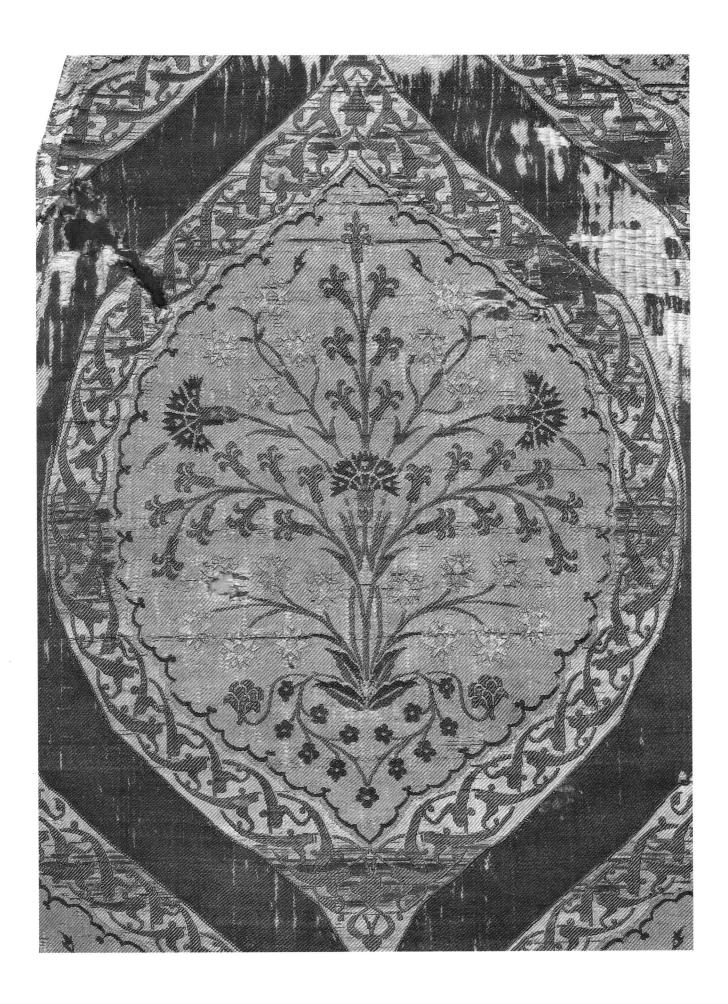

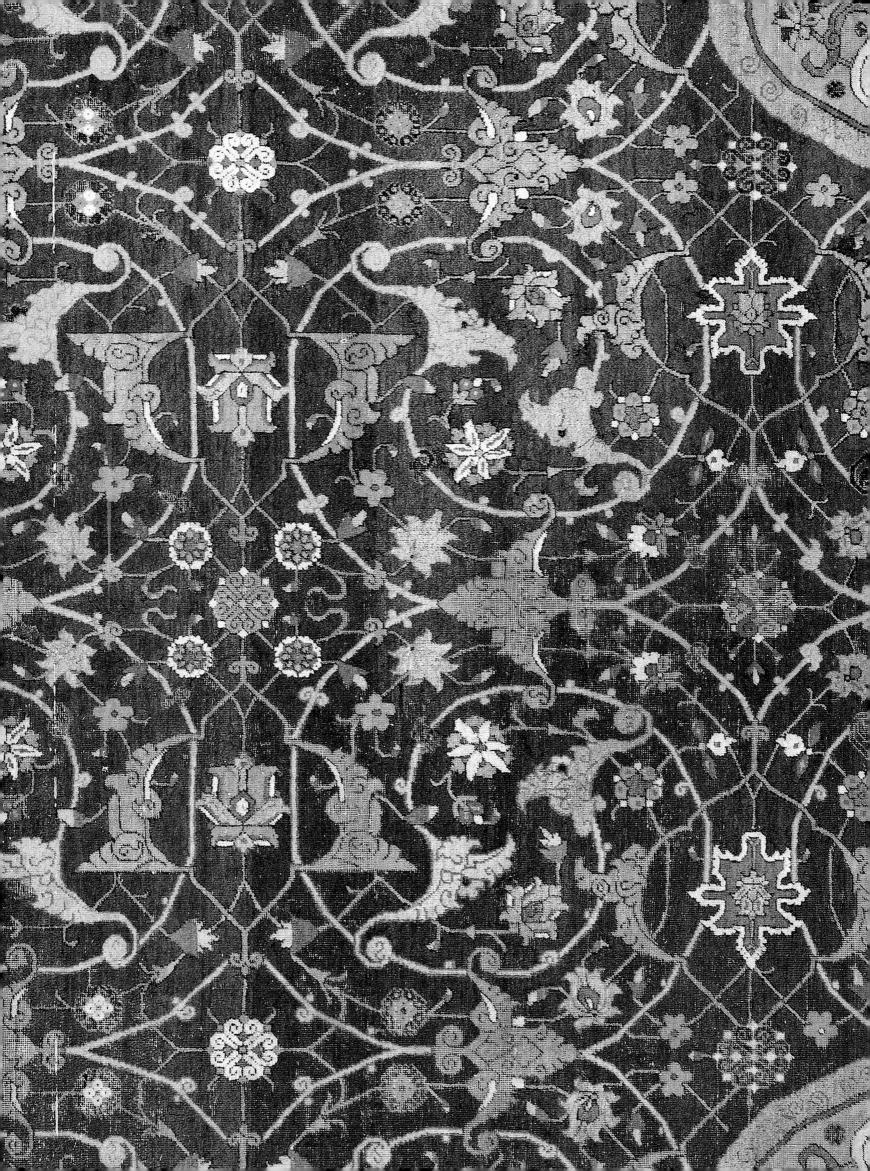

THE ART OF THE CARPET
A TRIUMPH OF COLOUR AND SYMMETRY

Michael Franses

Introduction

Eastern attitudes to "old" carpets have probably not changed over the past three millennia: old carpets, like old bedding, were replaced with each new generation. New carpets were commissioned to celebrate events such as births, weddings, and funerals. Carpets were once essential for the journey to the afterlife, and it is only from the Islamic period onward that bodies were simply wrapped. Old carpets retained no value because new ones could always be made, and their rare survival was rather by default than by design. The concept of collecting old things for their historical or artistic merit did not apply to soft furnishings. The making of new carpets was important economically and culturally: from an early age, women were taught skills and an understanding of the tribal patterns, symbols, and ornaments. Patterns, the hidden language of the tribe, were woven into useful materials and repeated so that their meanings were passed on, although with repetition and time both the images and their significance evolved. Only new carpets are to be seen in Eastern homes today.

In the West, Eastern carpets have been cherished and admired for at least 800 years; their ownership has been a symbol of wealth and status, as evidenced by their appearance in European paintings from as early as the thirteenth century. Shipping documents and inventories of noble families from the fifteenth century onward give testament to the great value placed on Eastern carpets. Initially, the carpets collected were new or nearly new, and it was only over the past two centuries that "antique" carpets were collected and valued for their extraordinary beauty. Between 1851 and 1900, public awareness of antique carpets blossomed, in particular among artists and art connoisseurs: world fairs and international exhibitions stimulated numerous collectors; museums in London, Vienna, New York, Lyon, Paris, and Istanbul started to form their collections; publications by eminent scholars such as Julius Lessing, Alois Riegl, and Wilhelm von Bode gained acclaim.

Detail of **Barbieri Spiral Carpet** (Cat. No. 38) Tabriz, Iran, 1468–1514; wool pile on cotton foundation; 135 × 326 cm and 138 × 315 cm, two sections

A few of the Eastern carpets that members of the Western nobility originally acquired as new and kept in their homes for hundreds of years were then bought by wealthy Americans as historical decoration for their mansions. After the economic devastation of the 1920s and 1930s and the two world wars, many of these passed into museum collections. From the 1960s onward, with the encouragement of numerous galleries, new collectors emerged, in particular in Italy.

David Sylvester's essay "On Western Attitudes to Eastern Carpets," in the catalogue of the 1972 exhibition of 149 carpets belonging to the American collector Joseph McMullan, best presents a general history of collecting classical carpets. The 1976 exhibition *Arts of Islam* included forty historical carpets, and in 1983 a further eighty-four were presented at *The Eastern Carpet in the Western World*. Those three exhibitions in London had enormous influence on the collecting of historical carpets during the last quarter of the twentieth century.

In 1973 I was introduced to the Bruschettinis by Edmund de Unger and visited their home in Genoa where there was already a magnificent collection. Alessandro Bruschettini had started to acquire Chinese and Islamic works of art in the mid-1960s. Studying the cultures in depth, he has travelled widely over much of the Middle East, India, China, and Japan, visiting museums, monuments, and great collections. Year on year he has carefully enlarged his collection, each potential acquisition deeply studied and considered.

Over the past fifty years, there have only been a few connoisseurs of historical carpets, and Alessandro Bruschettini stands among the most significant of them. His collection embraces the carpet-making world from Spain to China. Several carpet types are very well represented such as those from Cairo, Karabagh, Kerman, and Ushak, perhaps suggesting a conservative approach of continuing on well-trodden roads. However, the collection is an intensely personal assemblage, and what is noticeable above all is his eye for excellence, bringing in both his mind and his heart to his acquisitions.

Carpet Making in Spain

Much has been written on Spanish carpets over the past hundred years, and information has been found in archives concerning various places of production, although no surviving early examples can be securely linked to any specific workshop. In 1154 Muhammed al-Idrisi wrote that it was difficult to surpass the quality of the woollen carpets from Chinchilla de Monte Aragón and Cuenca.[1] Two other Arab authors confirmed that Spanish carpets were being exported to the Middle East.[2] During the fifteenth and sixteenth centuries, the principal places of production were reportedly Letur and Alcaraz in the Albacete region. The surviving carpets were made entirely using knots tied on single warps with each row offset, often known as the "Spanish knot."[3]

Carpets were probably made in Spain during the Roman period (218 BCE–409 CE). It is likely a second phase was introduced into the Córdoba Caliphate under the Umayyads (711–929 CE), possibly from the eastern Mediterranean. Single-warp knot rugs dated to 750–1171 CE have been discovered in Fustat and Akhmim in Egypt, and some of these might have been made in Spain.[4] R.B. Serjeant cites tenth-century Arabic documents mentioning carpet making in Spain.[5] Other fragments with single-warp knots found in Egypt are attributed to twelfth- to fourteenth-century Spain.[6] The largest single-warp knot carpet was made between 1184–1203 at the Quedlinburg Convent in Lower Saxony, probably copying the weave of a Spanish original.[7] Spanish carpets were certainly exported to France and England in the fourteenth century.[8] The earliest near-complete Spanish carpet is the fourteenth-century Bode "Synagogue rug" in Berlin.[9]

Examples from the fifteenth century either have a distinctly Spanish style, mirroring ceiling patterns, or are adaptations of silk designs and Turkish carpets with compartments or octagons. Two Spanish carpets feature in a fresco in Avignon dated to 1346.[10] Certain designs of fifteenth-century Spanish carpets have led authors to suggest that some could have been made by the Jewish and/or Christian populations,[11] in particular those carpets of the "Admiral" group with coats of arms, but there is no evidence for this. Most probably the Christian nobility were the main clients, the Jews were the procurers of materials and the traders, and the weavers were Muslims.

After the expulsion of non-Christians in 1492, some of the weavers might have converted to Christianity and stayed; others might have taught their craft to Christians. So accustomed had the Spaniards become to Moorish artisans and ideas of art that some workers were allowed to remain and pursue their crafts for their conquerors, producing so-called Mudejar art: the pictorial art and symbols of the Christians combined with the motifs and workmanship of the Arabs, as evidenced by these carpets. The knotting techniques and materials are indistinguishable between examples made before the expulsion and those made after; however, prior to around 1500 the dyes were light-fast, whereas sixteenth-century Spanish carpets are subject to fading, suggesting that the earlier dyeing techniques were lost or the dyers had departed. Patterns became more floral, as Ottoman velvets and Safavid carpets were added to the design repertoire. The character of Spanish rugs then became increasingly Western, as Christians began to replace the Mudejar weavers and the patronage became entirely Christian.

Many of the surviving early Spanish carpets came from convents, several of them having been donated by noble ladies. Our ability to study Spanish carpets today is largely due to the fact that, after these convent collections came onto the market and when a revival of interest in fifteenth-century Spanish carpets followed the famous *Masterpieces of Muhammadan Art*

exhibition in Munich in 1910, a number of astute dealers and collectors acquired them and they subsequently came to be preserved in museums worldwide. Fewer than 350 Spanish carpets made between 1430 and 1720 are known to survive, just a tiny, random selection of what must have been created.[12] Few are complete, due to their fragile weaving technique.

Carpet Making in the Eastern Mediterranean Region

The eastern Mediterranean carpet-making region stretches from east Anatolia, Syria, Jordan, and Palestine to Egypt and has a long history. Some of the oldest surviving loosely piled covers, combined with tapestry weave and made of linen, come from the Nile Valley in the early years of the New Kingdom, around 3,500 years ago.[13] No fully knotted pile weavings have survived in Egypt or indeed the whole eastern Mediterranean region that date from before the Roman and Byzantine periods (30 BCE–641 CE). Large numbers of looped-pile weavings and some knotted-pile weavings from these times do survive. One remarkable example with a mosaic design was reportedly discovered in Antinoë in Upper Egypt.[14] Two looped-pile rugs in the British Museum were excavated at the cemeteries of Qasr Ibrim, Nubia.[15] Made around 1,500 years ago, they retain much of the Ptolemaic (305–30 BCE) and Hellenistic style from some five to eight centuries earlier and also stylistically link to some slightly earlier carpets found in northern Afghanistan.[16] Their similarities to mosaic designs are made particularly clear on a carpet in Chicago.[17]

A large number of looped-pile covers that continue the Roman and Byzantine patterns are attributed to Coptic Egypt. These can be related to both wall paintings and mosaic floors. Many links can be found between the first carpet patterns and mosaic floors, which were covered with warm weavings of similar designs in the winter months. The floors not only reflected the ceilings above them but were also seen as illustrations of the heavens and a view of paradise.

Numerous tiny carpet fragments, some probably made in Egypt, have been found among the ancient rubbish dumps of Fustat, Old Cairo.[18] One of the most significant of these is knotted on single warps, similar to Spanish carpets, and attributed to between the sixth and eighth centuries CE.[19] Some contemporaneous examples from Fustat are reportedly knotted on single warps,[20] while others are apparently made in looped pile, although several of these possibly require careful re-examination.[21] The only "complete" rug discovered in Fustat is in the de Young Museum in San Francisco,[22] but this is symmetrically knotted on a wool foundation, quite unlike any other weavings found in Egypt, and far more similar to later, Anatolian weavings.

It is highly likely that carpets continued to be made during early Islamic times under the Umayyads, who from 661–750 controlled Iran, Arabia, the Caucasus, Syria, Palestine, Egypt,

the whole of north Africa, and much of Spain. Their legacy was inherited by the Abbasids (750–1258) and Fatimids (909–1171). Carpets were most likely made domestically for home use by the various tribes who settled in the region, in particular the waves that arrived in southeast Anatolia and northern Syria from Central Asia from the tenth century onward, as well as the Turkic Tulunid tribes (868–905) that settled in Egypt (although only tapestry weaves are currently attributed to the Tulunids).

Moving on to the fifteenth to seventeenth centuries, attributing Middle Eastern carpets made hundreds of years ago to places we know today, within political borders that were only established after 1919, is understandably difficult. During the eleventh to seventeenth centuries, the major ruling powers that controlled these regions — the Seljuqs, Timurids, Turkmen, Safavids, Mamluks, and Ottomans — often did so by proxy through local chiefs, the leaders of tribes who moved from region to region in search of new pastures or plunder. There were no fixed boundary lines, only ever-changing spheres of influence over areas that were often only under partial control. Carpets would have continued to be woven as a tradition by most of the tribes. However, none of these "tribal" rugs made for domestic use have survived in the eastern Mediterranean region apart from some in central and eastern Anatolia.

Detail of
Count Moy Medallion Carpet
(Cat. No. 31)

We are therefore considering here the carpets made in Egypt and Syria between 1450–1650, under both the Mamluks (Cat. Nos. 30 and 31) and the Ottomans (Cat. Nos. 32 and 33), probably by settled urban weavers. They were largely acquired by traders, mostly Italian, for shipment on to Venice and Genoa. Carpets from Syria were for the most part exported through Bursa and Constantinople, while those made in Cairo went through Alexandria.

Ernst Kühnel suggested that Egyptian carpets of the Mamluk period (1250–1517) might have their design origins in the purple Coptic tapestries.[23] De Unger reminds us of Kurt Erdmann's concern, "whether it is possible that the almost 1,000 years which separate the Coptic period from that of the Mamluk carpets is not too great a gap."[24] However, the Fustat fragments indicate that carpets were clearly being made in Egypt between the eighth and fifteenth centuries, although no complete examples have survived — perhaps simply because there was no tradition of keeping old carpets — and we therefore have no examples of their designs.

Three carpets survive that were made in the early fifteenth century in central-eastern Anatolia,[25] and their patterns are antecedents of several Mamluk carpets made in Cairo in the

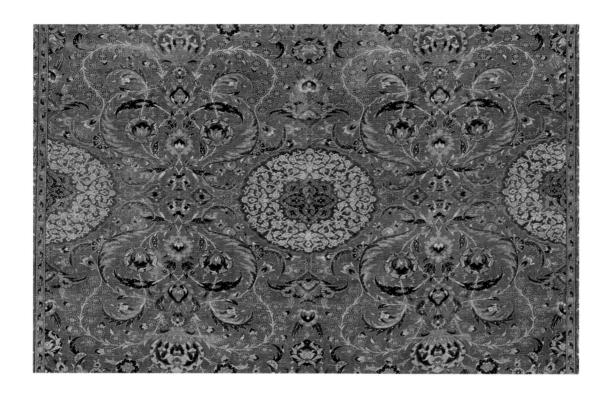

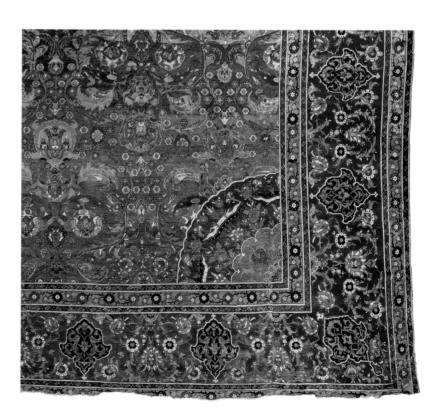

Details of
Ottoman Floral Carpet (Cat. No. 32)
French & Co. Medallion Carpet (Cat. No. 33)

second half of the fifteenth century.[26] Until 1516–17, large parts of Anatolia were not under Ottoman rule, but either formed part of the Mamluk Sultanate or were ruled by local chiefs, some of whom were allied with, or tributary to, the Mamluk sultans,[27] whereas the lands from Syria to Egypt were directly ruled by the Mamluks. A number of other carpets that

follow on from the two Anatolian examples are attributed to Damascus and are known as the "para-Mamluks."

The oldest surviving Mamluk carpets made in Egypt date from the second half of the fifteenth century.[28] The same workshops in Cairo continued to make carpets through the seventeenth century. After the Ottoman conquest of Syria and Egypt, carpets were still made there in the Mamluk style, but tiny Ottoman-style patterns began to infiltrate the designs. By the middle of the sixteenth century, Cairo carpets were being made entirely in the Ottoman style, notable for a profusion of naturalistic flora, but using the same materials and techniques, and probably the same looms, as the earlier Mamluk-style rugs.

Approximately 550 eastern Mediterranean carpets survive from ca. 1400–1625, providing a small — and random — glimpse into carpet making in this region. These can be divided into four principal types: Anatolian para-Mamluks, ca. 1400–50 (three); Syrian para-Mamluks, ca. 1450–1525 (twelve); Syrian "Damascus" carpets with "compartment" or "chequerboard" designs (eighty) and other patterns (twelve), ca. 1525–1625; Mamluk-style rugs from Cairo, ca. 1450–1550 (174); Ottoman-style rugs made in Cairo, ca. 1550–1625 (268).[29] Almost none of these have survived in their place of manufacture and many have been in Western collections for at least a century, and more likely since the time they were made. This strongly suggests that the types that have survived in the West might have been specifically made for export.

Ushak Carpets from Anatolia

Carpets were probably being made in Anatolia in eastern Turkey more than 5,000 years ago, although nothing from these times has survived. The oldest Anatolian rug currently known, from the seventh century CE, was found in Cairo.[30] It is incorrect to assume, as has been repeated so often, that carpet weaving was introduced to Anatolia by the Turks in the eleventh century. Turks had been making carpets since at least the sixth century and brought their design heritage from Central Asia to Anatolia, as can be seen in the early "Konya" carpets of the thirteenth to fifteenth centuries.[31] It is also apparent that Anatolian carpet designs developed from a fusion of Turkic ornaments with local ancient patterns, as witnessed by the early animal rugs.[32]

It would be impossible to summarize the past seven centuries of Turkish carpet making in the space available here, considering the variety of village and nomadic production across virtually the entire 755,000 square kilometres of Anatolia. I will concentrate instead on examples from the Ushak region of west Anatolia. The Bruschettini Collection includes Anatolian carpets from the fourteenth to seventeenth centuries and is particularly strong in examples from Ushak, so choosing only two for this exhibition proved challenging.

Evidence from documents and paintings shows that Anatolian carpets were being exported to the West by the thirteenth century if not before, in particular to Italy. The number of surviving examples suggests that carpets, especially from Ushak, must have been produced in significant numbers from the last quarter of the fifteenth century onward in order to satisfy demand. Authors have therefore suggested — without any established documentary evidence — that Ushak carpets were made in organized workshops and designed or at least inspired by professional "court" artists. A study of the surviving examples, however, suggests a greater likelihood that merchants keen to trade with Europe might have organized weavers working on looms in their homes in and around Ushak to fulfill their orders. It is likely that materials were supplied centrally. The patterns were probably designed locally, adapted from different sources, and the most popular ones were continuously repeated.

It has also been suggested that Ushak carpets were made for the Ottoman court,[33] although this does not take into account that the taste and style of the court for a long time favoured Persian carpets, and that the number of Ushak carpets surviving in Turkey is surprisingly low compared with the numbers that have been found in Western Europe.

Unfortunately, no records have yet been found of the circumstances under which any carpet attributed to Ushak was made. The workshop theory stems in part from the survival of so many Ushak carpets, but this might, in fact, just be because they were well marketed. Observing the close similarities that exist between certain "village" rugs, one soon realizes that these are all representatives of a traditional art. We can therefore probably assume that large numbers of similar works were made in even the smallest communities. There is no reason to suppose that the survival of a particular early rug, or the fact that greater numbers of rugs survive from one location rather than another, is due to anything more than chance.

Virtually all the Ushak carpets have endlessly repeating designs,[34] containing between one to three different forms of medallion, which generally alternate diagonally and repeat vertically. Two of the best-known designs are the "medallion" and the "star." The medallion Ushaks (Cat. No. 34) proved so popular that the pattern continued to be used, little changed, for more than 300 years. On the central axis are onion-shaped medallions surrounded by lotus-leaf tracery in the field, and part-viewed on the side axis is a circular, sixteen-lobed secondary medallion. The background is mostly a soft madder-dyed tomato-red, with the floral work in blue or green and the central medallion having a light or dark blue

Detail of
Castellani-Stroganoff
Medallion Carpet (Cat. No. 34)

ground. In the earlier examples, however, the backgrounds are mostly blue, with the floral work in ivory or yellow and central medallions red. The secondary sixteen-lobed medallion was probably adapted from the central medallion of carpets made by Turkmen and taken in 1514 from Tabriz.[35] The popular Ushak carpet patterns were copied in villages throughout Anatolia, fusing them with existing, older patterns.

The star Ushaks have as their principal ornament an eight-lobed star medallion. This type was exported to Europe by 1545, as demonstrated by a rather crude example depicted by Paris Bordone (1500–71) at the feet of a doge.[36] Several variations of the star medallions exist,[37] and the star Ushaks' traditional backgrounds of stems and leaves differ from the lotus leaf seen on most of the medallion Ushaks.[38] The so-called "star variants" are among the oldest surviving Ushak carpets.[39]

Perhaps the best-known Ushak design is the so-called "Lotto" or arabesque (Cat. No. 35). It is not known whether this pattern was first created in Ushak or elsewhere in Anatolia, but it was certainly used in many centres. It is already so developed on the surviving examples

Detail of
"Lotto" Arabesque Carpet
(Cat. No. 35)

that it might have been first produced by the mid-fifteenth century. More arabesque carpets survive from Ushak than from elsewhere, and more classical-period Anatolian carpets survive with arabesque designs than any other.

The Ushak looms used other patterns for both large carpets and more finely woven rugs, including multi-niche designs for prayer carpets or *safs*, which were specifically woven for mosques; lattices; large cloudbands; and border designs repeated in the field. Selendi, forty kilometres to the west of Ushak, was famous for "bird," *çintemani*, and "scorpion" designs on ivory backgrounds. The smaller rugs proved so popular in Europe as table carpets that small Ushak and Selendi rugs, as well as those made farther west in Manisa, can be seen depicted in hundreds of Western paintings from the early sixteenth through to the nineteenth centuries.

Early Caucasian Carpets

Later Caucasian rugs of the nineteenth century have an immediate appeal because they often juxtapose large areas of bright primary colours within a bold, basic geometry. The ornaments depict abstracted creatures adapted from archaic tribal symbols, part of a lost language of ancient folklore. Caucasian rugs have been admired by artists and can be seen depicted in numerous nineteenth-century paintings from the time of Eugène Delacroix (1798–1863) and

in particular the Orientalist painters. Photographs of artists' studios from this period attest to the fact that these were among the most popular studio props and decoration.

It seems remarkable that no early Caucasian carpets, those made before 1800, have so far been identified in paintings, while carpets from virtually all other weaving regions were often illustrated. This is because very few sixteenth- to eighteenth-century Caucasian rugs reached Europe. It was not until 1891 that the first two early Caucasian carpets were exhibited and published: a dragon carpet with Theodor Graf that had reportedly been acquired from a mosque in Damascus and later passed to Wilhelm von Bode; and another dragon carpet that came from Burano in Venice.[40]

In 1956 Serare Yetkin studied 103 early Caucasian carpets in Turkey, approximately a quarter of all those known made between the late fifteenth and late eighteenth centuries.[41] Possibly 500 examples survive worldwide, including about 150 with dragon designs (Cat. No. 36),[42] of which twenty are in Turkey, and over 100 with large blossoms (Cat. No. 37). Many now in Western museums and private collections were reportedly acquired post-1900 in Istanbul. Yetkin did not address the question of how and when the Caucasian carpets arrived in mosques all over Turkey, but Persia was again at war with the Ottomans from 1730 to 1735, and when the latter retreated from Karabagh they might well have carried carpets back to Turkey as war booty and later distributed them to the mosques. Many of the examples that have survived in Turkey have been cut vertically, presumably because their large size made them unsuitable for Turkish homes, and found a new function hanging in front of mosque doors and windows.

Only a few of the survivors might have been made in the late fifteenth and sixteenth centuries; most are attributed to the end of the seventeenth and the eighteenth centuries. Yet a continuity of pattern can be seen right through to nineteenth- and twentieth-century Caucasian rugs, and a close study of the earliest examples provides some insight into the art history of carpet making in the region.[43] It is perhaps strange that no pre-1750 carpets seem to have survived in the Caucasus and specifically in the Karabagh region where many were made, and that very few post-1750 examples survived in Turkish mosques. This might give some credence to the idea that all the older carpets might have been removed from the Caucasus in 1735.

The attribution of early Caucasian carpets to this area is based upon similar patterns occurring on nineteenth-century carpets made in the Karabagh, Shirvan, Kazak, and other regions, and on specific similarities in weave between the pre-1800 examples attributed to Karabagh and some nineteenth-century Karabagh carpets. Stylistically and structurally, they have no connection to carpets made in Anatolia where so many of them were found. The designs are a combination of indigenous patterns with a great deal of influence from Iran.

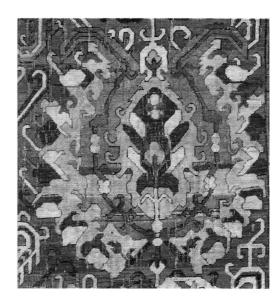

Details of
Simonetti-Bardini Dragon Carpet
(Cat. No. 36)
Schürmann Blossom Carpet
(Cat. No. 37)

Probably the first collector and admirer of Caucasian dragon carpets in the West was Wilhelm von Bode, who owned at least three and encouraged other Berliners such as Eduard Simon and Alfred Cassirer to acquire them. At this same time, and perhaps prompted by the newly arrived Armenian diaspora who controlled much of the carpet trade in America and were well connected to colleagues in Constantinople, there were a number of collectors in America. Among these were Charles Deering (1852–1927), Philip M. Sharples (1857–1954), John D. McIlhenny (1865–1925), and George Hewitt Myers (1875–1957). Myers assembled the most significant collection. Another passionate collector was the author Erich Maria Remarque (1898–1970). In Italy the late Marino Dall'Oglio (1924–2013) acquired a number of examples, as did Alessandro Bruschettini. The Simonetti dragon (Cat. No. 36) and Schürmann blossom carpets (Cat. No. 37) in this exhibition are two outstanding examples of Caucasian weaving.

Carpet Making in Iran

Sheep were reportedly domesticated for wool production 8,000 years ago in Mesopotamia,[44] and what are probably wool pile covers can be seen on Ur and Bactrian figures from 4,000 to 4,500 years ago. Until recently the oldest surviving knotted-pile carpet was believed to be the Pazyryk carpet, made probably about 2,400 years ago.[45] Its field can be directly associated with tile-like patterns in Assyria, and the procession of lions and horsemen around the border can be linked to wall decoration in ancient Near Eastern palaces, in particular in Iran. But many features are distinctly Scythian in character such as the motifs on the horse blankets, the human figures, and the deer. There have been suggestions that the Pazyryk carpet could be Armenian,[46] and it is also often erroneously claimed by the Iranians. New discoveries have brought to light several other complete knotted-pile rugs that predate the Pazyryk. The pattern of one, scientifically dated to between 2,400 and 2,800 years ago, is in the style of Achaemenid Iran (550–330 BCE).[47]

Many millions of carpets must have been made in Iran over the following 2,000 years. Examples are depicted beneath rulers on silver from the Sasanian period (224–651 CE) and on wall carvings. Historical accounts record the famous Spring of Khosrow Carpet made in silk, gold, silver, and jewels for the Ctesiphon palace, cut into pieces as trophies for Arab soldiers in 637 CE. Friedrich Spuhler has suggested that a large group of carpets from the first to seventh centuries CE discovered in Afghanistan were products of the Sasanian Empire.[48] But, although northern Afghanistan was within that empire, this carpet art more truly represents a continuum of a local weaving tradition that in part stemmed from both Bactrian and Scythian art as well as embracing other immediate cultures, and that both preceded and succeeded Sasanian rule. Thus no Iranian carpets with discernible patterns survive from the sixth century BCE until the late fifteenth century CE, although this does exclude two carpets from the Seljuq period with designs that have little to do with Seljuq art and more likely represent the art of the Kurds, who have probably lived in the same region of present-day western Iran, northeastern Iraq, eastern Anatolia, and eastern Syria for 7,500 years.[49]

Mongol Ilkhanid control over Iran started to wane in the mid-fourteenth century. The land was divided between numerous princes and tribal chiefs, creating a tale of brothers poisoning brothers and a constant quest for personal gain, of ferocious battles and monstrous deeds, in which Islam was the only cohesive force. It is hard to imagine that such beautiful art was created under these circumstances: magnificent buildings, outstanding manuscripts, ceramics, wood carving, glass, and poetry, to mention but a few.[50]

Our interest here centres on the art of the carpet. Numerous outstanding carpets are depicted in Iranian paintings from 1350 to 1450,[51] but no intact example has been attributed to the Timurid period, only small fragments.[52] In 1468 the Sunni Aqqoyunlu Turkman defeated the Qaraqoyunlu in Tabriz and from there controlled Iraq, western Iran, Azerbaijan, the Caucasus, and Armenia. In 1501 Shah Ismail (1487–1524) became the first Safavid ruler of Iran, establishing a dynasty that came to dominate much of eastern Turkey and all of present-day Iraq and Iran. Ismail made Tabriz his capital, and in 1507 he defeated the Sunni Uzbeks in Herat and Merv in northeastern Iran. The shah was determined to make Shia the official religion and forced the people to convert from Sunni Islam. This infuriated the Sunni Ottomans, who immediately went to war against Iran. Ismail was defeated at Çaldıran in 1514, after which Tabriz was occupied by the Ottomans, and again in 1534, 1547, and 1585–1603. Much of western Iran and present-day Iraq was lost to the Ottomans. The oldest complete Iranian carpets known today probably date from the second half of the fifteenth century and are attributed to Tabriz (Cat. No. 38).

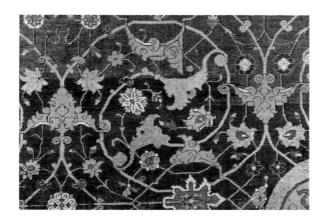

Detail of
Barbieri Spiral Carpet
(Cat. No. 38)

During the rule of Shah Tahmasp (r. 1524–76), reports by foreign visitors indicate that carpets were made in many other centres, including Hamadan, Dargazan, Mosul, Baghdad, Qazvin, Kashan, Isfahan, Joshagan, Qum, Kerman, Yazd, Herat, and Mashhad, but only a few actual carpets can be attributed to some of these cities (Cat. Nos. 39 and 40), and even these with little certainty. While particular types of Iranian carpets are depicted in European paintings from the late sixteenth century onward, this only indicates that they were being exported from this time. In fact, European inventories record Iranian carpets from the fifteenth century onward but with descriptions too vague to identify them as specific types. Shah Tahmasp sent hundreds of carpets as tribute to the Ottomans in the mid-sixteenth century, and many more must have been plundered from Tabriz, so it is hardly surprising that numerous Ottoman paintings depict Safavid carpets in use in the Istanbul court. Remarkably few Safavid carpets survived in Iran because there was no tradition for keeping old carpets, and so it is really thanks to their export and plunder that we have some to enjoy today.

The Safavids ruled Iran until 1736. Some fabulous carpets were made during the sixteenth and seventeenth centuries, and around 1,500 examples survive from this period, some complete, a few in pristine condition, and others quite worn, along with many fragments. The only methods for more accurately dating Safavid carpets are by comparison with the very small number that have inscribed dates,[53] or with the very few that can be documented back to the sixteenth century. Unfortunately, none of the latter include records of their places of manufacture.

Details of
Persian "Vase" Carpet
(Cat. No. 39)
Benguiat–Vasco Parreira
"Portuguese" Carpet
(Cat. No. 40)

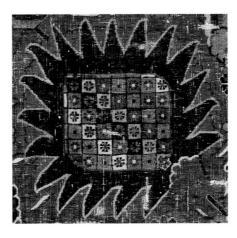 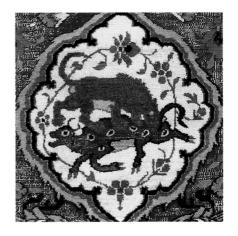

Groups can be formed of carpets with similar compositions but different techniques, suggesting that the same designs were used and adapted by various workshops in diverse regions. More usefully, alternative groupings can be made of examples that share similar materials and construction, indicating they were made in the same region, city, workshop, or even on the same loom. It is then possible to suggest the origins of some surviving classical-period carpets by linking these technique-based groups with carpets from the eighteenth century that have known origins (in the case of Herat and Kerman), or with the few examples for which there is reasonably strong documentary evidence of origin. For instance, the majority of the silk-pile "Polonaise" rugs can be attributed with fair certainty to Isfahan. Determining the origins of the remaining Safavid Iranian carpets is extremely difficult, but by forming clusters of related examples (based, for example, on identical minor borders or specific colour combinations), and then identifying sequences from one cluster to another, and using the few fixed points as references, it is possible to propose likely attributions for the majority.

Carpet Making in Mughal India

Carpets have been made on the Indian subcontinent for the past 3,000 years. A group of nine rugs from the fifth and sixth centuries CE, discovered in 2008 in Khotan in western China, include Hindu iconography and ancient Khotanese inscriptions in Brahmi script.[54] The next known Indian carpet, knotted in silk and probably made for an Islamic court in the Deccan, dates from 600 years ago.[55] A few carpets remain that were probably made in northern India during the last quarter of the sixteenth century, and many Mughal carpets survive from the seventeenth century. The survival of the latter owes much to the Dutch and British East India Companies, which brought back hundreds of carpets that were acquired by European nobility. The other great source of Mughal carpets was the storerooms of the maharajas of Jaipur, who sold off many of their carpets between 1890 and 1970.

Early Indian carpets can be grouped by materials and technique, although the workshops or cities to which each group belongs have not yet been identified. The first Mughal carpets used a "Persian" style most evident in the so-called "Lahore" group.[56] This style continued to be used throughout the seventeenth century, with Mughal carpets being specially commissioned by Europeans.[57] These carpets were so highly regarded that contemporaneous copies were woven in England.[58]

During the first quarter of the seventeenth century, a local style began, developing first from the finest carpets from the early years of Shah Abbas of Iran, as can be seen in probably the oldest Mughal carpet with pashmina pile on silk.[59] Later this style is marked by highly realistic representations of plants and animals influenced by the interest of Emperor Jahangir (r. 1605–27)

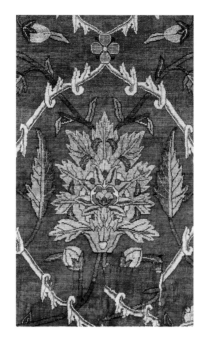
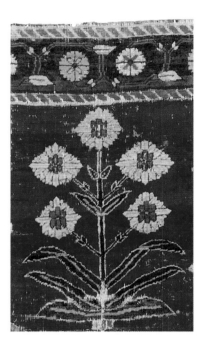

Details of
Mughal Lattice Carpet
(Cat. No. 42)
Jaipur Palace Shaped Shrub Carpet
(Cat. No. 41)

in the natural world. Initially, these new elements were combined with the more traditional design conventions.[60] During the reign of Shah Jahan (1628–58), these complex designs gave way to large-scale depictions of single plants influenced by Dutch herbal paintings and other European artistic devices. These patterns can be seen on the marble decoration of buildings as well as on the carpets of the period.[61] During the second half of the seventeenth century, workshops in northern India made very fine carpets with pashmina pile (Cat. No. 42). Many varieties of pile carpets have continued to be made in all the various styles throughout India right up to today.

The largest collection of Mughal carpets was with the maharajas of Jaipur where many remain. The collection reportedly once had the best group of pashmina pile carpets, as well as examples of the Lahore group and one further type that was specific to the Jaipur collection, with wool pile and often with silk in the foundation, depicting a variety of shrubs (Cat. No. 41). The latter have also been attributed to Lahore, although they differ in various aspects from other Lahore carpets.

The only reliable publications so far on Mughal carpets have been Daniel Walker's catalogue for the major New York exhibition in 1997,[62] and some subsequent articles by Steven Cohen. Until a complete catalogue of the different types becomes available, sorted by technical considerations, which will indicate place of manufacture, some confusion on the subject will persist.[63]

Imperial Chinese Carpets of the Ming Dynasty

Pile fragments and a few carpets dating from the first century BCE to the fifth century CE have been discovered in western China,[64] and ancient Buddhist caves in Afghanistan have revealed more examples of the same types. However, it is now believed that most of these carpets were made in northern Afghanistan rather than in China. Numerous references do exist to carpet

making in China in this same period,[65] and by around 800 CE, carpets were clearly being made in immense sizes for palaces.[66] Portraits of Chinese emperors seated on thrones with a carpet beneath commence with the Ming dynasty Hongwu emperor (r. 1368–98).[67] Construction of the Palace in Beijing began in 1406 under the Yongle emperor (r. 1402–25), and a painting of him depicts a carpet with a pattern derived from textile designs.[68] During the reign of the Hongzhi emperor (1488–1550), the Directorate for Imperial Regalia requested permission for more than a hundred plain and dragon carpets.[69] Carpets would have been made for the Palace in Beijing soon after it was constructed, but none of these have survived. Twelve carpets can be attributed to the reign of the Jiajing emperor (1521–67).

In 1596–97 the Wanli emperor (r. 1572–1620) had several buildings in the Forbidden City rebuilt and refurbished, and he must have set up carpet workshops in Beijing. The Hall of Supreme Harmony alone contained some thirty huge carpets covering the entire hall floor and throne platforms. The other Great Halls were also filled with deep-piled wool carpets, each made to fit specific positions. The designs reflected the ornaments used within the Palace, often mirroring the architecture of the pavilions they occupied. Those that were made for the Hall of Supreme Harmony, for instance, copy the immense carved "stone carpets" that form the Imperial Way through the Forbidden City.[70] Probably around 120 carpets were originally commissioned for the principal buildings of the Forbidden City. Around seventy-four of these are known today, forty-eight in the Palace Museum, and twenty-six in Western collections (Cat. No. 43). Many of the carpets in Beijing are incomplete or fragmented; only eleven in the West are complete.[71]

Detail of
Wanli Emperor Throne Dais Cover (Cat. No. 43)

The Ming carpets became known through photographs, the earliest of which were taken by Ogawa Kazumasa in 1906,[72] and show most of the Wanli carpets in situ in the Great Halls where they remained until the late 1920s. At this time some forty-six of them were rolled up and taken into storage where they were sealed in until their rediscovery in 2000.[73]

The Imperial Palace Ming carpets form a reasonably homogeneous group, linked by a number of distinctive design features as well as by their weave and colour. Virtually all the surviving Wanli carpets are woven on silk warps, the exceptions being the much more finely woven cotton-foundation carpets made for the Hall of Supreme Harmony throne platforms. Brightly coloured, naturalistic pictorial designs are placed against what was originally a deep

red background that has since changed to a golden beige due to oxidization of the dye (the original colour can still be glimpsed on parts of the carpets that were permanently covered by pieces of furniture). A number of them feature one or more dragons. One with confronting phoenixes was probably intended for a throne platform of the empress. Those with lotus patterns were made for the hall floors. The Wanli Palace carpets are now recognized as masterpieces of Ming decorative style.

NOTES

1 Al-Idrisi, *Descripción de España* (Madrid: Imprenta y Litografia de Depósito de la Guerra, 1901), 197, 237–40; al-Himyari, *La péninsule Ibérique au Moyen Âge d'après le Kitab ar-rawd al-mi'tar* (Leiden, Neth.: Brill, 1938), 184.

2 Sarah B. Sherrill, *Carpets and Rugs of Europe and America* (New York: Abbeville Press, 1996), 30.

3 Single-warp knots are to be found on some of the oldest knotted-pile carpets, including four Scythian rugs from Mongolia, carbon-dated to the fifth to seventh centuries BCE.

4 For example: (1) Textile Museum, Washington, D.C., 73.726; (2) Victoria and Albert (V&A) Museum, London, T.33-1942.

5 R.B. Serjeant, *Islamic Textiles: Material for a History up to the Mongol Conquest* (Beirut: 1972), 173.

6 For example: (1) Textile Museum, Washington, D.C., 73.133, 73.75, 73.471; (2) Metropolitan Museum of Art (MMA), New York, 27.170.8.

7 Leonie Von Wilckens, "The Quedlinburg Carpet," *Hali* 65 (1992): 96–105.

8 Pope Clement V at Avignon (r. 1305–14) had fifty-four pile carpets, and Pope John XXII reportedly had Spanish carpets with coats of arms. The Duc de Berry had thirteen Spanish carpets.

9 For example: 385 × 95 cm, Museum of Islamic Art, Berlin, I.27.

10 Matteo di Giovanetto of Viterbo, 1344–46, Palace of the Popes, Avignon.

11 Anton Felton, *Jewish Symbols and Secrets: A Fifteenth-Century Spanish Carpet* (London: Vallentine Mitchell, 2012); Volkmar Gantzhorn, *The Christian Oriental Carpet* (Cologne: Taschen, 1991).

12 I have images of 323 Spanish carpets: six pre-1400, eighty-one pre-1500, 176 pre-1600, fifty-seven pre-1700, and three pre-1720.

13 For example: (1/2) Textile Museum, Egypt, TM50/52, TM53; (3/4) Egyptian Museum, Turin, S.8528, S.8529.

14 For example: 117 × 102 cm, wool looped pile on wool, MMA, New York, 31.2.1. Antinoë has been a source for hundreds of textiles from Byzantium, Rome, Iran, and beyond, but this is the only important pile carpet.

15 British Museum, London, EA67073, EA66708.

16 Friedrich Spuhler in Al-Sabah Collection, Kuwait, *Pre-Islamic Carpets and Textiles from Eastern Lands* (London: Thames & Hudson, 2014).

17 Oriental Art Institute, Chicago, 20812A.

18 Carl Johann Lamm, "The Marby Rug and Some Fragments of Carpets Found in Egypt," *Svenska Orientsällskapets, Årsbok 1937* (Stockholm: Thule, 1937), 51–130.

19 MMA, New York, 49.97a/b. Possibly the earliest knotted-pile carpet from Egypt.

20 For example: (1/2) Textile Museum, Washington, D.C., 73.726, 1962.56.3. Dated 818–819 CE; (3) V&A Museum, London, T.33-1942.

21 For example: (1–6) Benaki Museum, Athens, 15692, 16148, 16151, 16165, 16172, 16180; (7) Museum of Islamic Art, Berlin, I.6688.

22 Fustat Lion Rug, Anatolia?, carbon-14 dating 580–920, 91 × 165 cm, wool pile, de Young Museum, San Francisco, 1986.4.

23 Textile Museum, *Spanish Rugs*, 5.

24 Edmund de Unger, "The Origin of the Mamluk Carpet Design," *Hali* 2, no. 4 (1980): 321.

25 Vakiflar Museum, Istanbul, A-217, A-344; Museum of Islamic Art, Cairo.

26 For example: V&A Museum, London, 150-1908; MAK, Vienna, T 8348.

27 Irwin, "Egypt," 77.

28 Kühnel suggested — without specific evidence — that a carpet industry was established in Egypt in the mid-fifteenth century by Persian weavers. See de Unger, "Origin."

29 Although some authors attribute a few of these to Istanbul/Bursa, the difference between the supposed "Turkey" and "Egypt" types is by no means clear, since all share similar materials, dyes, wool, and techniques (see Cat. Nos. 33, 34).

30 See note 22.

31 Michael Franses, "An Early Anatolian Animal Carpet and Related Examples." In Sheila Blair and Jonathan Bloom, eds., *God Is Beautiful and Loves Beauty: The Object in Islamic Art and Culture* (New Haven, CT: Yale University Press, 2013), 249–54.

32 Franses, "An Early Anatolian Animal Carpet and Related Examples," figs. 237–39.

33 Julian Raby, "Court and Export: Part 2. The Ushak Carpets." In *Oriental Carpet & Textile Studies II* (London: OCTS, 1986): 177–88.

34 Many of the Ushak designs are represented in the V&A Museum, London. See Michael Franses and Robert Pinner, "Turkish Carpets in the Victoria & Albert Museum," *Hali* 6, no. 4 (1984): 356–81.

35 Jon Thompson, "Medallion Carpets of Ushak: An Inheritance from the Timurid and Turkoman Dynasties." In Jon Thompson, *The Sarre Mamluk and 12 Other Classical Rugs* (London: Lefevre, 1980), 33–45. Carpets probably continued to be made by the same weavers long after Tabriz was conquered by Shah Ismail in 1501, although by 1514 many carpets were taken as war booty by the Ottomans after their siege of the city.

36 *The Fisherman Presenting St. Mark's Ring to the Doge*, ca. 1544, Accademia, Venice, 320.

37 Franses and Pinner, 366–69.

38 Jon Thompson, *Milestones in the History of Carpets* (Milan: Tabibnia, 2006), 96, figs. 82–83.

39 See Michael Franses, "Some Anatolian Stars." In *Orient Stars: A Carpet Collection* (London: Hali Publications, 1993), 284–291.

40 For example: (1) Graf, 424 × 187 cm, section (originally 678 × 230 cm, largely destroyed in the Second World War in 1945), Museum of Islamic Art, Berlin, I.3 — formerly, reportedly, from a mosque in Damascus; Theodor Graf, Vienna; Dr. Eduard Simon, Berlin; Wilhelm von Bode, Berlin; (2) Burano, 523 × 224 cm, Museum of Islamic Art, Berlin, I.2 — formerly, reportedly, from a church on Burano Island, Venice; Wilhelm von Bode, Berlin. Both carpets were exhibited in Vienna in 1891. The Graf was published in *Orientalische Teppiche* (Vienna: Österreichischen Handels-Museum, 1892), Cat. No. 47, pl. 36.

41 Serare Yetkin, *Early Caucasian Carpets in Turkey* (London: Oguz Press, 1978).

42 Charles Grant Ellis, *Early Caucasian Rugs: The Textile Museum Fiftieth Anniversary 1925–1975* (Washington, DC: Textile Museum, 1976), 13.

43 Kurt Erdmann, "Later Caucasian Dragon Carpets," *Apollo* 22 (1935): 21–25.

44 Stefan Hiendleder et al., "Molecular Analysis of Wild and Domestic Sheep Questions …," *Proceedings of the Royal Society B* 269, no. 1494 (May 7, 2002): 893–904, www.ncbi.nlm.nih.gov/pmc/articles/PMC1690972/pdf/12028771.pdf, accessed July 10, 2017.

45 Hermitage Museum, St. Petersburg, 1687/94.

46 Ulrich Schürmann, *The Pazyryk: Its Uses and Origin* (New York: Symposium of the Armenian Rugs Society, 1982).

47 Reportedly acquired in Shiraz in the 1940s, remained in a Tehran collection until 1977, now in Los Angeles.

48 Friedrich Spuhler, *Pre-Islamic Carpets and Textiles from Eastern Lands* (London: Thames & Hudson, 2014).

49 For example: (1) Animal Carpet with "Faces," carbon-14 dating 1280–1395, 235 × 170 cm, Kirchheim Collection, Hannover; (2) Animal Border, carbon-14 dating 1228–1391, 73 × 122 cm, section, George and Marie Hecksher Collection, San Francisco.

50 Much of this text has been updated from Michael Franses, "A Museum of Masterpieces, Safavid Carpets in the Museum of Islamic Art, Qatar," *Hali* 155 (2008): 72–89.

51 Amy Briggs, "Timurid Carpets, I, Geometric Carpets," *Ars Islamica* 7, no. 1 (1940): 20–54; Amy Briggs, "Timurid Carpets, II, Arabesque and Flower Carpets," *Ars Islamica* 11–12 (1946): 146–58.

52 For example: (1) 35 × 56 cm, section, wool pile on wool, Benaki Museum, Athens, 16147. Probably Timurid, but materials and weave closer to Anatolian carpets; (2) 61 × 37.5 cm, section, silk pile on silk, Cleveland Museum of Art, 1988.243. Attributed to Rayy, northern Iran, thirteenth(?) century; possibly the only thirteenth-century Iranian rug and the oldest in silk.

53 Dated classical Iranian carpets: (1) Medici Hunting Carpet, dated 929 AH/1522–23 CE, 570 × 365 cm, Poldi Pezzoli Museum, Milan; (2) *Hori* and Inscription Rug, dated 1529 CE, 236 × 93 cm, silk pile on a silk foundation, Calouste Gulbenkian Museum, Lisbon, T. 113; (3/4) Ardabil Medallion Carpets, dated 946 AH/1539–40 CE, 1052 × 530 cm and 719 × 400 cm, wool pile on a silk foundation, V&A Museum, London, 272-1893, and Los Angeles County Museum of Art (LACMA), 53.50.2; (5) Kerman "Vase" Carpet, dated 1067 AH/1656 CE, Sarajevo Museum; (6) Kerman Tree Carpet, dated 1082 AH/1671 CE, Mausoleum of Shah Abbas II, Qum.

54 Information from Dr. Zhang He of William Paterson University.

55 Michael Franses, "Ashtapada," *Hali* 167 (2011): 80–89.

56 The best known include: (1) 765 × 293 cm, Museum of Islamic Art, Berlin, I.6/74; (2) 253 × 155 cm, Museum of Fine Arts, Boston, 93.1480; (3) 233 × 158 cm, MAK, Vienna, Or. 292; (4) 403 × 191 cm, National Gallery of Art, Washington, D.C., 1942.9.475.

57 For example: (1) 574 × 254 cm, V&A Museum, London, IM.1-1936, commissioned by William Fremlin, 1620–44; (2) 732 × 229 cm, Worshipful Company of Girdlers, ordered from Lahore in 1630.

58 For example: 518 × 240 cm, National Museum of Scotland, Edinburgh, H.SO 20.

59 For example: (a) 570 × 125 cm, section, Calouste Gulbenkian Museum, Lisbon, T.72; (b) 52 sections, Bruschettini Collection, Genoa.

60 For example: 833 × 289 cm, MMA, New York, 17.190.858, gift of J. Pierpont Morgan.

61 The most important of these include: (1) 157 × 102 cm, private collection, Grimbergen; (2) 125 × 90 cm, Museum of Islamic Art, Doha, CA.79; (3) 227 × 192 cm, incomplete, Frick Collection, New York, 16.10.7.

62 Daniel Walker, *Flowers Underfoot: Indian Carpets of the Mughal Era* (New York: Metropolitan Museum of Art, 1997).

63 Part of this text was adapted from Michael Franses and Daniel Shaffer, "An Early Indian Carpet," *Hali* 28 (1985): 33–39.

64 M. Aurel Stein, *Innermost Asia: Detailed Report of Explorations in Central Asia ...* (Oxford: Clarendon Press, 1928), pl. 44. Both the Xinjiang UAR Museum and the Xinjiang Institute of Archaeology in Urumqi have collections of more recent discoveries.

65 Adele Schlombs, Foreword. In Michael Franses and Hans König, *Glanz der Himmelssöhne, Kaiserliche Teppiche aus China 1400–1750* (London: Textile & Art Publications, 2005), 6–7.

66 "The Red Carpet" by Bai Juyi (772–846 CE), quoted by Schlombs, Foreword. In Franses and König, 6.

67 Franses and König, 19, fig. 11.

68 Franses and König, 20, fig. 13.

69 *Mingshi*, chap. 185, 4901, quoted by Schlombs, Foreword. In Franses and König, 7.

70 Franses and König, 17.

71 Seventy-four Wanli-period carpets: (a) dragons (thirty-five: twenty-four in Beijing, eleven in Western collections); (b) phoenixes (one in Beijing); (c) floral designs (sixteen: eleven in Beijing, five in the West); (d) clouds (four: three in Beijing, one in the West); (e) compartment designs (nine: seven in Beijing, eight fragments from at least two carpets in the West); (f) octagon centre (two: one in Beijing, one in the West); (g) lion-dogs (one in Beijing); (h) border fragments (six in the West).

72 See www.baxleystamps.com/litho/ogawa/ogawa_peking.shtml, accessed July 10, 2017.

73 Michael Franses, "Forgotten Carpets of the Forbidden City," *Hali* 173 (2012): 74–87. The collection of Wanli carpets in Beijing has been returned to storage, and several of the halls now contain recently commissioned reproductions.

29

BERNHEIMER LATTICE CARPET

Letur or Alcaraz, Spain, 1425–50
Wool pile on wool foundation
108 × 105 cm, section

What makes this small, cut, and pieced section of carpet of sufficient interest to be included in this exhibition? Is it a work of art in its own right or simply a historical document? This fragment (half the width and possibly about 10 percent of the original carpet), once in the famous collection of Otto Bernheimer in Munich,[1] is, in fact, a rare remnant of a great tradition of carpet making in Spain that reached an artistic zenith in the fifteenth century. It has an exceptional design, and its colours are remarkable considering it is almost 600 years old. More important, it presents an opportunity to look back to a time when Christians, Muslims, and Jews lived, worked, and flourished side by side in fourteenth- and fifteenth-century Spain.

Ten other carpets with this field of ascending palmettes and interlaced lattice are known,[2] and two others have related ogival lattices. This pattern was most probably derived from woven silk *lampas* or velvets. Silks with these designs came from Italy and were possibly only later made in Spain. This type of palmette could also have had its origins in the Islamic world. Contemporaneous paintings show patterned woven silks and velvets used for costume, wall decoration, and covers, and reveal how the ownership of imported material was a show of wealth and worldliness.

The primary border of a wide interlaced design in yellow on blue is not seen on later examples and is found on only one other Spanish carpet of the fifteenth century.[3] It might well have its origins in Roman mosaics.[4]

The significance of the Bernheimer section becomes more apparent when viewed together with a larger part of the same carpet that belonged to George Hewitt Myers (see page 171). The Myers section suggests that the lattice might not have been the field design originally intended by this carpet's weaver: after knotting some fifty centimetres at the lower end with a border pattern normally associated with the field design of the famous "Admiral" group of carpets, the weaver started on this lattice field instead.

The lower part of the Myers border is formed by a pictorial panel that would have been repeated at the upper end, depicting stylized trees and creatures, possibly copied from

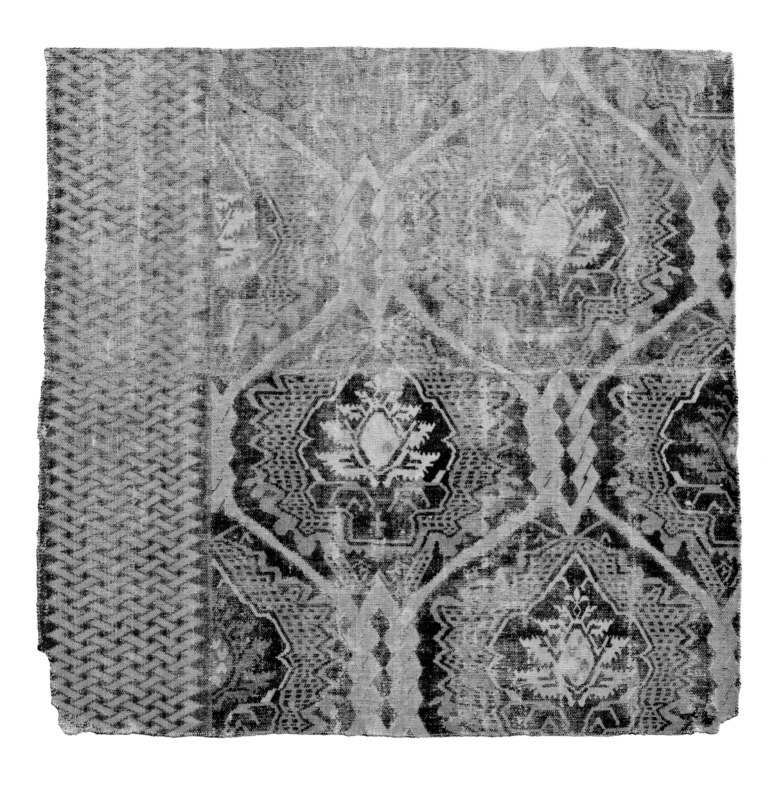

illustrations; these include "wild men," a popular motif in European art from the Middle Ages. Above this panel, the principal border resembles stylized Kufic script[5] in a form unlike the "Middle Eastern–style," Kufic-derived borders of two other fifteenth-century Spanish carpets.[6] The pattern seen here far more closely resembles the lower panel design found on nineteenth-century door rugs, the *ensi* of the Salor-Turkoman tribe, whose ancestors inhabited large areas of Anatolia in the fourteenth and fifteenth centuries.

NOTES

1 These include: (a) Formerly: Bernheimer, Munich, 53401, acquired 1951; Marino Dall'Oglio, Milan; Moshe Tabibnia, Milan. Published: Otto Bernheimer, *Alte Teppiche des 16. bis 18. Jahrhunderts der Firma L. Bernheimer* (Munich: Bernheimer, 1959), pl. 121; Christie's, London, auction catalogue, February 14, 1996, lot 75; *Hali* 86 (1996), 133; Palazzo Reale (Milan), *Sovrani Tappeti, Il Tappeto Orientale dal XV al XIX Secolo* (Milan: Skira, 1999), 192, Cat. No. 165. (b) Formerly: George Hewitt Myers, Washington, D.C., 219 × 184 cm, incomplete; now Textile Museum, Washington, D.C., R44.4.2.

2 These include: (1) Textile Museum, Washington, D.C., R44.2.1; (2) (a) whereabouts unknown; (b) Metropolitan Museum of Art (MMA), New York, 57.150.9; (3) Victoria and Albert Museum (V&A), London, 131-1905; (4) MMA, New York, 61.49; (5) Brooklyn Museum, New York, 43.24.6.

3 Bliss Cloud Pattern Carpet, 373 × 152 cm, Textile Museum, Washington, D.C., 1976.10.3.

4 Such as the border patterns on fourth-century CE Roman mosaics in La Villa Romana de Baños de Valdearados, Burgos.

5 The psuedo-Kufic border is on twenty-six fifteenth-century Spanish carpets: all nine Admiral carpets with coats of arms, four of the five without blazons, six fragments; two carpets with lobed medallions; and five with lattice fields.

6 For example: (1) Carnations Carpet, Museo del Instituto Valencia de Don Juan, Madrid, 3.860; (2) "Small Pattern Holbein" Carpet, Museum of Fine Arts, Boston, 39.614.

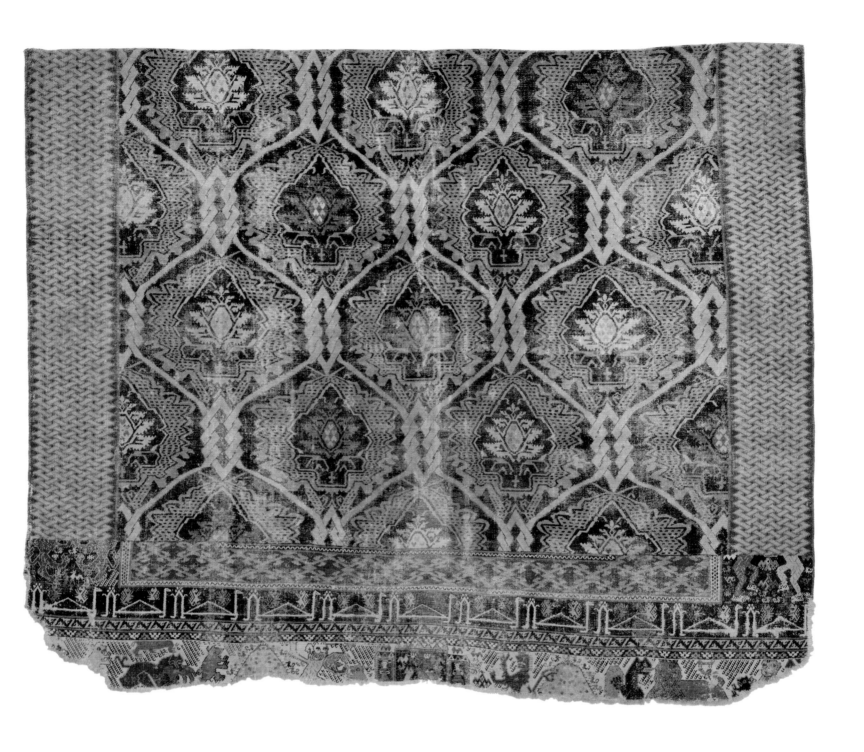

Myers Lattice Carpet

Letur or Alcaraz, Spain, 1425–50

Wool pile on wool foundation

219 × 184 cm, section

Acquired by George Hewitt Myers

Copyright © Textile Museum, Washington, D.C., R44.4.2

30

BERNHEIMER TREES CARPET

Cairo, Egypt, 1450–75
Wool pile on wool foundation
226 × 162 cm

The Bernheimer Trees Carpet is one of three surviving examples with directional designs made in Egypt in the Mamluk style.[1] The others are the Bode keyhole-design prayer rug in Berlin and the synagogue *parochet* in Padua.[2] All three are unique, but each have design motifs that can be recognized in other Mamluk rugs. The Bernheimer can only be related to the latter through small elements within the pattern such as the row of cypress and palm trees in the lower part of the field — the other trees depicted cannot be found on any existing Mamluks. Elements within the primary border can also be recognized, but here again the combined pattern is unique. The most obvious connection to other Mamluk rugs is through wool, weave, and colours.

The Mamluk carpets considered to be the oldest tend to use more colours for the pile, while the later versions usually employ only three: red, green, and blue. Here we find red, blue, two greens, yellow (in three shades), ivory, brown, black, and purple. The wider range of colours can be compared with other "first-period" examples such as the seven-colour Salvadori fragment in the Victoria and Albert Museum, London.[3] The Bernheimer also shares with the Salvadori carpet similar hues and loose wool as well as the generously spaced *s* serif-patterned border stripe separating the field from the primary border. Similar colours and wool can be seen on the three Mamluk carpets with blazons,[4] attributed to the last quarter of the fifteenth century.

The Bernheimer is in a wider format than Islamic prayer rugs, and consequently its function might have been similar to the Padua rug as a *parochet*.[5] The latter, probably made between 1525–50, was specifically designed to hang as a curtain in front of the cupboard containing the Torah scrolls in a Jewish synagogue.[6] It can be related to only one other rug: a Cairo *parochet* in the Ottoman style probably made ca. 1575–1600, once with Charles Yerkes and now in the Textile Museum, Washington, D.C.[7] Their field patterns were probably copied from etchings in Haggadah, prayer books for the Passover Seder service. Both the Padua and the Yerkes have an inscription in Hebrew from Psalm 118:20 reading, "This is the Gate of the Lord through

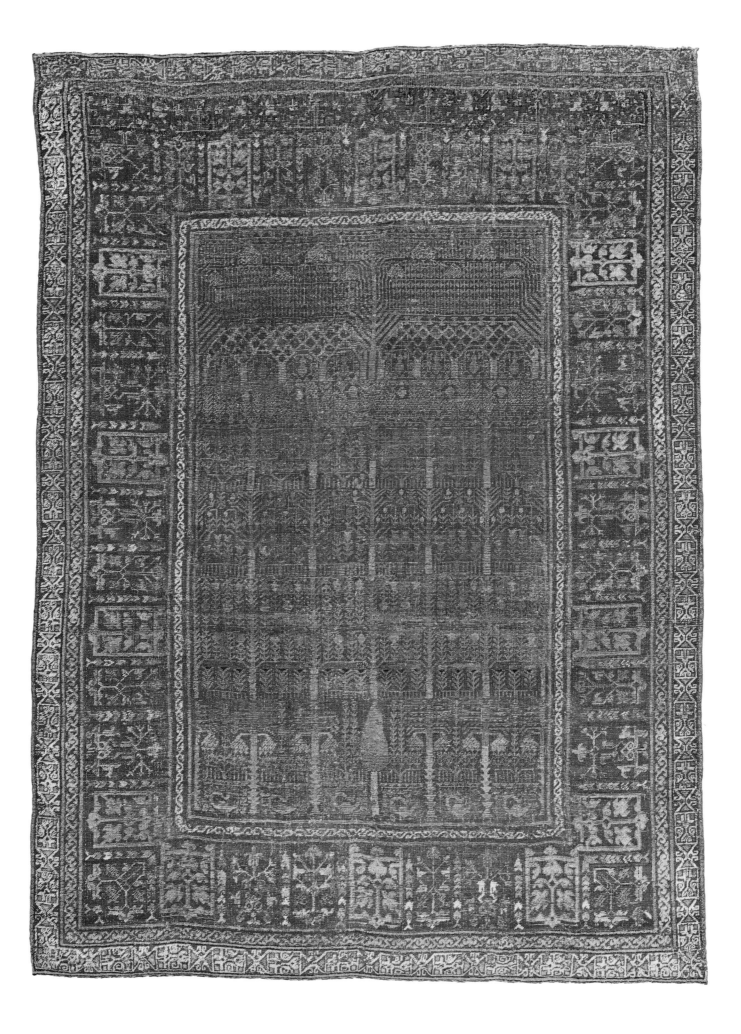

which the Righteous enter," often found on title pages of Hebrew books and on synagogue entrance doors. The depiction of trees on the Bernheimer carpet might be suggesting a "Gate of the Lord," a view into Paradise.

NOTES

1 Formerly: Bernheimer, Munich, 56180 158/225; Elio Cittone, Milan. Published: Otto Bernheimer, *Alte Teppiche des 16. bis 18. Jahrhunderts der Firma L. Bernheimer* (Munich: Bernheimer, 1959), pl. 4; Ulrich Schürmann, *Bilderbuch für Teppich- sammler* (Munich: Kunst und Technik Verlags, 1960), pl. 20; Charles Grant Ellis, "Mysteries of the Misplaced Mamluks," *Textile Museum Journal* 2, no. 2 (1967), 11, fig. 16; Carlo Maria Suriano, "A Mamluk Landscape: Carpet Weaving in Egypt and Syria Under Sultan Qaitbay," *Hali* 134 (2004), 97, figs. 5, 5a.

2 (1) Bode Keyhole Prayer Rug, 162 × 120 cm, Museum of Islamic Art, Berlin, KGM 1888,30; (2) Padua *Parochet*, 138 × 109 cm, Museum of the Jewish Community of Padua.

3 Robert Pinner and Michael Franses, "The East Mediterranean Carpet Collection," *Hali* 4, no. 1 (1981), 38, fig. 1; 42, Cat. No. 1 (analysis by Franses).

4 (1) (a) Textile Museum, Washington, D.C., 1965.49.1; (b) Bardini Estate, Florence, 526–542; (2) MMA, New York, 1970.135; (3) Bruschettini Collection, Genoa.

5 *Parochet*: from the Aramaic *parokta*, meaning "curtain" or "screen." Exodus 40:21: "He brought the ark into the Tabernacle and placed the screening dividing curtain so that it formed a protective covering before the Ark."

6 Alberto Boralevi, "Un tappeto ebraico italo-egiziano," *Critica d'Arte* 49, no. 2 (1984), figs. 1, 2. The carpet has reportedly been in Padua since the seventeenth century and might have been removed from another synagogue.

7 186 × 155 cm, Textile Museum, Washington, D.C., R16.4.4. Formerly: Charles T. Yerkes, New York; Benjamin Benguiat, New York; George Hewitt Myers, Washington, D.C.

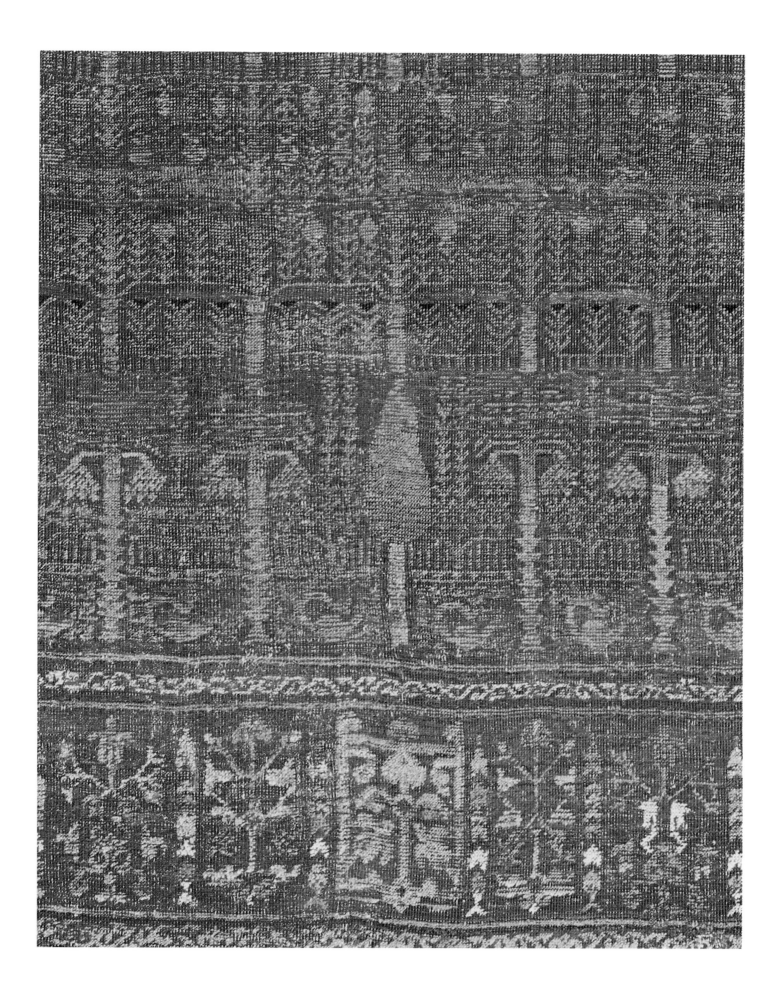

COUNT MOY MEDALLION CARPET

Cairo, Egypt, 1485–1520
Wool pile on wool foundation
205 × 172 cm

Mamluk-style rugs from Cairo, such as this beautiful example formerly with Count Moy in Germany,[1] have fascinated and intrigued art collectors since their first arrival in Europe. A number of the survivors can be traced back to Italy, to where they were imported in considerable numbers from the late fifteenth century onward, with many being re-exported to elsewhere in Europe, to France and England in particular.[2] Their magic has been extolled in the literature, highlighting their shimmering silky wool and the quality of their colours: shades of lac-dyed magenta and deepest claret combining with green like the richest grass and soft indigo blues to make these rugs quite unlike any others from the East. Numerous authors have written on this subject, Kurt Erdmann's essays being the most widely quoted.[3] He divided Mamluk rugs by their composition, based first on the number of medallions, then on elements within the design.[4]

One hundred and forty-five Mamluk carpets are recorded today, ninety-five in museums, twenty-five with private collectors, and the present location of the others unknown. Additional to these are a further twenty-nine examples that are mentioned but for which no images are available. The 145 can be placed into three probable phases of production: first period, ca. 1450–85 (ten); second period, probably before the Ottoman invasion of Cairo in 1517, ca. 1485–1520 (thirty-one); and third period, ca. 1520–50 (104). The oldest examples seem to use the most complex designs and the largest number of colours, whereas on the later examples the colour range is more limited. Most of the third-period rugs look similar to one another, whereas those in the second period, such as the Count Moy, initially appear to have a limited field pattern range but, in fact, are each unique. The more one studies these remarkable carpets, the greater the inventiveness of the individual craftsmen becomes apparent.

The widespread Mamluk-style primary border pattern of a long cartouche alternating with a circular medallion, found on virtually all the examples attributed to the third phase, can also be seen on thirteen of the second-period examples. The Count Moy rug, however, has a border of inward- and outward-facing trefoil-like forms connected to a spiralling stem

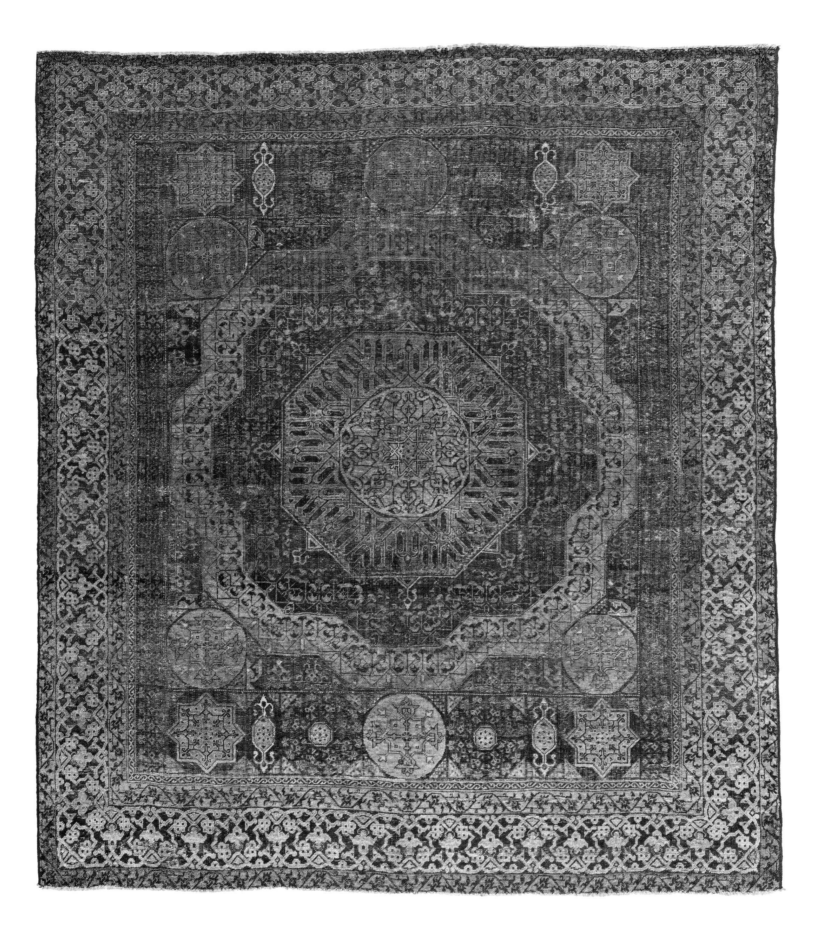

with interlaced knots. It is almost the sole survivor with this border and can only be compared with the famous Bode niche carpet in Berlin.[5] The borders on nearly all of the other seventeen second-period rugs are different from one another, demonstrating the extensive repertoire of pattern in the Mamluk carpet workshops.

NOTES

1 Formerly: Count Moy, Schloss Stepperg, Germany; Ulrich Schürmann, Cologne. Published: Kurt Erdmann, "Neuere Untersuchungen zur Frage der Kairener Teppiche," *Ars Orientalis* 4 (1961), 85, fig. 11; Schürmann advertisement in unknown magazine, 1961; Palazzo Strozzi, Florence, *Mostra Mercato Internazionale dell'Antiquariato: 2a Biennale*, exhibition catalogue, September 16 to October 16, 1961, stand 34; Ulrich Schürmann, *Oriental Carpets* (London: Hamlyn, 1966), 27; Musée d'art et d'histoire, Geneva, *Treasures of Islam* (London: Sotheby's, 1985), 322–23, Cat. No. 334; Marion Bösch, *Mamlukenteppiche. Probleme der Teppichforschung am Beispiel einer Gruppe des 15. bis 16. Jahrhunderts aus dem östlichen Mittelmeerraum* (Karl-Franzens Universität Graz, Institut für Kunstgeschichte, 1991), 366, Cat. No. 56 (cited).

2 Marco Spallanzani, *Carpet Studies 1300–1600* (Genoa: Sagep Editori, 2016), 25, 57–58, 80, 95.

3 Kurt Erdmann: "Some Observations on the So-Called 'Damascus Rugs,'" *Art in America and Elsewhere* 19, no. 1 (1930): 3–22; "Kairener Teppiche I. Europäische und Islamische Quellen des 15. bis 18. Jahrhunderts," *Ars Islamica* 5 (1938): 179–206; "Cairo as a Centre of Carpet Manufacture," *Research and Progress* 5 (1939): 173–79; "Kairener Teppiche II. Mamluken- und Osmanenteppiche," *Ars Islamica* 7 (1940): 55–81.

4 The currently known Mamluk rugs divided by design: five-medallion (one), three-medallion (twenty-four), single-medallion (ninety), undecorated fields (five), directional (three), circular (three), unclassifiable fragments (twelve), Mamluk-Ottoman "transitional" (seven), no image (twenty-nine).

5 162 × 120 cm, Museum of Islamic Art, Berlin, KGM 1888,30.

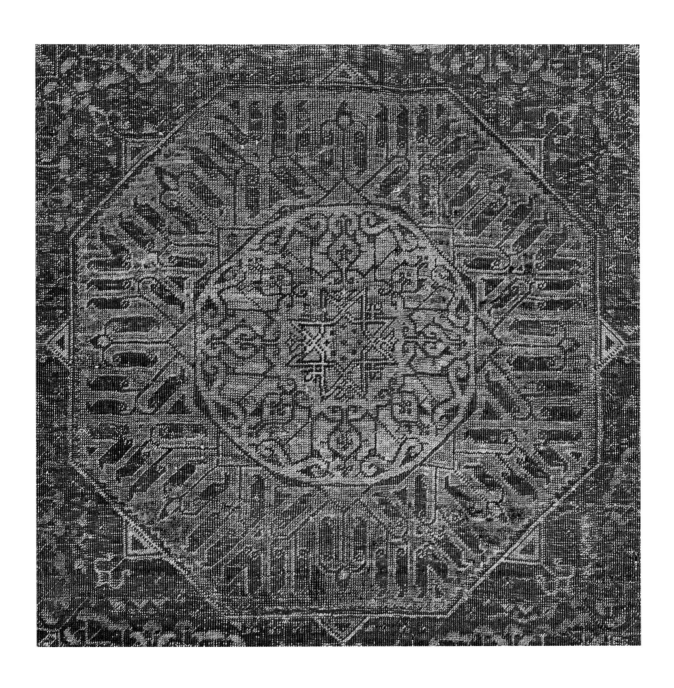

32

OTTOMAN FLORAL CARPET

Cairo, Egypt, 1550–75
Wool pile on wool foundation
399 × 283 cm

This outstanding carpet was acquired through an art dealer in Genoa, Vivioli, having pre-viously belonged to a Genoese noble family.[1] In 1969 Charles Grant Ellis was wedded to an attribution to Bursa in Turkey for all silk-foundation Ottoman carpets,[2] although they are, in fact, on examination of the currently available documentary and technical evidence, much more likely to have been made in Cairo. Ellis wrote captions for several carpets in Alessandro Bruschettini's collection, and extracts on this carpet from his unpublished manuscript are illuminating, although his conclusions remain less defensible:

> What a phenomenal object to come upon — an Ottoman floor carpet whose field repeats four times the field design of a court-quality prayer rug! Two arches reach out toward each end, the bases abutting mirror-fashion to create continuous pattern lengthwise, as indeed occurs laterally as well. Four corner-piece quarter-roundels of the prayer pattern thus become a yellow circular medallion, echoed by like halves at the sides of the carpet. At each end of the field the haunches of two head-and-shoulders arches combine to pro-duce a long, protuberant central element. One result of this is an echo of the age-old idea of a carpet for contemplation, in which the medallion serves as the polarity for the owner The general effect here is of golden keynotes scattered about a sea of wine red, the blues and greens providing fine-scale counterpoint. Each quarter of the carpet replicates the array of palmettes, of feathery, frond-like lancet leaves and sweeping sprays of rosettes that appears in the Ottoman court prayer rugs Colouring the rosette sprays light blue, on yellow stems, has produced a far tamer effect than the ivory flowers in the prayer pieces.... Reverse colouration of the spandrels and roundels, with beige arabesque-work on green in the former and beige knotted cloud-scrolls in the Chinese manner, again on green, in the latter, offers a quite different impression from the dark on ivory of the prayer rugs Due to its extremely close relationships to the prayer rugs cited, it will not seem strange if this carpet is believed to be a product of the same manufactory, despite the differences

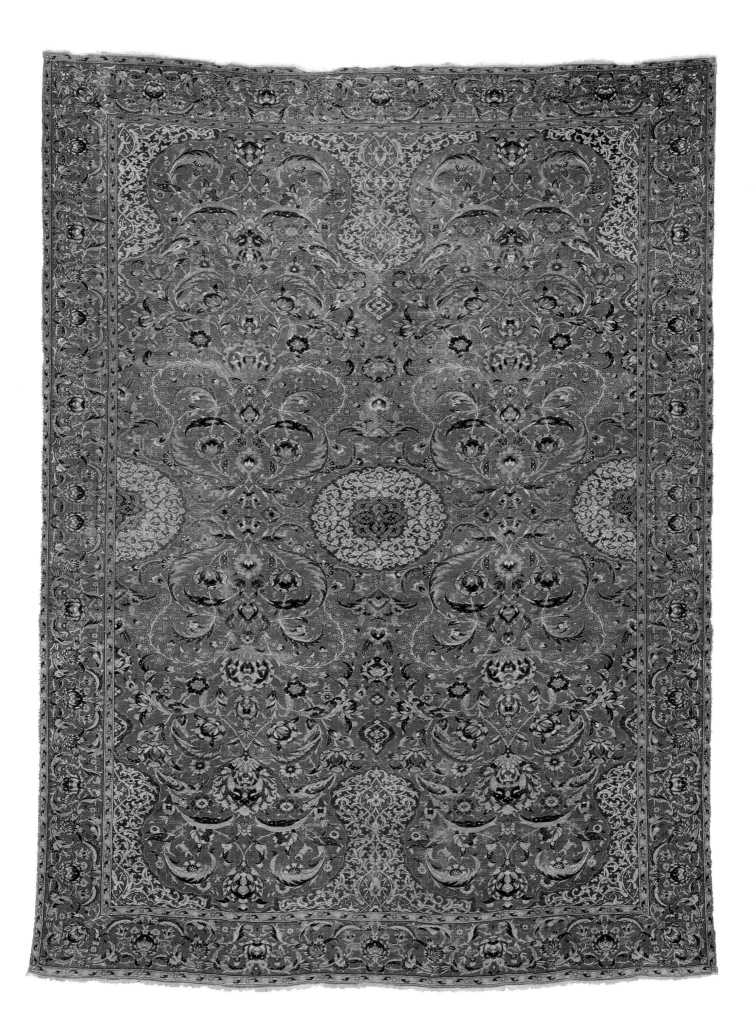

in quality arising from the materials used. Consequently, it will appear quite likely that it was made in or near Istanbul, rather than Cairo on the one hand, or on the other, Bursa, to which the rugs on silk have been assigned, mainly on the basis of that material, which has been associated with other textiles from that centre.

The design of the Genoa carpet is clarified by close study of the forty-two surviving single-niche Ottoman rugs. Ten of these have floral fields,[3] and their field design is repeated here four times. By comparing the pattern of the Genoa carpet with the most magnificent Ottoman niche rug, which belonged to the art collector Alphonse Kann,[4] it is clear that both must have employed the same cartoon and are probably contemporaneous. The other floral niche rugs seem more contrived and stiffer, without the remarkable elegance of these two. The Kann is woven on silk with 5,572 knots per dm², almost twice as fine as the larger Genoa carpet, which is on a wool foundation at 2,856 knots per dm².

Those still believing the Turkey attribution would ascribe the Kann rug to Turkey, chiefly because of its silk foundation, and the wool-foundation Genoa carpet to Cairo, despite the fact that they are otherwise so similar in both technique and design. This issue is discussed further in Cat. No. 33.

NOTES

1 Previously unpublished.

2 Charles Grant Ellis," The Ottoman Prayer Rugs," *Textile Museum Journal* 2, no. 4 (1969): 5–22.

3 Forty-two Ottoman niche rugs: floral fields (ten), plain fields (fourteen), ascending central ogival medallion (six), coupled-columns (two), *çintemani* fields with medallions (seven), multi-niche *safs* (three).

4 181 × 112 cm, wool pile on a silk foundation, MMA, New York, 1974.149.1. Formerly: Alphonse Kann, Paris; Joseph V. McMullan, New York.

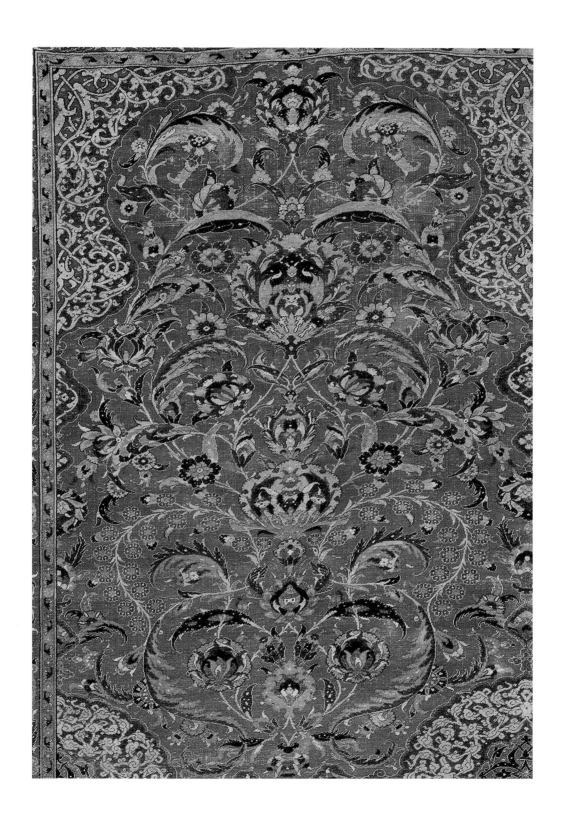

FRENCH & CO. MEDALLION CARPET

Cairo, Egypt, or Turkey, 1585–1600

Wool and cotton pile on silk foundation

733 × 476 cm

Many carpet scholars currently attribute this magical medallion carpet to Istanbul, largely because of its silk foundation.[1] As discussed in Cat No. 32, however, while this is a possibility, the greater probability, based on technique and some design elements, is that it was made in Cairo, Egypt.

Charles Grant Ellis wrote:

A highly individual carpet, spreading a field of variably tinted, light blue cotton across a surface of unusual size. The foundation is silk, so it is remarkably thin and flexible. The medallion scheme is miniature for the scale of the piece, as happens frequently among Ottoman carpets. It will seem a Chinese scheme, its medallions based upon the circle in form. It is laid upon the ground patterning, simply blotting it out wherever there is contact. The central medallion and the four corner pieces share a pattern of radiating spring flowers, across which spread pairs of clouds like lightning flashes....

This field pattern is a combination of the "display" pattern and the "chaplet" pattern. Across each end of the field, side-by-side, lie five "displays," as in the Vienna prayer rug,[2] and between the tips of their long, frond-like leaves, appear halved "chaplets." The display is carried as far as the lotus palmette from whose base spring the sweeping stems of little rosettes. Between these palmettes across the carpet are spaced, inverted, the similar palmettes that crown the next row of displays, which have been inverted and side-stepped.... Field repeats of the same portion of the display pattern, together with the chaplets and the same design for the medallions, appear in a carpet in Vienna.[3]

The fleur-de-lis plaques of the border provide pleasing accents in a frame which clearly differs from the field but does not contrast with it, as is likewise the case in other Ottoman carpets.... The guard stripes, with a sweeping vine connecting rosettes and smaller secondary blossoms, seem closest in pattern to those in a Victoria and Albert Museum carpet which is also on silk.[4] ... The guard bands show cloud wisps alternating with the three

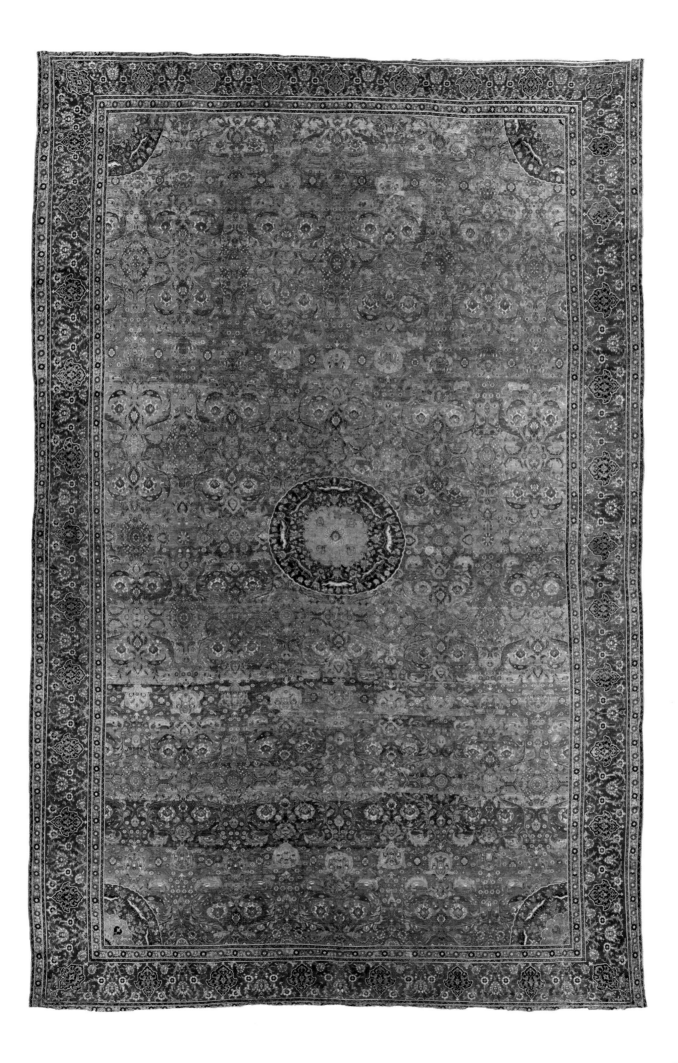

balls of the triratna, a holdover stripe from the Mamluk repertoire.[5] In Ottoman carpets it appears in silk-foundation carpets in New York and Vienna and its other pieces worldwide, in the Detroit carpet ...[6]

If the so-called "Bursa" or "Istanbul" carpets were newly designed in court workshops in Turkey, why would we find elements in this carpet that are apparently left over from the Mamluk workshops? Ottoman designs were certainly brought to Cairo workshops to be used for carpets, and surely only weavers working in Cairo would have retained design features from earlier Cairo production.

Ernst Kühnel attributed the silk-foundation members of this group to "possibly Bursa," and although there is no credible evidence whatsoever to support this, his theory was adopted by other authors without question.[7] The alternative attribution to Istanbul has been largely based on a document presented by Kurt Erdmann in 1938:

Carpet weavers with 30 Kantar [1,693 kilograms] of coloured yarns ordered [by command] from Egypt to Konstantinopel. The Beilerbei of Egypt receives the order: Since it is reported, that the following carpet master weavers are present there: Mu'Allim Abu'n-nasr; Mu'allim Muhammed Fuzûni; Hadschi Nebi; Muhammed Magribi(n); 'Ali Aswad; Redscheb; 'Atâullâh; 'Alî bin Mu'Allim Ahmed; Asl; 'Alemuddîn; Muhammed bin Aslan, and that it is necessary for them to be present at my Sublime Porte, I give the order, to send the named at once, with 30 Kantar of coloured yarns, as they are needed for weaving carpets, to my Threshold of Blessedness ... The above mentioned matter is important. Beware carefully of neglect and dawdling! (was delivered in the Imperial Divan to His Excellency the Wezir Ibrahim Pascha), on 3. Zi'l-ka'de 993 (7. October 1585).[8]

The 1,693 kilograms of silk and wool was sufficient for the eleven master weavers for forty months, during which time they could have produced thirty large carpets (each taking five weavers about sixty-nine weeks) or many more small rugs. This is far fewer than the number that survive, which are so tenuously attributed to the Istanbul workshop. Bearing in mind that probably far less than 1 percent of all the carpets made at this time have actually survived, then it would have required several hundred master weavers and large annual shipments of material from Egypt to create all the carpets of this type that could have been produced in Istanbul. It therefore seems reasonable to assume that the number of carpets produced by this Istanbul workshop was quite small, since to date no other document has been discovered regarding more weavers or more material (that does not preclude the possibility that the workshop was

larger, but that no further information about it has as yet come to light), and that none have survived. Since none of the carpets attributed by other authors to Istanbul can be specifically documented to have come from there, and as they are in all respects identical to carpets known to have been made in Cairo, but simply finer in weave, we should conclude that the case for an Istanbul attribution is possible but by no means proven and that at this stage a Cairo attribution seems more probable.

NOTES

1 Formerly: Mitchell Samuels of French & Co., New York, Cat. No. 39318; C. John, London; Umberto Cohen, Turin; Umberto Agnelli, Turin; Giuseppe Cohen, Turin. Published: Charles Fabens Kelly and Margaret O. Gentles, *An Exhibition of Antique Oriental Rugs* (Chicago: Art Institute of Chicago, 1947), Cat. No. 7 (detail); Giuseppe Cohen, *Il Fascino del Tappeto Orientale* (Milan: Görlich, 1968), pl. 27 (detail); unknown publication (Milan, 1970), 361, pl. 6 (detail).

2 181 × 127 cm, wool and cotton pile on a silk foundation, MAK, Vienna, T 8327.

3 713 × 442 cm, wool and cotton pile on a silk foundation. MAK, Vienna, T 8333.

4 284 × 251 cm, wool and cotton pile on a silk foundation. V&A, London, 476-1883.

5 For example: Museum of Islamic Art, Berlin, KGM 1883,571 (lost in the Second World War in 1945).

6 (1) 345 × 288 cm, incomplete, wool pile on a silk-and-wool foundation, MMA, New York, 22.100.55; (2) 254 × 440 cm, reduced, wool and cotton pile on a silk foundation, MAK, Vienna, Or 374. Other sections: Fine Arts Museums, San Francisco, 1718.54; Art Institute of Chicago, 1964.554; Kestner Museum, Hannover, Germany, 5424; Museum of Islamic Art, Berlin, KGM 1897,58 and KGM 1889,150; Textile Museum, Washington, D.C., R 34.33.5; (3) 88 × 219 cm, section, wool and cotton pile on a silk foundation, Detroit Institute of Arts, 29.233.A.

7 Ernst Kühnel and Louisa Bellinger, *Cairene Rugs and Others Technically Related* (Washington, DC: National Publishing Company, 1957), 57.

8 Kurt Erdmann, "Kairener Teppiche I. Europäische und Islamische Quellen des 15. bis 18. Jahrhunderts," *Ars Islamica* 5 (1938), 187, Cat. No. 5. He learned of this document from G. Jacob, *Deutsche Übersetzungen Türkischer Urkunden* 4 (Kiel, Germany: Walter Mühlau, 1920), doc. 50, 6. Jacob in turn probably found this in Ahmet Refik, *Onuncu 'asır Hicride İstanbul hayatı* (Istanbul: Matbaa-i Orhaniye, 1914), 187. My thanks to Christoph Rauch of the Staatbibliothek, Berlin, for locating the source, and to Detlef Maltzahn for the translation of Jacob into English.

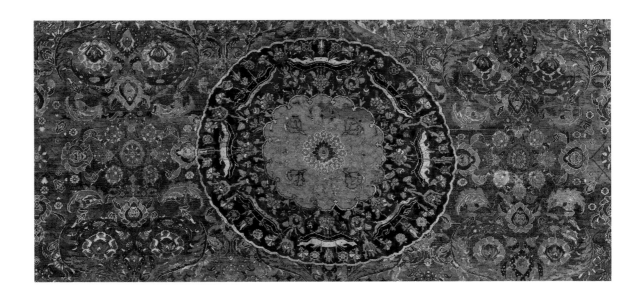

CASTELLANI-STROGANOFF MEDALLION CARPET

Ushak, Turkey, 1475–1525
Wool pile on wool foundation
527 × 285 cm

When Wilhelm von Bode illustrated the Castellani-Stroganoff carpet in 1901, he wrote: "The most beautiful specimen known to me, in colour as in drawing, is with Count Gregor Stroganoff in Rome; he bought it in 1883 in the auction of the Castellani collection, which offered a rich selection of interesting old carpets." It is not known who this magnificent carpet was made for or how it arrived in Italy, but most likely it passed through many noble families before being gifted to a church.

Its recent history begins in the 1870s when it was acquired by Alessandro Castellani (1823–83),[1] "the most successful collector of the remains of ancient art that this generation has seen."[2] It was later bought by Count Gregor Stroganoff (1829–1910), a connoisseur par excellence of fine art from many cultures. It was then acquired by the Principessa della Torre e Tasso, probably its most colourful owner, a thrice-married Michigan heiress.[3] She gifted her home and belongings to the Rockefeller Foundation. Each of these owners clearly cherished this glorious carpet, which is among the oldest and undoubtedly one of the most beautiful of its type known today. Its rediscovery in 1987 by Alberto Boralevi was the subject of a dedicated exhibition organized by him in Florence, with an accompanying publication.[4]

At least thirty medallion Ushaks are attributed to before 1550, but few survive in such superb condition. The fine drawing surpasses that of many others, especially the six other Ushak carpets that share this particular Kufic-style border. Two of these have field patterns on a red ground,[5] three on blue,[6] and only part of the border of the sixth survives.[7] From its earlier publications in black and white, it was assumed that this carpet had similar colouring to the Louvre, Schürmann, and Rossi examples. It was a surprise to many to discover that it has a red background, like the Czartoryski and the unusual Maciet example, which has blue dots in the field rather than the floral pattern of the others.

While this particular border combination can only be found on these medallion carpets, other Kufic-style borders without interlaced knots appear on Ushaks with different field designs, and other interlaced-knot borders can be seen on fifteenth- and early sixteenth-century

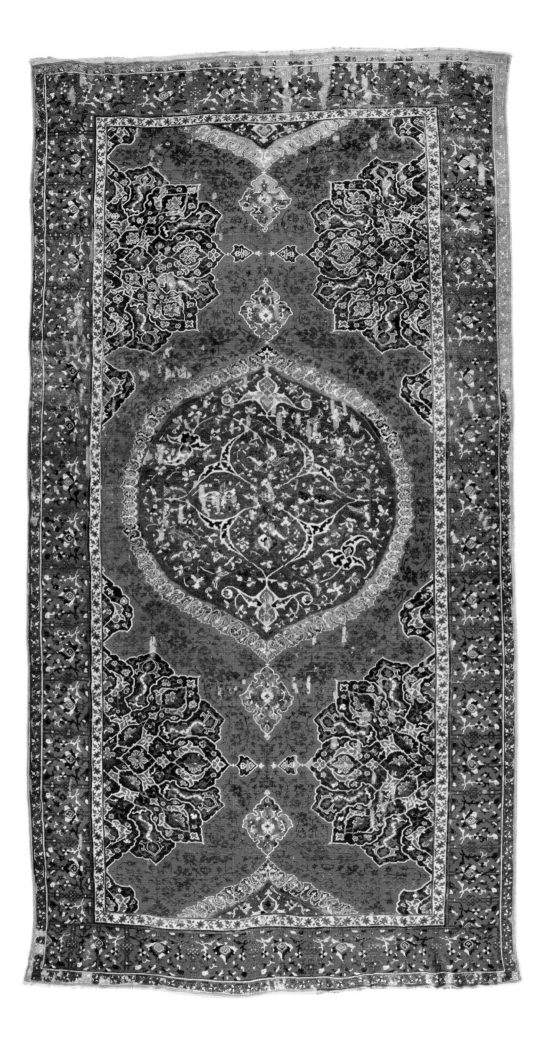

189

Anatolian rugs from other regions. An Ushak with interlaced-knot border appears in four still-life paintings by Bartolomeo Bettera (Bergamo, 1639–Milan, after 1688),[8] who was possibly the first connoisseur of antique carpets. Examples from his collection, several clearly from the early sixteenth century, appear in at least a hundred of his paintings. Early Ushak carpets were obviously particularly appreciated in Italy. The only other noted contemporaneous collection of Ushaks, assembled in England by Cardinal Wolsey and then acquired by King Henry VIII, is known solely from inventories and paintings. One should not forget that for the most part these collectors were only buying newly made carpets.

The Castellani-Stroganoff is undoubtedly one of the very best Ushak carpets surviving today. The freshness of its colours — a most glorious shade of red, the light blue of the medallion, the greenish-blue secondary medallion, and a brilliant fresh yellow, so often faded in other examples — combined with its particularly fine rendering of the pattern and remarkable condition certainly make it the most beautiful, as noted by Bode just over a century ago.

NOTES

1 Formerly: Alessandro Castellani, Rome; Count Gregor Stroganoff, Rome; Principessa della Torre e Tasso; Bellagio Center, Rockefeller Foundation, Villa Serbelloni; Roberto Faccioli and Alberto Boralevi, Florence. Published: M.H. Hoffman and Charles Mannheim, auction catalogue, Palazzo Castellani, Rome, March 17 to April 10, 1884, lot 1180 (cited); Wilhelm Bode, *Vorderasiatische Knüpfteppiche aus Älterer Zeit* (Leipzig: Seemann, 1901), fig. 38; Ludwig Pollak and Antonio Muñoz, *Pièces de choix de la collection du comte Grégoire Stroganoff à Rome*, vol. 1 (Rome, 1911–12), 23, http://rara.biblhertz.it/KatP-STR5369-5120-01?p=23, accessed July 10, 2017; Wilhelm von Bode and Ernst Kühnel, *Antique Rugs from the Near East* (New York: E. Weyhe, 1922), 67, and (London: Bell & Sons, 1970), fig. 20 (detail); Albert Achdjian, *Le tapis: un art fondamental* (Paris: Éditions Self, 1949), 187; Kurt Erdmann, "Orientteppiche im Besitz des Museums für Kunst und Gewerbe," *Festschrift für Erich Meyer* (Hamburg, 1959), 31, fig. 6 (detail); *Hali* 35 (1987): 37; Alberto Boralevi, *L'Ushak Castellani-Stroganoff* (Florence: KARTA, 1987), 8–18, pl. 1; Robert Pinner, "Multiple and Substrate Designs in Early Anatolian & East Mediterranean Carpets," *Hali* 42 (1988): 34, fig. 24c; *Hali* 182 (2014): 160.

2 www.britishmuseum.org/research/search_the_collection_database/term_details.aspx?bioId=141822, accessed July 10, 2017.

3 Née Ella Holbrook Walker (Detroit 1875–1959) married Count Manfred von Matuschka of Bechau in 1897. Moved to Rome in 1921. Married James Hazen Hyde; divorced. Acquired Villa Serbelloni on Lake Como in 1929. Married Prince Alessandro della Torre e Tasso (1881–1937) in 1932, becoming Princess of the Holy Roman Empire Lady Ella della Torre e Tasso.

4 Florence, 1987.

5 (1) 423 × 315 cm, Moshe Tabibnia, Milan, formerly, Czartoryski Collection; (2) 508 × 250 cm, Louvre, Paris, AD 14428, formerly, Jules Maciet, Paris.

6 (1) 550 × 270 cm, Louvre, Paris, MAO 959, without interlace; (2) 531 × 260 cm, Thyssen-Bornemisza Collection, DEC 0468/XIV, formerly, Giuseppi Rossi, Turin; (3) 500 × 250 cm, Museum für Kunst und Gewerbe, Hamburg, 1958,43, acquired from Ulrich Schürmann, Cologne.

7 26 × 30 cm, section, Moshe Tabibnia, Milan, formerly, Marino Dall'Oglio, Milan.

8 Including: Fine Arts Museums, San Francisco, 1941-21; Kunsthistorisches Museum, Vienna, CG2440.

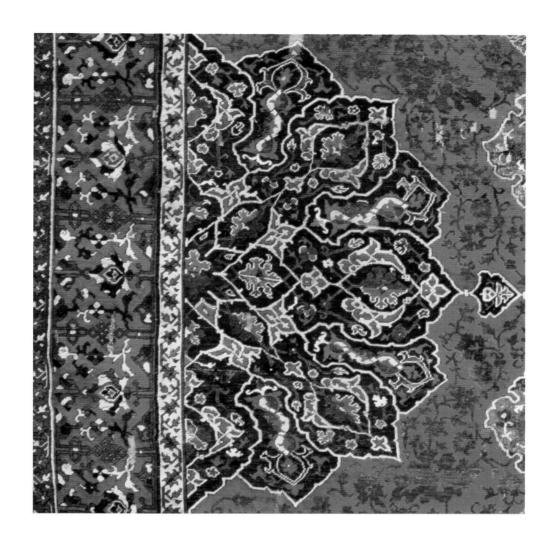

35

"LOTTO" ARABESQUE CARPET

Ushak, Turkey, 1575–1625
Wool pile on wool foundation
547 × 259 cm

Both the size and the condition of this arabesque design carpet, formerly in a Canadian collection, are exceptional.[1] The "Lotto" design, as it is also known after the depiction of two examples by the Venetian artist Lorenzo Lotto in paintings dated 1542 and 1547,[1] was certainly used in many regions in Anatolia and was probably conceived by the mid-fifteenth century. This is indicated by the fact that the first depiction is actually not by Lotto but by Sebastiano del Piombo in 1516.[3] His rug, which might have been nearly new at the time, has a well-articulated pattern and the "open-Kufic" and "leaf-meander" borders typical of early Ushak rugs. The arabesque became the most popular Turkish carpet pattern in Europe. Turkish originals can be seen in over 250 paintings by European artists.[4] They reach their apogee in Italian paintings during the 1530s and 1540s and thereafter are found more often in northern European paintings, being depicted with great frequency through the eighteenth and nineteenth centuries. Arabesque rugs were also copied in Spain and England from the sixteenth century.

Kurt Erdmann summarized the many descriptions of the arabesque design in 1964.[5] A decade later Charles Grant Ellis wrote: "The pattern in question is remarkably consistent and easily recognisable with its offset rows of arabesque octagons and quatrefoils, conjoined, and its characteristic limitation to a basically two-colour scheme: yellow and red."[6] He goes on to identify three variations in the pattern, which he labelled "Anatolian" (as seen here), "Ornamented," and "Kilim." In 1976,[7] together with Robert Pinner, I presented the basic elements of the design, which mirror and repeat horizontally and vertically. We proposed then, as I still believe today, that elements of the pattern can be found in early animal rugs, representing a highly abstracted form of confronting creatures: zoomorphic forms have been turned into floral motifs. This repeating-grid design — almost like a stained-glass window — radiates light in a magnificent manner.

The cartouche border of this arabesque carpet appears on Anatolian rugs by the last quarter of the sixteenth century, and by 1600 can be seen on examples depicted in English paintings.[8] This turquoise-background border is flanked by two rows of red pile on either side,

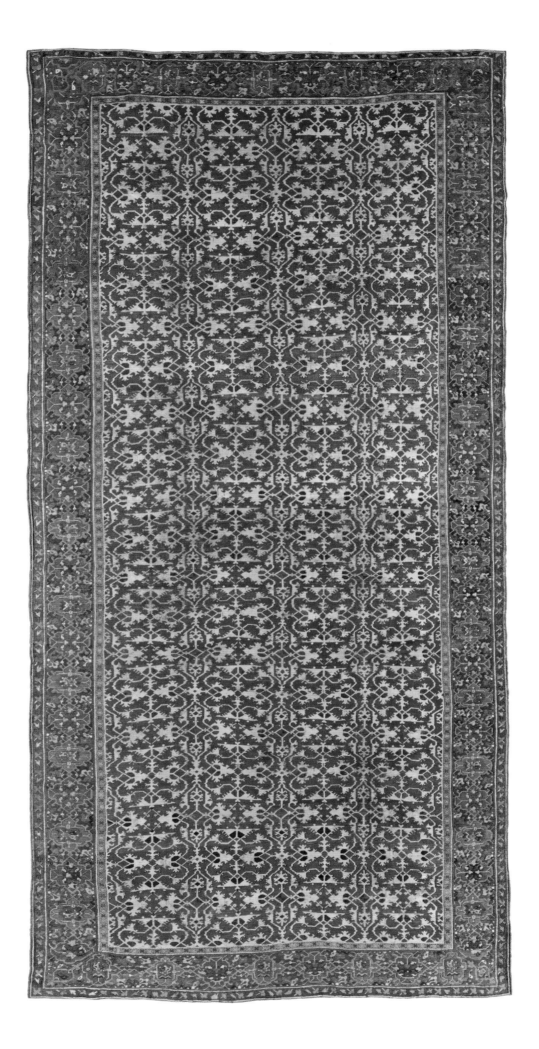

a separation that gives the impression that the border free-floats against the red background of the field. The drawing of the outer minor border is exceptionally good. The inner minor border, with its *x*-design alternating in red and tan set against blue, free-floats on yellow. The manner in which the yellow arabesque in the field joins this yellow edging along the minor border subtly contradicts the impression that the background colour of the field is red, suggesting alternatively a red pattern on a yellow background. The narrower inner and wider outer minor borders as well as the free-floating are features associated with rugs of the sixteenth century.

NOTES

1 Formerly: Private collection, Canada, until early 1970s; Franz Bausback, Mannheim, acquired at auction near Montreal. Published: Peter Bausback, *Antike Meisterstücke Orientalischer Knüpfkunst* (Mannheim: Bausback, 1975), 49; Peter Bausback, *Antike Orientteppiche* (Braunschweig, Germany: Klinkhardt & Biermann, 1978), 50–51.

2 (1) *Sant'Antonino Elemosinario*, 1542, Church of San Giovanni e Paolo, Venice; (2) *Family Group*, 1547, National Gallery, London, 1047.

3 National Gallery, Washington, D.C., 1961.9.37.

4 John Mills, "'Lotto' Carpets in Paintings," *Hali* 3, no. 4 (1981): 278–89. Mills listed eighty-two paintings known to him then.

5 Kurt Erdmann, "Türkische Teppiche. III. Die "Lotto" Teppiche," *Heimtex* (1964): 39–43.

6 Charles Grant Ellis, "The 'Lotto' Pattern as a Fashion in Carpets." In *Festschrift für Peter Wilhelm Meister* (Hamburg: Hauswedell, 1975), 19.

7 "Profile of a Carpet Design," presented at the First International Conference on Oriental Carpets, London, 1976.

8 See paintings by Marcus Gheeraedts and Robert Peake the Elder.

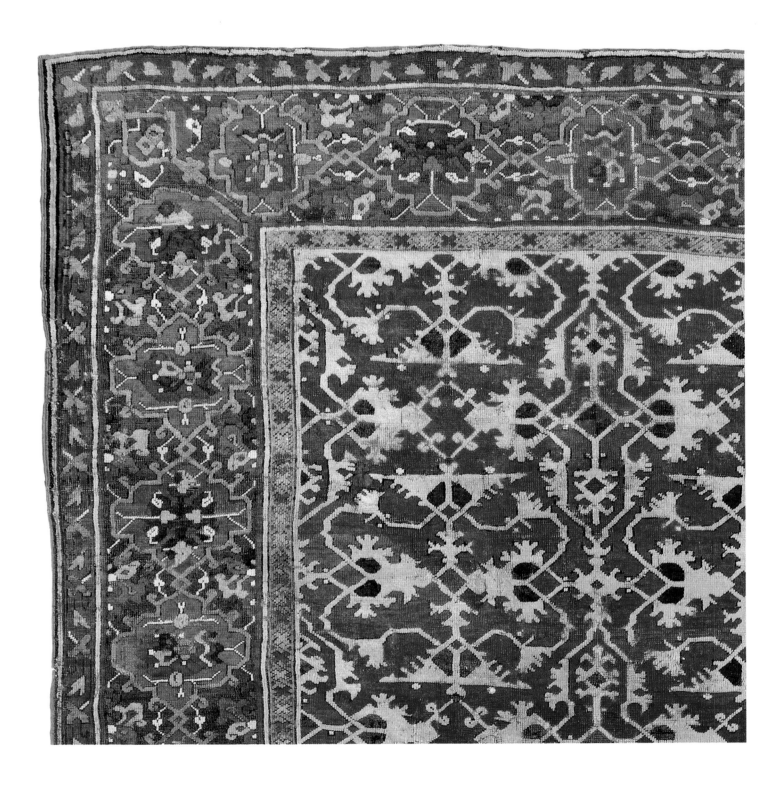

36

SIMONETTI-BARDINI
DRAGON CARPET

Karabagh, southwest Caucasus, 1500–50
Wool pile on wool foundation
515 × 208 cm, rewoven upper and lower borders

The Simonetti is one of the oldest, most important, and undoubtedly most beautiful Caucasian carpets in the world.[1] It is the purest example of its type, with the very best drawing. It is closest to the Graf dragon carpet in Berlin,[2] which has historically been considered the oldest and purest by many scholars. Berlin has a second early example, the Burano dragon carpet,[3] although the pattern of the latter cannot compete with that of the Simonetti. This carpet is almost complete, while the remaining seven examples of this very early group survive just as fragments.

The majority of Caucasian carpets with dragon and blossom designs (see Cat. No. 37) appear to come from a single location, since they share the same overall characteristics. They tend to be quite stiff, the wefts are tightly inserted, and a harsh wool has been used. Their technique is related to nineteenth-century carpets attributed to Karabagh in the western Caucasus; they bear no relation in materials or structure to any of the carpet types of the eastern Caucasus, in particular Kuba, to where they are so often misattributed.[4]

It is widely written that the designs of dragon carpets were inspired by Iranian models, in particular the "vase" carpets from Kerman, which also have a pattern of overlaid ogival lattices. However, lattices have been used in textile designs from at least the thirteenth century onward. Other similarities between Safavid Iranian carpets and Caucasian dragon carpets can be seen in the top-view flowers that flank the dragons, although comparative examples even to these can readily be found on fifteenth-century textiles. The most cogent connection can be found in the border pattern of this early group of dragon carpets, which is similar to that on a late sixteenth-century Kerman fragment.[5] However, both groups could easily have derived from a common heritage. The opinions of authors such as Friedrich Sarre and Maurice Dimand might have formed in part because of the earlier misattributions of both a number of Herat carpets with compartment and tree designs from Khorasan in eastern Iran, along with others with lattices and palmettes, to the Caucasus.[6]

Art historians and connoisseurs with a broader reach saw the dragon rugs as a most exciting group of Eastern carpets, the work of an ancient and isolated culture.[7] It is certain that

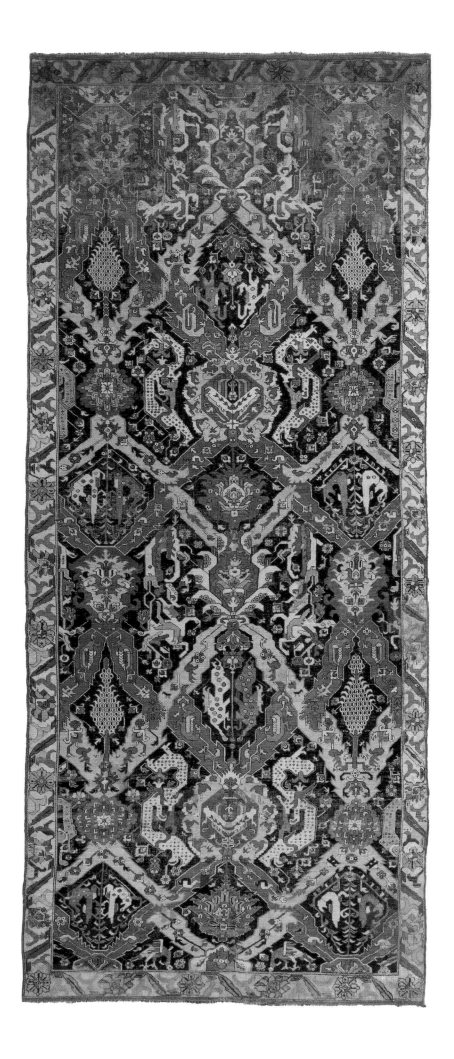

their abstraction was not invented in the later fifteenth century, a period to which the oldest surviving examples are attributed, but must have developed over a number of decades, if not centuries. The later dragon carpets from the end of the seventeenth and early eighteenth centuries are poor reproductions. The oldest and very best examples, of which the Simonetti stands at the pinnacle, have enormous vigour and still retain their original magic.

NOTES

1 Formerly: Simonetti, Rome, 1900; Stefano Bardini, Florence; C. John, London. Published: Wilhelm Bode, *Vorderasiatische Knüpfteppiche aus Älterer Zeit* (Leipzig: Seemann, 1901), fig. 76; F.R. Martin, *The History of Oriental Carpets Before 1800* (Vienna, 1908), 116; A.F. Kendrick and C.E.C. Tattersall, *Hand-Woven Carpets: Oriental and European* (London: Benn Brothers, 1922) 8, 13, pl. 5a; Rudolf Neugebauer and Julius Orendi, *Handbuch der Orientalische Teppichkunde* (Leipzig: Hiersmann, 1923), 11, fig. 4; Friedrich Sarre and Hermann Trenkwald, *Old Oriental Carpets*, vol. 2 (Leipzig, 1926–29), pl. 3 (cited); Kurt Erdmann, "Orientalische Tierteppiche auf Bildern des XIV und XV Jahrhunderts," *Jahrbuch der Preußischen Kunstsammlungen* 50 (1929): 295 (cited); Albert Achdjian, *Le tapis: un art fondamental* (Paris: Éditions Self, 1949), 59 (detail); Serare Yetkin, *Early Caucasian Carpets in Turkey* (London: Oguz Press, 1978), vol. 2, 13, fig. 122.

2 See page 160, note 40 (1).

3 See page 160, note 40 (2).

4 Charles Grant Ellis, *Early Caucasian Rugs: The Textile Museum Fiftieth Anniversary 1925–1975* (Washington, DC: Textile Museum, 1976), 10–11.

5 Ellis, *Early Caucasian Rugs*, 13, fig. 4.

6 Sarre and Trenkwald, 15; Maurice Dimand, *Oriental Rugs in the Metropolitan Museum of Art* (New York: Metropolitan Museum of Art, 1973), 265–69.

7 Bode, *Vorderasiatische*, 110–18.

37

SCHÜRMANN BLOSSOM CARPET

Karabagh, southwest Caucasus, 1600–50
Wool pile on wool foundation
577 × 240 cm

This Caucasian blossom carpet is one of the most spectacular examples of a well-known type.[1] Rarely do they survive in such excellent condition. Ulrich Schürmann, the previous owner, was the greatest connoisseur of Caucasian carpets, in particular those from the early nineteenth century. He developed a widespread following in both his native Germany and throughout the world through his many publications and exhibitions. Most popular were the small rugs variously known as "sunburst," "eagle," or "Chelaberd" Kazaks from Karabagh, which have their antecedents in the workshop blossom design carpets from the sixteenth to eighteenth centuries such as the example presented here. Looking back toward the origins of the designs, which often lose their original magic in repetition, we discover sublime beauty.[2]

Blossom carpets often combine at least two of three specific ornaments. One is the large "sunburst" blossom motif (not present on the Schürmann carpet). The second is a large, amorphous floral form (seen here in the very centre and near each corner), which is sometimes diamond-shaped, sometimes more hexagonal (as here), often (but not in this instance) outlined in continuous bird-like hooks, and which gives the overall impression of a zoomorphic creature. These amorphous forms are filled with a classic, abstracted "animal-tree" composition, originally comprising two birds or creatures facing a tree with a bird on top, which is repeated, mirrored through the horizontal axis. The bird is sometimes in the shape of a crown or an eagle's wing. The third ornament is a pair of huge leaf-like motifs with curled ends that bracket, either completely or partially, the previous two ornaments. These are similar to the "leaves" forming the lattice on dragon carpets (Cat. No. 36).

Large palmette-like ornaments and various other floral motifs also feature in the fields of the blossom carpets. Some of these elements are similar to those seen on dragon carpets at the intersections of the lattice, as well as enclosed in some of the compartments formed by the lattice. Although the basic composition of these blossom carpets is different from that of the dragon carpets, the repertoire of ornaments is very similar, apart from the various animal motifs that are specific to the latter. Many of the blossom carpets have the same border designs

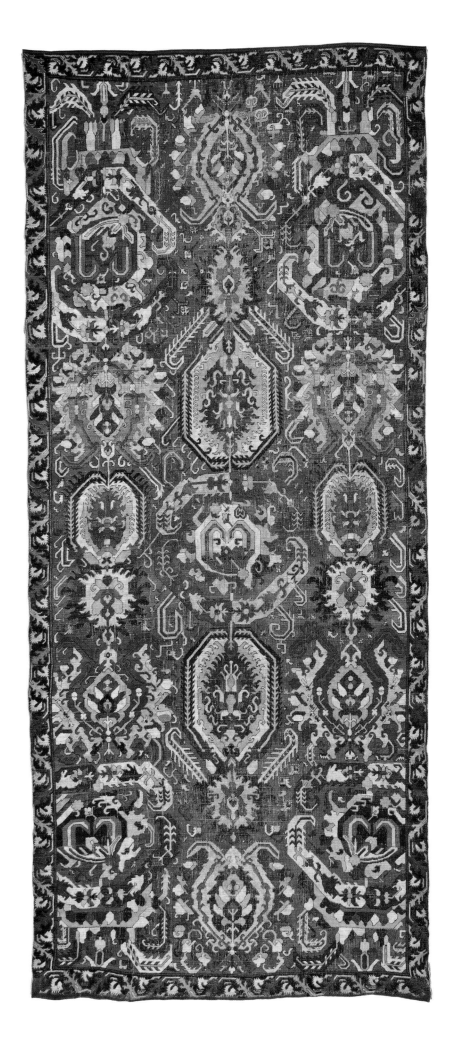

as the dragon carpets, as well as the same colours, wool, and construction. There is no reason to assume that the blossom carpets are anything other than an alternative design, and that the earliest examples of each composition might be contemporaneous. Of course, when attempting to assemble tidy groups of carpets, there are always exceptions to the general rules, and inevitably examples are found that combine elements of more than one and fit neatly into none.

With antique carpets, the examples that remain are, of course, merely chance representatives of an unknown original number, but the Schürmann blossom carpet is undoubtedly a unique and spectacular survivor of its type. The very curvilinear rendering of the floral blossoms suggests some influence from seventeenth-century carpets from southern Iran, but the style here is so distinctly Caucasian it is as if the artist wanted to pay tribute to Iranian weavers but in his own particular style.

NOTES

1 Formerly: Ulrich Schürmann, Frankfurt-am-Main; Elio Cittone, Milan. Published: Ulrich Schürmann, *Bilderbuch für Teppichsammler* (Munich: Kunst und Technik Verlags, 1960), pl. 37; Ulrich Schürmann, *Kaukasische Teppiche* (Braunschweig, Germany: Klinkhardt & Biermann, 1961), Cat. No. 3, pl. 2; Ulrich Schürmann, *Kaukasische Teppiche* (Braunschweig, Germany: Klinkhardt & Biermann, 1964), 56–57, pl. 1.

2 Part of this text has been adapted from earlier, more comprehensive essays by the author. See Michael Franses, *Orient Stars: A Carpet Collection* (London: Hali Publications, 1993), 88–114.

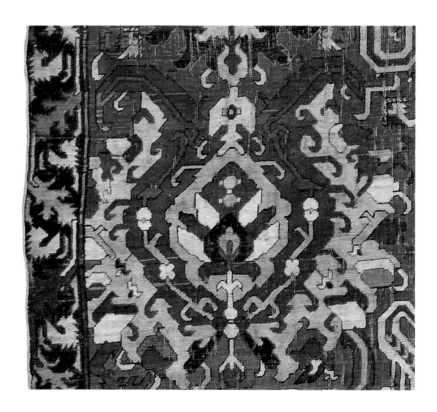

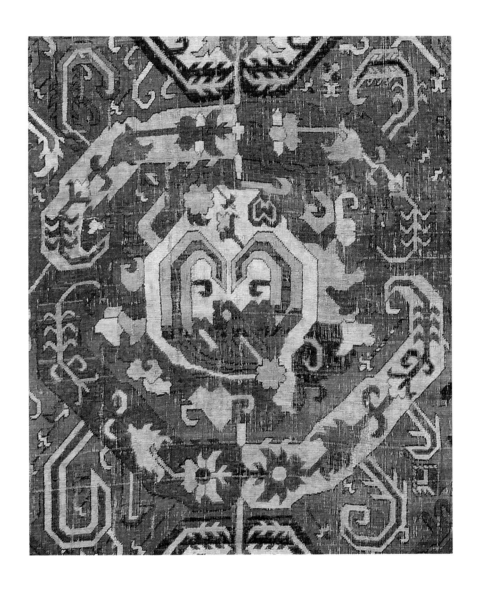

BARBIERI SPIRAL CARPET

Tabriz, Iran, 1468–1514
Wool pile on cotton foundation
135 × 326 cm and 133 × 315 cm, two sections

Carpets must have been made in and around Tabriz since antiquity, and certainly during the Seljuq, Mongol, and Timurid periods. Examples are depicted in thirteenth- to fifteenth-century Tabriz paintings, although none remain from that era. The oldest surviving Tabriz carpets can be attributed to 1468–1514. Up to 1501, the city was under the control of the Aqqoyunlu Turkmen, but it is likely that the owners of the workshops continued to make carpets after Shah Ismail I made it his capital and that the designs of Tabriz carpets continued for some time afterward in the Aqqoyunlu style.

In 1514 Tabriz was occupied and sacked by the Ottomans, subsequently being taken in 1534, 1547, and 1585–1603. It is directly because of these defeats at the hands of the Ottomans that some fifty-four complete Safavid carpets and sixty fragments attributed to Tabriz survive, since many of them were sold through the Istanbul bazaar to the West between 1830 and 1920. Most of the survivors were probably made in commercial workshops for local use.[1] Almost all of the remaining Tabriz carpets of the classical period have wool pile, asymmetrically knotted on an all-cotton foundation (a small group have red wool in the wefts). Some Tabriz carpets reached Portugal and were copied there. Not many are known to have reached Europe at this time, although the Medici hunting carpet in Milan, made in 1522, might have been among the first to arrive in Italy.[2]

Very few Tabriz carpets survive in full pile and good colours, and these remarkable sections (the upper part is better preserved and has its original outer border, while the lower part has patches) from a once-magnificent carpet still display much of the original beauty.[3] Colour is one of the most important attractions of antique carpets. If the wool pile remains at its full height and the colours unfaded, the pile absorbs most of the light shining on to it, and this combines with the light that it does reflect to give an intense depth to the colours. The angle of the pile also causes the light to reflect in different ways, depending on the angle of view.

The spiral field is not unique, appearing on at least twenty-three examples, the most famous of which is the Charles V carpet in Lisbon.[4] The strapwork border appears on thirty-six,

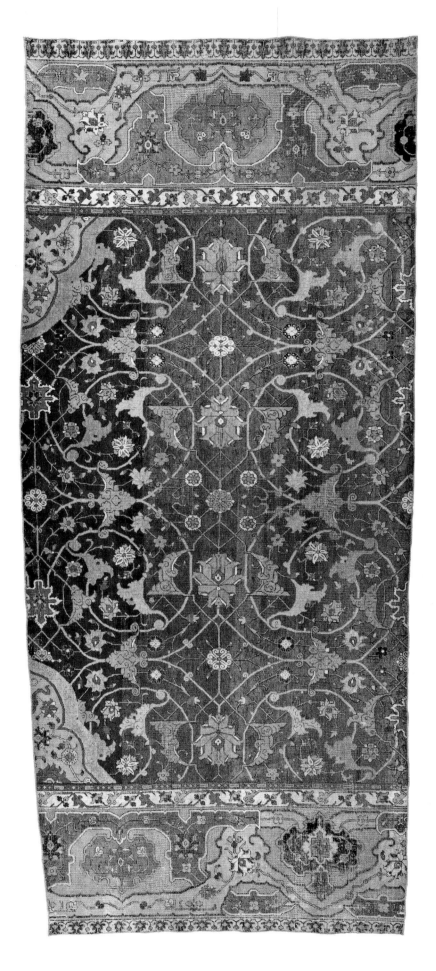
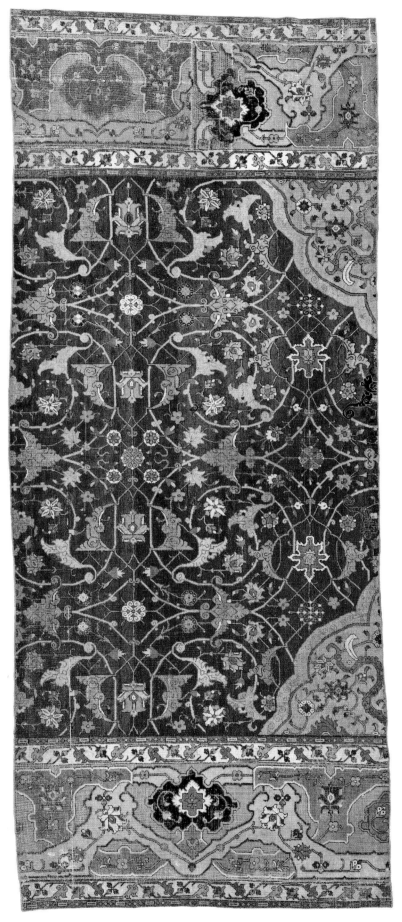

at least nine with green backgrounds and nine with quartered lobed-medallion corner pieces with cloudbands. Those with interlocking cartouche borders tend to have cloudband or compartment designs in the field. Those with cartouche and lobed-medallion borders usually have field designs of inward- and outward-pointing palmettes. A particular feature of many Turkman Tabriz carpets is the small ivory "Talish" rosette that appears here in the centre of the large diamonds. A workshop "signature" of a cartouche separated by three diamonds can be seen in the inner minor border.

NOTES

1 First period, wool pile on a cotton and silk foundation: (1) 793 × 419 cm, MMA, New York, 46.128; (2) 498 × 340 cm, reduced in size, MMA, New York, 10.61.3; (3) 800 × 400 cm, Musée des Tissus, Lyon, 25.423. Second period, wool pile on a cotton foundation: (1) 783 × 379 cm, Musée du Louvre, Paris, OA 6610; (2) originally 604 × 365 cm, damaged in the Second World War and now a patchwork of fragments, Museum of Islamic Art, Berlin, Inv. No. I.1; (3) 701 × 366 cm, LACMA, Los Angeles, 49.8; (4) 541 × 315 cm, V&A Museum, London, 589-1890.

2 (a) 670 × 353 cm, wool and cotton pile on a cotton foundation, with inserted silk fringes, Pinacoteca di Brera, Milan, since 1923 on loan to the Poldi Pezzoli Museum, Milan. Dated 929 AH/1522–23 CE; (b) 48 × 135 cm, section of lower-right-hand border, Poldi Pezzoli Museum, Milan; (c) section of lower border, Eberhart Herrmann, Emmetten.

3 Formerly: Piero Barbieri, Genoa. Previously unpublished.

4 530 × 222 cm, Calouste Gulbenkian Museum, Lisbon, T. 97.

A Turkish Notary Drawing Up a Marriage Contract
in Front of the Kiliç 'Ali Pasha Mosque, Constantinople

Painted by Martinus Rørbye (1803–48)
Denmark, 1837
Oil on canvas
95 × 130 cm
Copyright © Christie's Images Limited

39

PERSIAN "VASE" CARPET

Kerman, Iran, 1625–75
Wool pile on cotton-and-wool foundation
207 × 142.5 cm, section

This remarkable section is from the field of a large carpet that originally possibly measured around two by five metres (seventeenth-century Kerman carpets tend to be long and narrow).[1] The Bruschettini Collection contains a substantial number of examples of this type, which are worthy of a catalogue on their own.

Carpets were woven in and around the city of Kerman in south-central Iran certainly from the mid-sixteenth century onward. Their patterns include rows of shrubs, shrubs in lattice, arabesque, leaf-lattice, stem-lattice, lattice with medallions, cartouche-compartments, multiple-medallions, sickle-leaf, garden designs, and hunting designs. The largest surviving and best-known group are the so-called "vase design" floral carpets, which has somewhat confusingly led the label "vase" to often be used for *all* Kerman carpets. The vase design carpets have field patterns composed of multiple overlaid lattices of ascending stems, with a profusion of various large palmettes and flower heads placed among them, along with the occasional decorated vase. Some seventy-five mostly complete vase design carpets survive along with around fifty-nine fragments, providing a substantial body for study.

At an exhibition dedicated to *The Carpets of Central Persia* in Sheffield in 1976,[2] May H. Beattie clarified "vase technique" carpets, basing her attributions on a shared structure rather than design.[3] She demonstrated the extraordinary multiplicity of patterns that it was possible to ascribe to a single major Safavid weaving centre. At the international colloquium and in her accompanying publication, Beattie attributed all carpets woven in the vase technique to Kerman. This was generally accepted by the experts on Safavid carpets in attendance. She was not, of course, the first to assign individual design groups to this Iranian province and city, but her work is an indication of the growing importance of systematic structure analysis. It was this discipline — almost unknown to, and greatly unappreciated by, the majority of carpet scholars in the first half of the twentieth century — that allowed her to construct so convincing a hypothesis for so many disparate design groups.

NOTES

1 Formerly: Probably Jekyll, London; Sado, Brussels; Textile Gallery, London, on consignment for sale to Spink & Son, London. Previously unpublished.

2 May H. Beattie, ed., *Carpets of Central Persia* (London: World of Islam Festival Publishing Co., 1976).

3 Beattie's definition of the technique is as follows: "There are three passes of weft after each row of knots. The first and third are of Z2Sw wool, tightly stretched between the closely laid warps, which are thus divided into a definite upper and lower plane, the two being held together by a fine second weft. Much of the woollen weft yarn may be in shades of ash, brindle (mixed fibres in natural colours) and brown, but an unusual feature is the use of varying amounts of coloured yarn such as is found in the pile. The introduction of these coloured wefts seems to be quite haphazard as though to utilise available oddments of wool. The use of yarns and dyes in the fine second wefts is somewhat more regular than in the case of the first and third woollen ones. Silk, in all or some of the second wefts, appears in rugs of the best quality but a Z2Sw cotton weft is much more usual. At times one strand may be silk, the other cotton. There may even be a few rows of fine wool and this yarn predominates in the second wefts in two rugs usually classified with the Sanguszko group. Apart from natural light cotton, preference goes to pink and blue with occasionally other shades, even orange, but deep red is most usual in silk."

40

BENGUIAT–VASCO PARREIRA "PORTUGUESE" CARPET

Mashhad, Iran, 1575–1625
Wool pile on cotton foundation
551 × 243 cm, with replaced spandrels

This magnificent carpet belongs to a group with a very particular design: the central field, enclosed by a strapwork border, features a medallion composed of bands of multiple colours separated by jagged lines that radiate outward from the centre.[1] They are known as the "Portuguese" carpets because the nine "key" examples made in Khorasan in eastern Iran have pictorial scenes in each corner of the central field depicting fish and European-type boats with sailors in supposedly Portuguese costumes.[2] This can be seen in a small carpet section now in the Museu do Caramulo (see page 215).

In 1979 I was able to compare the Benguiat side by side with some other carpets similarly woven on a cotton foundation with *jufti* knotting in which each knot is tied on four warps rather than on the two employed on most carpets. The compared carpets also shared very similar hues, in particular the reds and greens, and a similar hard, dry wool. Carpets of this type are today believed to have been made in Khorasan. The "Portuguese" carpets had been discussed by many authors, ascribing them to Iran, but in 1972 Charles Grant Ellis attributed them to India, based mostly upon the imagery in the pictorial scene. However, I was unable to relate them physically to any others known to have come from India. I pointed out the similarities between the compared carpets to Siawosch Azadi, who further suggested that the Benguiat was remarkably similar to early nineteenth-century carpets from Mashhad in Khorasan, on which he is the leading authority.

There are also versions of the "Portuguese" carpets without the pictorial scenes that are attributable to other regions: two examples probably woven in eastern Anatolia or Kurdistan, most likely from 1650–1700;[3] three small silk-pile rugs with silver thread made in Isfahan, 1625–50;[4] one Mughal version probably from Lahore, 1650–75;[5] and seven examples from Azerbaijan, probably 1625–1725.[6] The last group covers the longest period, and the oldest of these is certainly contemporaneous with the Khorasan originals.

The "Portuguese" carpets have been the subject of two extensive essays by Ellis and another by Steven Cohen.[7] Ellis brought the whole group together, and unlike other authors,

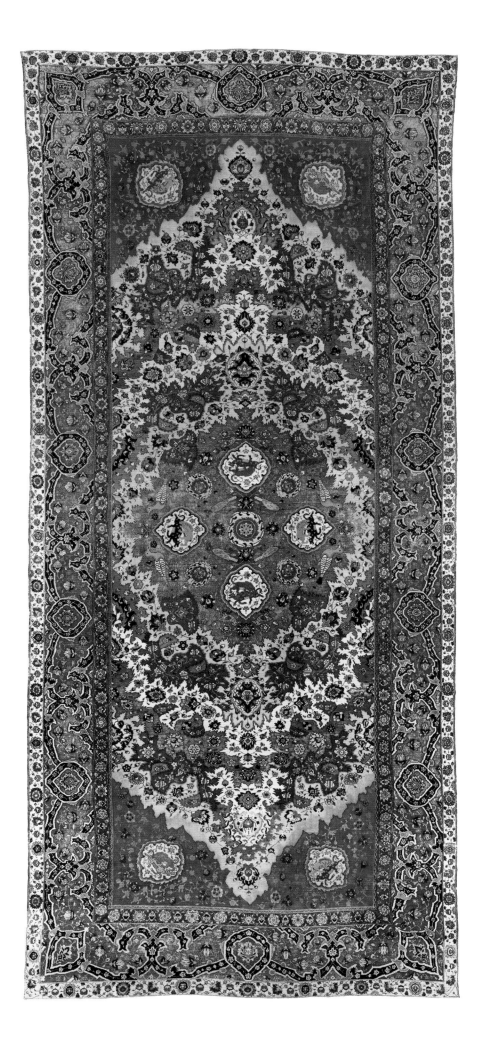

213

personally examined and analyzed virtually all of them before unfortunately coming to the erroneous conclusion that the primary subgroup of Mashhad carpets were made in Gujarat, India. Whereas Cohen, who examined fewer examples, correctly attributed the primary group to the Khorasan region of eastern Iran, although not specifically to Mashhad.[8]

NOTES

1 (a) Formerly: Vitall Benguiat, Florence and New York, to 1920; Parish-Watson, New York; P. W. French & Co., New York; Horace Harding, United States, to 1941; private collection, New York; Wildenstein, Paris; M. Akran Ojjeh, SS *France*; Textile Gallery, London; Marino Dall'Oglio, Milan. Published: American Art Association, New York, April 8–10, 1920, lot 44; Friedrich Sarre, "A 'Portuguese' Carpet from Knole," *The Burlington Magazine* 58, no. 338 (1931): 214 (cited); Iranian Institute, *Exhibition of Persian Art* (New York, 1940), 146, Cat. No. 4 (cited); Parke-Bernet, New York, March 1, 1946, lot 122; Charles Grant Ellis, "The 'Portuguese' Design Carpets of Gujarat." In Richard Ettinghausen, ed., *Islamic Art in the Metropolitan Museum of Art* (New York: Metropolitan Museum of Art, 1972), 270, 287, fig. 4; Sotheby's, Monte Carlo, June 25–26, 1979, lot 98; Michael Franses, "Auction Reports, Classical Carpets in Monte Carlo," *Hali* 2, no. 3 (1979): 256; Charles Grant Ellis, "Where Have the Other Corners Gone?" *Islamic Art III, 1988–1989* (New York: Islamic Art Foundation, 1989): 216, fig. 1, pls. 13, 14a; Alberto Boralevi, "View from the Summit," *Hali* 180 (2014): 75, fig. 5; (b) 47 × 55 cm, section, Museu do Caramulo, Portugal, formerly, Vasco Parreira Collection, Portugal.

2 The other eight: (1) three sections, Museum of Islamic Art, Berlin, KGM 1887,974; (2) 660 × 290 cm, Musée des Tissus, Lyon, 25095; (3) 680 × 313 cm, MAK, Vienna, T.8339; (4) 510 × 200 cm, Rijksmuseum, Amsterdam, BK-17272; (5) 690 × 305 cm, Lord Sackville, Knole; (6) 411 × 180 cm, MMA, New York, 44.63.6; (7) 477 × 200 cm, Calouste Gulbenkian Museum, Lisbon, T. 99; (8) 444 × 194 cm, Winterthur Museum, Delaware, 59.914.

3 Museum of Turkish and Islamic Arts, Istanbul, 993 and 617.

4 (1) Museu Nacional de Machado de Castro, Coimbra, 16; (2) whereabouts unknown; (3) Walters Art Museum, Baltimore, 81.16.

5 Cincinnati Art Museum, 1966.1182. Ellis, "The 'Portuguese' Design Carpets of Gujarat," 288, notes that it has *jufti* knotting, suggesting Khorasan (I have not personally examined it). The inner guard border pattern is associated with Lahore carpets.

6 (1) (a) Textile Museum, Washington, D.C., 17272; (b) whereabouts unknown; (2) MMA, New York, 08.234.2; (3/4) Kirchheim Collection, Hannover; (5) private collection, Lanaken; (6) Museum of Islamic Art, Berlin, KGM 1885,248; (7) whereabouts unknown; (8) Lala Mustafa Pasha Mosque, Erzurum.

7 Ellis, "The 'Portuguese' Design Carpets of Gujarat"; Ellis, "Where Have the Other Corners Gone?"; Steven Cohen, "'Portuguese' Carpets from Khorasan, Persia." In Ruth Barnes, ed., *Textiles in Indian Ocean Societies* (London: RoutledgeCurzon, 2005), 35–43.

8 Steven Cohen's attributions of the other types of carpets with the "Portuguese" design are more confused.

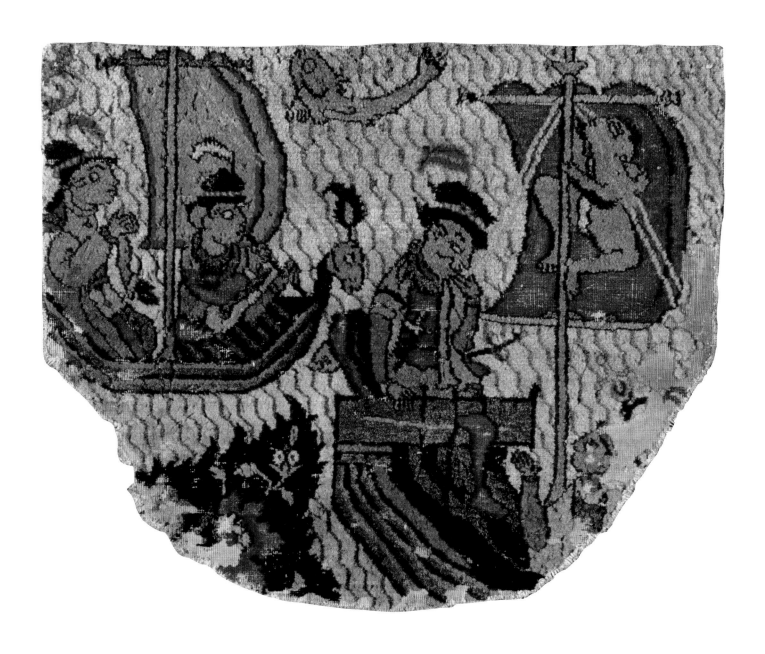

"Portuguese" Carpet Fragment

Mashhad, Iran, 1575–1625
Wool pile on cotton foundation
47 × 55 cm
Donated by Vasco Parreira
Copyright © Museu do Caramulo —
Fundação Abel e João de Lacerda

41

JAIPUR PALACE
SHAPED SHRUB CARPET

Possibly Lahore, Pakistan, 1650–75
Wool pile on cotton-and-silk foundation
428 × 231 cm

This Mughal shrub-design carpet is one of a series, each individual and yet all noticeably similar, known as the "Jaipur" group.[1] Some of them have labels on the back. When these were attached and who wrote them is yet to be revealed, but several of them state that the carpets were made in Lahore. It is likely they were ordered under Maharaja Mirza Raja Jai Singh I (r. 1621–67).[2]

More than sixty Jaipur group carpets are known today in a variety of formats.[3] The majority are shaped like the Bruschettini carpet, suggesting that they were made to be placed around throne platforms, probably inside tents used by the maharajas during their progresses around their lands; the circular ones were possibly made for the platforms. When not in use, they would have been kept in safe storage in the palaces, which would help explain why they have survived in such good condition.

The collections of the Jaipur palaces were catalogued by T. H. Hendley in 1900–05, A. J. D. Campbell in 1929, May H. Beattie in 1972,[4] Daniel Walker in 1997,[5] and more recently Steven Cohen.[6] Several carpets still survive in various institutions in Jaipur, but many were sold both before and after 1905.

The majority of the Jaipur carpets have designs of individual flowering plants arranged in rows on a red ground. Many of the rectangular ones repeat this same pattern in the border; the shaped ones have rosettes joined by a meandering stem.

Mughal Emperor Jahangir (r. 1605–27) was a particularly keen botanist, and his court painter, Mansur, was commissioned to produce albums of flower paintings, each miniature executed with an absolute fidelity of detail. Thus, around the beginning of the seventeenth century, rows of free-standing flowering plants were used to decorate the margins of manuscript illuminations, similar to Dutch herbal manuscripts beginning a century or so earlier. Dutch artists are known to have been active in both the Safavid and Mughal courts.

The Jaipur carpets were made in different qualities, the coarsest having all-cotton foundations. Most are of medium quality, with silk in the weft, averaging around 2,250 knots per dm².

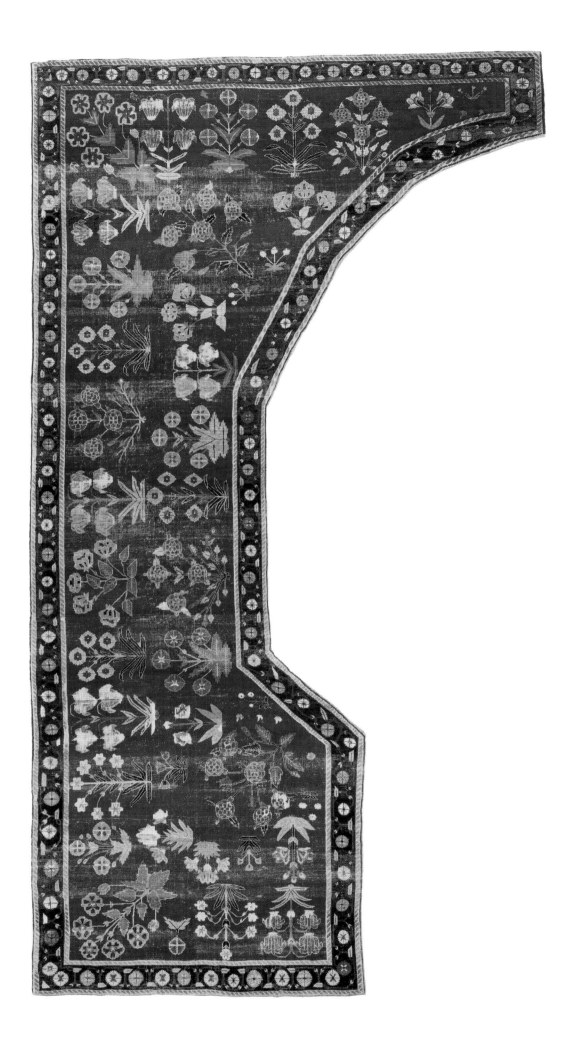

217

The finest examples were made with pashmina pile on silk foundations, reaching as high as 9,000 knots per dm². Even this is unremarkable in a weaving culture in which 15,000 knots per dm² is almost commonplace, and the finest examples achieve over 30,000.[7] Fineness of knotting in itself, however, is no mark of artistic excellence, and the Jaipur carpets, with their beautifully delineated and clearly recognizable varieties of flora — over sixteen separate species have been identified — mark one of the high points of Eastern weaving.

NOTES

1 Formerly: C. John, London; Marino Dall'Oglio, Milan. Published: Sotheby's, London, auction catalogue (1975?).

2 The earliest label on the circular carpet (Hendley No. 27) is dated 1655, the same year as the earliest label on one of the arched carpets (No. 21); the other arched piece (No. 30) is not described as having any labels.

3 I collated an initial list of thirty-five in 1981. See *Il Tappeto Orientale dal XV al XVII secolo* (Milan: Eskenazi, 1981), pl. 36. I currently have (still incomplete) records of twenty-eight shaped carpets; two circular; fourteen rectangular, landscape orientation; four rectangular, portrait orientation; three with mirrored patterns; three with shrubs in a lattice; two with shrubs and large trees; one shaped for a particular hall; one niche rug; and numerous fragments.

4 T.H. Hendley, *Asian Carpets, XVI and XVII Century Designs from the Jaipur Palaces* (London: Griggs, 1905). Campbell's and Beattie's reports are unpublished.

5 Daniel Walker, *Flowers Underfoot: Indian Carpets of the Mughal Era* (New York: Metropolitan Museum of Art, 1997), 12–14.

6 Catalogue is in progress with Oxford University Press.

7 Walker, 91, fig. 88.

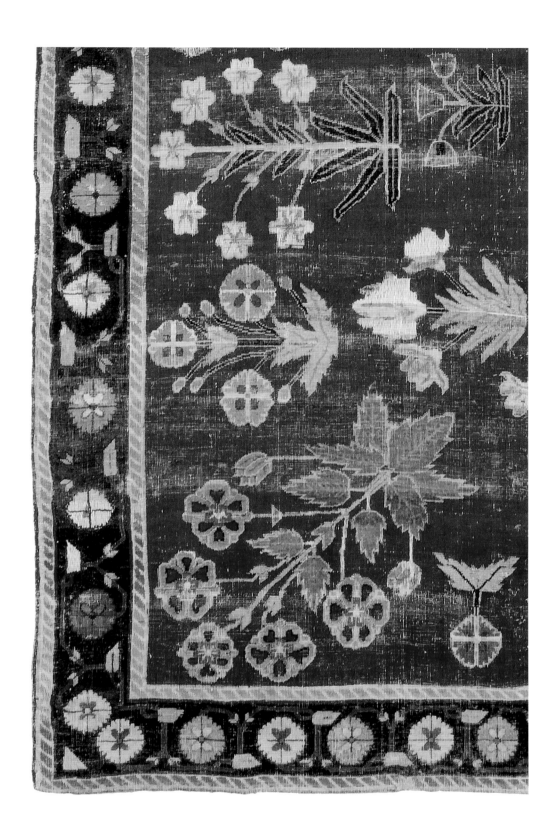

42

MUGHAL LATTICE CARPET

India, ca. 1650 or earlier
Pashmina wool pile on silk foundation
235 × 72 cm, section

This section from a lattice carpet utilizes one of the most vivid patterns used on the pashmina carpets from Mughal India, composed of diagonal rows of an assortment of different top-view and side-view flowers.[1] These stylized flowers seem to be chosen randomly, as one might expect in a natural garden, but are each connected by a dark green winding and spiralling stem with leaves. The flowers are overlaid with a diamond-shaped lattice in ivory, which curves and twists with flame-like protrusions; at each interstice is a small pink four-petalled flower.

The finest Mughal carpets were by far the most costly and labour-intensive ever produced, combining the best materials available. The pashmina wool used for the pile was taken from the under-fleece of young Cashmere mountain goats. It was exceptionally expensive, and vast quantities were required to make even a small rug, never mind a carpet as huge as this was originally. The pile is very tightly spun, quadrupling the amount of material required for more standard carpets, and the wefts are pulled so taut that the pile becomes incredibly dense on the surface, surpassing the finest velvet in texture. The use of lac for the red required dyeing in small quantities, since each batch had to be dyed up to seventeen times to achieve this extraordinary intensity, and the same applies to the deep indigo-dyed blues and greens, which would all have taken months to produce. Natural dyes are soft and subtle and reflect the colours of nature, unlike modern synthetic dyes.

What makes the earliest examples greatly surpass later ones is not just the use of intense yet sublime colours but also the inventive juxtapositions of ornaments, the exquisite proportions, the remarkable balance, and the refined use of negative space. The beauty and elegance of the Mughal pashmina carpets is the result of a combination of superb artistry and exceptional craftsmanship that has never been achieved since.

This fabulous section is part of a huge carpet from the Imam Reza Shrine in Mashhad, of which several other sections also survive, the largest still in Mashhad.[2] It offers a glimpse into the luxury and splendour of the Mughal court. The Imam Reza Shrine has another Mughal pashmina pile carpet,[3] and both were reportedly presented in the early seventeenth

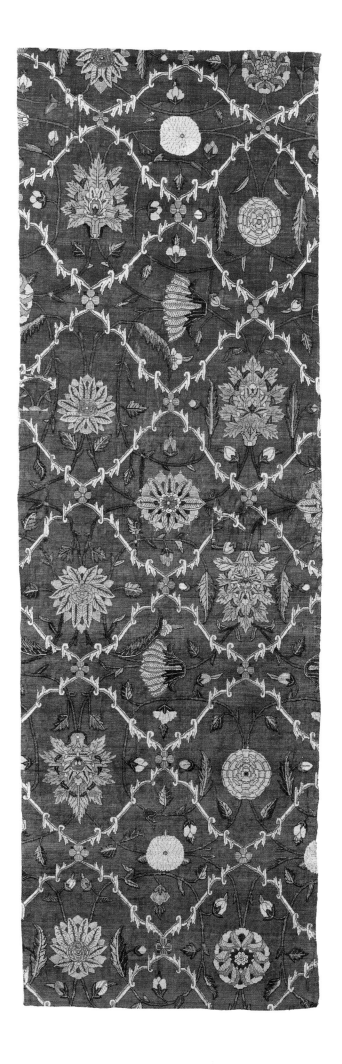

century by Emperor Jahangir to Safavid Shah Abbas I (r. 1588–1629). Magnificent gifts were exchanged between these two great rulers, who maintained exceptionally cordial relations despite never meeting.[4]

Mughal pashmina carpets are rare, and only a small number survive in both Western and Middle Eastern collections. The best collection is in the Metropolitan Museum of Art in New York, and the subject was comprehensively surveyed by Daniel Walker in 1997.[5]

NOTES

1 Formerly: James A. Garland, Sr., New York; James A. Garland, Jr., Boston, to 1924; Duveen Brothers, New York; Norton Simon Foundation, New York, to 1971; private collection, to 1991. Published: American Art Association, New York, auction catalogue, *The James A. Garland Collection*, January 19, 1924, lot 523; Parke-Bernet Galleries, New York, auction catalogue, May 8, 1971, lot 218; Sotheby's, New York, auction catalogue, December 11, 1991, lot 14. Exhibited: Pennsylvania, University Museum, 1925; Detroit Institute of Art, 1930.

2 (a) 464 × 283 cm, section, Astan Quds Razavi Carpet Museum, Imam Reza Shrine, Mashhad; (b–l) MMA, New York, six sections, 32.100.457; St. Louis Art Museum, 73.1929; Moshe Tabibnia, Milan; private collection, Doha; private collection, London.

3 550 × 400 cm, wool pile on a silk foundation, Astan Quds Razavi Carpet Museum, Mashhad.

4 See *Allegory of a Meeting: Jahangir Embracing Shah Abbas*, Freer Gallery of Art, Washington, D.C., F1945; Clara Cary Edwards, "Relations of Shah Abbas the Great, of Persia, with the Mogul Emperors, Akbar and Jahangir," *Journal of the American Oriental Society* 35 (1915): 247–68.

5 Daniel Walker, *Flowers Underfoot: Indian Carpets of the Mughal Era* (New York: Metropolitan Museum of Art, 1997).

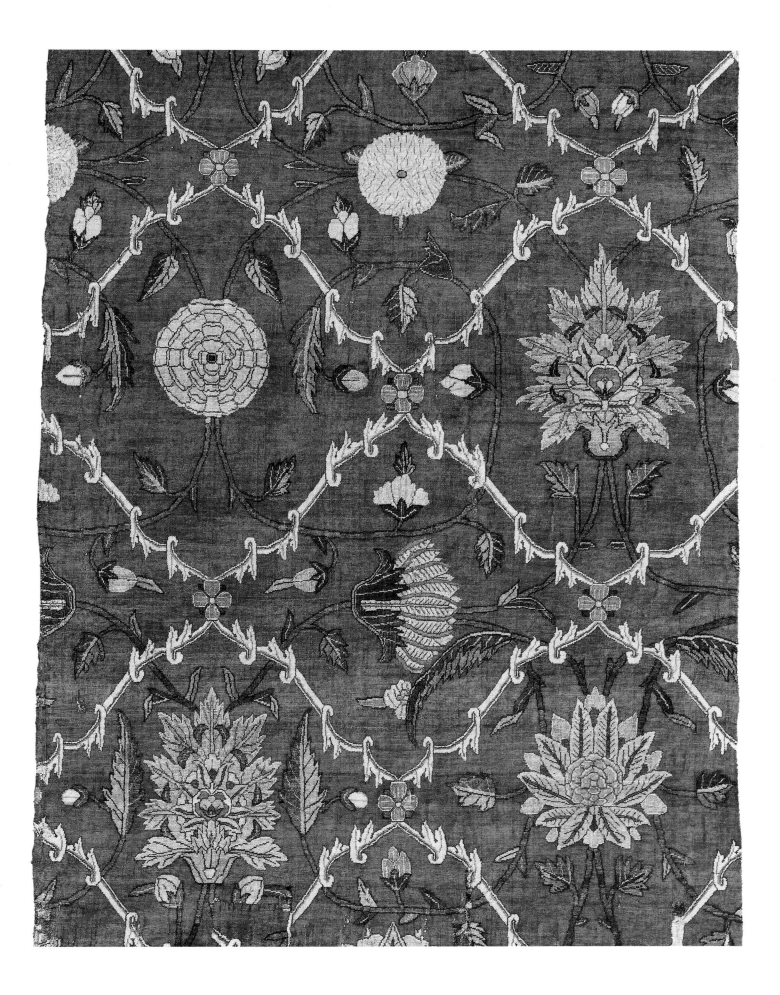

WANLI EMPEROR THRONE DAIS COVER

Beijing, China, 1585–1600
Wool pile on cotton foundation
115 × 85 cm, section of field and border

This section from an imperial dais cover with an octagonal medallion and cloud-collar corners, acquired by Frank Michaelian, possibly in Beijing in the 1920s,[1] is one of only two examples known with this design. The other, which is complete but more coarsely woven, survives in the Palace Museum, Beijing.[2] These two carpets are the only examples known that were made specifically for the dais that sat immediately underneath the imperial throne. The example in Beijing was made for the throne dais in the Hall of Supreme Harmony, placed in front of a great screen on a larger throne platform. This hall lies on a south-north axis in the middle of the Forbidden City, and the emperor was considered here to be sitting at the very centre of the world. The Michaelian section might well be from the Wanli reign period (1572–1620), and the Palace Museum carpet is most likely a slightly later copy.

The very elegant style of drawing seen on the Michaelian section displays the greatest refinement of this pattern. In the centre was an octagonal medallion delineated by a blue band; in each of the four corners was a trefoil motif, the four together forming a cloud-collar. The border is a three-level key pattern with a perfectly composed corner resolution. The plain turquoise, yellow, and black stripes that flank the border are typical of Beijing workshop carpets.

The cloud-collar, which signifies a "sky-door" forming a connection between earth and heaven, appears on the backs of mirrors from the time of the Zhou and Warring States periods through to the Han dynasty.[3] From at least the twelfth century CE, this motif can be found externally around the open centre of the roofs of circular nomadic tents from Central Asia and in particular Mongolia, creating a window to the heavens. The cloud-collar can also be seen on the upper parts of Chinese ceramics of the Mongol period and around the neck of imperial costumes.

This remarkable fragment is from probably the most finely woven carpet, at 650 knots per dm², that survives from the imperial Beijing workshops of the Wanli emperor.[4] This pales in comparison with the finest imperial Mughal Indian pashmina-pile carpets, at more than 30,000 knots per dm². However, the skill of Chinese carpets cannot be measured simply by knot density, but lies rather in their complexity and in the ability of their weavers to combine

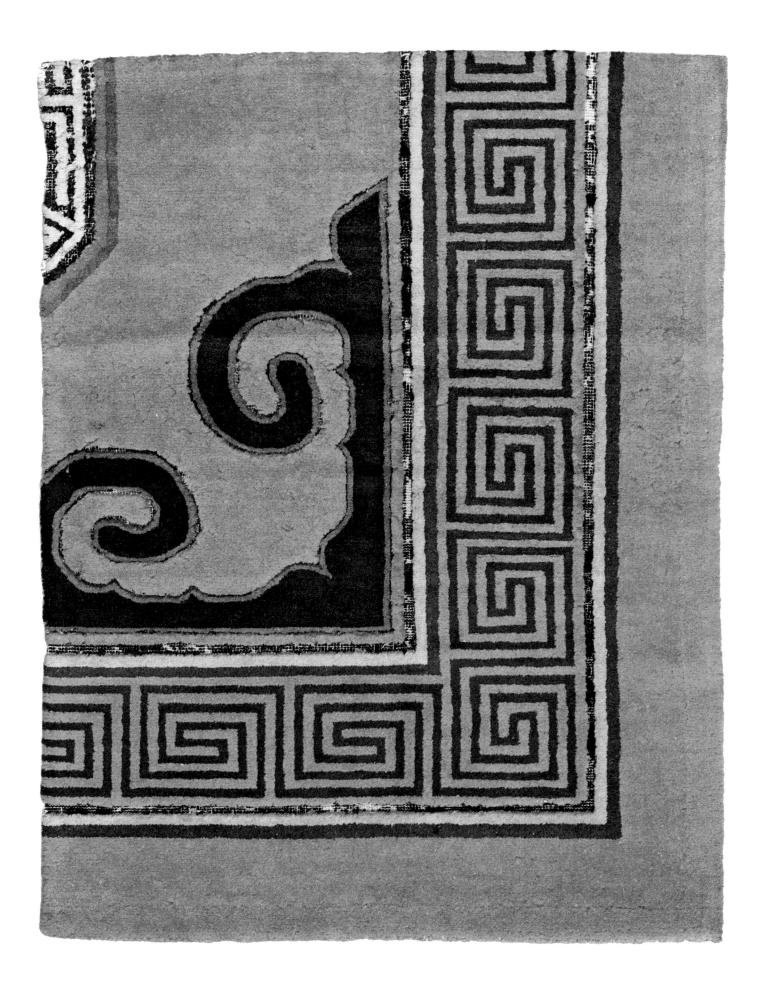

multiple knotting techniques in the same carpet to create elegant curvilinear designs. As Elena Tsareva wrote in 2005: "To make these magnificent and lasting carpets, the craftsmen had to use highly elaborate methods of weaving, incorporating a perfect balance between the thickness of the warps, wefts and pile threads, the knot count and the pile height …. The precise combination of these factors helped the Chinese master weavers to produce carpets with complicated patterns and great strength so that after hundreds of years of intensive use these creations of anonymous artists still radiate charm and beauty."[5]

NOTES

1 Formerly: Wanli emperor, Forbidden City, Beijing; Imperial Palace, Beijing, by descent; Frank M. Michaelian, New York; Vojtech Blau, New York; Textile Gallery, London. Published: *Von Konya bis Kokand, Seltene Orientteppiche*, exhibition catalogue (Munich: Herrmann, 1980), 187, Cat. No. 121; Sotheby's, New York, auction catalogue, December 14, 2006, lot 63.

2 315×240 cm, Palace Museum, Beijing.

3 Schuyler Cammann, "The Symbolism of the Cloud Collar Motif," *The Art Bulletin* 33, no. 1 (March 1951): 1–9.

4 Most of the Wanli carpets have a density of 120–180 knots per dm². See Michael Franses and Hans König, *Glanz der Himmelssöhne, Kaiserliche Teppiche aus China 1400–1750* (London: Textile & Art Publications, 2005). Only the Hall of Supreme Harmony five-dragon carpet (Franses and König, 62–63, Cat. No. 4) approaches 320–420 per dm².

5 Elena Tsareva, "Some Notes on the Structure of Classical Chinese Carpets." In Franses and König, 187–95.

APPENDIX:
STRUCTURE ANALYSES OF CARPETS

Luisella Belleri

Size: Maximum measurement of weft across width
 of carpet × maximum length in centimetres.
Knot Count: Horizontal × vertical in square decimetres (dm²).

Catalogue 29
Size: 108 × 105.
Warp: Wool, undyed, Z2S.
Weft: Wool, undyed, 3Z, 1 shoot.
Knot: Wool, single-warp ("Spanish"), 2Z, 3Z; 37 × 37 = 1,369.
Colours: Nine — blue, deep light blue, dark yellow, light yellow,
 tan, white, black, greenish-brown, reddish-brown.
Sides: Missing.
Ends: Missing.

Catalogue 30
Size: 226 × 162.
Warp: Wool, undyed, S4Z (yellow–light green).
Weft: Wool, red, 3S–4S, 3 shoots (1 slack, 2 tight) or 4 shoots
 (2 slack, 2 tight).
Knot: Wool, 4S, asymmetrical, open to the left;
 30–33 × 28–30 = 840–990.
Colours: Eleven — red, light blue, blue-green, green, lemon yellow,
 green-yellow, beige-yellow, ivory white, brown, black, dark
 violet red (only in a strip in calyces of flowers).
Sides: Not original.
Ends: Not original.

Catalogue 31
Size: 205 × 172.
Warp: Wool, S4Z, straw yellow, yellow-green on fringes.
Weft: Wool, 3S, red, pink, pinkish-beige.
Knot: Wool, 3S, occasionally 2S, asymmetrical, open to the left;
 43 (denser on whole right side, average 46) × 42 = 1,806.

Colours: Nine — dark red, light green, dark green, light blue, dark/
 light blue, yellow, light yellow, white, brown.
Sides: Not original; borders incomplete.
Ends: Incomplete.

Catalogue 32
Size: 399 × 283.
Warp: Wool, deep yellow (ochre), S4Z.
Weft: Wool, Bordeaux red, 2S, 2 shoots, one tight and one slack
 (every shoot is formed of 2 threads); on edge of upper end,
 1 shoot red, 1 shoot yellow.
Knot: Wool, 2S, asymmetrical, open to the left; 56 × 51 = 2,856.
Colours: Ten — Bordeaux red, petroleum green, dark green, light
 green, light yellow, yellow or ochre, light blue, blue, turquoise,
 white.
Sides: Two pairs of two warps wrapped in Bordeaux red wool still
 present in small areas.
Ends: Original, small areas of kilim and some rows of knots are
 missing; on lower end the flatweave is red in colour, like the
 wefts, while on upper end it is in yellow ochre with subtle and
 occasional shoots in red.

Catalogue 33
Size: 733 × 476.
Warp: Silk, yellow-green, S3Z, slightly depressed.
Weft: Bundle of silk threads, vermillion red, 2 shoots.
Knot: Wool, 2S; cotton, 2Z (?); 58 (bottom),
 53–62 (top) × 53 (bottom), 45–48 (top).
Colours: Cotton: (2) ivory white, light blue used in field with fre-
 quent abrash that varies from very light blue to dark turquoise.
 Wool: (8) wine red, yellow, mustard yellow, blue, light blue,
 aquamarine green, petroleum green, black brown.
Sides: Not original.
Ends: Missing on both sides of part of yellow minor border.

Catalogue 34

Size: 527 × 285.

Warp: Wool, undyed, Z2S; wool, rose red, Z2S,
 for approximately 20–30 cm of ends.

Weft: Wool, red, rose red, 1Z, 2Z, 2 shoots (1 slightly tight, 1 slack),
 occasionally 3 shoots (1 slightly tight, 1 slack, 1 slightly tight).

Knot: Wool, symmetrical, 2Z, 3Z, occasionally 1Z; 35 × 42 = 1,435.

Colours: Nine — red, cream, yellow, very light blue, light blue,
 blue, dark blue, petroleum green-blue, black.

Sides: Not original.

Ends: Upper not original; lower not original in places.

Catalogue 35

Size: 547 × 259.

Warp: Wool, undyed fawn, sometimes fawn and brown, Z2S.

Weft: Wool, rose beige, salmon pink or red, Z, 2 shoots (tight-slack).

Knot: Wool, symmetrical; 40 × 32 = 1,280.

Colours: Ten — white, gold yellow, ochre yellow, vermillion red,
 carmine red, light blue, bright blue, dark bright blue,
 peacock green, black.

Sides: Not original.

Ends: Not original.

Catalogue 36

Size: 515 × 208.

Warp: Wool, undyed with different tones from ivory to brown
 (occasionally dyed red, light blue, yellow), Z2S.

Weft: Wool, undyed, 2Z; occasionally wool, red, 1Z.

Knot: Wool, 2Z, symmetrical; 35 × 40 = 1,400.

Colours: Ten — black, white, light yellow, mustard yellow,
 red, light blue, dark blue, light blue, light green,
 petroleum green.

Sides: Not original.

Ends: Not original.

Catalogue 37

Size: 577 × 240.

Warp: Wool, undyed, Z2S.

Weft: Wool, rose, 1Z 2Z, 2 shoots (1 tight, 1 slack, and at
 irregular intervals of 4–8 cm a single tight weft).

Knot: Wool, 2Z, symmetrical; 35 × 31 = 1,085.

Colours: Ten — red, violet, pink, light blue, blue, white,
 beige, brown, yellow, green.

Sides: Not original.

Ends: Not original.

Catalogue 38

Left Fragment

Size: 135 × 326.

Warp: Cotton, undyed, Z4S.

Weft: Cotton, undyed, 3Z, 3 shoots; occasional shoots (in one
 instance 3) of red wool in upper part.

Knot: Wool, 2Z, asymmetrical, open to the left;
 41–43 × 39–44 = 1,599–1,892.

Colours: Eleven — petroleum green, dark blue, light blue, very light
 blue, green, dark yellow, light yellow, white, black, coral red,
 apricot orange.

Sides: Missing.

Ends: Missing.

Right Fragment

Size: 138 × 315.

Warp: Cotton, undyed, Z4S.

Weft: Cotton, undyed, 3Z, 3 shoots; occasional shoots of red wool.

Knot: Wool, 2Z, asymmetrical, open to the left;
 40–42 × 42–44 = 1,680–1,848.

Colours: Ten — petroleum green with a blue abrash in upper part,
 dark blue, light blue, very light blue, dark yellow, light yellow,
 white, black, coral red, apricot orange.

Sides: Missing.

Ends: Missing.

Catalogue 39

Size: 207 × 142.5.

Warp: Cotton, white, Z4S.

Weft: Two tight, 1 slack; tight weft, wool, undyed grey/white,
 yellow, Z2S; slack weft, cotton, white, Z2S.

Knot: Wool, 2Z, asymmetrical, open to the left; 64 × 60 = 3,840.

Colours: Twenty — purple red, violet red (ground colours);
 raspberry red, reddish pink, lilac pink, flesh pink, Bordeaux
 red, cream white, light blue-white, yellow, light green,
 blue-green, turquoise, light blue/grey, pearl grey, grey/brown,
 indigo, sky blue, bright blue, dark blue (others).

Sides: Missing.

Ends: Missing.

Catalogue 40

Size: 551 × 243.

Warp: Cotton, undyed, S2Z.

Weft: Cotton, undyed, Z, 2Z, 3 shoots (2 tight, 1 slack).

Knot: Wool, 2Z, jufti, open to the left, and asymmetrical,
 open to the left; 65 × 80 = 5,200.

Colours: Ten — Bordeaux red, red, white, dark green, light green,
 light blue, blue, brown, orange, yellow.
Sides: Not original.

Catalogue 41

Size: 428 × 231.
Warp: Cotton, undyed, Z8S.
Weft: Cotton, beige, slack, 3Z or 4Z; cotton, beige, tight, 6Z or 5Z;
 bundle of silk threads, red, slack.
Knot: Wool, 3Z to 6Z, asymmetrical, open to the left; 50 × 50 = 2,500.
Colours: Thirteen — red, deep rose, blue, light blue, petroleum
 green, green, light green, yellow-green, light blue green,
 white, ivory, ochre yellow, mustard yellow.
Sides: Left side missing; right side wrapped in beige cotton on
 4 warps.
Ends: Upper end, 1 red weft and then flatweave in beige cotton;
 lower end, flatweave in beige cotton.

Catalogue 42

Size: 235 × 72.
Warp: Silk, undyed, green, red, Z2S, 2 levels.
Weft: Silk, red, unspun or 2Z, 3 shoots (2 tight, 1 slack).
Knot: Pashmina (?) wool, 4Z, asymmetrical, open to the left;
 89 × 79 = 7,031.
Colours: Eleven — light green, dark green, green-blue,
 light green-blue, light rose, dark rose, red, ivory, light yellow,
 sand yellow, light brown.
Sides: Missing.
Ends: Missing.

Catalogue 43

Size: 115 × 85.
Warp: Cotton, white, Z3S (each single threads seems to be
 made up of two threads slightly plied together).
Weft: Cotton, white, Z2, occasionally Z3, 2 shoots (sometimes
 the single weft seems to be made up of 2 threads slightly Z
 twisted).
Knot: Wool, Z3 (deep and light yellow), Z4 (light blue, blue), and Z2
 (black), asymmetrical, open to the left; 25 × 26 = 650;
 irregularities include *jufti* (only in black in vertical border),
 packing knots (of two different colours in same space),
 and 3 knots on 4 warps.
Colours: Eight — dark ochre, light ochre, yellow, ivory, petroleum
 green, blue, light blue, black.
Sides: Missing.
Ends: Warp turned and folded under a light blue cotton band.

BIBLIOGRAPHY

A

Abu'l Fazl 'Allami. *The Akbarnama*. Vol. 1. Translated by Henry Beveridge. Delhi, 1972 reprint.

_____. *The History of Akbar*. Translated and edited by W.M. Thackston. Cambridge, MA: Harvard University Press, 2014.

Achdjian, Albert. *Le tapis: un art fondamental*. Paris: Éditions Self, 1949.

Ackerman, Phyllis. "A Biography of Ghiyath the Weaver." *Bulletin of the American Institute for Persian Art and Archaeology* 7 (1934): 10.

_____. "Textiles Through the Sassanian Period." In *A Survey of Persian Art: From Prehistoric Times to the Present*. Edited by Arthur Upham Pope. New York: Oxford University Press, 1938.

Adamova, Adel T., and Manijeh Bayani. *Persian Painting: The Arts of the Book and Portraiture*. London: Thames & Hudson, 2015.

Aga Khan Museum. *Spirit & Life: Masterpieces of Islamic Art from the Aga Khan Museum Collection*. Geneva: Aga Khan Trust for Culture, 2007.

Alhacen. *Alhacen's Theory of Visual Perception: A Critical Edition*. Vol. 2. Translated with a commentary by A. Mark Smith of the first three books of Alhacen's *De aspectibus*, the medieval Latin version of *Kitab al-Manazir*. Philadelphia: American Philosophical Society, 2001.

Allan, James W. "Merchants and Metal in Early Islamic Iran." *Akten des VII. Internationalen Kongresses für Iranische Kunst und Archäologie* (1979): 522.

_____. "My Father Is a Sun and I Am the Star: Fatimid Symbols in Ayyubid and Mamluk Metalwork." *Journal of The David Collection* 1 (2003).

_____. "'Oljeitu's Oranges': The Grilles of the Mausoleum of Sultan Oljeitu at Sultaniyya." Unpublished essay.

_____. "Silver: The Key to Bronze in Early Islamic Iran." *Kunst des Orients* 11 (Wiesbaden, Germany: 1976/77): 21.

Allan, James W., and A.T. Aron. *Metalwork of the Islamic World: The Aron Collection*. London: Sotheby's, 1986.

Allan, James W., and Nuhad Es-Said. *Islamic Metalwork: The Nuhad Es-Said Collection*. London: Sotheby Parke Bernet Publications, 1982.

Allan, James W., and Francis Maddison. *Metalwork Treasures from the Islamic Courts*. Doha, Qatar: Museum of Islamic Art, 2002.

Allsen, Thomas T. *Commodity and Exchange in the Mongol Empire: A Cultural History of Islamic Textiles*. Cambridge: Cambridge University Press, 1997.

Alpaslan Arca, Sibel. "Catalogue Entries," 146, 152. In *Tulpen, Kaftane und Levni: höfische Mode und Kostümalben der Osmanen aus dem Topkapı Palast Istanbul*. Edited by Deniz Erduman Çalış. Munich: Hirmer, 2008.

Armstrong, Edward A. "The Symbolism of the Swan and the Goose." *Folklore* 55, no. 2 (1944): 54–58.

Atasoy, Nurhan. *A Garden for the Sultan: Gardens and Flowers in the Ottoman Culture*. Translated by Robert Bragner and Angela Roome. Istanbul: Kitap Yayinevi, 2011.

Atasoy, Nurhan, and Julian Raby. *Iznik: The Pottery of Ottoman Turkey*. London: Alexandria Press, 1989.

Atıl, Esin. *Renaissance of Islam: Art of the Mamluks*. Washington, DC: Smithsonian Institution Press, 1981.

B

Bağcı, Serpil. "Takdim Minyatürlerinde Farkli Bir Konu: Süleyman Peygamber'in Divani." In *Sanat Tarihinde Ikonografik Araştırmalar, Festschrift Güner Inal*. Ankara: Hacettepe Üniversitesi, 1993.

Baer, Eva. "'Fish-Pond' Ornaments on Persian and Mamluk Metal Vessels." *Bulletin of the School of Oriental and African Studies, University of London* 31, no. 1 (1968): 14–27.

_____. *Metalwork in Medieval Islamic Art*. New York: State University of New York Press, 1983.

Baker, Patricia L. *Islamic Textiles*. London: British Museum Press, 1995.

Bakır, Sitare Turan. *İznik çinileri ve Gülbenkiyan koleksiyonu*. Ankara: T.C. Kültür Bakanlığı, 1999.

Barthold, Wilhelm. *An Historical Geography of Iran*. Translated by Svat Soucek. Princeton, NJ: Princeton University Press, 1984.

Bausback, Peter. *Antike Orientteppiche*. Braunschweig, Germany: Klinkhardt & Biermann, 1978. World of Islam Festival Publishing Co., 1976.

Beach, Milo Cleveland. "The Gulshan Album and Its European Sources." *Bulletin of the Museum of Fine Arts, Boston* 63, no. 332 (1965): 63–91.

_____. *The Imperial Image: Paintings for the Mughal Court.* Washington, DC: Freer Gallery of Art/Arthur M. Sackler Gallery, Smithsonian Institution, 1981.

Beach, Milo Cleveland, Eberhard Fischer, and B.N. Goswamy, eds. *Masters of Indian Painting.* 2 vols. Zurich: Artibus Asiae Publishers, 2011.

Behrens-Abouseif, Doris. *The Arts of the Mamluks in Egypt and Syria: Evolution and Impact.* Göttingen, Germany: V&R Unipress, 2012.

_____. "The Jalayirid Connection in Mamluk Metalware." *Muqarnas* 26 (2009): 149–59.

Beltrame, Carlo, Sauro Gelichi, and Igor Miholjek. *Sveti Pavao Shipwreck: A 16th Century Venetian Merchantman from Mljet, Croatia.* Oxford: Oxbow Books, 2014.

Bernheimer, Otto. *Alte Teppiche des 16. bis 18. Jahrhunderts der Firma L. Bernheimer.* Munich: Bernheimer, 1959.

Bier, Carol. *Woven from the Soul, Spun from the Heart: Textile Arts of Safavid and Qajar Iran, 16th–19th Centuries.* Washington, DC: Textile Museum, 1987.

Bilgi, Hülya. *Dance of Fire: Iznik Tiles and Ceramics in the Sadberk Hanım Museum and Ömer M. Koç Collections.* Istanbul: Vehbi Koç Foundation, 2009.

Blair, Sheila S., *Islamic Calligraphy.* Edinburgh: Edinburgh University Press, 2006.

_____. "The Mongol Capital of Sultaniyya, 'The Imperial.'" *Iran* 24 (1986): 143.

Blair, Sheila S., and Jonathan Bloom. "Decorative Arts: The Abbasids." In *Islam: Art and Architecture.* Edited by Markus Hattstein and Peter Delius. Potsdam, Germany: HF Ullmann, 2013.

_____. "Decorative Arts of the Great Seljuks." In *Islam: Art and Architecture.* Edited by Markus Hattstein and Peter Delius. Potsdam, Germany: HF Ullmann, 2013.

_____. "Decorative Arts: Islamic Mongols." In *Islam: Art and Architecture.* Edited by Markus Hattstein and Peter Delius. Potsdam, Germany: HF Ullmann, 2013.

Blair, Sheila S., and Jonathan Bloom, eds. *God Is Beautiful and Loves Beauty: The Object in Islamic Art and Culture.* Princeton, NJ: Yale University Press, 2013.

Blair, Sheila S., Jonathan Bloom, and Richard Ettinghausen. *The Art and Architecture of Islam 1250–1800.* New Haven, CT: Yale University Press, 1994.

Bloom, Jonathan, and Sheila S. Blair, eds. *The Grove Encyclopedia of Islamic Art and Architecture.* 3 vols. Oxford: Oxford University Press, 2009.

Bode, Wilhelm von. *Vorderasiatische Knüpfteppiche aus Älterer Zeit.* Leipzig, Germany: Seemann, 1901.

Bode, Wilhelm von, and Ernst Kühnel. *Antique Rugs from the Near East.* New York: E. Weyhe, 1922.

_____. *Antique Rugs from the Near East.* London: Bell & Sons, 1970.

Boehm, Barbara Drake, and Melanie Holcomb. *Jerusalem, 1000–1400: Every People Under Heaven.* New York: Metropolitan Museum of Art, 2016.

Boorstin, Daniel J. *The Discoverers: A History of Man's Search to Know His World and Himself.* New York: Random House, 1985.

Boralevi, Alberto. *L'Oushak Castellani-Stroganoff ed altri tappeti ottomani dal XVI al XVIII secolo.* Florence: KARTA, 1987.

_____. "Un tappeto ebraico italo-egizano." *Critica d'Arte* 49, no. 2 (1984): 34–47.

_____. "View from the Summit." *Hali* 180 (2014): 70–81.

Bösch, Marion. *Mamlukenteppiche. Probleme der Teppichforschung am Beispiel einer Gruppe des 15. bis 16. Jahrhunderts aus dem östlichen Mittelmeerraum.* Graz, Austria: Karl-Franzens Universität Graz, Institut für Kunstgeschichte, 1991.

Brend, Barbara, and Charles Melville, eds. *Epic of the Persian Kings: The Art of Ferdowsi's* Shahnameh. London: I.B. Tauris, 2010.

Briggs, Amy. "Timurid Carpets, I, Geometric Carpets." *Ars Islamica* 7, no. 1 (1940): 20–54.

_____. "Timurid Carpets, II, Arabesque and Flower Carpets." *Ars Islamica* 11/12 (1946): 146–58.

Brown, Percy. *Indian Painting Under the Mughals A.D. 1550 to A.D. 1750.* New York: Hacker Art Books, 1975.

Burnham, Harold B. *Chinese Velvets: A Technical Study.* Toronto: University of Toronto Press, 1959.

C

Çakır Phillip, Filiz. *Enchanted Lines: Drawings from the Aga Khan Museum Collection.* Toronto: Aga Khan Museum, 2014.

_____. *Iranische Hieb-, Stich- und Schutzwaffen des 15. bis 19. Jahrhunderts. Die Sammlungen des Museums für Islamische Kunst der Staatlichen Museen zu Berlin und des Deutschen Historischen Museums (Zeughaus) in Berlin.* Berlin: De Gruyter, 2015.

_____. "The *Shahnama*: On the Forging of Heroes and Weapons." In *Heroic Times: A Thousand Years of the Persian Book of Kings.* Edited by Julia Gonnella and Christoph Rauch. Munich: Edition Minerva, 2012.

Cammann, Schuyler. "The Symbolism of the Cloud Collar Motif." *The Art Bulletin* 33, no. 1 (1951): 1–9.

_____. *Catalogue of Fine Indian and Persian Miniatures and a Manuscript.* London: Sotheby & Company, 1972.

Campbell, Caroline, Sylvia Auld, Alan Chong, Deborah Howard, and J.M. Rogers. *Bellini and the East.* London: National Gallery Company, 2005.

Canby, Sheila R. "Yakut al-Musta'simi." In *The Encyclopaedia of Islam*. New edition, vol. 11, 263–64. Edited by P.J. Bearman. Leiden, Neth.: Brill, 2002.

Canby, Sheila R., Deniz Beyazit, Martina Rugiadi, and A.C.S. Peacock, eds. *Court & Cosmos: The Great Age of the Seljuqs*. New York: Metropolitan Museum of Art, 2016.

Carswell, John. "Ceramics." In *Tulips, Arabesques and Turbans: Decorative Arts from the Ottoman Empire*. Edited by Yanni Petsopoulo. London: Alexandria Press, 1982.

_____. *Iznik Pottery*. London: British Museum Press, 1998.

Cherry, Ron. "History of Sericulture," *Bulletin of the Entomological Society of America* 35 (1989): 83.

Chodyński, Antoni Romuald, ed. *Oręż perski i indoperski XVI–XIX wieku ze zbiorów polskich*. Malbork, Poland: Muzeum Zamkowe w Malborku, 2000.

Cohen, Giuseppe. *Il Fascino del Tappeto Orientale*. Milan: Görlich, 1968.

Cohen, Steven. "'Portuguese' Carpets from Khorasan, Persia." In *Textiles in Indian Ocean Societies*. Edited by Ruth Barnes. London: RoutledgeCurzon, 2005.

Combe, Étienne, Jean Sauvaget, and Gaston Wiet. *Répertoire chronologique d'épigraphie arabe*. Cairo: Institut français d'archéologie orientale du Caire, 1931.

Concaro, Edoardo, and Alberto Levi, eds. *Sovrani Tappeti, Il Tappeto Orientale dal XV al XIX Secolo/Sovereign Carpets, Unknown Masterpieces from European Collections*. Milan: Skira, 1999.

Curatola, Giovanni, ed. *Eredità dell'Islam: Arte islamica in Italia*. Milan: Silvana, 1993.

D

Das, Asok Kumar. *Mughal Painting During Jahangir's Time*. Calcutta: Asiatic Society, 1978.

Degeorge, Gérard, and Yves Porter. *The Art of the Islamic Tile*. Paris: Flammarion, 2002.

Denny, Walter B. *Iznik. The Artistry of Ottoman Ceramics*. London: Thames & Hudson, 2015.

_____. "Turkish Tiles of the Ottoman Empire." *Archaeology* 32, no. 6 (1979): 8–15.

Diba, Layla S., and Maryam Ekhtiar, eds. *Royal Persian Paintings: The Qajar Epoch, 1785–1925*. New York: Brooklyn Museum of Art/I.B. Tauris, 1998.

Dimand, Maurice. "Persian Velvets of the Sixteenth Century." *The Metropolitan Museum of Art Bulletin* 22, no. 4 (1927): 108–11.

Dimand, Maurice, and Jean Mailey. *Oriental Rugs in the Metropolitan Museum of Art*. New York: Metropolitan Museum of Art, 1973.

Doerfer, Gerhard. *Tuerkische und Mongolische Elemente im Neupersischen: unter besonderer Beruecksichtigung aelterer neupersischer Geschichtsquellen, vor allem der Mongolen und Timuridenzeit 3*. Wiesbaden, Germany: F. Steiner, 1963.

E

Edwards, Clara Cary. "Relations of Shah Abbas the Great, of Persia, with the Mogul Emperors, Akbar and Jahangir." *Journal of the American Oriental Society* 35 (1915): 247–68.

Egger, Gerhart. *Hamza-Nāma: Vollständige Wiedergabe der bekannten Blätter der Handschrift aus den Beständen aller erreichbaren Sammlungen*. Graz, Austria: Akademische Druck- u. Verlagsanstalt, 1974.

Eilers, W., M. Bazin, C. Bromberger, and D. Thompson. "Abrisam, Silk." In *Encyclopaedia Iranica*. www.iranicaonline.org/articles/abrisam-silk-index, accessed May 19, 2017.

Ekhtiar, Maryam, et al., eds. *Masterpieces from the Department of Islamic Art in the Metropolitan Museum of Art*. New York: Metropolitan Museum of Art, 2011.

Ellis, Charles Grant. *Early Caucasian Rugs*. Washington, DC: Textile Museum, 1975.

_____. "The 'Lotto' Pattern as a Fashion in Carpets." *Festschrift für Peter Wilhelm Meister* 65 (1975): 19–31.

_____. "Mysteries of the Misplaced Mamluks." *Textile Museum Journal* 2, no. 2 (1967): 2–20.

_____. "The Ottoman Prayer Rugs." *Textile Museum Journal* 2, no. 4 (1969): 5–22.

_____. "The 'Portuguese' Design Carpets of Gujarat." In *Islamic Art in the Metropolitan Museum of Art*. Edited by Richard Ettinghausen. New York: Metropolitan Museum of Art, 1972.

_____. "Where Have the Other Corners Gone?" *Islamic Art* 3 (1989): 209–26.

Encyclopaedia Britannica. "Siege of Vienna." www.britannica.com/event/Siege-of-Vienna-1683, accessed May 19, 2017.

Enderlein, Volkmar. *Die Miniaturen der Berliner Bäisonqur-Handschrift*. Berlin, 1991.

Erdmann, Kurt. "Kairener Teppiche I. Europäische und Islamische Quellen des 15. bis 18. Jahrhunderts." *Ars Islamica* 5 (1938): 179–206.

_____. "Kairener Teppiche II. Mamluken- und Osmanenteppiche." *Ars Islamica* 7 (1940): 55–81.

_____. "Later Caucasian Dragon Carpets." *Apollo* 22 (1935): 21–25.

_____. "Neuere Untersuchungen zur Frage der Kairener Teppiche." *Ars Orientalis* 4 (1961): 65–105.

_____. "Orientalische Tierteppiche auf Bildern des XIV und XV Jahrhunderts." *Jahrbuch der Preussischen Kunstsammlungen* 50 (1929): 261–98.

_____. "Orientteppiche im Besitz des Museums für Kunst und Gewerbe." *Festschrift für Erich Meyer*. Hamburg: Hauswedell, 1959.

_____. "Some Observations on the So-Called 'Damascus Rugs.'" *Art in America and Elsewhere* 19, no. 1 (1930): 3–22.

_____. "Türkische Teppich. III. Die 'Lotto' Teppich." *Heimtex* (1964): 39–43.

Eslami, Kambiz. "Golsan Album." In *Encyclopaedia Iranica*. www.iranicaonline.org/articles/golsan-album, accessed June 30, 2017.

F

Falk, Toby, ed. *Treasures of Islam*. London: Sotheby's/Philip Wilson, 1985.

Farhad, Massumeh, and Serpil Bağcı, eds. *Falnama: The Book of Omens*. Washington, DC: Arthur M. Sackler Gallery, Smithsonian Institution, 2009.

Fehérvári, Géza. *Islamic Metalwork from the Eighth to the Fifteenth Century in the Fehervari Collection*. London: Faber & Faber, 1976.

Felton, Anton. *Jewish Symbols and Secrets: A Fifteenth-Century Spanish Carpet*. London/Portland: Vallentine Mitchell, 2012.

Firdausi. *The Houghton Shahnameh*. Edited by Martin Bernard Dickson and Stuart Cary Welch. Cambridge, MA: Harvard University Press, 1981.

_____. *Shahnama*. Vol. 5. Edited by Rustam Aliyev and A. Nushin. Moscow: Institute of Oriental Studies of the Academy of Sciences of the U.S.S.R., 1967.

_____. *The Shahnama of Shah Tahmasp: The Persian Book of Kings*. Edited by Sheila R. Canby. New York: Metropolitan Museum of Art, 2014.

Folsach, Kjeld von, and Anne-Marie Keblow Bernsted. *Woven Treasures: Textiles from the World of Islam*. Copenhagen: The David Collection, 1993.

Fowlkes-Childs, Blair. "The Sasanian Empire (224–651 A.D.)." *Heilbrunn Timeline of Art History*, Metropolitan Museum of Art, www.metmuseum.org/toah/hd/sass/hd_sass.htm, accessed May 19, 2017.

Franses, Michael. "Ashtapada." *Hali* 167 (2011): 80–89.

_____. "Auction Reports, Classical Carpets in Monte Carlo." *Hali* 2, no. 3 (1979): 255–57.

_____. "An Early Anatolian Animal Carpet and Related Examples." In *God Is Beautiful and Loves Beauty: The Object in Islamic Art and Culture*. Edited by Sheila S. Blair and Jonathan Bloom. Princeton, NJ: Yale University Press, 2013.

_____. "Forgotten Carpets of the Forbidden City." *Hali* 173 (2012): 74–87.

_____. "A Museum of Masterpieces, Safavid Carpets in the Museum of Islamic Art, Qatar." *Hali* 155 (2008): 72–89.

_____. "Some Anatolian Stars." In *Orient Stars: A Carpet Collection*. London: Hali Publications, 1993.

Franses, Michael, and Ian Bennett. *Il Tappeto Orientale dal XV al XVII secolo*. Milan: Eskenazi, 1981.

Franses, Michael, and Hans König, eds. *Glanz der Himmelssöhne, Kaiserliche Teppiche aus China 1400–1750*. London: Textile & Art Publications, 2005.

Franses, Michael, and Robert Pinner. "Turkish Carpets in the Victoria & Albert Museum." *Hali* 6, no. 4 (1984): 356–81.

Franses, Michael, and Daniel Shaffer. "An Early Indian Carpet." *Hali* 28 (1985): 33–39.

G

Gabrieli, Francesco. "Al-Ma'mun e gli 'Alidi." *Morgenländische Texte und Forschungen* 2, no. 1 (1929).

Galloway, Francesca. *Islamic Courtly Textiles & Trade Goods: 14th to 19th Century*. London: Francesca Galloway, 2011.

Gandjavi, S. "Prospection et fouille a Sultaniyeh." *Akten des VII. Internationalen Kongresses für Iranische Kunst und Archäologie* (1979): 523–26.

Gantzhorn, Volkmar. *The Christian Oriental Carpet*. Cologne: Benedikt Taschen, 1991.

Ghazali, al-. *Revival of Religion's Sciences*. Translated by Mohammad Mahdi al-Sharif. Beirut: Dar Al-Kotob Al-ilmiyah, 2011.

Gladiss, Almut von. "Architecture: The Ottoman Empire." In *Islam: Art and Architecture*. Edited by Markus Hattstein and Peter Delius. Potsdam, Germany: HF Ullmann, 2013.

_____. "Decorative Arts: The Ottoman Empire." In *Islam: Art and Architecture*. Edited by Markus Hattstein and Peter Delius. Potsdam, Germany: HF Ullmann, 2013.

_____. "Islamic Metal Art." In *A Collector's Fortune: Islamic Art from the Collection of Edmund de Unger*. Edited by Claus-Peter Haase. Munich: Hirmer, 2007.

Gonnella, Julia, and Christoph Rauch, eds. *Heroic Times: A Thousand Years of the Persian Book of Kings*. Munich: Edition Minerva, 2012.

Gonnella, Julia, Friederike Weis, and Christoph Rauch, eds. *The Diez Albums: Contexts and Contents*. Leiden, Neth.: Brill, 2016.

Grewenig, Meinrad Maria, ed. *Schätze aus 1001 Nacht: Faszination Morgenland* Annweiler, Germany: Völklinger Hütte — Springpunkt Verlag, 2005.

Guy, John, and Jorrit Britschgi. *Wonder of the Age: Master Painters of India, 1100–1900.* New York: Metropolitan Museum of Art, 2011.

H

Haase, Claus-Peter. "Sumptuous Hues of Gold and Colors to Serve the Iranian Narrative of Kings and Heroes: Yet Another Safavid *Shahnama* in Berlin." In *Heroic Times: A Thousand Years of the Persian Book of Kings.* Edited by Julia Gonnella and Christoph Rauch. Munich: Edition Minerva, 2012.

Haase, Claus-Peter, ed. *A Collector's Fortune: Islamic Art from the Collection of Edmund de Unger.* Munich: Hirmer, 2007.

Haldane, Duncan. *Islamic Bookbindings in the Victoria and Albert Museum.* London: World of Islam Festival Trust/Victoria and Albert Museum, 1983.

Hanaway, William L. "Darab-Nama." In *Encyclopaedia Iranica.* www.iranicaonline.org/articles/darab-nama, accessed June 30, 2017.

Hattstein, Markus, and Peter Delius, eds. *Islam: Art and Architecture.* Potsdam, Germany: HF Ullmann, 2013.

Hauenschild, Ingeborg. *Tiermetaphorik in türksprachigen Pflanzennamen.* Wiesbaden, Germany: Harrassowitz, 1996.

Helmecke, Gisela. "Brocade and Velvet." In *A Collector's Fortune: Islamic Art from the Collection of Edmund de Unger.* Edited by Claus-Peter Haase. Munich: Hirmer, 2007.

Hendley, T.H. *Asian Carpets, XVI and XVII Century Designs from the Jaipur Palaces.* London: Griggs, 1905.

Herrmann, Eberhart. *Von Konya bis Kokand, Seltene Orientteppiche.* 1980, Munich: Teppich-Antiquitäten, 1980.

Herzig, Edmund. "The Iranian Raw Silk Trade and European Manufacture in the Seventeenth and Eighteenth Centuries." In *Textiles: Production, Trade, and Demand.* Edited by Maureen Fennell Mazzaoui. New York: Routledge, 2016.

Hiendleder, Stefan, Bernhard Kaupe, Rudolf Wassmuth, and Axel Janke. "Molecular Analysis of Wild and Domestic Sheep Questions Current Nomenclature and Provides Evidence for Domestication from Two Different Subspecies." *Proceedings of the Royal Society B* 269, no. 1494 (May 7, 2002): 893–904.

Himyari, al-. *La péninsule Ibérique au Moyen Âge d'après le Kitab ar-rawd al-mi'tar.* Leiden, Neth.: Brill, 1938.

Hoch, Adrian S. "The Franciscan Provenance of Simone Martini's Angevin St. Louis in Naples." *Zeitschrift für Kunstgeschichte* 58 (1995): 22–38.

Hoeniger, Cathleen S. "Cloth of Gold and Silver: Simone Martini's Techniques for Representing Luxury Textiles." *Gesta* 30, no. 2 (1991): 154–62.

Hond, Jan de, and Luitgard Mols. "A Mamluk Basin for a Sicilian Queen." *The Rijksmuseum Bulletin* 59, no.1 (2011): 6–33.

I

Idrisi, al-. *Descripción de España.* Madrid: Imprenta y Litografía del Depósito de la Guerra, 1901.

Ismail ibn Kathir. *Al-Bidaya wa'n-nihaya.* Edited by Abdallah bin Abdalmuhsin al-Turki. Giza, Egypt: 1998.

J

Jacoby, David. "Silk Economics and Cross-Cultural Artistic Interaction: Byzantium, the Muslim World, and the Christian West." *Dumbarton Oaks* 58 (2004): 197–240.

Jahangir. *The Jahangirnama: Memoirs of Jahangir, Emperor of India.* Translated by W.M. Thackston. Washington, DC/New York: Freer Gallery of Art and Arthur M. Sackler Gallery, Smithsonian Institution/Oxford University Press, 1999.

Jodidio, Philip, Ruba Kana'an, Henry S. Kim, Assadullah Souren Melikian-Chirvani, Luis Monreal, and D. Fairchild Ruggles. *Pattern and Light: Aga Khan Museum.* Toronto/New York: Aga Khan Museum/Skira Rizzoli, 2014.

K

Kafadar, Cemal. "A Rome of One's Own: Reflection on Cultural Geography and Identity in the Lands of Rum." *Muqarnas* 24 (2007): 7–25.

Kelley, Charles Fabens, and Margaret O. Gentles, eds. *An Exhibition of Antique Oriental Rugs.* Chicago: Art Institute of Chicago 1947.

Kendrick, A.F., and C.E.C. Tattersall. *Hand-Woven Carpets: Oriental and European.* London: Benn Brothers, 1922.

Komaroff, Linda. "Tragbare islamische Objekte." In *Kunstgeschichte Global: Europa, Asien, Afrika und Amerika 1300–1600.* Edited by Ulrich Pfisterer and Matteo Burioni. Darmstadt, Germany: Wissenschaftliche Buchgesellschaft, 2017.

Komaroff, Linda, and Stefano Carboni, eds. *The Legacy of Genghis Khan: Courtly Art and Culture in Western Asia, 1256–1353.* New York: Metropolitan Museum of Art, 2002.

L

Laird, Elizabeth. *Two Crafty Jackals: The Animal Fables of Kalilah and Dimnah.* Toronto: Aga Khan Museum, 2013.

Lamm, Carl Johann. "The Marby Rug and Some Fragments of Carpets Found in Egypt." *Svenska Orientsällskapets, Årsbok 1937* (1937): 51–130.

Lane, Arthur. "The Ottoman Pottery of Iznik." *Ars Orientalis* 2 (1957): 247–81.

Lane-Poole, Stanley. *The Art of the Saracens in Egypt*. Beirut: Librarie Byblos, 2012 reprint.

Leach, Linda York. *Indian Miniature Paintings and Drawings*. Cleveland, OH: Cleveland Museum of Art, 1986.

Lentz, Thomas W., and Glenn D. Lowry. *Timur and the Princely Vision: Persian Art and Culture in the Fifteenth Century*. Washington, DC: Smithsonian Institution Press, 1989.

Lessing, Ferdinand, ed. *Mongolian-English Dictionary*. Berkeley, CA: University of California Press, 1960.

Little, Donald P. "The Founding of Sultaniyya: A Mamluk Version." *Iran* 16 (1978): 170–75.

Louvre. "Three Empires of Islam: Masterpieces of Ottoman, Safavid and Mughal Art from the Louvre Museum." http://mini-site.louvre.fr/trois-empires/en/informations.php, accessed May 19, 2017.

M

Mack, Rosamond E. *Bazaar to Piazza: Islamic Trade and Italian Art, 1300–1600*. Berkeley, CA: University of California Press, 2002.

Mackie, Louise W. *Symbols of Power: Luxury Textiles from Islamic Lands, 7th–21st Century*. Cleveland: Cleveland Museum of Art, 2015.

Mahir, Banu. "Osmanlı Sanatında Saz Üslubundan Anlaşılan." *Topkapı Sarayı Müzesi: Yıllık* 2 (1987): 123–33.

_____. "Saray Nakkaşhanesinin ünlü Ressamı Şah Kulu ve Eserleri." *Topkapı Sarayı Müzesi: Yıllık* 1 (1986): 113–30.

Makariou, Sophie, and Carine Juvin. *The Arts of the Mamluks in Egypt and Syria: Evolution and Impact*. Edited by Doris Behrens-Abouseif. Göttingen, Germany: V&R Unipress, 2012.

Mannheim, Franz Bausback. *Antike Meisterstücke Orientalischer Knüpfkunst*. Edited by Peter Bausback. Mannheim, Germany: Bausback, 1975.

Marshak, B.I., and M.G. Kramarovsky. "A Silver Bowl in the Walters Art Gallery, Baltimore: Thirteenth-Century Silversmiths' Work in Asia Minor." *Iran* 31 (1993): 119–126.

Martin, F.R. *The History of Oriental Carpets Before 1800*. Vienna: I. and R. State and Court Printing Office, 1908.

Maternati-Baldouy, Danielle. *Un collectionneur et mécène marseillais: faïences provençales et céramiques ottomanes*. Marseille: Musées de Marseille, 2006.

Matthee, Rudolph R. *The Politics of Trade in Safavid Iran: Silk for Silver, 1600–1730*. Cambridge, UK: Cambridge University Press, 1999.

Mayer, L.A. *Islamic Metalworkers and Their Works*. Geneva: A. Kundig, 1959.

McWilliams, Mary. "A Safavid Velvet in the Isabella Stewart Gardner Museum, Boston: A Contribution to the 'Botanical' Study of Safavid Voided Velvets." In *Carpets and Textiles in the Iranian World 1400–1700: Proceedings of the Conference Held at the Ashmolean Museum on 30–31 August 2003*. Edited by Jon Thompson, Daniel Shaffer, and Pirjetta Mildh. Oxford: May Beattie Archive, Ashmolean Museum, University of Oxford, 2010.

Meister, Michael W. "The Pearl Roundel in Chinese Textile Design." *Ars Orientalis* 8 (1970): 255–67.

Melikian-Chrivani, Assadullah Souren. "Bargostvan." www.iranicaonline.org/articles/bargostvan-armor-specifically-horse-armor-a-distinctive-feature-of-iranian-warfare-from-very-early-times-on, accessed June 24, 2017.

_____. *Le chant du monde: l'art de l'Iran Safavide 1501–1736*. Paris: Somogy/Musée du Louvre, 2007.

_____. "Parand and Parniyan Identified: The Royal Silks of Iran from Sasanian to Islamic Times." *Bulletin of the Asia Institute*, New Series 5 (1991): 175–79.

_____. "Le royaume de Salomon: les inscriptions persanes de sites achéménides." In *Le Monde Iranien et l'Islam* 1. Geneva and Paris: Librairie Droz, 1971.

_____. "State Inkwells in Islamic Iran." *The Journal of the Walters Art Gallery* 44 (1986): 70–71.

Mills, John. "'Lotto' Carpets in Paintings." *Hali* 3, no. 4 (1981): 278–89.

Mols, Luitgard E.M. *Mamluk Metalwork Fittings in their Artistic and Architectural Context*. Delft, Neth.: Eburon, 2006.

Mostra Mercato Internazionale dell'Antiquariato: 2a Biennale. Florence: Vallechi Editore, 1961.

Mueller, Claudius. "Kunst- und Ausstellungshalle der Bundersrepublik Deutschland, und Staatliches Museum für Völkerkunde München." In *Dschingis Khan und seine Erben: Das Weltreich der Mongolen*. Munich: Hirmer, 2005.

Munroe, Nazanin Hedayat. "Fashion in Safavid Iran." *Heilbrunn Timeline of Art History*, www.metmuseum.org/toah/hd/safa_f/hd_safa_f.htm, accessed May 19, 2017.

_____. "Silks from Ottoman Turkey." *Heilbrunn Timeline of Art History*, www.metmuseum.org/toah/hd/tott/hd_tott.htm, accessed May 19, 2017.

_____. "Silk Textiles from Safavid Iran, 1501–1722." *Heilbrunn Timeline of Art History*, www.metmuseum.org/toah/hd/safa_3/hd_safa_3.htm, accessed May 19, 2017.

N

Necipoğlu, Gülru. "From International Timurid to Ottoman: A Change of Taste in Sixteenth-Century Ceramic Tiles." *Muqarnas* 7 (1990): 136–70.

Neugebauer, Rudolf, and Julius Orendi. *Handbuch der Orientalische Teppichkunde*. Leipzig, Germany: Hiersmann, 1923.

Nöldeke, Theodor. *Das Iranische Nationalepos*. In *Grundriss der Iranischen Philologie*. Edited by Wilhelm Geiger and Ernst Kuhn. Vol. 2 (Berlin, 1896–1904; 2nd ed., Berlin, 1920; Berlin/New York, 1974 reprint): 130–211.

O

O'Kane, Bernard. *The Treasures of Islamic Art in the Museums of Cairo*. Cairo and New York: American University in Cairo, 2006.

Okumura, Sumiyo. "Garments of the Ottoman Sultans." Turkish Cultural Foundation. www.turkishculture.org/textile-arts-159.htm, accessed May 19, 2017.

Otto-Dorn, Katharina, ed. *Das islamische Iznik*. Berlin: Archäologisches Institut des Deutschen Reiches, 1941.

Öz, Tahsin. *Turkish Ceramics*. Ankara: Turkis Press, Broadcasting and Tourist Department, 1954.

———. *Turkish Textiles and Velvets*. Ankara: Turkish Press, Broadcasting and Tourist Department, 1950.

P

Paquin, Gerard. "Çintamani." *Hali* 64 (1992): 104–19, 143–44.

Pevsner, S. B. "Bronzovyi penal v sobranii Gosudarstvennogo Muzeya kul'turi i iskusstva narodov vostoka." *Epigrafika Vostoka* 19 (1969): 51–58.

Pfaffenbichler, Brigitte Matthias. "Die Begegnung Europas mit dem Osmanischen Reich." In *Schätze aus 1001 Nacht, Völklinger Hütte*. Edited by Meinrad Maria Grewenig. Annweiler, Germany: Plöger, 2005.

Phipps, Elena. "Lampas." In *Looking at Textiles: A Guide to Technical Terms*. Los Angeles: J. Paul Getty Museum, 2011.

Pinner, Robert. "Multiple and Substrate Designs in Early Anatolian and East Mediterranean Carpets." *Hali* 42 (1988): 23–42.

Pinner, Robert, and Michael Franses. "The East Mediterranean Carpet Collection [in the Victoria & Albert Museum]." *Hali* 4, no. 1 (1981): 37–52.

Pitarakis, Brigitte, and Christos Merantzas. *Treasured Memory: Ecclesiastical Silver from the Late Ottoman Istanbul in the Sevgi Gönül Collection Istanbul*. Istanbul: Sadberk Hanım Museum, 2006.

Pliny the Elder. *Naturalis Historia*. 3 vols. Translated by D. Detlefsen. Berlin: Weidmann, 1866.

Pollak, Ludwig, and Antonio Muñoz. *Pièces de choix de la collection du comte Grégoire Stroganoff à Rome*. Rome: Imprimerie de l'Unione Editrice, 1911.

Pope, Arthur Upham, ed. *A Survey of Persian Art: From Prehistoric Times to the Present*. London: Oxford University Press, 1938.

R

Raby, Julian. "Court and Export: Part 2. The Ushak Carpets." In *Oriental Carpet & Textile Studies II*. Edited by Robert Pinner and Walter B. Denny (London: Hali Publications, 1986).

———. "The Principal of Parsimony and the Problem of the 'Mosul School of Metalwork.'" In *Metalwork and Material Culture in the Islamic World: Art, Craft and Text*. Edited by Venetia Porter and Mariam Rosser-Owen. London: I. B. Tauris, 2012.

Raby, Julian, and James W. Allan. "Metalwork." In *Tulips, Arabesques and Turbans: Decorative Arts from the Ottoman Empire*. Edited by Yanni Petsopoulos. London: Alexandria Press, 1982.

Raby, Julian, and Alison Effeny, eds. *İpek: The Crescent and the Rose: Imperial Ottoman Silks and Velvets*. London: Azimuth, 2001.

Rackham, Bernard. *Islamic Pottery and Other Italian Maiolica: Illustrated Catalogue of a Private Collection*. London: Faber & Faber, 1959.

Ribeiro, Maria Queiroz. "Eastern Islamic Art." In *Calouste Gulbenkian Museum*. Edited by João Carvalho Dias. Lisbon: Calouste Gulbenkian Foundation, 2011.

———. *Iznik Pottery and Tiles in the Calouste Gulbenkian Collection*. Lisbon: Calouste Gulbenkian Foundation, 2009.

Robbeets, Martine Irma. *Is Japanese Related to Korean, Tungusic, Mongolic and Turkic?* Wiesbaden, Germany: Harrassowitz, 2005.

Rossabi, Morris. *The Mongols: A Very Short Introduction*. Oxford: Oxford University Press, 2012.

Roxburgh, David J. *The Persian Album, 1400–1600: From Dispersal to Collection*. New Haven, CT: Yale University Press, 2005.

———. *Writing the Word of God: Calligraphy and the Qur'an*. Houston, TX: Museum of Fine Arts, 2007.

Roxburgh, David J., ed. *Turks: A Journey of a Thousand Years, 600–1600*. London: Royal Academy of Arts, 2005.

Rumi, Jalal al-Din. *Spiritual Verses: The First Book of the* Masnavi-ye Ma'navi. Translated by Alan Williams. London/New York: Penguin, 2006.

S

Şahin, Seracettin, ed. *The 1400th Anniversary of the Qur'an*. Istanbul: Antik A.Ş. Publications, 2010.

Salam-Liebich, Hayat. "Masterpieces of Persian Textiles from the Montreal Museum of Fine Art Collection." In *The Carpets and Textiles of Iran: New Perspectives in Research 1992. Iranian Studies* 25, nos. 1–2 (1992): 24.

Sardar, Marika. "Silk Along the Seas: Ottoman Turkey and Safavid Iran in the Global Textile Trade." In *Interwoven Globe: The Worldwide Textile Trade, 1500–1800*. Edited by Amelia Peck. London: Thames & Hudson, 2013.

Sardi, Maria. "Swimming Across the Weft: Fish Motifs on Mamluk Textiles." In *Art, Trade and Culture in the Islamic World and Beyond: From the Fatimids to the Mughals: Studies Presented to Doris Behrens-Abouseif*. Edited by Alison Ohta, Michael Rogers, and Rosalind Wade Haddon. London: Gingko Library, 2016.

Sarre, Friedrich. "A 'Portuguese' Carpet from Knole." *The Burlington Magazine* 58, no. 338 (1931): 214–19.

Sarre, Friedrich, and Hermann Trenkwald. *Old Oriental Carpets*. Vienna: Anton Schroll & Co.; Leipzig, Germany: Karl W. Hiersemann, 1926–29.

Schimmel, Annemarie. *Calligraphy and Islamic Culture*. New York: New York University Press, 1984.

Schlombs, Adele. Foreword. In *Glanz der Himmelssöhne, Kaiserliche Teppiche aus China 1400–1750* (London: Textile & Art Publications, 2005), 6–7.

Schürmann, Ulrich. *Bilderbuch für Teppichsammler*. Munich: Kunst und Technik Verlag, 1960.

_____. *Kaukasische Teppiche*. Braunschweig, Germany: Klinkhardt & Biermann, 1961.

_____. *Kaukasische Teppiche*. Braunschweig, Germany: Klinkhardt & Biermann, 1964.

_____. *Oriental Carpets*. London: Hamlyn, 1966.

_____. *The Pazyryk: Its Uses and Origin*. New York: Symposium of the Armenian Rugs Society, 1982.

Serjeant, R.B. *Islamic Textiles: Material for a History up to the Mongol Conquest*. Beirut: Librairie du Liban, 1972.

Seyller, John William. "Codicological Aspects of the Victoria and Albert Museum *Akbarnama* and Their Historical Implications." *Art Journal* 49, no. 4 (1990): 379–87.

Seyller, John William, and W.M. Thackston. *The Adventures of Hamza: Painting and Storytelling in Mughal India*. Washington, DC: Freer Gallery of Art, 2002.

Sheperd, Dorothy G. "A Persian Velvet of the Shah Tahmasp Period." *The Bulletin of the Cleveland Museum of Art* 36, no. 4 (1949): 46, 49, 53.

Sherrill, Sarah B. *Carpets and Rugs of Europe and America*. New York: Abbeville Press, 1996.

Sims, Eleanor. "Ibrahim-Sultan's Illustrated *Zafar-nameh* of 839/1436." *Islamic Art* 4 (1990–91): 175–217.

_____. "Ibrahim-Sultan's Illustrated *Zafarnama* of 1436 and Its Impact in the Muslim East." In *Timurid Art and Culture: Iran and Central Asia in the Fifteenth Century*. Edited by Lisa Golombek and Maria Subtelny. Leiden, Neth.: Brill, 1992.

Sims, Eleanor, Boris I. Marshak, and Ernst J. Grube. *Peerless Images: Persian Painting and Its Sources*. New Haven, CT: Yale University Press, 2002.

Sonday, Milton. "A Group of Possibly Thirteenth-Century Velvets with Gold Disks in Offset Rows." *Textile Museum Journal* (1999/2000): 101–51.

_____. "Pattern and Weaves: Safavid Lampas and Velvet." In *Woven from the Soul, Spun from the Heart: Textile Arts of Safavid and Qajar Iran, 16th–19th Centuries*. Edited by Carol Brier. Washington, DC: Textile Museum, 1987.

Soucek, Priscilla P. "Ebrahim Soltan." www.iranicaonline.org/articles/ebrahim-soltan, accessed July 12, 2017.

Spallanzani, Marco. *Carpet Studies 1300–1600: Bruschettini Foundation for Islamic and Asian Art, Textile Studies III*. Genoa: Sagep Editori, 2016.

_____. *Metalli Islamici: A Firenze nel Rinascimento*. Florence: SPES, 2010.

Spuhler, Friedrich. *Al-Sabah Collection, Kuwait: Pre-Islamic Carpets and Textiles from Eastern Lands*. London: Thames & Hudson, 2014.

_____. *Islamic Carpets and Textiles in the Keir Collection*. London: Faber & Faber, 1978.

Stein, M. Aurel. *Innermost Asia: Detailed Report of Explorations in Central Asia, Kansu and Eastern Iran*. Oxford: Clarendon Press, 1928.

Stöckel, J.M., E. Kühnel, and A. Riegl. *Orientalische Teppiche*. Vienna: Österreichischen Handels-Museum, 1892.

Stronach, David. *Pasargadae: A Report on the Excavations Conducted by the British Institute of Persian Studies from 1961 to 1963*. Oxford: Oxford University Press, 1978.

Stronge, Susan. *Painting for the Mughal Emperor: The Art of the Book, 1560–1660*. London: Victoria and Albert Museum, 2002.

Suriano, Carlo Maria. "A Mamluk Landscape: Carpet Weaving in Egypt and Syria Under Sultan Qaitbay." *Hali* 134 (2004): 94–105.

T

Tabari, al-. *The History of al-Tabari*. Vol. 32. Translated by C.E. Bosworth. Albany, NY: State University of New York Press, 1987.

Tanındı, Zeren. "Topkapı Palace." In *Encyclopaedia Iranica*. www.iranicaonline.org/articles/topkapi-palace, accessed May 19, 2017.

Tezcan, Hülya, Selma Delibaş, and J.M. Rogers. *The Topkapı Saray Museum: Costumes, Embroideries and Other Textiles*. Boston: Little, Brown, 1986.

Thompson, Jon. "Medallion Carpets of Ushak: An Inheritance from the Timurid and Turkoman Dynasties." In *The Sarre Mamluk and 12 Other Classical Rugs.* London: Lefevre, 1980.

_____. *Milestones in the History of Carpets.* Milan: Moshe Tabibnia, 2006.

_____. *Silk 13th to 18th Centuries: Treasures from the Museum of Islamic Art, Qatar.* Doha: National Council for Culture, Arts and Heritage, 2004.

Thompson, Jon, and Sheila R. Canby. *Hunt for Paradise: Court Arts of Safavid Iran, 1501–1576.* Milan: Skira, 2003.

Tokatlian, Armen. *Falnamah: livre royal des sorts.* Paris: Gourcuff-Gradenigo, 2007.

Townsend, Gertrude. "A Persian Velvet." *Bulletin of the Museum of Fine Arts* 26, no. 154 (1928): 24–29.

Trilling, James. *Ornament: A Modern Perspective.* Seattle: University of Washington Press, 2003.

U

Uluç, Lale. *Turkman Governors, Shiraz Artisans, and Ottoman Collectors: Sixteenth-Century Shiraz Manuscripts.* Istanbul: Türkiye İş Bankası, 2006.

Unger, Edmund de. "The Origin of the Mamluk Carpet Design." *Hali* 2, no. 4 (1980): 321–22.

W

Walker, Daniel. *Flowers Underfoot: Indian Carpets of the Mughal Era.* New York: Metropolitan Museum of Art, 1997.

Ward, Rachel. "Brass, Gold and Silver from Mamluk Egypt: Metal Vessels Made for Sultan Al-Nasir Muhammad. A Memorial Lecture for Mark Zebrowski." *Journal of the Royal Asiatic Society, Third Series* 14, no. 1 (2004): 62.

Ward, Rachel, ed. *Court and Craft: A Masterpiece from Northern Iraq.* London: Paul Holberton Publishing, 2014.

Wardwell, Anne E. "Flight of the Phoenix: Crosscurrents in Late Thirteenth- to Fourteenth- Century Silk Patterns and Motifs." *Bulletin of the Cleveland Museum of Art* 74, no. 1 (1987): 3.

_____. *Panni Tartarici: Eastern Islamic Silks Woven with Gold and Silver (13th and 14th Centuries).* Genoa: Bruschettini Foundation for Islamic and Asian Art/New York: Islamic Art Foundation, 1989.

_____. "Two Silk and Gold Textiles of the Early Mongol Period." *The Bulletin of the Cleveland Museum of Art* 79, no. 10 (1992): 354–78.

Watt, James C.Y., Anne E. Wardwell, and Morris Rossabi. *When Silk Was Gold: Central Asian and Chinese Textiles.* New York: Metropolitan Museum of Art/Cleveland Museum of Art, 1997.

Welch, Anthony. *Collection of Islamic Art, Prince Sadruddin Aga Khan.* 4 vols. Geneva: Château de Bellerive, 1972 and 1978.

Welch, Stuart Cary. "The Islamic World." New York: Metropolitan Museum of Art, 1987.

Wilckens, Leonie von. "The Quedinburg Carpet." *Hali* 65 (1992): 96–105.

Wing, Patrick. "Rich in Goods and Abounding in Wealth: The Ilkhanid and Post-Ilkhanid Ruling Elite and the Politics of Commercial Life at Tabriz, 1250–1400." In *Politics Patronage and the Transmission of Knowledge in 13th–15th Century Tabriz.* Edited by Judith Pfeiffer. Leiden, Neth.: Brill, 2014.

Wright, Elaine. *The Look of the Book: Manuscript Production in Shiraz, 1303–1452.* Washington, DC: Freer Gallery of Art, Smithsonian Institution, 2012.

Y

Yalman, Suzan. "The Art of the Timurid Period (ca. 1370–1507)." www.metmuseum.org/toah/hd/timu/hd_timu.htm, accessed May 19, 2017.

Yetkin, Serare. *Early Caucasian Carpets in Turkey.* London: Oguz Press, 1978.

Z

Ziegler, Gudrun, and Alexander Hogh. *Die Mongolen: Im Reich des Dschingis Khan.* Stuttgart, Germany: Theiss, 2005.

CONTRIBUTORS' BIOGRAPHIES

Filiz Çakır Phillip is Curator at the Aga Khan Museum in Toronto. She previously worked as a curator at the Museum für Islamische Kunst in Berlin and was Senior Fellow at Excellence Cluster TOPOI and Research Fellow at both the Kunsthistorisches Institut — Max-Planck-Institut in Florence and the Metropolitan Museum of Art in New York. Çakır Phillip is the author of *Enchanted Lines: Drawings from the Aga Khan Museum Collection* (2014) and *Iranian Arms and Armour from the 15th–19th Centuries* (2016). She has curated numerous exhibitions since the opening of the Aga Khan Museum in 2014, including *In Search of the Artist: Signed Drawings and Paintings from the Aga Khan Museum Collection* (2014); *Inspired by India: Paintings by Howard Hodgkin* (2015) and *Visions of Mughal India: The Collection of Howard Hodgkin* (2015); and *A Thirst for Riches: Carpets from the East in Paintings from the West* (2015), in collaboration with the Metropolitan Museum of Art. Her most recent exhibitions were *A City Transformed: Images of Istanbul Then and Now* (2016) and *Syria: A Living History* (2016).

Michael Franses was born in Brighton, England, in 1949. He co-founded the International Conference on Oriental Carpets and *Hali* magazine, of which he was Publisher and Co-Editor until 1986 and is still a contributor. He was the owner of London's The Textile Gallery and Longevity Textile Conservation from 1971 to 2009 after which he retired from business to devote himself to full-time research. In 2010 he received the George Hewitt Myers Award in recognition of lifetime contributions, having written over sixty articles and several books. From 2011 to 2016, he was the director of Special Cultural Projects at Qatar Museums. Currently, he lives in Florence, Italy.

Claus-Peter Haase has been Honorary Professor at the Free University in Berlin, Institute for Art History, since 2004. Between 1998 and 2001, he taught Islamic art and archaeology at the University of Copenhagen. He was the Director of the Museum of Islamic Art in Berlin from 2001 to 2009. In the 1980s, he was involved in the cataloguing project "Katalogisierung der Orientalischen Handschriften in Deutschland" and also worked on an archaeological excavation project of early Islamic settlements in Syria.

ACKNOWLEDGEMENTS

The Aga Khan Museum, The Bruschettini Foundation for Islamic and Asian Art, and the contributors would like to acknowledge and thank the following people for their very kind assistance in the preparation of this catalogue: Nora von Achenbach, James Allan, Rainer Arnold, Zeynep Atbaş, Peter Bausback, Luisella Belleri, Ian Bennett, Annette Beselin, Deniz Beyazıt, Alberto Boralevi, Patricia Brattig, Alessandro Bruschettini, Michael Carroll, Christie's, Alessandra Cirelli, Steven Cohen, Walter Denny, Charles Grant Ellis, FAI Fondo Ambiente Italiano, Tom Farnham, Tiago Patrício Gouveia, Hannes Halder, Zhang He, Bruce Healy, Yuan Hongqi, Alison Kenzie, Donald King, Linda Komaroff, Sumru Krody, Jens Kröger, Georg Kugler, Anu Liivandi, Detlef Maltzahn, Rüdiger Mayer, Charles Melville, John Mills, Gunnar Musan, Esra Müyesseroğlu, Antonella Nesi, Ludovica Nicolai, Open Care — Servizi per l'arte (Milano), Murathan Özgen, Robert Pinner, Bita Pourvash, Julian Raby, Elisabetta Raffo, Christoph Rauch, Lidia Rende, William Robinson, Elisabeth Rochau-Shalem, Alexandra Yasmina Roy, R. T. Restauro Tessile, Alessandro Ruggera, Robert Sackville-West, Ali and Ina Sarikhani, Clara Serra, Daniel Shaffer, Pankaj Sharma, Shrimati Krishna Kanta Sharma, Emma Slocombe, Sotheby's, Laure Soustiel, Maria Subtelny, Moshe Tabibnia, Textile Conservation Department (Metropolitan Museum of Art), Lale Uluç, Rachel Ward, Rupert Waterhouse, and Li Wenru.

INDEX

House of Wisdom, 14
Hülegü, 124, 126
Humayun, Mughal Emperor, 100, *101*, 102
Humayun Defending the Afghans, 102
Hungary, 118
Husayn, Imam, 24, 106

I
Ibn al-Haytham (Alhacen), 88, 89
Ibn Iyas, 30, 32
Ibn Tabataba, 104, 106
Ibrahim Sultan, 64, 72, 74, 76
Ilkhanid (Mongols), 14, 22, 32, 33, 40, 74, 118, 122,
 124, 160
Imam Reza Shrine, 220
India (*see also* Mughal Empire, Mughals), 32, 43,
 63, 72, 93, 107, 112, 114, 150, 162–63, 212, 214, 220
*Indulgent Vizier Pleads for the Life of a Robber's
 Son, The*, 102
International Timurid Style, 39, 40, 43
Iran, 14, 15, 20, 22, 33, 40, 41, 42, 62, 64, 65, 78, 80,
 92, 93, 100, 104, 117–20, 124, 130, 136, 140, 144,
 152, 158, 159–62, 165, 167, 196, 202, 208, 212, 214
Iraq, 15, 104, 117, 118, 122, 160
Isfahan, 78, 114, 119, 136, 161, 162, 212
*Iskandar Oversees the Building of the Wall Against
 Gog and Magog*, 97, 99
Ismail I, Shah, 160, 166, 204
Ismail ibn Kathir, 104
Ismailis, 62, 94
Israel, 15, 92
Istanbul (*see also* Constantinople), 40–42, 46,
 77, 84, 119, 140, 142, 144, 146, 149, 158, 161, 166,
 182, 184, 187, 204
Italy, 54, 61, 128, 150, 156, 159, 168, 176, 188, 190, 204
Izmir, 41, 74
Iznik, 41, 42, 44, 46, 56, 119, 146

J
Ja'far al-Sadiq, 62, 94
Jahangir (Salim), Mughal Emperor, 65, 66, 74,
 108, *109*, 111, 112, 114, 162–63, 216, 222
Jahangirnameh, 108
Jaipur Palace Shaped Shrub Carpet (Cat. No. 41),
 163, 216, *217*, *218*, *219*
Japan, 150
Jazira, 15, 20
Jiajing emperor, 164
jinn, 90, 92
John XXII, Pope, 165
Jordan, 15, 152

Joshagan, 161
Juvin, Carine, 28

K
Ka'ba, 106, 107
*Kai Khusrau Distributes His Treasury to His
 Generals*, 25
Kann, Alphonse, 182
Kar-Kiya dynasty, 64, 82
Kara Memi, 41, 42, 46, 48, 52, 54, 144
Kara Mustafa Pasha, Grand Vizier, 130, 134
Karabagh, 150, 158, 196, 200
Karnal, 110
Kashan, 130, 161
Kazak, 158
Kazakhstan, 34
Kazumasa, Ogawa, 164
Kemha with Çintemani (Cat. No. 27), 140, *141*,
 142, *143*
Kemha with Floral Motif (Cat. No. 28), 122, 144,
 145, *146*, *147*
Kerman, 150, 161, 162, 196, 208
Khamseh (Quintet), 78, 134
Khorasan, 78, 104, 107, 196, 212, 214
Khotan, 162
kitabkhaneh, 64, 98, 102
Komaroff, Linda, 121
Konya, 86, 155
Korea, 118
Kufa, 104, 106
Kühnel, Ernst, 153, 166, 186
Kurdistan, 212
Kurds, 160
kursi, 14, 26, 28
Kütahya, 42

L
Lahijan, 82
La'l, 100, 102, *103*
Lampas Panel (Cat. No. 22), 122, *123*, 124, *125*,
 130, 144
Lampas Panel with Courtly Scene (Cat. No. 26),
 116, *117*, 138, *139*
Lebanon, 15
Lessing, Julius, 149
Letur, 150
Lion Hunt of Prince Salim, The (Cat. No. 20), 65,
 66, 108, *109*, 110, *111*
Lotto, Lorenzo, 192
"Lotto" Arabesque Carpet (Cat. No. 35), *157*, 192,
 193, 194, *195*

Louis XIV (France), King, 114

M
Maciet carpet, 188
Mackie, Louise W., 124
Maharaja Mirza Raja Jai Singh I, 216
maharajas of Jaipur, 162, 163
Mahir, Banu, 43
Mahmud Tughluq, Shah/Sultan, 2, 72, *73*
Majolica, 54
Makariou, Sophie, 28
Malik Dailami, 94
Mamluk, 14, 18, 20, 26, 28, 30, 32, 144, 153
 Bahri, 30
Mamluk Empire, 14, 15, 30, 32, 153, 154
Ma'mun, al-, 104
Manisa, 34, 157
Mansur, 216
Martini, Simone, 118, 126, *129*
Mashhad, 161, 212, 214, 220
Masnavi-i Ma'navi, 64, 86, *87*, 88, *89*
Masterpieces of Muhammadan Art (exhibition),
 151–52
Mayer, L. A., 20
Mazandaran, 64
McIlhenny, John D., 159
McMullan, Joseph, 150
McWilliams, Mary, 132
Mecca, 100, 104, *105*, 106, 107
Medici hunting carpet, 204
Mehmet Ağa Mosque, 46
Mehmet II, Sultan, 24
Menteshe, 34
Merv, 104, 160
Mesopotamia, 18, 56, 159
metalwork, 12–37
Michaelian, Frank, 224
Ming dynasty, 40, 41, 54, 140, 163–65
Mirza Kamran, 100
Miskina, 103
Mongol Empire, 14, 15, 61, 63, 118, 128
Mongolia, 74, 165, 224
Mongols, 15, 22, 24, 30, 32, 34, 63, 64, 67, 72,
 74, 76, 92, 117, 118, 120, 122, 128, 138, 140, 146,
 204, 224
morning star, 84
Moses Challenges Pharaoh's Sorcerers (Cat. No. 17),
 60, 61, 62, 94, *95*, *96*, 98
Moses (Musa), 60, 61, 94, 95, 96, 98
Mosul, 13, 15, 18, 30, 161
Mudejar, 151

IMPRINT

Published in conjunction with *Arts of the East:
Highlights of Islamic Art from the Bruschettini Collection*,
an exhibition organized by the Aga Khan Museum
and The Bruschettini Foundation for Islamic and Asian Art
and presented from September 23, 2017, to January 21, 2018.

AGA KHAN MUSEUM

The Aga Khan Museum in Toronto, Canada, has been established
and developed by the Aga Khan Trust for Culture (AKTC),
which is an agency of the Aga Khan Development Network (AKDN).
The Museum's mission is to foster a greater understanding and
appreciation of the contributions that Muslim civilizations have
made to world heritage while often reflecting, through both its
permanent and temporary exhibitions, how cultures connect
with one another.

The Bruschettini
Foundation
for Islamic
and Asian Art

The Bruschettini Foundation for Islamic and Asian Art is a non-
profit organization founded by Alessandro Bruschettini in Genoa,
Italy. The Foundation serves as an organization whose aim is the
promotion, appreciation, and protection of Islamic and Asian
art. Its mandate includes the creation and facilitation of cultural
initiatives at national and international levels that contribute
to the development and diffusion of knowledge of Islamic and
Asian art and the promotion and support — independently and
jointly — of exhibits, expositions, research, conservation, restor-
ation, publications, conferences, scholarships, teaching activities,
and undergraduate and postgraduate courses whose main focus is
Islamic and Asian art.

All opinions expressed within this publication are those of the
authors and not necessarily of the publishers.

First published in Canada and Germany in 2017 by

Aga Khan Museum
77 Wynford Drive
Toronto, Ontario, Canada
M3C 1K1
www.agakhanmuseum.org

Hirmer Verlag GmbH
Nymphenburger Str. 84
80636 Munich
Germany
www.hirmerpublishers.com

For the Aga Khan Museum
Editor and Exhibition Curator: Filiz Çakır Phillip
Project Manager and Text Editor: Michael Carroll
Exhibition Designer: Gerard Gauci
Exhibition Manager: Sarah Beam-Borg

For The Bruschettini Foundation for Islamic and Asian Art
Director: Elisabetta Raffo
Coordination and Conservation: Luisella Belleri
Photography: Ghigo Roli, Paolo Vandrasch, and Carlo Vannini

For Hirmer Verlag GmbH
Project Manager: Rainer Arnold
Senior Editor: Elisabeth Rochau-Shalem
Design: Akademischer Verlagsservice Gunnar Musan
Colour Management: Rüdiger Mayer
Prepress: Repromayer, Reutlingen
Printing and Binding: Westermann Druck Zwickau GmbH
Paper: LuxoArt Samt New 150 g/m²

ISBN 978-1-926473-11-6 (Aga Khan Museum)
ISBN 978-3-7774-2964-9 (Hirmer)

Library and Archives Canada Cataloguing in Publication

The Bruschettini Foundation for Islamic and Asian Art
 Arts of the East : highlights of Islamic art from the
 Bruschettini collection.

Catalogue of an exhibition held at the Aga Khan Museum
 from September 23, 2017, to January 21, 2018.
 Art selected from the Bruschettini Collection.
Includes bibliographical references and index.
ISBN 978-1-926473-11-6 (hardcover)

 1. The Bruschettini Foundation for Islamic and
Asian Art--Exhibitions.
2. Islamic art--Exhibitions.
3. Islamic antiquities--Exhibitions.
4. Art--Private collections--Italy--Genoa--Exhibitions.
I. Çakır Phillip, Filiz, writer of added commentary, organizer
II. Aga Khan Museum (Toronto, Ont.), issuing body, host
institution
III. Title.

N6264.I8G46 2017 709.17′67074713541 C2017-905203-9

Bibliographic information published by the Deutsche National-
bibliothek. The Deutsche Nationalbibliothek lists this publication
in the Deutsche Nationalbibliografie; detailed bibliographic data
is available on the Internet at http://www.dnb.de.

Printed in Germany

Front Cover:
Detail of *Greek and Chinese Painter Competition* (Cat. No. 15)
Folio from a manuscript of *Masnavi-i Ma'navi* (Spiritual Couplets)
by Jalal al-Din Rumi (Maulana) (d. 1273); Tabriz, Iran, ca. 1540–50;
opaque watercolour, ink, and gold on paper; 22 × 14 cm